EVEREST

SUMMIT OF ACHIEVEMENT

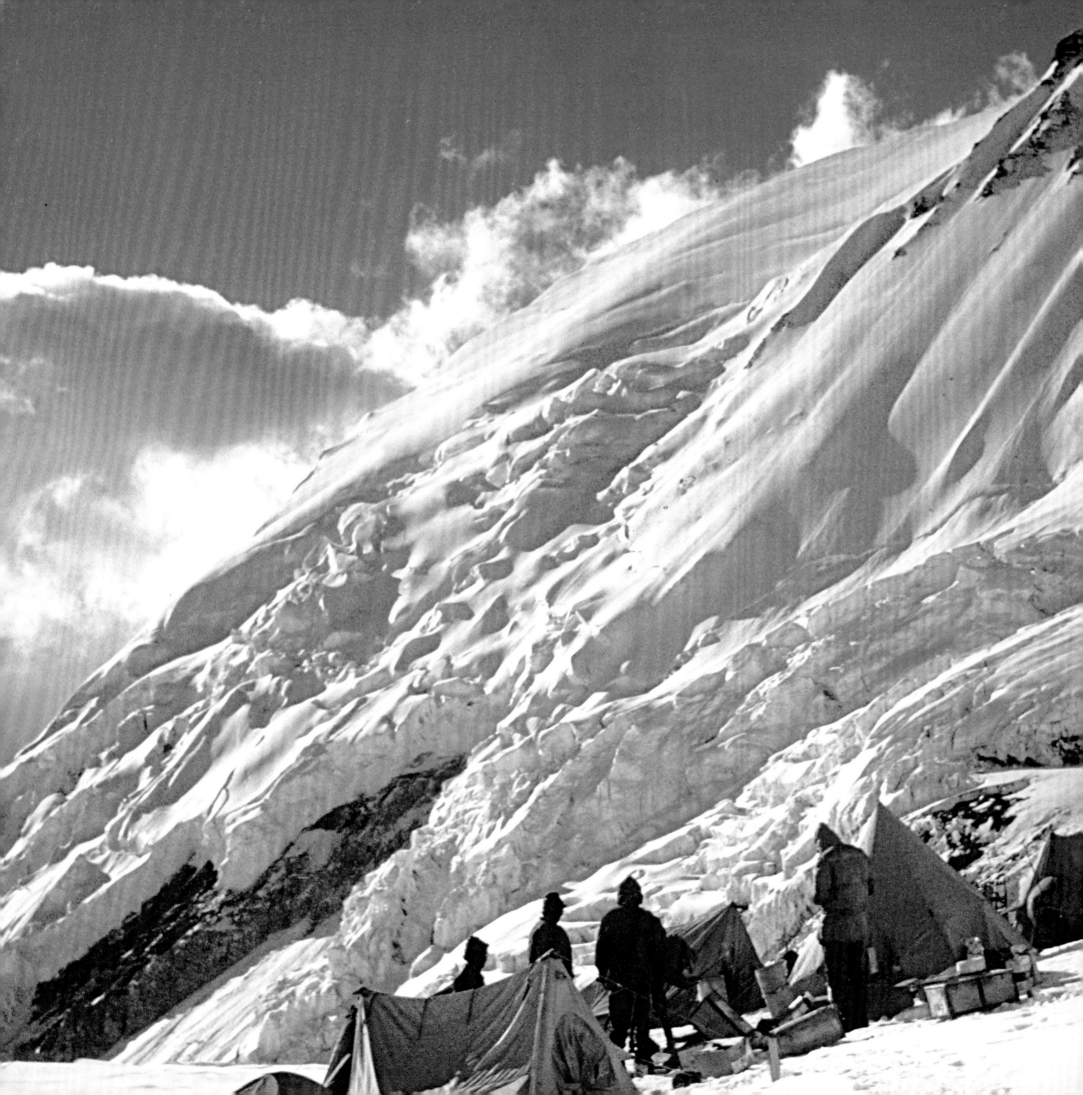

EVEREST

SUMMIT OF ACHIEVEMENT

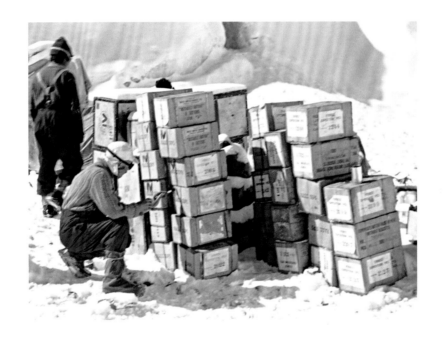

Royal Geographical Society, London

SIMON & SCHUSTER
New York London Toronto Sydney Singapore

First published in 2003 by Simon and Schuster, Inc.

SIMON & SCHUSTER
Rockefeller Center
1230 Avenue of the Americas
New York, NY 10020

For information about special discounts for bulk purchases, please contact Simon & Schuster Special Sales:
1-800-456-6798 or business@simonandschuster.com

Published by arrangement with Book Creation Services, Ltd., London, and Book Creation LLC, New York
Publishing Directors: Hal Robinson and John Kelly

Photography permissions

© Still photographs under licence from the Royal Geographical Society, London, unless otherwise
stated in the picture acknowledgments on page 252. The photographer is acknowledged with the
caption to each photograph. Special thanks are due to Sandra Noel for permission to use the photographs
by Captain John Noel as noted in the picture acknowledgments on page 252. Copyright © John Noel
Photographic Collection.

The Royal Geographical Society (with The Institute of British Geographers) would like to thank Rolex
for its generous support of the Everest Archive Project 2001–03. This support has allowed photographs
taken on nine British Mount Everest Expeditions, of which a selection are featured in this book, to be cataloged
and electronically databased. This important information will be available on-line and widely accessible.

Contributors and consultants
Ed Douglas, ExplorersWeb, Sir Edmund Hillary, John Keay, Reinhold Messner, Jan Morris, Tenzin Gyatso
(His Holiness the 14th Dalai Lama), Tashi and Judy Tenzing, Sue Thompson, Stephen Venables, Mike
Westmacott, and Joanna Wright.

Occasional reference is made in the text of the book to publications, using superscript numerals. The list of these
references can be found in the endnotes on page 252.

Designer: Peter Laws
Managing editor: Tamiko Rex
General editor: Joanna Wright
Senior consultant editor: Stephen Venables
Copy editors: Janice Anderson, Jonathan Dore, and Alison Moore

Photographs on pages
2. Camp V at the foot of the Lhotse Face looking toward the West Ridge of Everest.
Alfred Gregory, 1953
3. Charles Evans organizes the vital stores at Camp I after a snowfall. George Lowe, 1953
5. Edmund Hillary leads a party of Sherpas into the Western Cwm. George Lowe, 1953
6. Villagers from Kharta set up camp at Pethang Ringmo. Stephen Venables, 1988

Front cover: A camp beside the upper Kharta Glacier. A. F. R. Wollaston, 1921
Back cover: Mount Everest above the top of the Lhotse-Nuptse Ridge. Jeff Hall, 1999
Jacket flap portraits: Chris Wright, Caroline Forbes, Sue Carpenter, and Mike Banks

Manufactured in China

10 9 8 7 6 5 4 3 2 1

Library of Congress Cataloging-in-Publication Data is available

ISBN 0-7432-4386-2

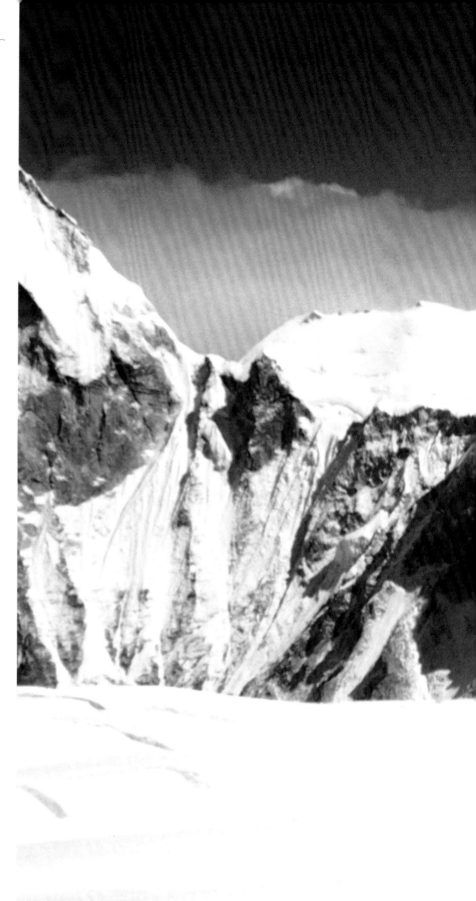

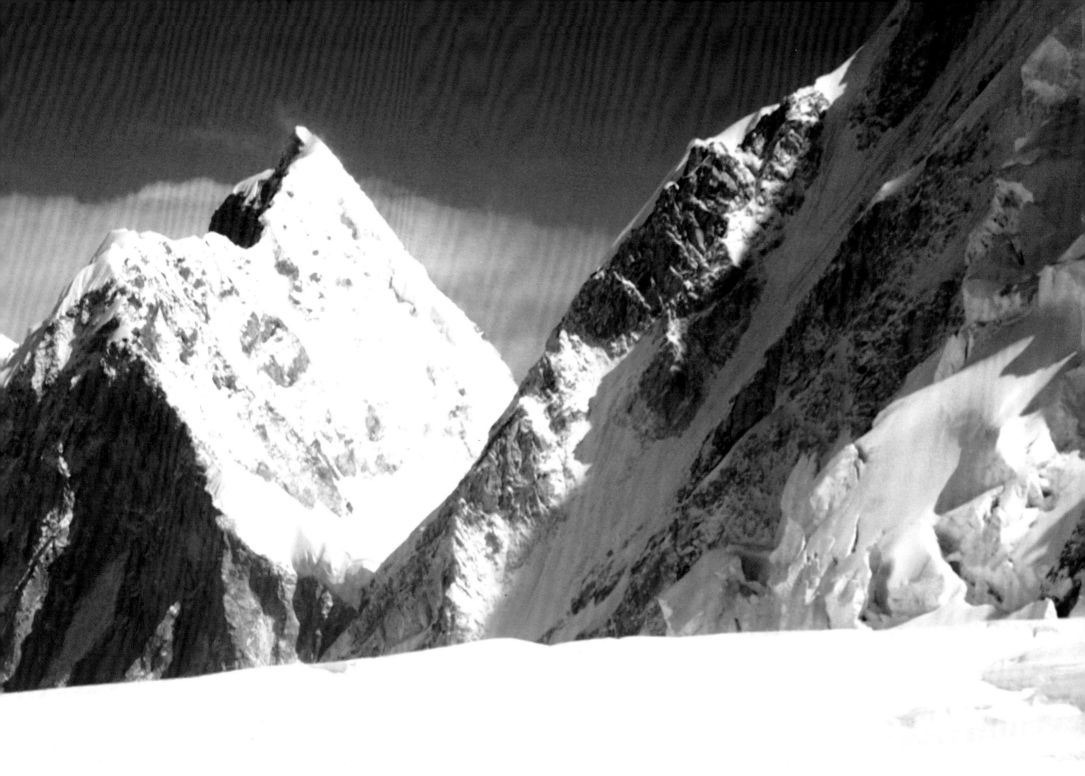

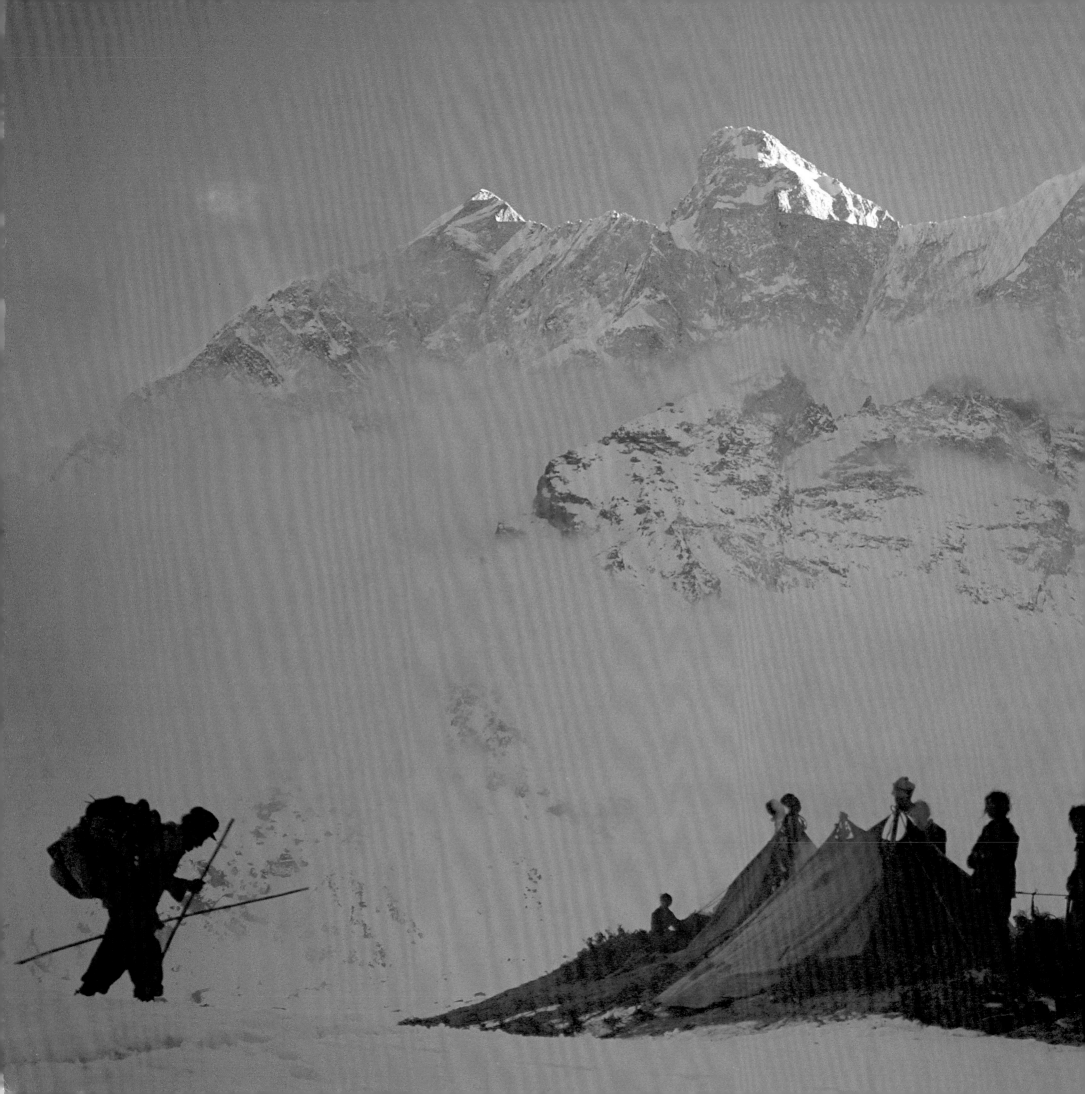

CONTENTS

FOREWORD

SIR EDMUND HILLARY

MOUNT EVEREST was first attempted in 1921 when the team crossed through into Tibet and examined the mountain's North Face. They concluded that a route via the North Col was the most satisfactory one.

The three expeditions in the 1920s had strong and determined men but their clothing and equipment were decidedly primitive. Despite this, several climbers battled their way to around 28,000 feet (8530 m), a rather amazing effort in the circumstances. The most dramatic incident was when George Leigh Mallory and Andrew Irvine climbed high toward the summit in June 1924 and never returned. Some are still debating whether they fell on the ascent or when descending after reaching the top. I personally believe the answer to this is of little consequence. I regarded Mallory as the heroic figure of those early days on Everest. He was the dominant climber of the early reconnaissances and his name became synonymous worldwide with Mount Everest. It would be nice to think that he had successfully reached the summit, but getting safely back to the bottom again is an equally important part of mountaineering and that, alas, he failed to do.

In the 1930s there were a number of new expeditions—all still from the Tibetan side—and once again several climbers reached 28,000 feet but could go no further. It almost seemed that 28,000 feet was as high as man could reach and survive. By then I was old enough to be interested in mountains and I reveled in one book—*Camp Six* by Frank Smythe. With Smythe I climbed every weary foot of the way up the north side of Everest. I too suffered the driving wind, the bitter cold, and the dreadful fight for breath in the thin air. And when he turned back at 28,000 feet I didn't regard it as a defeat but as a triumph.

The other book that filled my mind was *Nanda Devi* by Eric Shipton—I must have read it a dozen times. Shipton in his Himalayan explorations and climbs epitomized for New Zealanders the ideal of mountaineering. We too in our icy

Sir Edmund Hillary, 1953

Southern Alps had to pioneer new routes and lug huge loads across high passes and broken glaciers. We too still had new peaks to climb and fierce new routes to ascend in our remote mountain areas. I never believed I would get the chance to meet Eric Shipton. Eric had taken a small expedition to Everest in 1935 and one of his members was a New Zealand friend called Dan Bryant who was a very accomplished climber with great skill on snow and ice. He certainly impressed Shipton, which was to have considerable consequences for me later.

In 1951 I was a member of a four-man New Zealand party that ventured into the Gharwal Himalayas. We had a most successful time climbing six unclimbed peaks of up to 23,760 feet (7242 m) in height. And then we had exciting news—although Tibet was now closed for expeditions, Nepal (which had forbidden entry to outsiders for well over a century) had adopted a more liberal policy. Eric Shipton was taking a small reconnaissance to Everest from Nepal even though it was still regarded as impossible from that side. When news of our success in Gharwal reached London, Eric Shipton remembered Dan Bryant and immediately invited two of our party to join his expedition. It was an amazing opportunity!

Earle Riddiford and I raced by train across India, stopping in Lucknow to purchase the extra food we required. Two days later we arrived in the railhead of Jogbani in pouring rain—the monsoon was still in full strength. Shipton and his three companions had already left some days before and we chased after them, crossing flooded streams and being transported by canoe across the great Arun river. High above the river we reached the village of Dingla and met Shipton and his team for the first time. In pouring rain we carried on over the great Himalayan ridges, climbed steeply up through the remote village of Bung, and finally emerged in the valley of the Dudh Kosi river. To our great relief the rain eased and we could see the mighty snow-clad summits of Everest and its surrounding peaks.

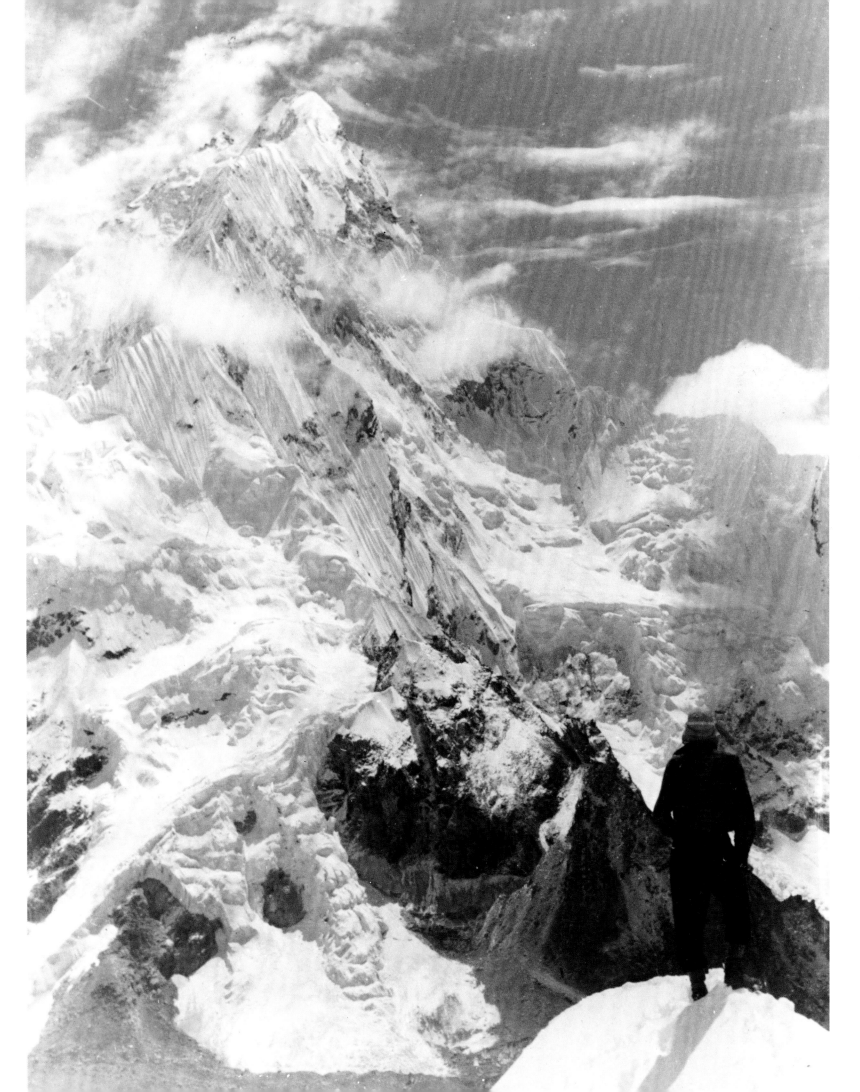

Edmund Hillary
in mountaineering
heaven, high on a ridge
of Pumori. Together,
Hillary and his great
hero Eric Shipton
scouted a new route
up Everest and, from
here, looked across the
Khumbu Valley to the
West Face of Nuptse,
a climbing objective
unimaginable in 1951.
It was finally climbed
by a Slovenian team
nearly 50 years later.

UNKNOWN, 1951

For the first time we passed through the Sherpa villages of Namche Bazar and Khumjung and looked in wonder on the amazing summit of Ama Dablam. We climbed the long Khumbu Glacier leading to the bottom of the mountain and the closer we got the more depressed Shipton became at the possibility of an ascent from this desperate-looking Nepalese side. "At least we have to go and have a look," he said, "then head off and explore some reasonable mountains."

We established our Base Camp some distance from the mighty icefall—a tumbled ruin of iceblocks and crevasses. Shipton had taken me under his wing and together we climbed up the ridge of Pumori to get a good view of the icefall and what lay beyond. As we reached above 19,000 feet (5790 m) we realized to our delight that we could look up the icefall, into the great snow valley of the Western Cwm, up the steep Lhotse Face, and even to the South Col—a demanding but clearly possible route to the summit was available. Our team struggled up the difficult icefall and looked into the Western Cwm before returning to Kathmandu with the cheerful confidence that next year a much stronger British expedition would have a good chance of reaching the summit. Alas we were greeted with the news that two Swiss expeditions had been granted permission for Everest in the following year—one to climb before the monsoon and one after. We'd have to wait an extra year!

In 1952 the Swiss tried very hard indeed. On their pre-monsoon assault, Raymond Lambert and Sherpa Tenzing Norgay reached 28,000 feet before they were forced to retreat. In the post-monsoon effort they experienced very strong winds and cold temperatures and reached little above the South Col.

So 1953 was free for our British expedition. Not without some disharmony our leadership was changed from Eric Shipton to John Hunt. We were well equipped with an excellent group of experienced Himalayan climbers and a strong team spirit. I discovered that I was probably the fittest and led the ascent of the icefall. My fellow New Zealander George Lowe played a dominant role in establishing the way up the Lhotse Face and finally our Sherpa team deposited a large amount of supplies and oxygen on the South Col. We were ready for the final assault.

We retreated to Advance Base Camp and all night the light shone in Hunt's tent. He gathered us together in the morning and announced the various teams and what they would do.

Charles Evans and Tom Bourdillon, with their powerful but erratic closed-circuit oxygen equipment, would have the South Summit as their main objective. If they felt strong enough they could push on to the summit. Tenzing and I with our more reliable open-circuit oxygen would aim for the summit itself.

And so the plan unfolded. As Tenzing and I climbed to the South Col we could see Evans and Bourdillon disappearing into the mist high on the Southeast Ridge; all too soon we saw them wearily descending again. They had reached the South Summit—higher than anyone had ever been before—but their oxygen equipment was faulty and with great reluctance they had returned. They arrived back on the South Col absolutely exhausted, but they had made a mighty effort.

Now it was the turn of Tenzing and myself. With a small support party of Lowe, Gregory, and Ang Nyima we moved slowly up the Southeast Ridge and established a final camp at 27,900 feet (8504 m). Then with many shouts of goodwill our support team turned downward again. Tenzing and I established our tiny tent and crawled in for the night. Great gusts of wind shook our tent at times but by early morning they had eased and we slowly emerged and climbed upward. We struggled slowly up the long, steep, snowy slope and stood at last on the South Summit. Ahead of us was the long, narrow summit ridge.

I dropped down onto the ridge and cut a continuous line of steps. Halfway along I met what I estimated to be a 40-foot (12-m) high rock wall. I wriggled to the top and Tenzing joined me. I continued hacking steps along the ridge, then up a few more to the right … to my great delight I realized we were on the top of Mount Everest and that the whole world spread out below us.

Even after 50 years I can still remember my feelings of satisfaction. I had no thought of the impact this ascent might have on the world in general, or indeed of the changes it might produce in my own life. We had succeeded where so many other great climbers had failed—that was enough in itself.

Ed Hillary

A MESSAGE FROM THE DALAI LAMA
TENZIN GYATSO, HIS HOLINESS THE 14TH DALAI LAMA

MOUNT EVEREST, or as she is known in Tibet, Chomolungma, provides a vivid example of how the same object can stimulate quite different responses among human beings. When British surveyors declared in the mid-nineteenth century that Mount Everest was the highest mountain in the world, the fact captured popular imagination and presented a challenge to many in the West. Plans were hatched to climb her. The enormous difficulties and dangers involved, far from discouraging the adventurers, seemed, if anything, only to have made the undertaking more daring. George Mallory, who was the first man nearly to succeed in the quest, famously answered, when asked why he wanted to climb Everest, "Because it's there." I imagine that for most Tibetans, "Because it's there" was a very good reason for not making the attempt.

Nevertheless, as most people know, Tenzing Norgay, a man of Tibetan origins, ultimately accompanied Sir Edmund Hillary in 1953 when the two of them became the first human beings to reach the summit, the highest place on earth. It was a proud achievement celebrated around the world. I understand the news reached Britain in time to coincide with Queen Elizabeth II's coronation, although ironically one of the few places where there were no celebrations was Tibet, struggling as we were to come to terms with the hardships of the Chinese Communist occupation.

Hillary and Tenzing's triumph, the result of great planning, teamwork, and individual effort, became an inspiring and positive example of what human beings can achieve. It was also another instance of the human ability to overcome nature, to dominate the world in which we live.

The traditional Tibetan attitude to mountains is quite different. They are treated with respect as the abodes of presiding deities. Tibetans, who generally live in the valleys or on the plains, would rather salute their mountains, offering juniper incense smoke in their direction, or piously circumambulating their bases, than try to conquer their summits. When climbing a mountain is the only way to complete a journey, Tibetan travelers respectfully add a stone to the cairns at the top of the pass with a shout of "Lha-gyal-lo—Victory to the gods."

However, there is one class of people who frequent the mountains for the very reason that other people stay away from them. Meditators welcome the simplicity and quiet that abound

His Holiness the Dalai Lama

in the mountains, for there they can meditate undisturbed. Since the practice of Buddhism involves seeing phenomena as empty of inherent existence, it is helpful for a meditator to be able to look into the vast, empty space seen from a mountain. Indeed, one of Tibet's most renowned meditators, the great yogi Milarepa, spent a fruitful period of his quest for spiritual enlightenment meditating in the vicinity of Mount Everest. He is remembered today as something of a national hero because, although he started out as an ordinary layman, he had the determination and made the necessary effort to achieve enlightenment in one lifetime.

Readers of this beautiful book about Mount Everest with its breathtaking illustrations will no doubt be struck by the natural majesty of the world's tallest mountain. They will gain a sense of her daunting and inspiring moods and expressions. They will be impressed by the climber's marvelous physical attainment in conquering the summit. However, may I remind them that in Tibet we remember Milarepa for meditating on her slopes and conquering the mind.

Dharmsala

THE PHOTOGRAPHS

JOANNA W[standard]

Handwritten note: • standard • Photographs

LIKE MANY LEARNED SOCIETIES throughout the world, the Royal Geographical Society (with the Institute of British Geographers) is home to a large collection of archives that record and chart the life of the institution, its subject, and its members. This Society, since being founded in 1831, has made a conscientious effort to collect maps, books, documents, and photography relating to its history and to geography, and today has amassed a collection of over two million items, which provides an outstanding resource and a valuable research tool.

Amidst this copious mass of material lies a unique collection relating to the world's highest mountain, the Everest Archive. Since the 1850s, when Everest was first identified as the tallest peak in the world, members of the Society have sought to reach this space, to know this mountain: Here at the Society's headquarters of Lowther Lodge can be found the traces of that pursuit. In numerous drawers, boxes, files, and containers, lie documents, letters, receipts, charts, drawings, maps, and photographs connected solely with the pursuit of climbing, mapping, and understanding this mountain. It is a tangible body of evidence for it provides details that bring to life the early stories of Everest in the form of letters and telegrams; lists of the food and equipment taken; diaries and passports; and general paperwork and housekeeping details.

The Royal Geographical Society and the Alpine Club formed a joint committee in 1920 called the Mount Everest Committee (MEC), which in turn became the Joint Himalayan Committee (1947). The objective of the MEC was twofold: to reach the summit of Everest, and to research its distinctive environment.

Wollaston's Dallmyer camera used on the 1921 Mount Everest Expedition.

MEC sent out nine expeditions to [the] mountain which at that time was in [p]laces on earth. The North Pole and [...] reached successfully before any Westerner had laid a foot near Everest's rocks and glaciers. For a time, Everest was even called the Third Pole, as it had become a defined space in the Victorians' minds that needed to be won. The Everest Archive is part of the Victorian legacy of Empire. They believed the world could be theirs and to make it so required them to conquer and survey it. The documentation and knowledge of far-flung regions brought back to such learned institutions as the British Museum and the Royal Geographical Society were made available to discerning minds and later archived.

When members of these Mount Everest expeditions, as they became known, finally reached the deified space in 1921 they were keen to record their memory of the mountain and of the people who live in its shadow. Everesters used the camera as one of their tools and today the Society holds approximately 20,000 images taken during the nine expeditions, a unique legacy. Today, work is in progress to curate and catalog these images onto one electronic database, which will be available to the public. However, it would be impossible to show all of this material in one publication. The intention of this book is to provide the reader with a unique selection of photographs from the Everest Archive that is informative, arresting, and beautiful.

The excitement and magic of seeing Everest for the first time at close quarters can be felt in the words of George Mallory during the 1921 Mount Everest Expedition:

Mountain shapes are often fantastic seen through a mist: these were like the wildest creation of a dream … Gradually, very gradually, we saw the great mountain sides and glaciers and arêtes, now one fragment and now another through the floating rifts, until far higher in the sky than imagination had dared to suggest the white summit of Everest appeared.[1]

Mountain areas have not always been considered places of beauty or exaltation, as described by Mallory. They were not places where one went to be motivated or enlightened. They were once terrible places, places our imagination feared, where demons lived. It is really only in the past two centuries that our ideas of mountainous regions have changed from places to be traveled through as quickly as possible to places we want to go to and spend time. So too have the language and art that represent them changed. Notions of the sublime imbue many of the photographic representations of mountains. The developing science of photography was combined with Romantic notions, and numerous photographers went out into the world to record the mountains as "temples of grandeur." From early photographs by the Bisson Brothers taken in the Alps (1860s), images by Vittorio Sella (1859–1943) of the Caucasus and the Himalayas, through to the iconic pictures of North America by Ansel Adams (1902–1984), mountain landscapes are part of Western ideas of splendor and refuge, spaces for recuperation, places to awaken the soul. The camera has been carried to the highest points to capture these ideas of the sublime and bring them back for us to see and connect with.

In his book *The Story of Everest* (1927, published in Britain as *Through Tibet to Everest*), team member and photographer of the 1922 and 1924 expeditions Capt. J. B. Noel ("St. Noel of the Cameras," as Brig.-Gen. Bruce referred to him) ponders the magnitude of the task of producing images that really show what he describes as the "power and majesty of the mountains." Noel comments that he needed all his physical strength and artistic ability to produce images that conveyed the reality of Everest to an audience, for "to dabble fatuously in trivialities in face of Everest's grandeur would be sacrilege."[2] It is interesting to note that Noel took some 25,000 cigarettes with him to keep his photographic porters happy while he aimed for the perfect picture.

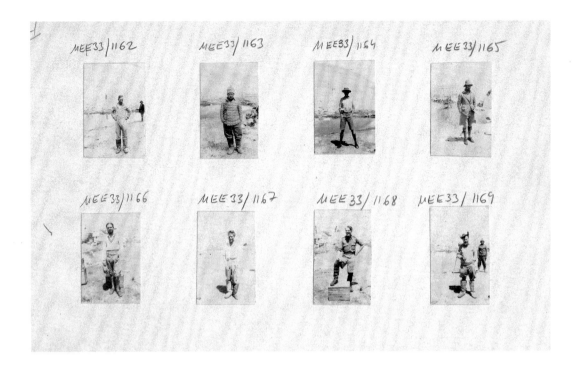

An example of original contact prints of expedition members taken by Raymond Greene in 1933. Shown here are eight of the original Everest images from the approximate 20,000 held in the Society's photographic collection.

Photography always has been an important component of Mount Everest expeditions. Even today it would be hard to imagine an expedition without a camera. Since the birth of photography, explorers have understood the "added value" of imagery and how it is a useful device in constructing the visual narrative to their tales of adventure and exploration. The expeditions to Everest were no exception.

From the first Everest expedition onward, cameras and the paraphernalia required were part of the equipment factored into the logistics of climbing the mountain. For the porters it was certainly a heavy load, from cameras to lenses, glass-plate negatives, tripods, and chemicals. These early expeditions took all that was needed both to expose and to develop pictures on the mountain; they also encountered technical difficulties with the apparatus. Lt.-Col. Howard Bury was "gassed" by fumes from the fixing agent used to develop negatives, and lost his voice for several days. George Mallory put the negative plates back to front in the camera he was operating and writes about his frustration on discovering his mistake: "It was a depressing evening. I thought of the many wonderful occasions when I had caught the mountain as I thought just at the right moment, its moments of most lovely splendor—of all those moments that would never return and of the record of all we had seen which neither ourselves nor perhaps anyone else would ever see again."[3]

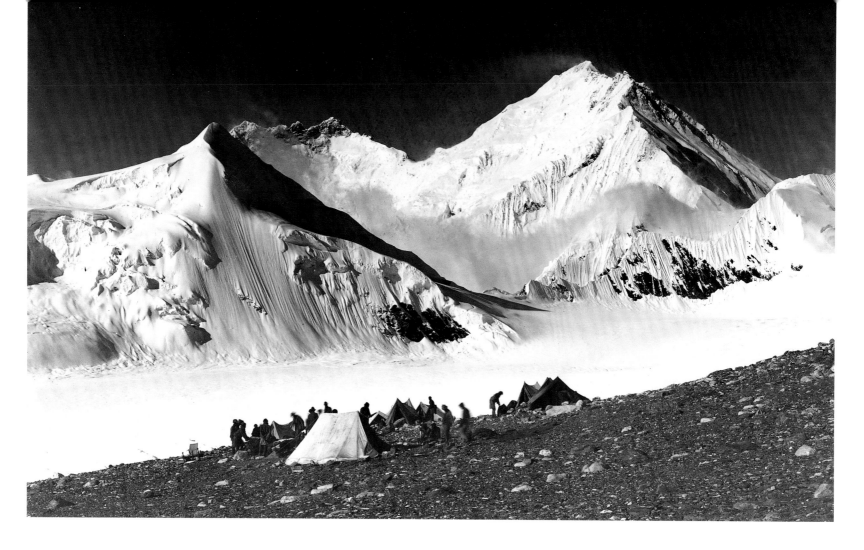

Mallory and Guy Bullock reconnoitered high to take these pictures. Both soon learned that the most effective way to climb was to listen to their breathing and to consciously breathe hard. With every step, the in-breath and the out-breath was thought through. Almost meditatively they listened to their breathing to reach these lofty elevations. On looking at images of Everest one can almost hear the arduous breaths of the photographer behind every photograph.

Mallory famously disappeared with Andrew Irvine near the summit of Everest in 1924. Whether they did or did not reach the summit is still being questioned today. Several expeditions in recent years have hunted for the elusive camera and film anticipating they would hold some proof of what happened to the pair. The photographic record is seen as tangible evidence; there is still the faint hope of seeing through the lens of the camera the image last seen by Mallory's eyes.

Though images have been lost, some forever, we do have the legacy of those that remain. These photographs were taken by a disparate group of men from naturalists to climbers, doctors of medicine to army generals, and there are fascinating differences in how each saw and recorded his time on or near the mountain. Often it is the small but significant detail that leaps out at us, for instance, in the image of "Everest from a camp at 20,000 feet" taken by A. F. R. Wollaston. Everest sits majestic in the background, with a small, inconsequential camp in the foreground. To the left sits a lone chair set out at a short distance from the camp. Lt.-Col. Howard Bury wrote of how he and the others sat and watched the extraordinary sight of Everest from this camp for some time, transfixed by the mountain and the "plume of smoke" created by wind-blown snow at the summit. The small detail of the chair captures the imagination and allows viewers to escape into the image, to take the seat themselves, to hear and see Everest.

These early images of Everest are quite astonishing in their ability to transport the viewer to another time and place. They are also important as historical documents for the Tibetan and Nepali peoples. Everest, located on the border of Tibet and Nepal, was inaccessible from Nepal before World War II, as this hidden Himalayan kingdom did not allow access to Western visitors. Tibet, under the spiritual and temporal leadership of His Holiness the 13th Dalai Lama, was more amenable. In the 1920s and 1930s, the Dalai Lama gave access to the North Face

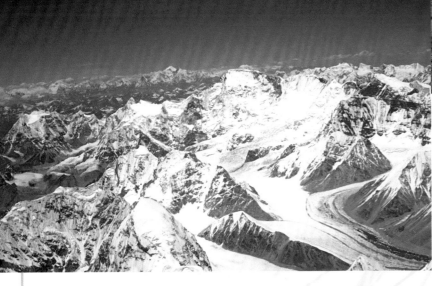

North from the summit (Rongbuk Glacier, Changtse, and the East Rongbuk Glacier).

Photo: Edmund Hillary, 1953

View from the Top

When Tenzing Norgay and Edmund Hillary reached the summit of Everest on May 29, 1953, Hillary took one of the definitive images of the twentieth century—Tenzing on top of the world holding aloft the flags of the United Nations, Great Britain, Nepal, and India. Then, as unassailable proof of their achievement, he took a series of views over the land he knew so well from three momentous seasons of Himalayan exploration.

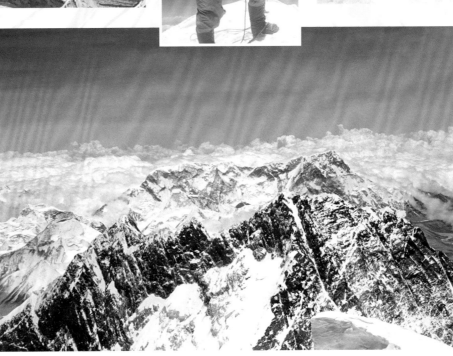

West from the summit, showing Pumori (foreground), the West Rongbuk Glacier, and Cho Oyu (center).

Photo: Edmund Hillary, 1953

South from the summit, showing the black ridge of Shartse, Lhotse Middle, and Lhotse, with Chamlang in the distance.

Photo: Edmund Hillary, 1953

East from the summit, showing Kangchenjunga in the far distance and, left to right, Chomolönzo, Makalu II, and Makalu.

Photo: Edmund Hillary, 1953

The revered Abbot of Shekar-Chöte, considered a saint by Tibetans, was dressed in robes of golden brocades for this photograph. Copies of it were often given as a gift by Everest expedition members to Tibetans, who then placed the image in a shrine to worship.

PHOTO: LT.-COL. HOWARD BURY, 1921

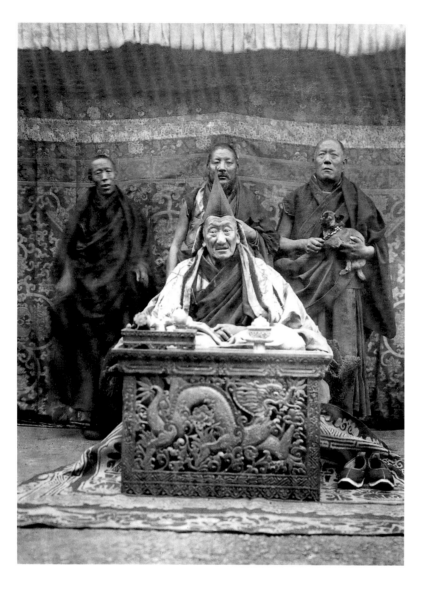

the importance of photography in their relationships and encounters with Tibetans. Howard Bury wrote:

> *…and here I photographed a group of several monks. They had never seen a camera or photographs before, but they had heard that such a thing was possible and were very much interested in it. Before leaving we went in to see the Head Lama who had lived over sixty-six years in this monastery. He was looked upon as being extremely holy … After much persuasion the other monks induced him to come outside and have his photograph taken, telling him he was an old man, and that his time on earth was short, and they would like to have a picture to remember him by … The fame of this photograph spread throughout the country and in places hundreds of miles away I was asked for photographs of the Old Abbot.[4]*

Tibetans embraced photography and were happy to oblige team members by posing for them. These images have contributed to how we see Tibet and Tibetans even today—as a place and a people set outside time. In the early 1950s the Chinese closed the door of Tibet to the West, preventing any further attempts on Everest from the North Face for many years. A new route would have to be found. Using photographs from the 1920s and 1930s and aerial images taken during a covert flight by RAF Flight Lieutenant Neame in 1947, new information about the south side of Everest was gleaned—the face that lay inside Nepal's border.

As Tibet closed, Nepal slowly opened its border and gave access to a steadily increasing number of Western climbers and visitors, to what has in our minds come to be a "Shangri-La." Today, images abound of Nepal's architecture of Buddhist sites, the fertile paddy steps, and the magnificent Himalayan peaks. Until the 1950s, it was a remote country and very little of it had been photographed. The last two Mount Everest Expeditions sent by the Joint Himalayan Committee were given unprecedented access, and the images from the Everest Archive show areas such as the Solu Khumbu before the advent of mass tourism. Thus the Everest Archive is an important record for the Tibetan and Nepali peoples; how they see these images and use them is yet to be seen.

of Everest, which required journeying through Sikkim and Tibet. Climbing Everest gave members an opportunity to see a previously "blank space on the map" and to meet the people who inhabited it. Maps of Everest today are compiled from the early survey work carried out on these expeditions. Team members first learned about the landscape that surrounds Everest by talking with the local Tibetans. Everesters commented that initially their questions regarding distances received responses that did not make sense when plotted onto the map they were compiling. It soon transpired that distance was measured in cups of tea, with three cups of tea equaling approximately 5 miles. Having once made this translation, team members found it easier to calculate their journeys.

The Everest Archive holds some of the first photographs of the people in this region of Tibet. Even at the time the photographs were taken, members of the expedition realized

By the turn of the twentieth century there were various ways of producing color photographs, such as the Autochrome process and Paget plates. These processes were not used on Everest, possibly because of the technical difficulties involved. The predominance of black-and-white images in the Everest Archive is obvious; it was a proven method of producing images. Captain Noel, however, was not satisfied and wanted to show the Tibetan landscape and its people in color to the audiences to which he lectured. During his time in Tibet, Noel laboriously collected information about the colors he encountered using watercolors and an American color chart, and on his return he meticulously hand-colored his lecture set of lantern slides.

Noel entranced many audiences with his lantern-slide lecture, the materials of which have been carefully preserved since his death by his daughter Sandra Noel. A number of these hand-colored images are published here for the first time along with the first color transparencies taken during the 1930s by Everest expedition members Frank Smythe and Charles Warren. These rare color images bring Everest to life and provide a new perspective.

From the 1950s color photography was beginning to be used widely by the general public, and Alfred Gregory, official photographer of the 1953 expedition, used it extensively and encouraged other team members to do so as well. The most striking difference between the color images and the black-and-white is to be seen in the color blue. At high altitude the sky becomes a pulsatingly electric blue and the images transmit this stimulating light back to the viewer.

The most famous image of Everest is that taken by Sir Edmund Hillary of Tenzing Norgay on the summit at 11:30 a.m. on May 29, 1953; it sums up more than 30 years of tenacious endeavor to reach this pinnacle. It also provides clues to understanding how Everest has become a byword for success and achievement. Edmund Hillary wrote of that moment: "I had carried my camera, loaded with colour film, inside my shirt to keep it warm, so I now produced it and got Tenzing to pose for me on the top, waving his ice-axe on which was a string of flags—British, Nepalese, United Nations, and Indian. Then I turned my attention to the great stretch of country lying below us."[5]

There is no picture of Hillary on the summit, a fact often unknown to picture researchers. Tenzing did not know how to use a camera and, as Hillary pointed out, it was not the moment to teach him! Importantly, however, Hillary also took a panorama from the summit of the view below, almost as proof that they had reached the summit. Indeed it would have been easy to forge an image of a member of the team, zipped in a feathered jacket and goggled up on what looks to be a compact pinnacle of snow with the indigo-blue void behind. But to simulate a complete view from the roof of the world would have been impossible. These images allow us to gaze across the Himalayas—snaking glaciers, outcrops of bare rock, pure white snow, and billowing clouds—a vast magnitude of space taken from a tiny but highly significant point of the earth's surface that had finally been reached.

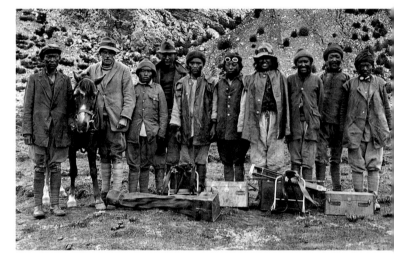

If they had not had a camera with them, would we have believed that they had reached the summit of the highest mountain in the world? This is an important question to ask as it allows us to reflect on the other images from the Everest Archive. These images provide a platform to understanding how the Western gaze on Everest has developed and been redefined again and again, creating a place in which we have invested our hopes and fears. Since few of us have been to the Himalayas, the only way we have come to feel connected to the Everest story is through the images that we have seen published in books, magazines, and on television. For the majority of us, photography is a way of traveling to see the highest mountain in the world.

It is important to think of the Everest Archive as a group of fragments. No archive of documents, however well collected and organized, can paint the whole picture. What this archive provides is a gateway to glimpsing the people who have become part of the story of the mountain; it allows us to make connections and to understand the world they inhabited, to which we are all in some way inextricably linked.

"St. Noel of the Cameras" stands alongside his photographic porters and some of the equipment that was needed to take both his still photographs and cine film. Noel's aim was to democratize the work of the expedition by disseminating information through images.

PHOTO: CAPT. J. B. NOEL, 1922

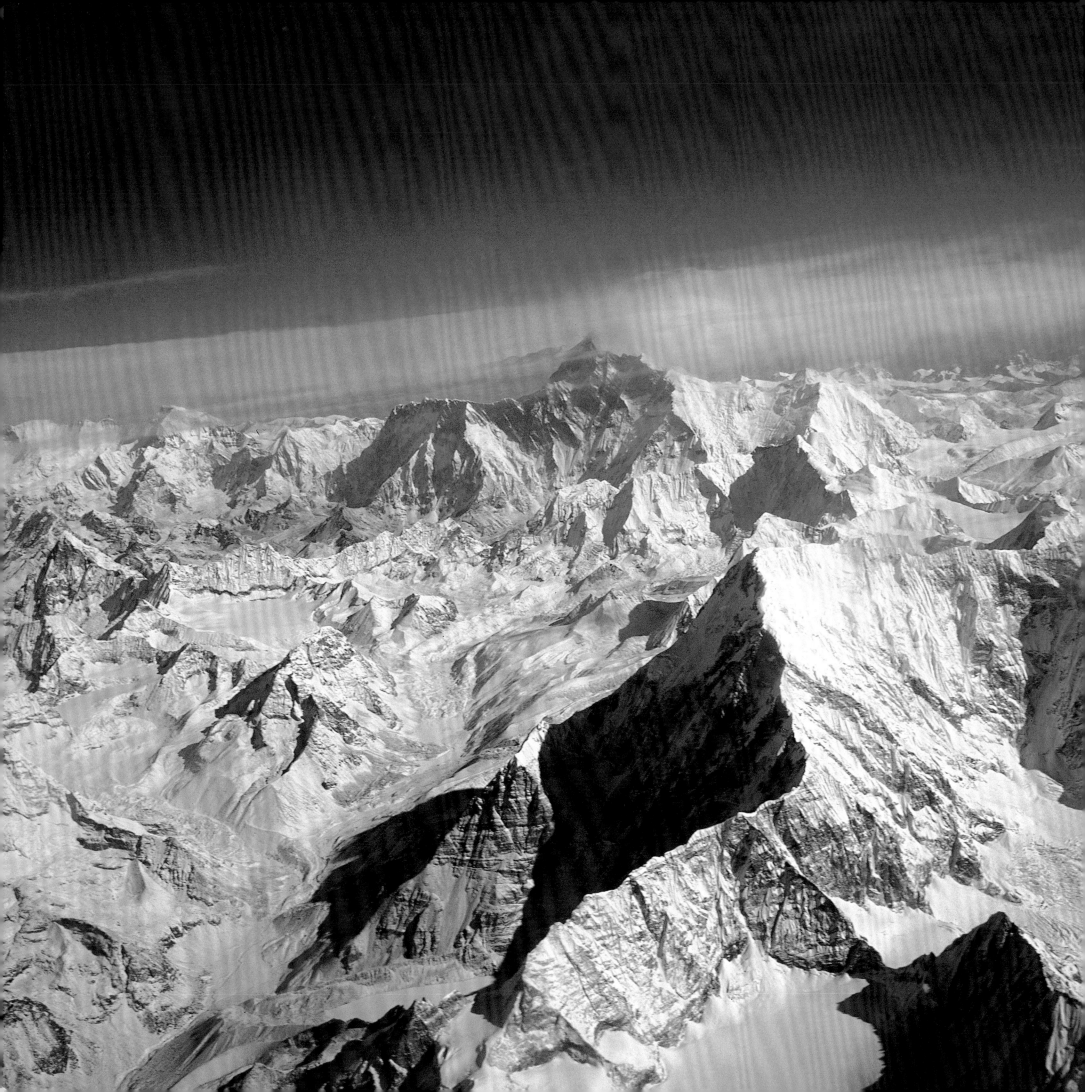

THE HIGHEST MOUNTAIN IN THE WORLD

The discovery of the mountain was the crowning achievement of labors just as complicated and demanding as those required to eventually climb it. Both endeavors faced formidable obstacles—physical, psychological, political, and technical—that often appeared insurmountable. The story of Everest, therefore, is the story of both its discovery and its conquest.

JOHN KEAY

GEORGE LEIGH MALLORY'S famous answer to the question "Why climb Everest?" was "Because it's there." Why it was there, like why it was called Everest, did not concern him. In fact, its magnificent height, the summit of the highest range of mountains on earth, is the result of tectonic action—the inconceivably powerful geologic force that moves the continental landmasses against each other. The landmass of India is forced against the landmass of Asia, and the Himalayan ranges are pushed up in between. The process continues inexorably to this day, lifting the entire Himalayan range by several millimeters each year.

This range, which is really a complex skein of ranges, is the mightiest geographical feature on the earth's surface. About half as long as the Atlantic is wide, it boasts more than a hundred peaks in excess of 24,000 feet (7315 m) above sea level and at least 20 of more than 26,000 feet (7925 m), which is higher than the highest mountains found anywhere else in the world.

Seen from the moon, the range would be the frown on the face of our planet. It is also Asia's "Great Barrier Ridge" and India's "Great Wall of China." Defining the south Asian subcontinent, its peaks intercept the clouds, sundering climatic zones, peoples, and lifestyles. By repulsing the monsoon of south Asia it denies to inner Asia the lushness enjoyed by India and condemns it to extremes of temperature and aridity. Immediately north of the mountains, trees are rare and the (Mongoloid) people are mainly graziers; immediately to the south the slopes are well forested and the (Aryan) people are mainly farmers and crop growers.

A climatic barrier and a rampart against invaders, the Himalayas also control Asia's life-support system. From the Tibetan plateau, which is swagged and supported by the Himalayas, 10 of the world's largest rivers plunge south and east, around and through the Himalayan wall, heading for the Indian Ocean and the China Seas. On the banks of these rivers (including the Indus, Ganges, Brahmaputra, Irrawaddy, Mekong, and Yangtze), Asia's civilizations were nurtured; on their floodwaters half the world's population still depends. To these people, droughts apart and dams permitting, the frown on the face of our planet is more like a benevolent smile.

In the heart of these mountains lurks the peak we know as Everest. But although it has always been there, Everest was for a long time unacknowledged. It was not especially obvious,

In this modern aerial view, Everest's summit (rising center above the Lhotse-Nuptse wall) towers above everything else. PHOTO: DAVID CONSTANTINE, 1990

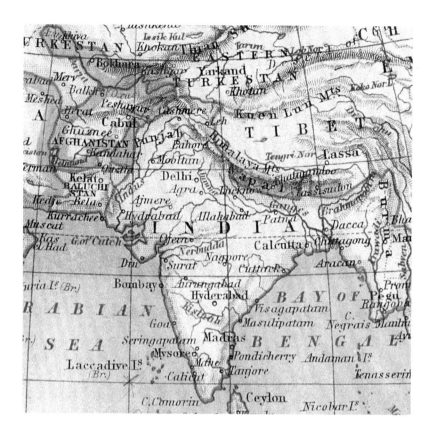

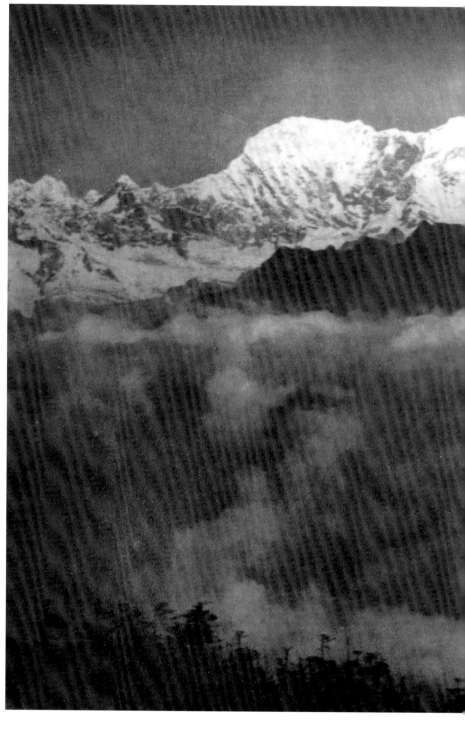

like Mount Fuji; nor was its existence a geodetic certainty, like the North and South Poles; nor was it, until recently, an accepted geographical feature, as is the River Nile. Exploration left it till last because it was the last terrestrial challenge to be identified. To mapmakers the mountain was unknown until the mid-nineteenth century; and when, in 1856, it finally made its cartographic debut, it came with an exact location, a measured height, and an easily recognizable name. Like DNA, it burst upon the world's consciousness as the result of an extraordinary scientific odyssey; and there it has stayed because of its one outstanding property as the world's highest point, a place a little nearer the stars than anywhere else on our planet. The discovery of the mountain marked the crowning achievement of labors just as demanding as those involved in actually climbing it. In both endeavors, the obstacles—physical, psychological, political, and technical—were formidable and, for a long time, deemed insurmountable. The story of Everest, therefore, is the story of both its discovery and its conquest.

THE CHALLENGE

From the plains of northern India, the mountains appear (cloud cover permitting) as a long, serrated ridge of snowy peaks sublimely etched against the horizon. Closer acquaintance

reveals something much more complex. The serrated ridges disappear behind a tangle of densely wooded outer ranges, and the glistening fangs, when glimpsed from closer quarters, present unfamiliar profiles. The Himalayan wall, some 2000 miles (3200 km) long, is about 300 miles (480 km) wide, with its successive ranges so stepped that the highest peaks are always the furthest and often appear dwarfed by lesser peaks nearer at hand. In fact, just to reach the base of Everest from the plains, one must climb and descend several times its actual height,

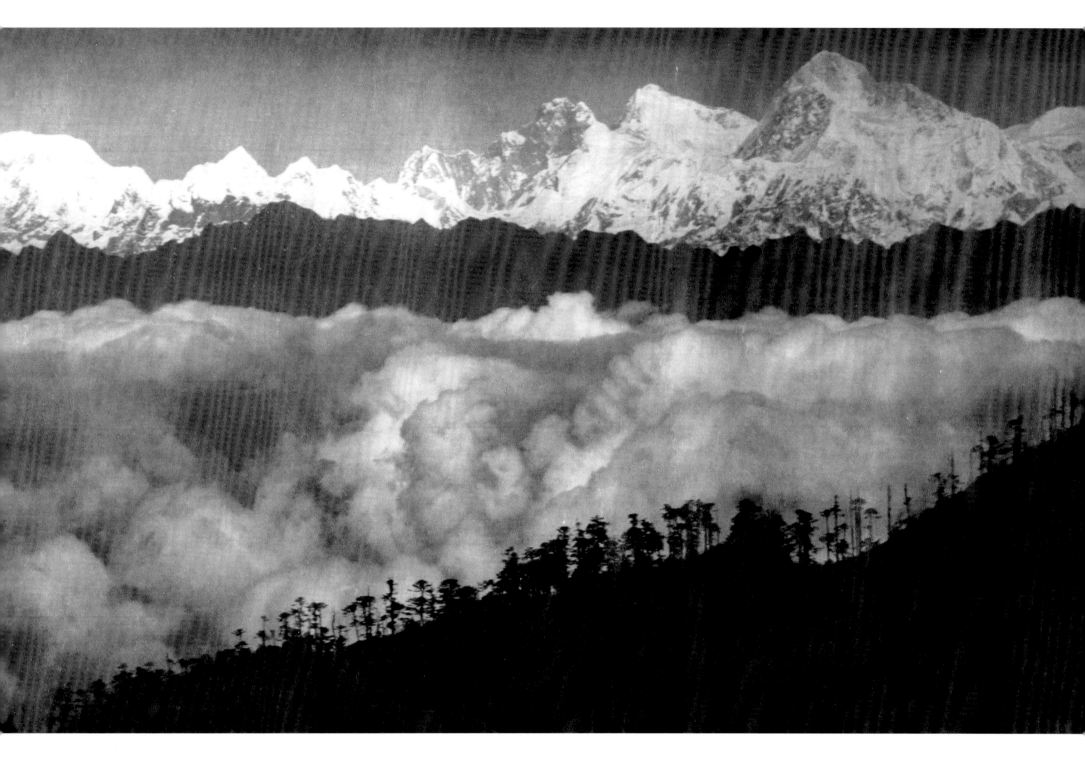

fording innumerable torrents in the process, removing hordes of highly intrusive leeches, experiencing extremes of temperature and precipitation, as well as suffering from the premature decrepitude (or worse) caused by oxygen deficiency. It is as if the mountains objected to trespassers.

Until the nineteenth century few contested this desire for privacy. India's peoples called the range *Him-alaya*, "the abode of snows." It was also known as "the abode of the gods;" there Lord Shiva reigned and only ascetics and pilgrims occasionally

ventured. Tibet's Buddhists reportedly referred to it as "the Lamasery of the Snows"[1] (a lamasery being a monastery for lamas). Sanctity clung to its remote fastnesses, and unbelievers were discouraged from desecrating this most holy place. Nepal, whose territory embraces the range's central section, refused all access to the mountains from the south from 1815 until 1945; and Tibet, the "forbidden land" *par excellence*, tried to prevent access from the north for nearly as long. For one hundred years, only the extremities of the range were accessible.

The Himalayan range from Sandakphu on the Singalela Ridge in Sikkim. Makalu dominates on the right, with the Kangshung Face of Everest rising behind. Left is the massive South Face of Lhotse and Nuptse.

PHOTO: UNKNOWN, 1890–1900

The first printed European map that named Tibet was published in the Jesuit Atlas Description Géographique Historique *by Jean Baptiste d'Anville in 1733, and was based on an earlier Chinese map from 1717–18.*

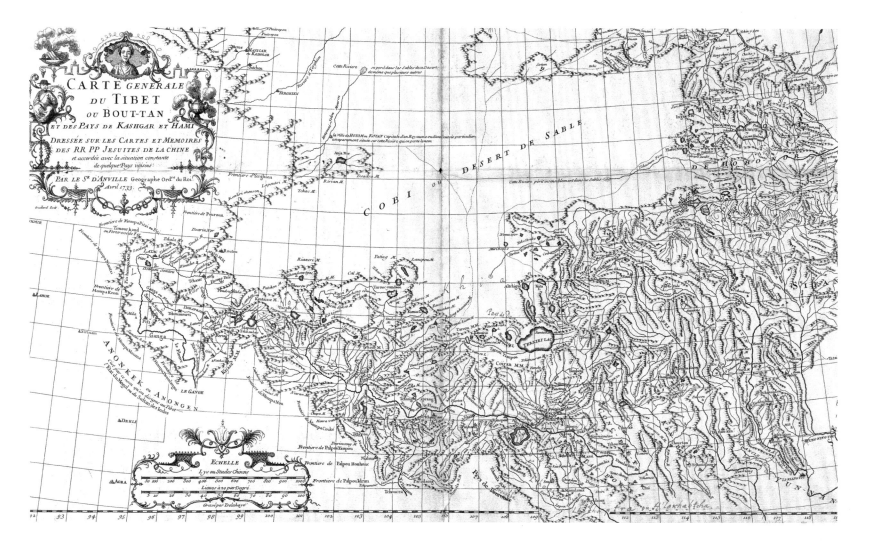

Political considerations were involved, but this isolationism was essentially cultural, and founded upon the belief that misfortune would surely follow from any disrespectful penetration. That Tibet was populated by monks and ruled by a god-king added to the mystery. It seemed appropriate that, halfway to heaven, "the roof of the world" should host so otherworldly a society. But it was also tantalizing. The allure of the mountains was heightened by their mystique.

EARLY EXPLORATION

The nineteenth century's great age of exploration was inspired in part by a spirit of acquisition that, though usually political or commercial, was sometimes dignified with the cloak of scientific inquiry. Science, as an adjunct to exploration, involved rationalizing, classifying, quantifying, and representing the natural world. It could be, in other words, another form of control, and was not always easily distinguishable from cruder methods of exploitation and conquest.

Typical of such activity was the measuring and mapping of the earth's lesser-known regions, those *terrae incognitae* whose blank spaces so intrigued the nineteenth-century explorer. Along with the polar regions and the inner realms of Africa, Australia, and Arabia, the Himalayas were a major challenge. Jesuit missionaries had reached Tibet via Kashmir and the western Himalayas in the early eighteenth century, and emissaries from the British East India Company in Bengal had done so through Bhutan in the late eighteenth century. But they took little interest in the mountains themselves; and maps, like that of Jean Baptiste d'Anville of 1733, showed "the snowy range" simply as a single ridge of unknown height.

The first suggestion that the Himalayas might be "among the highest mountains of the old world" came from Maj. James Rennel, who in the 1770s surveyed up to the mountains in Bengal on behalf of that province's recent British conqueror, Col. Robert Clive (later Lord Clive of Plassey). At that time, the world's highest mountains were thought to be the Andes,

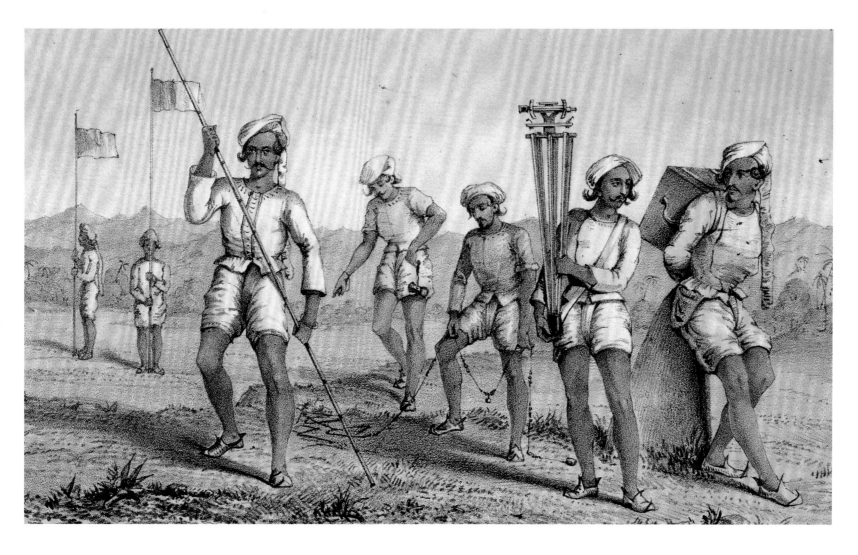

Indian survey porters carry the equipment needed for the massive task of mapping India. Clearly to be seen in this nineteenth-century lithograph are a level, its tripod, measuring chain, and leveling staff, which measures 10 feet (3 m) high.

while the highest peak in the "old world" (that is, Eurasia and Africa) was supposed to be Pico de Teide on the island of Tenerife. It was difficult to measure altitudes, even when observing them from sea level. The height of Pico de Teide, despite being measured by marine sextants, was in fact overestimated by several thousand feet (its true height is actually 12,198 feet/3718 m).

In 1784, Sir William Jones, a Calcutta judge and British India's greatest polymath, went one further than Rennel and declared that the Himalayas were the highest mountains in the world "not excepting the Andes." Jones had corresponded with two explorers who had crossed into Tibet. He deduced that the highest peaks were much more distant than was generally thought, and from the banks of the Ganges he measured the angle of elevation to one in Bhutan (it was Chomolhari), which he calculated to be 244 miles (393 km) away. The height thus roughly gauged from this calculation, plus the fact that it was covered in snow throughout the year, convinced him that

the Himalayan peaks rose to a height greater than the 20,000 feet (6100 m) then measured in the Andes.

He could not prove it, however, and his claim was discarded by the scientific establishment—dismissed as just another tall tale from the land of the Raj. Also discredited, this time correctly, was a suggestion that the Himalayas were a range of active volcanoes (their plumes of wind-blown snow had been mistaken for smoke); as well as a report that, despite their proximity to the tropics, they were flanked by great glaciers. This report turned out to be perfectly true.

As British rule spread across the plains of northern India, surveyors followed in its wake; more peaks were revealed along the northern horizon, and more measurements were attempted. From Bihar in 1790 an elevation of 26,000 feet (7925 m) was deduced, but was again dismissed; and from the Nepalese frontier in 1810 came further claims of altitudes exceeding 26,000 feet. One such claim related to a peak that actually had a name, Dhaulagiri. In 1816, it prompted a long

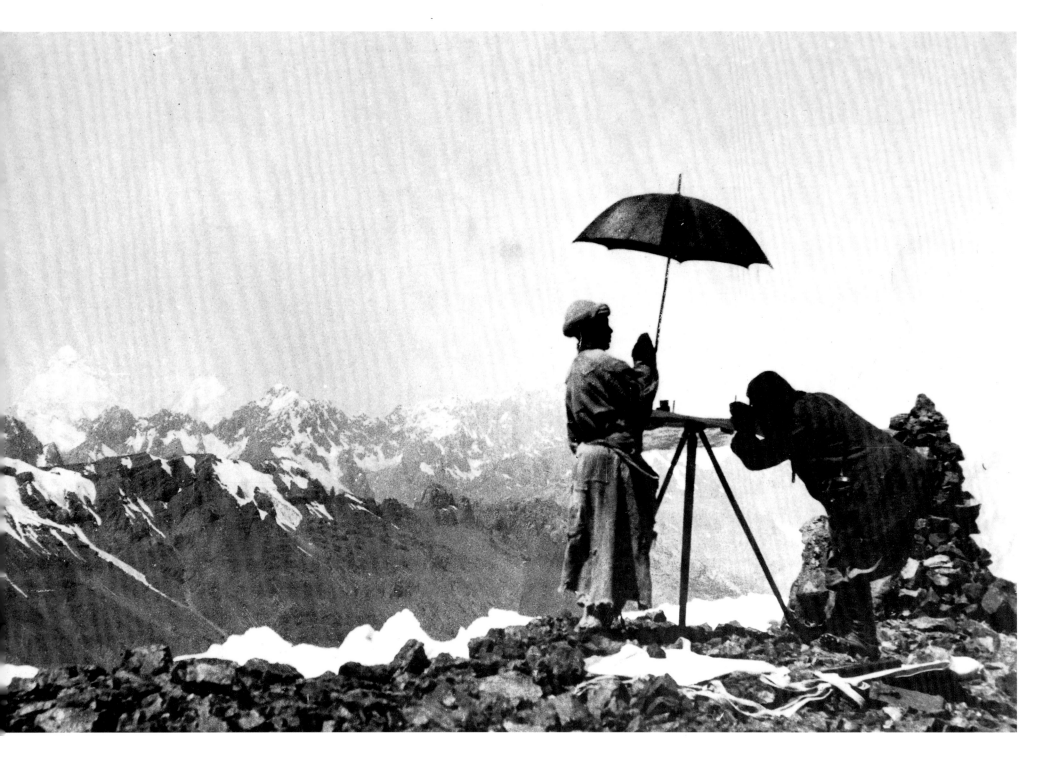

paper on the subject that urged "an unreserved declaration" that the Himalayas "greatly exceed" the Andes.[2] But this was also rejected: the distances from which these angles of elevation were being taken were so great, and the angles themselves therefore so small (usually around 2° above the horizontal), that the smallest error would produce a colossal distortion. The instruments then available were not accurate enough for such work and there were too many unknowns, such as the precise height from which the observations were being taken.

Only in 1817–20, when the first surveyors penetrated the mountains to the west of Nepal and began measuring them at close quarters, did the evidence become overwhelming. Trekking up to heights of 12,000–16,000 feet (3660–4880 m), Lt. William Webb and Capt. John Hodgson were among colossal glaciers and eternal snows; and still the main summits towered above them. But now proximity to the peaks meant that the observed angles of elevation were much greater and so much less liable to distortion. Careful measurements were taken, and

Khan Sahib and Afraz Sul Khan plane tabling for Kenneth Mason from the Tartar La, Kashmir. Not personally involved in the Everest expeditions, Major Mason made very ambitious survey expeditions elsewhere.

PHOTO: MAJ. K. MASON, 1926

one giant looked to be, according to a scribbled note in Webb's angle book, "so far as our knowledge extends, the highest mountain in the world."[3] Its local name was Nanda Devi and for the next 30 years, while expeditions into the central Himalayas from Tibet and Nepal remained impossible, Nanda Devi reigned supreme as the world's highest mountain (its height is now established at 25,645 feet/7817 m).

THE GREAT TRIGONOMETRICAL SURVEY

Ironically, the techniques required for accurately measuring the height of mountains from a distance had already been developed elsewhere in India. In 1802, William Lambton had begun from Madras what has been called "one of the most stupendous works in the whole history of science."[4] Lambton was interested in geodesy, the study of the precise shape of the earth. Replicating similar experiments in Europe and South America, but to a much higher degree of accuracy, he had embarked on a mission to measure the curvature of the earth.

This could be done by comparing the distance between two points as ascertained by astronomical observation, with the figure obtained by actual measurement taken along the ground; from the difference between the two the curvature could

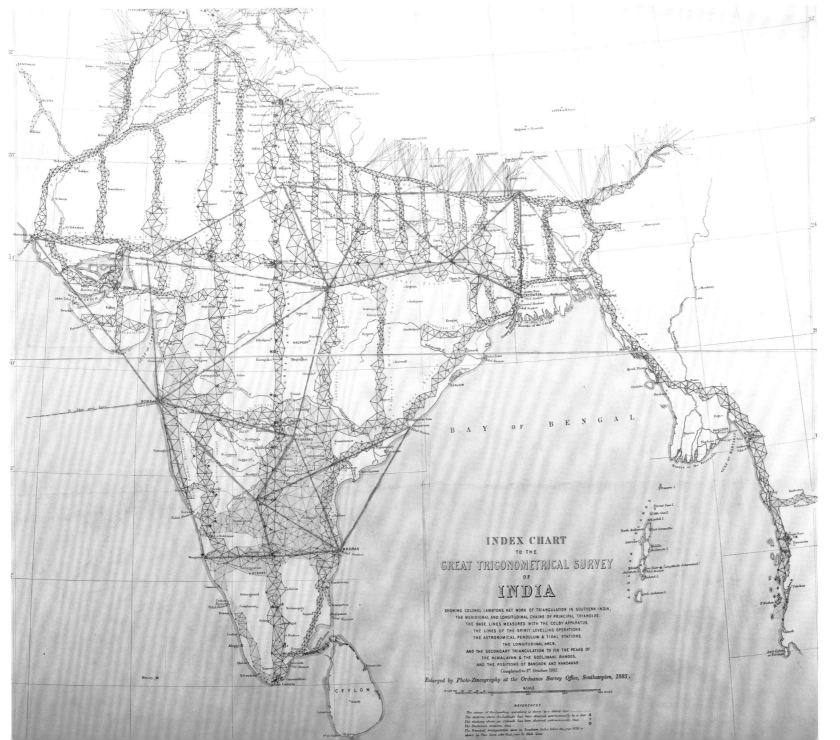

The 1870 Index Chart to the Great Trigonometrical Survey of India showing the extension of William Lambton's triangulation network in southern India. For the first time, this scientific endeavor allowed an accurate framework for a map of India. This in turn unraveled the heights of the Himalayan mountains and established Mount Everest as the highest mountain in the world.

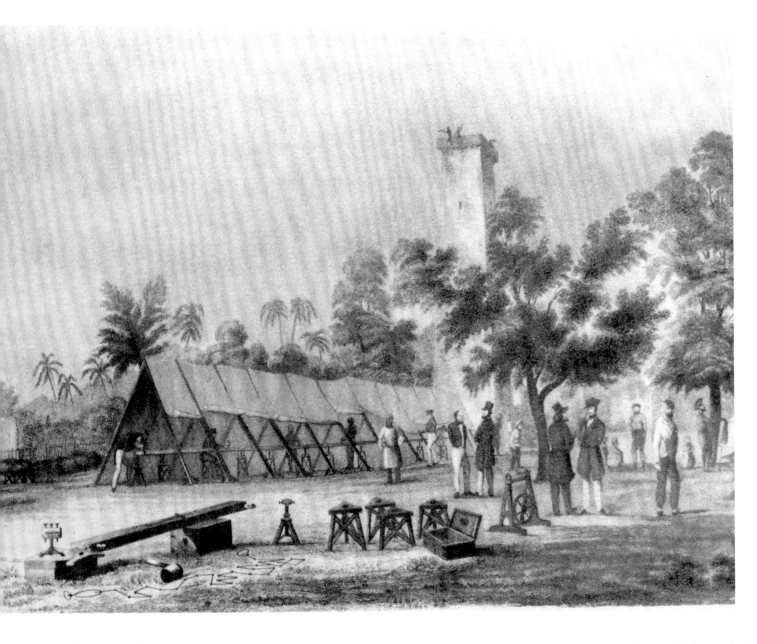

The Calcutta Base Line, constructed from 1831–32, aroused much interest among residents, seen here viewing the first set of compensation bars (under the awning).

William Lambton (1753/6–1823), Surveyor General of India. In 1802 Lambton began to measure the curvature of the earth from Madras. His life's work brought hardships of malaria and other fevers that eliminated entire survey parties, but resulted in "one of the most stupendous works in the whole history of science." It was not completed until many years after Lambton's death.

be calculated. It sounded simple, but the required accuracy was possible only with very elaborate instruments (Lambton's theodolite weighed half a ton and was the size of a small tractor) and over enormous distances (his Great Arc from the south of India to the Himalayas would be about 1600 miles long, more than 2550 km).

Such an ambitious geodetic exercise had the added virtue of greatly facilitating the mapping of India. Lambton's measurement along the ground was achieved not with a measuring tape but by a process known as "triangulation." A baseline between two points, usually about seven miles (11 km) apart, was carefully measured over a period of several weeks using a chain of precisely known length mounted on wooden trestles. Then, from each of the same two points, the angle between this baseline and the sight line to a third point was measured using a theodolite (a standard surveyor's tool: A basic theodolite is a tripod-mounted telescope that swivels and tilts within calibrated rings, measuring horizontal and vertical degrees). A triangle was thus formed and, if the length of one of its sides (the baseline) plus two of its angles was known, the lengths of its other sides could be calculated by means of trigonometry. One of these sides could then be used as the baseline for another triangle without the need for ground measurement, further triangles being projected and calculated solely through triangulation between intervisible points. As the triangulation progressed, chain measurements along the ground were necessary only to check from time to time the accuracy of the exercise. This "trigonometrical survey"

On the low-lying plains of India and along the northern borders, towers were erected to sight trigonometrical observations for long-distance measurement. This tower station enabled the Survey of India to continue its ever-extending chain of measurements.

PHOTO: UNKNOWN

resulted in a scattering of locations, or "trig points," usually in the form of a chain zigzagging across the landscape.

Since Lambton's survey started at sea level in the vicinity of the Madras observatory (whose coordinates in terms of latitude and longitude were precisely known), the elevation and coordinates of all subsequent trig stations could be deduced with unimpeachable accuracy. They therefore constituted invaluable reference points for mapmakers throughout India, providing them with a template into which detailed local surveys could be slotted.

As Lambton's chain of triangles extended north, with other chains branching off to east and west, they formed a grid that would eventually encompass all of India. The Great Trigonometrical Survey, as it came to be known, would thus, for the first time, accurately quantify and define what the British understood by the term "India." Its maps provided a paradigm, a blueprint for British dominion in the sub-continent. And Lambton's Great Arc, in addition to giving a new value for the earth's shape, would also, almost incidentally, provide the means for unraveling the secrets of the Himalayas and thereby discovering the great peak that would be known throughout the world as Everest.

ENTER EVEREST

It was a slow and arduous process. The Great Arc took 40 years to reach the Himalayas. It generated the most complex mathematical equations known to the precomputer age; and it cost more lives and more rupees than most contemporary Indian wars. Malaria and other maladies eliminated entire survey parties; porters were devoured by tigers; and where no handy hills existed for establishing the lines of sight required, flag men atop bamboo scaffolding tumbled to their death through the jungle canopy.

Lambton himself breathed his last in 1823 when his Arc was about halfway up the spine of India. His successor, who

Lambton's Great Theodolite, used by both William Lambton and George Everest during the Great Trigonometrical Survey of India, was capable of measuring both the vertical and the horizontal axes. It weighed approximately half a ton and needed 12 men to carry it.

PHOTO: UNKNOWN, 1870–74

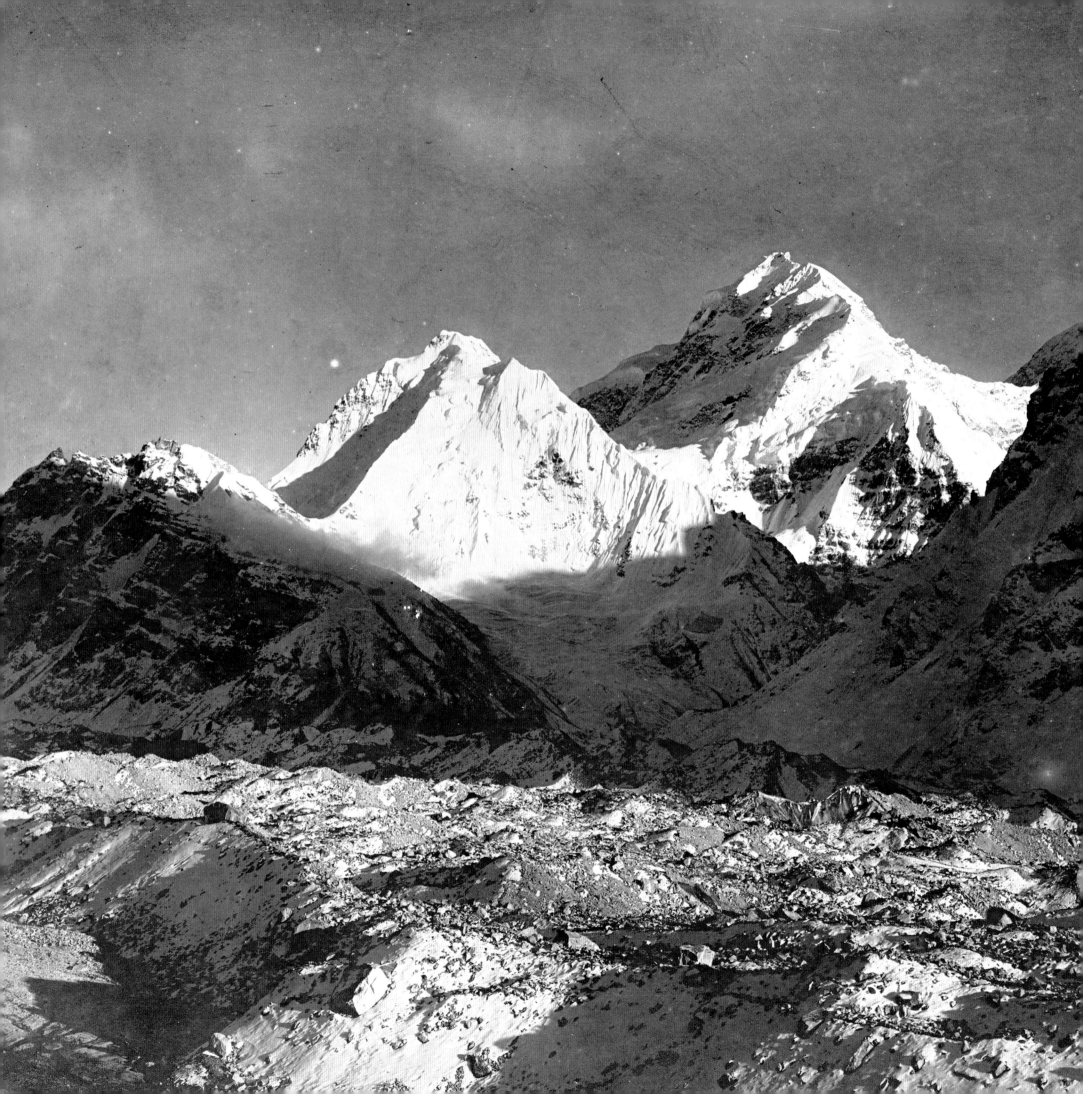

conducted the Arc to its grand Himalayan finale, was already debilitated by malaria and dysentery when he took over. He soon got worse, enduring temporary blindness, recurring paralysis, and several bouts of certifiable insanity. Not surprisingly, he also gained a reputation as the most ill-tempered sahib in India. His name was Col. George Everest.

Everest the man never saw Everest the mountain. But when he retired in 1843, the Arc was complete all the way to Dehra Dun in the foothills north of Delhi, and arms of triangulation were being extended east and west along the Himalayan glacis. The eastern arm provided the first precise locations from which the positions and heights of the central Himalayan peaks could be established. In 1847 Andrew Scott Waugh, Everest's successor as superintendent of the Great Trigonometrical Survey, while observing from near Darjeeling in the eastern Himalayas, calculated a new height for the great massif of Kangchenjunga. At 28,176 feet (8590 m) it far exceeded any peak yet measured, including Nanda Devi, and Waugh duly recognized it as the world's highest mountain (it is in fact the third highest, though the modern accepted value for its height is 28,208 feet/8598 m).

But Waugh did not publish his findings. For, from the same point, he had glimpsed a much more distant cluster of peaks, more than a hundred miles away, on the Nepal-Tibet border. They might be higher still; and in the hope of a better sighting, he instructed his surveyors to look for them from other points along this eastern arm of the Arc.

Later in 1847, and again in 1849, the same cluster of peaks was sighted and angles taken. Each sighting resulted in a new designation for their highest point, and it was soon clear that Waugh's "peak gamma," and the "peak b" and "sharp peak h" of his colleagues in the field, were one and the same. Averaging the various values obtained, this peak was unquestionably higher than Kangchenjunga. Still Waugh delayed. He redesignated all the main peaks with Roman numerals, he checked sea level as far away as Karachi, and he got his staff to

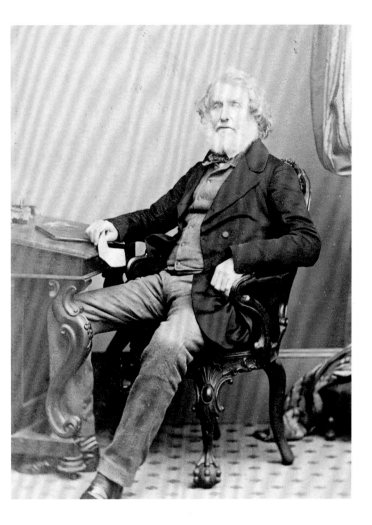

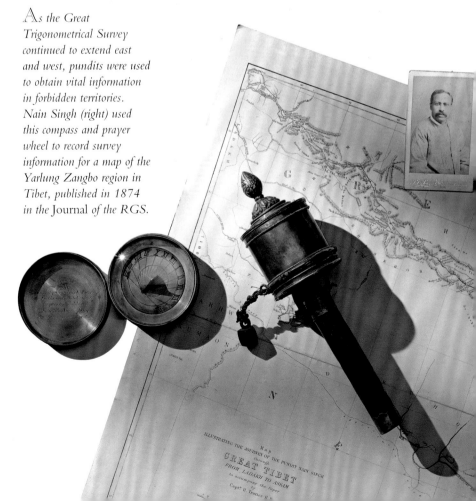

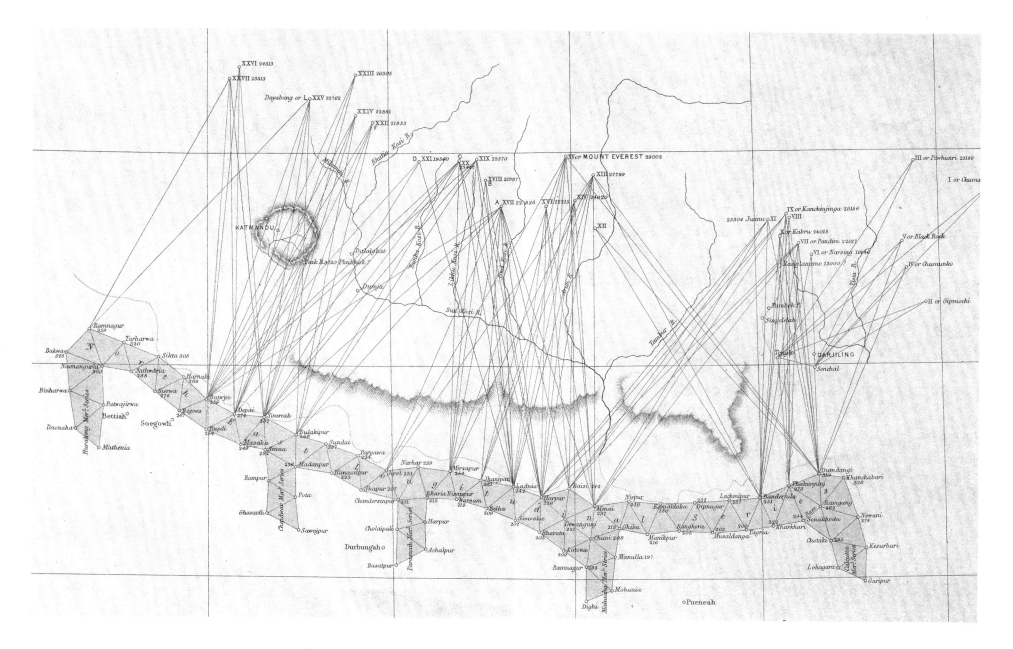

go over and over all the calculations. A Bengali number-crunching genius called Radhanath Sickdhar was his "chief computer," and Sickdhar soon became convinced that "Peak XV," as it was now called, had no rival.

Eventually, in 1856, Waugh went public. In a letter to the Asiatic Society of Bengal he announced that at 29,002 feet (8840 m) "Peak XV" in the Nepalese Himalayas was "most probably" the world's highest mountain. In honor of his predecessor, "the illustrious master of accurate geographical research," whose Great Arc had made the measurement possible, he also declared that "this noble peak" should henceforth be known as "Mont Everest."[5] The "Mont" soon became "Mount" and the height has been revised several times since (the latest value, calculated with the Global Positioning System in 1999, is 29,035 feet/8850 m). But, despite objections from some, the name Everest has stuck.

EARLY RECONNAISSANCE EFFORTS

No one seriously thought of climbing Everest at the time. The mountain was inaccessible as Tibet and Nepal were still closed to Europeans; and mountaineering, or "Alpinism," was still in its infancy. In Europe, peaks half the height of Everest were still defying the efforts of climbers kitted out only with thick tweeds, stout sticks, and heavy ropes. Even if the climb proved technically feasible, it wasn't known whether a man could actually survive at such a height.

By coincidence, Mount Everest's only serious rival as the world's highest mountain was discovered just as Waugh was

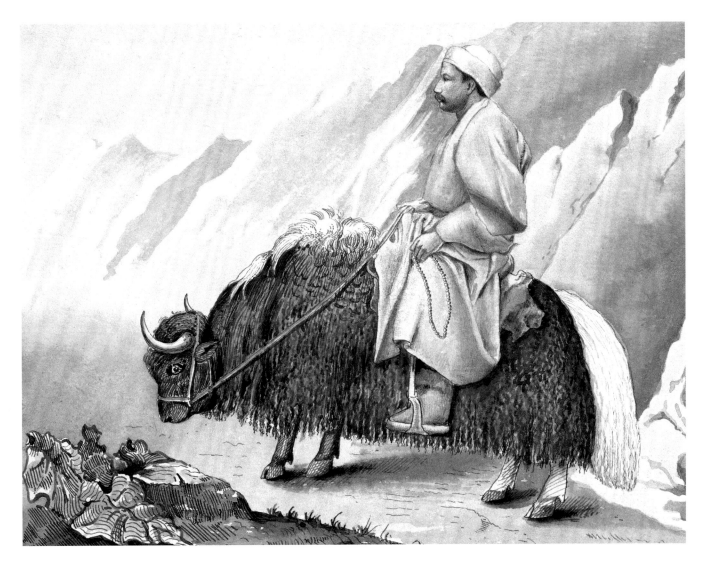

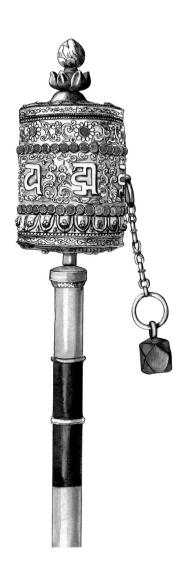

This prayer wheel, sketched by Sarat Chandra Das in 1879, was formerly in the possession of the mother of the late Tashi Lama. The prayer wheel is silver and is studded with corals and turquoise. Prayer wheels helped to disguise pundits as pilgrims, but were also used by them to record measurements and hide survey notes.

The pundit Sarat Chandra Das, traveling incognito on a yak, crosses the Donkhya Pass at 18,000 feet (5490 m) in 1879. The information that Chandra Das and the pundit codenamed "M H" recorded was all that was known about the approaches to Everest in the early years of the twentieth century.

making his announcement. This was the peak listed as the second in the survey of the Karakorams (a satellite range of the Himalayas in Kashmir) and it is still known today as "K2." The Great Trigonometrical Survey had rapidly been extended west, as well as east, of the Great Arc, and in the 1860s embraced the whole of Kashmir. Here, too, were Himalayan giants, and although K2 itself looked as unassailable as Everest, surveyors found themselves obliged to climb many lesser peaks. In 1862–64 William Henry Johnson not only climbed to 21,000 and 22,000 feet (6400–6700 m) but constructed trig stations there, set up his instruments, and stayed for days waiting for the clouds to clear. His altitude record would stand for the next 20 years.

The mountains of Kashmir had been given the highest priority because the British Empire, having conquered all India, perceived threats to its "jewel in the crown" from beyond the mountains. The most worrying of these was that

supposedly posed by Czarist Russia's conquests in central Asia. The Russian advance had already prompted a disastrous British occupation of Afghanistan in 1839–41 and by 1860 was exercising British minds as to the security of the Himalayas themselves. Anxious to know more about the high passes and the lands that lay beyond them—and still inhibited by Tibetan xenophobia—Capt. T. G. Montgomerie of the Kashmir Survey hit on the idea of equipping and training Tibetan-looking Indians so that they could explore and survey beyond the mountains on Britain's behalf.

These men, recruited in regions of the mountains already under British control, were known as "pundits" (from the Hindi *pandit*, "teacher," for the profession of the first of their number, Nain Singh). For the next 20 years they performed a series of amazing journeys across Tibet and into central Asia. Traveling incognito and in constant danger of detection, they carried only the most basic instruments, including a compass

concealed in a prayer wheel and a rosary designed for counting off their carefully measured paces. They were in no position to measure mountains or to climb them. But they did bring back valuable route surveys and other material for the mapmakers, plus a mass of unpublished political and strategic data. "As late as the early years of the [twentieth] century, the journeys of Sarat Chandra Das who passed by the east, and of the explorer 'M H' (another of the pundits), who passed by the west, comprised the sum total of our knowledge of the approaches to Mount Everest," noted John Noel before attempting to follow in their footsteps.[6]

PIONEERING ENDEAVORS

Probes like these revealed that Tibet was not entirely innocent of political affairs, and was in contact with the dreaded Russians. By now, the romantic but deadly "Great Game" of espionage and counter-espionage north of the mountains had

several non-Indian exponents. A notable British player of the Great Game was Capt. Francis Younghusband, who in 1888–92 roamed freely in the region north of the Karakorams "where three empires meet" (British, Russian, and Chinese). Operating in the name of geography but in reality a spy, he had many hairbreadth escapes, climbed to more than 20,000 feet (6100 m), and conceived a deep passion for the mountains. He also underwent a profound spiritual experience from which he would later derive "a new religion."

Returning to India via the Chitral Valley (in Pakistan) in 1893 Younghusband met a small coterie of British officers stationed there, who spent their days climbing and shooting in the neighboring mountains of the Hindu Kush. It was in conversation with one of them, Hon. C. G. Bruce, that the possibility of climbing Everest is said to have first been aired. Nothing immediately came of the idea, but it lodged in Younghusband's mind.

In 1904 this was the closest view (opposite) British officers had yet encountered of Mount Everest. From Kampa Dzong, Everest rises magnificently from the Tibetan plateau only some 60 miles (100 km) away. This landscape photograph was taken with a telephoto lens.

PHOTO: JOHN CLAUDE WHITE, 1904

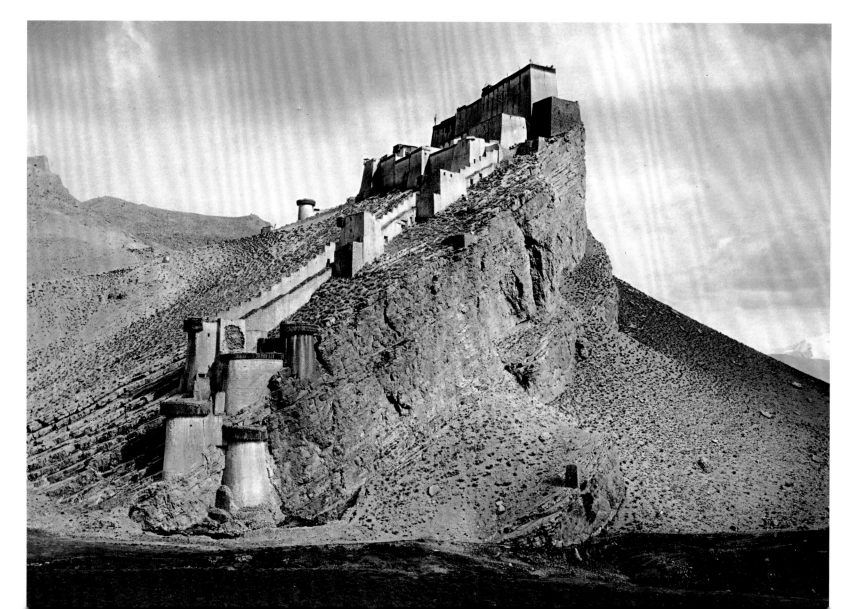

Kampa Dzong (left), a fort built on top of an outcrop of rock that was reached by a party reconnoitering during Younghusband's British Mission to Lhasa. This fort was to become one of the many sights regularly seen by expeditions to Everest during the 1920s and 1930s.

PHOTO: JOHN CLAUDE WHITE, 1904

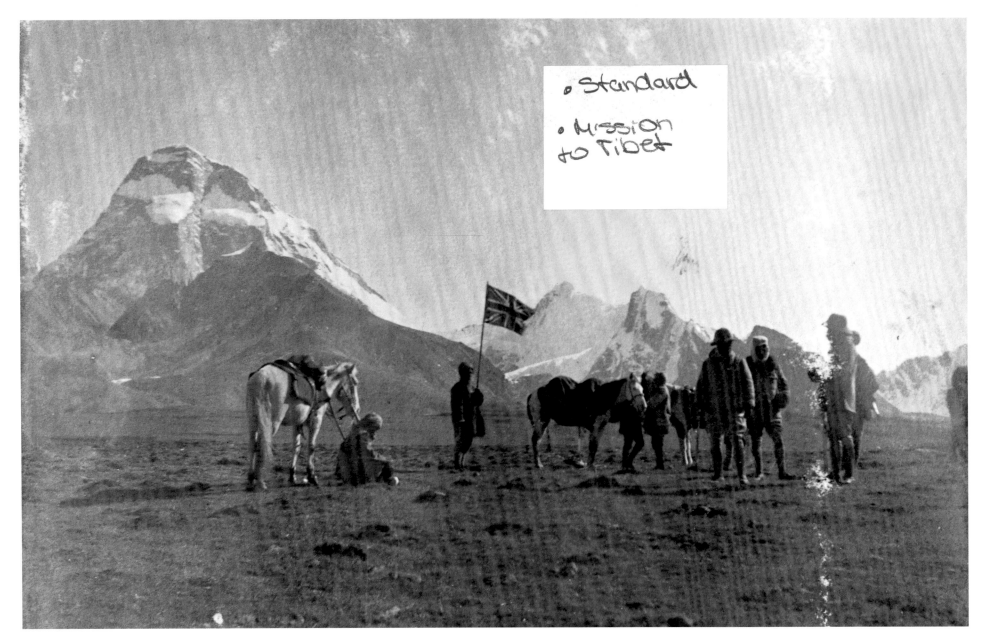

During Francis Younghusband's British Mission to Tibet, troops reach the top of the Tang La (above) and raise the Union Jack "proper for the first time." In the background is the summit of Chomolhari, which would become a familiar landmark for climbing expeditions approaching Everest.

PHOTO: LT. G. I. DAVY, JANUARY 1904

Senior Tibetan officials pass between intimidating lines of armed soldiers after one of many meetings with Younghusband and his staff during their negotiation of trading rights. Younghusband had the presence of mind to include a clause allowing future access to Himalayan peaks via Tibet.

PHOTO: CAPT. C. G. RAWLING, 1904

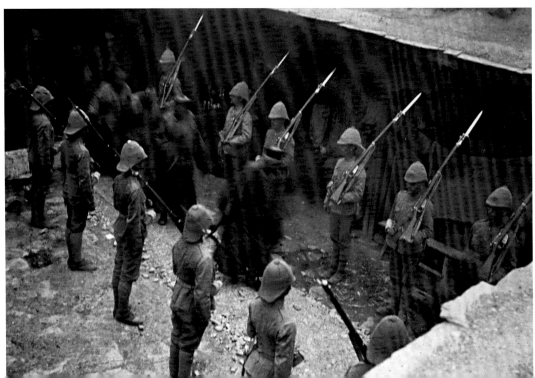

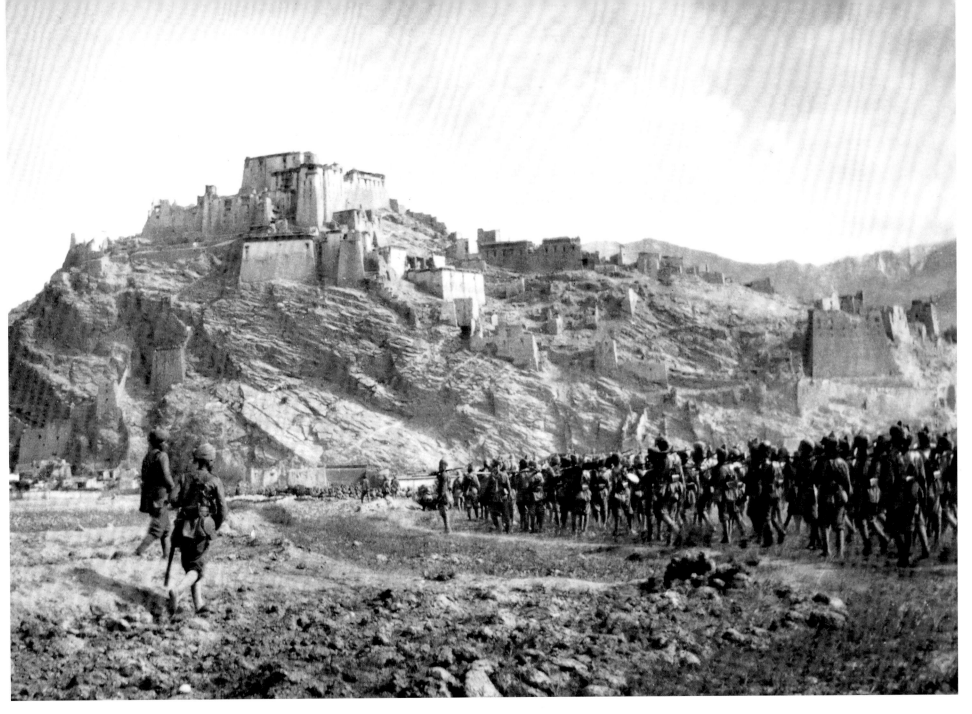

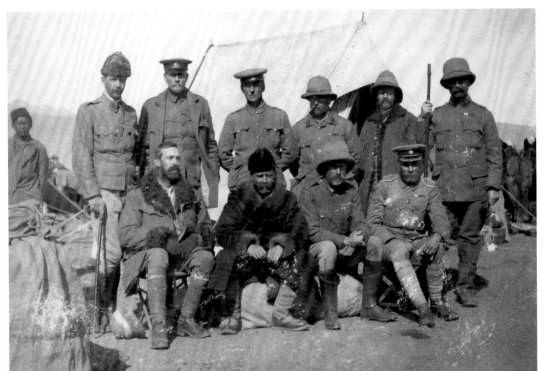

Sir Francis Younghusband (seated, center) wears a thick fur coat against the cold winds of the Tibetan plateau at Phari Dzong, Tibet, January 1904. His mission to Lhasa, a major military expedition during which many Tibetans were killed, led to the signing of the Treaty of Lhasa with His Holiness the 13th Dalai Lama.

PHOTO: UNKNOWN, 1904

The 40th Pathans of the British Mission to Tibet march in to occupy the fort of Gyangtse Dzong after its capture on July 6, 1904. When the British forces took Gyangtse, Tibetans were horrified, now realizing that the British were intent on reaching Lhasa by any possible means.

PHOTO: LT. G. I. DAVY, 1904

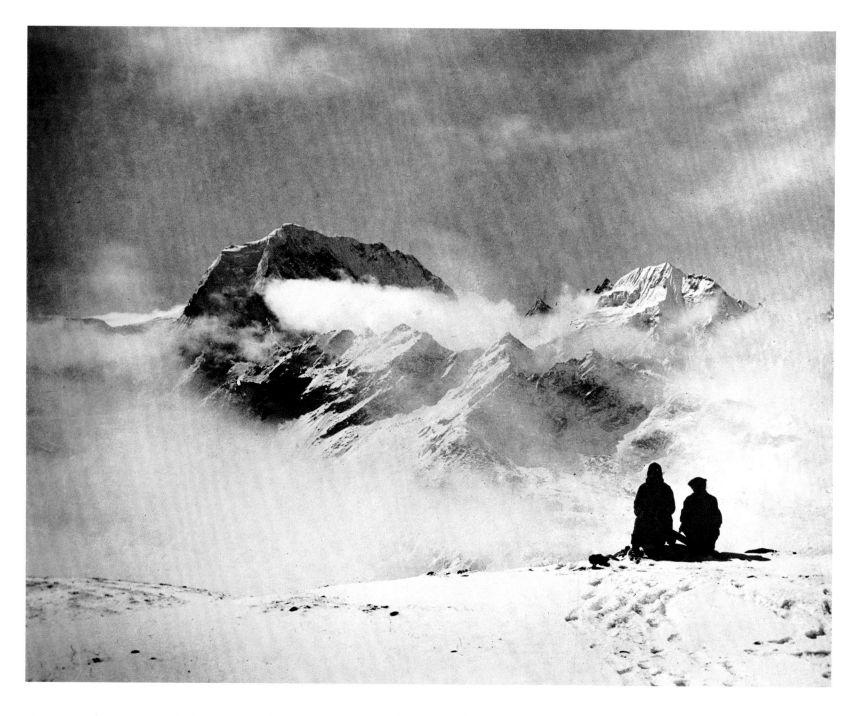

In 1913 Capt. J. B. Noel set off incognito as a Muslim, determined to get as close as possible to Mount Everest. He got within 40 miles (65 km) of his goal before he was recognized as a foreigner and turned back by Tibetan soldiers. En route he passed through Sikkim and photographed the Tsen-Gui-Kang seen here.

PHOTO: CAPT. J. B. NOEL, 1913

Ten years later, at the height of another Russian scare, the British dispatched a trade-cum-diplomatic mission to the Tibetan border with Younghusband in charge of its military escort. When in 1904 the Tibetans refused to receive it, the mission became an expedition, the escort became a small army, and its objective became the Tibetan capital of Lhasa.

Fighting resulted in scenes, captured on film, of monks armed with nothing more than sticks being mowed down by machine guns. It was a brutal affair for which Younghusband was later heavily criticized. But in Lhasa, while imposing terms on the Tibetans, he had the presence of mind to include a clause providing foreigners with future access to the central Himalayan peaks via Tibet.

Although Younghusband's treaty would be revised, this initiative resulted in several attempts to reconnoiter an approach route to Everest. The Yarlung Zangbo/Brahmaputra Valley was surveyed and gave glimpses of Everest from only 60 miles (100 km). Dr. A. M. Kellas, a maverick climber who divided his time between hospital duties in London and clambering over the mountains of Sikkim (where he was the first to discover the high-altitude abilities of the Sherpas), may have got closer. He certainly obtained unique information by

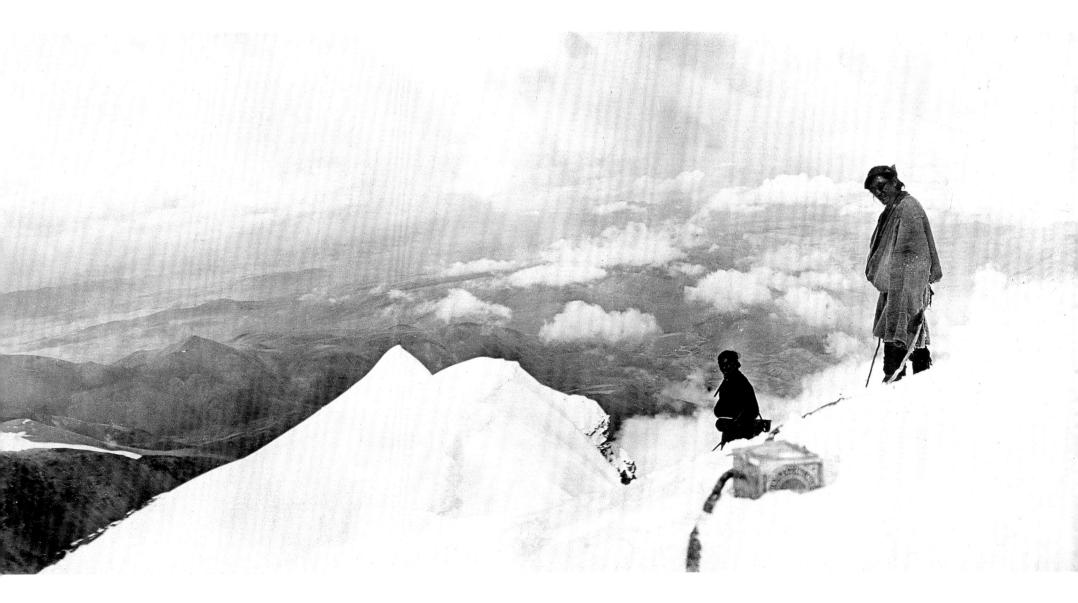

sending one of his men, plus camera, to photograph the glacial Tibetan approaches to the mountain. And in 1913 Kellas's friend Capt. John Noel got to within 40 miles (65 km), "nearer at that time than any white man had been," he boasted. He was not, at the time, very white, having blacked his face as part of an unsuccessful attempt at disguise. Fired upon by a suspicious Tibetan guard, he was forced to withdraw.

Captain Noel's official report of his expedition was postponed by the outbreak of World War I and was not delivered to the Royal Geographical Society in London until March 1919. Younghusband, who was about to assume the presidency of the Society, was present. After Noel spoke, Capt. Percy Farrar of the Alpine Club pledged climbers and funds for "an attempt to ascend Mount Everest," and Younghusband quickly reciprocated on behalf of the RGS. A joint Mount Everest Committee resulted, under Younghusband's direction.

In 1920 negotiations were opened with the Dalai Lama when Sir Charles Bell visited Lhasa. Permission was obtained for an exploratory expedition (which in 1921 mapped approach routes to the mountain and climbed to 23,000 feet/7000 m) and for the first major attempt on the mountain itself in 1922. It would be led by Bruce, with whom Younghusband had first discussed the idea three decades earlier.

But whether an ascent of Everest was truly feasible remained in doubt. The greatest altitude yet achieved (by an Italian expedition in the Karakorams) was approximately 24,000 feet (7315 m), beyond which survival, let alone progress, was considered doubtful. The technical difficulties of Everest were still unknown and the logistical challenge of mounting a sustained assault in such a remote region had yet to be addressed. It would be another three decades of endeavor, and tragedy, before the summit was actually achieved.

"Sherpas on a peak in Sikkim," a photograph taken by Alexander Kellas on one of his many expeditions in the Himalayas in 1907–09, during which he made several first ascents in Sikkim. He was said to have sent a Sherpa with a camera to the North Face of Everest, which would have given him unique information about the mountain. No photograph has yet been found, however.

PHOTO: DR. A. M. KELLAS, 1907–09

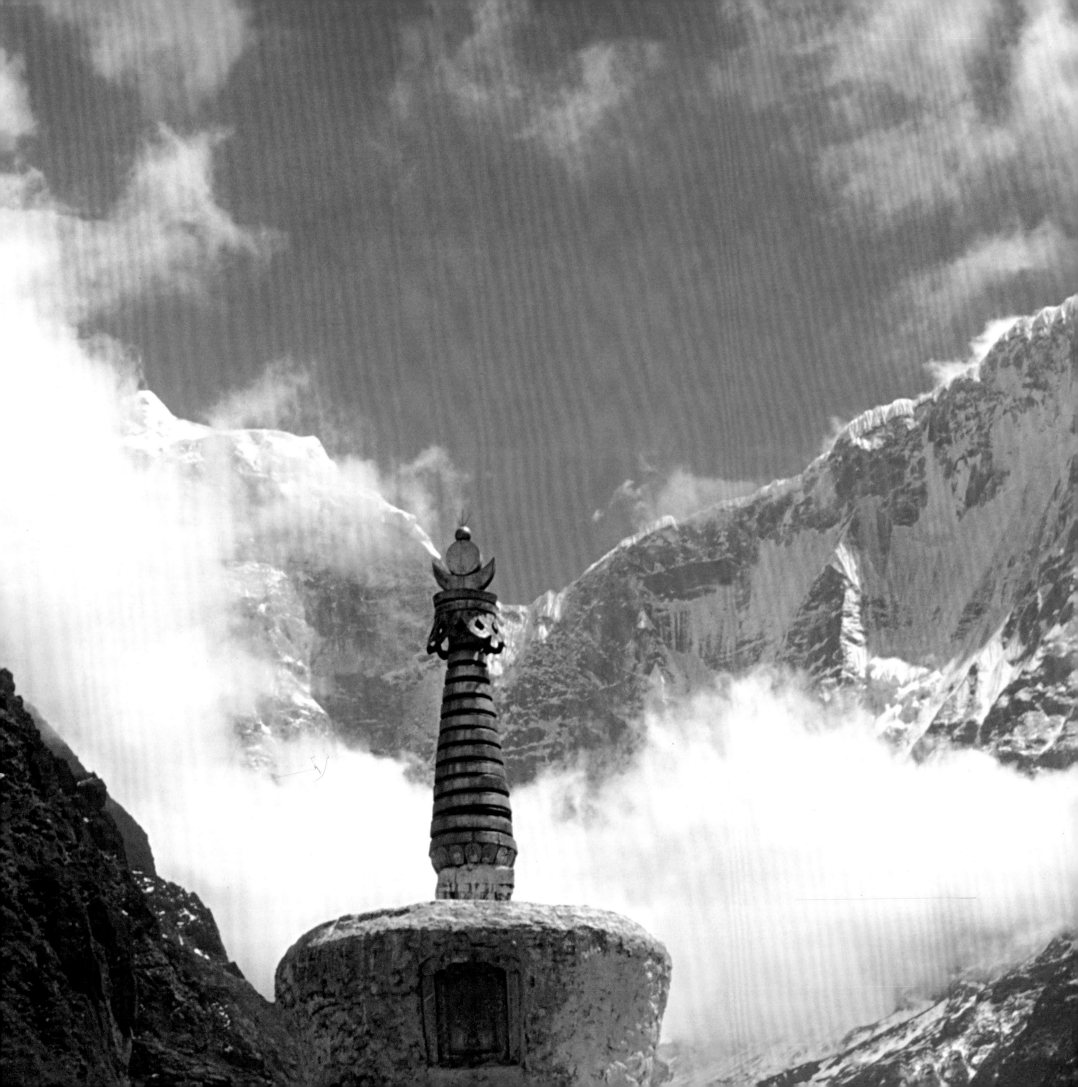

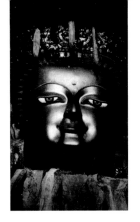

CHOMOLUNGMA: ABODE OF THE GODS

If the many stories of fabulous creatures and gods made up one vision of the mountains,
then Buddhism, like Hinduism, saw the mountains as something else again, the zenith
of consciousness. They reflect a physical expression of a higher state of being that exists
beyond time and space, a kind of pure understanding.

ED DOUGLAS

JUNG-MO IS COLLECTING WATER from the river when we arrive, the first person we've seen in two days. She ushers my translator Kalsang and me into the tent where she has spent the whole summer while herding her yaks, and puts a kettle into the embers of the fire for tea. Her shelter is square, about 12 feet (3.5 m) on each side, and woven from yak hair; light seeps through gaps in the weave, but when the rain starts falling after we arrive it proves surprisingly waterproof.

Everything in the tent seems to originate either from a yak, or from the barley fields of her home village, or from the forests that surround us. She pours the tea into a tall churn and adds gobs of yak butter, mashing them together as she talks. The tent is suffused with smoke from the fire and my eyes are soon irritated and red. After sitting for a while, I find myself shifting so I can get my face as low to the ground as possible to breathe the fresh air seeping through the door of the tent.

A huge yak skin, 4 feet (1.2 m) long and bloated with fermenting milk, takes up much of the floor. Outside is a cheese press weighted with rocks, and Jung-mo promises that before we leave she will give us a bag of dried cheese, *churpi* in Tibetan, for our journey. Meanwhile we drink her buttery, salt tea and I dip my fingers into the proffered bag of *tsampa*, the roasted barley flour mixed with butter and tea. It is solid stuff, but surprisingly tasty and very sustaining. It's a high-fat diet that keeps out the cold and allows Jung-mo and her family to keep working in the bitter cold of winter.

Jung-mo is in her sixties and has been living this way for most of her life, just as her parents did before her, following the life of a nomad on the east side of Everest. In many ways, little has changed here for centuries. The only obvious concessions to modern life are a thermos flask in one corner of the tent and a photograph of the Dalai Lama on the low stone altar that features in every Tibetan nomad's tent. She has no watch or clock, no radio or telephone, no electricity, and very few possessions; it's difficult to believe that a few miles away on the other side of Everest, at Namche Bazar in Khumbu, tourists are watching satellite television. She tells us that in the next couple of days she will dismantle her tent, collect her yaks, and drive them over the Shao La, a 16,200-foot (4940-m) pass, on their way to winter grazing, the pattern of each year repeating itself.

In other ways, this old woman's life has been changed utterly, and by events and forces that she could never have

The golden-topped chorten at Thyangboche monastery in the Solu Khumbu, site of the first Base Camp of the 1953 expedition. PHOTO: EDMUND HILLARY, 1953

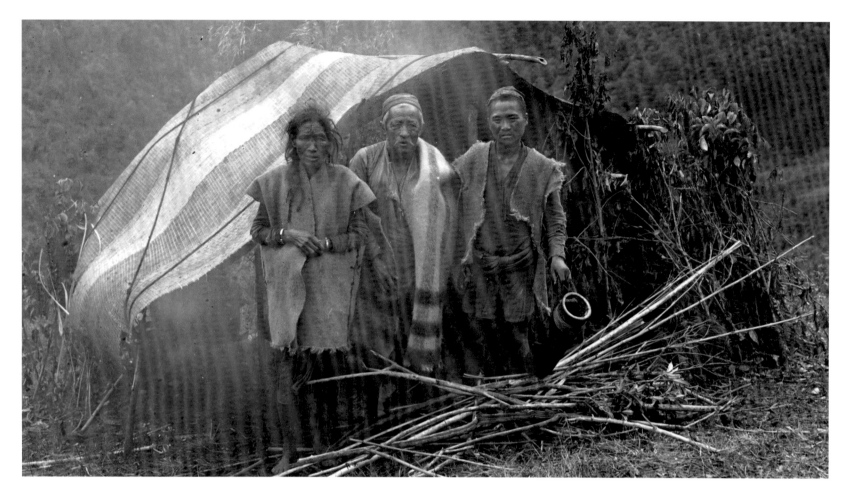

A *Nepalese family (left) from Dhoubute in eastern Nepal at their summer grazing camp in the Arun Valley.*

PHOTO: C. J. MORRIS, 1922

anticipated as a girl. Jung-mo has been married twice, although only one of her husbands is still living—her first. She has not seen him in more than 40 years. He is now a monk living in a Tibetan Buddhist monastery in India, a refugee from the Chinese occupation of Tibet that began with the invasion of 1950 and culminated in the Lhasa uprising of 1959 and the exile of the 14th Dalai Lama. This was when Jung-mo's husband fled, along with 100,000 other Tibetans, taking their daughter with him. It was supposed to be only a temporary arrangement, but the little girl is now a middle-aged woman living and working at Dharmsala in northern India; mother and daughter haven't seen each other either, although they manage to share news through intermediaries. I ask Jung-mo if she's ever tried to visit India to see her daughter. She laughs sarcastically. "How am I going to do that? I have no papers. I have to go to Shigatse or Lhasa to get a passport and even then the officials probably won't give me one. Maybe you could bring her here to me?" Jung-mo's second husband died some time ago, but they had children too, and a son is with her now, sitting patiently in a corner of the tent while she talks.

Jung-mo wants to know what we are doing in the Kama Valley. She sees a handful of tourists every year and occasionally encounters a climbing expedition, but meeting one Westerner and one Tibetan on their own prompts curiosity. We explain that we are on a pilgrimage to Tshechu, the spring of "life water." She smiles and nods. Tshechu is renowned for being one of the holiest sites of pilgrimage in this *beyuel* or "sacred valley." Below Tshechu, at the bottom of a steep scree slope, is a lake about six-tenths of a mile (one kilometer) in length and roughly pear-shaped, its stalk—where a stream drains it to the south—pointing down the Kama Valley and into Nepal. Makalu, the fifth highest mountain in the world, dominates the skyline, appearing abruptly above the lake to the southwest. Everest itself lies to the east.

The lake, Jung-mo says, is a famous site for prophetic visions, for those who are pure enough in spirit to see them. She describes some other lakes in the area, their particular characteristics and legends. "Near Tso-sho-rimi, there is another lake, called Tso-me-lung, and there people can see their future," she says.

A *group of Bhotias (opposite) encountered by the 1921 expedition at Lingga. The villagers, noted for their hospitality, were happy to produce tea and beer as soon as the expedition members arrived.*

PHOTO: GEORGE MALLORY, 1921

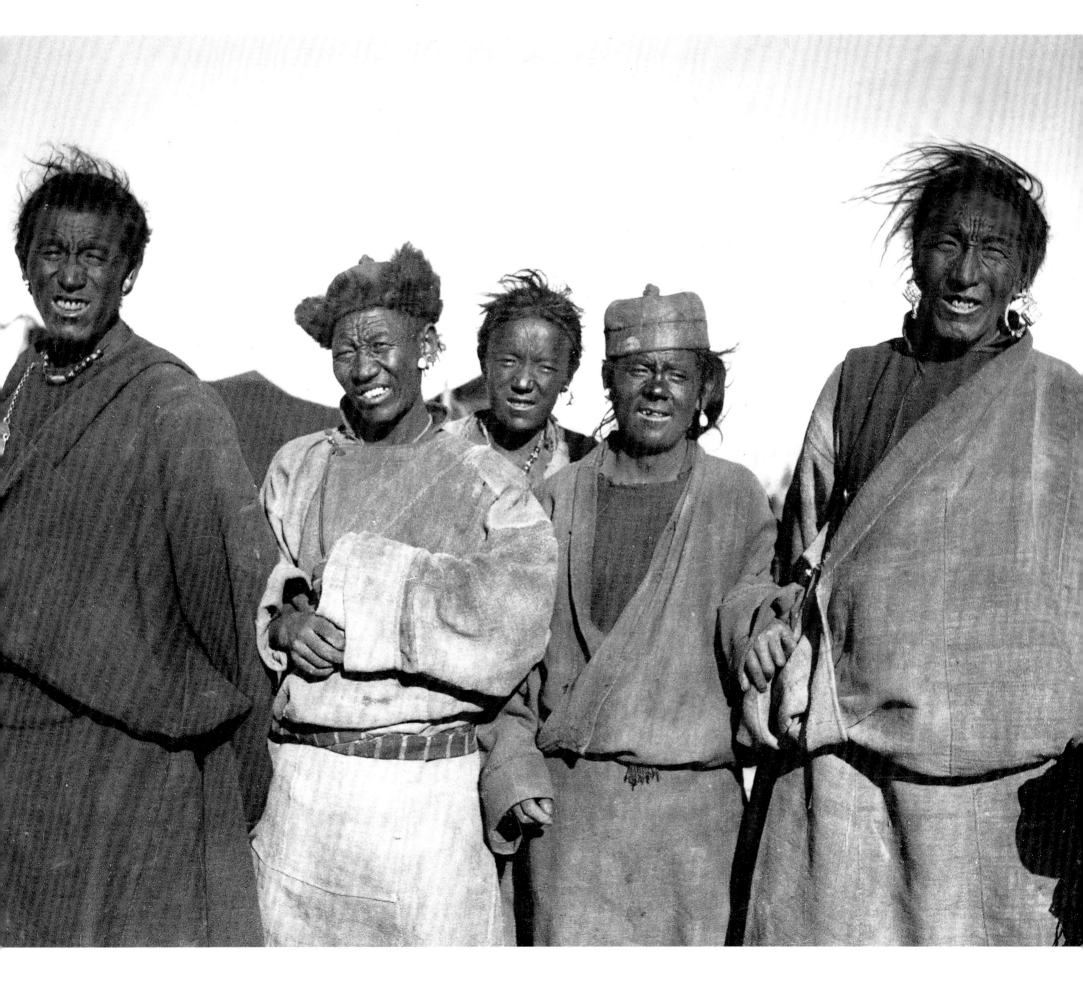

Nomads and their yak-haired tent (right) on the windy Tibetan plateau. Capt. J. B. Noel was enchanted by the hospitality and the friendly and welcoming nature of the Tibetans that he met. He was often welcomed into their homes and offered buttery, salt tea.

PHOTO: CAPT. J. B. NOEL, 1922/24

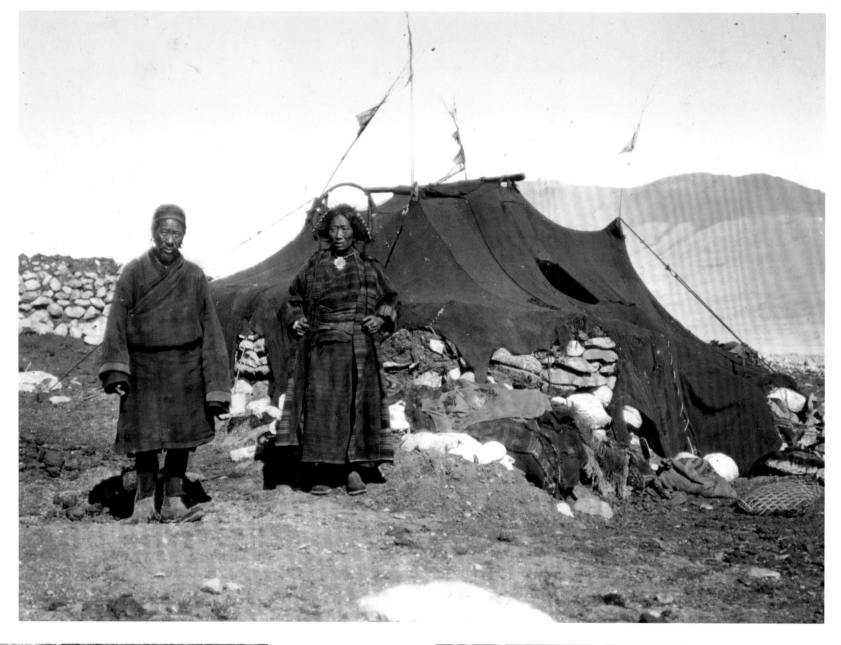

A Sherpani (below) weaving yak wool at a loom in a village en route to Everest.

PHOTO: GEORGE LOWE, 1953

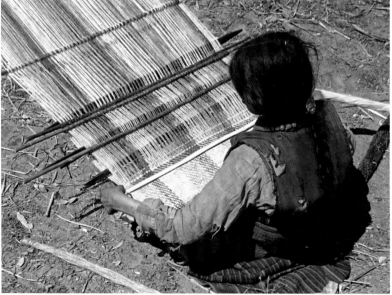

Tibetan man (right) from Lhasa making paper from elder bark in the Rongshar Valley. The paper would end up in Lhasa, where it was used for official purposes.

PHOTO: BENTLEY BEETHAM, 1924

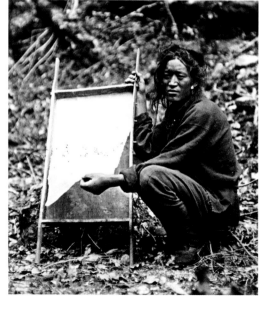

Accompanied by two children, a Tibetan woman (opposite) spins wool in the doorway of her home.

PHOTO: C. J. MORRIS, 1922

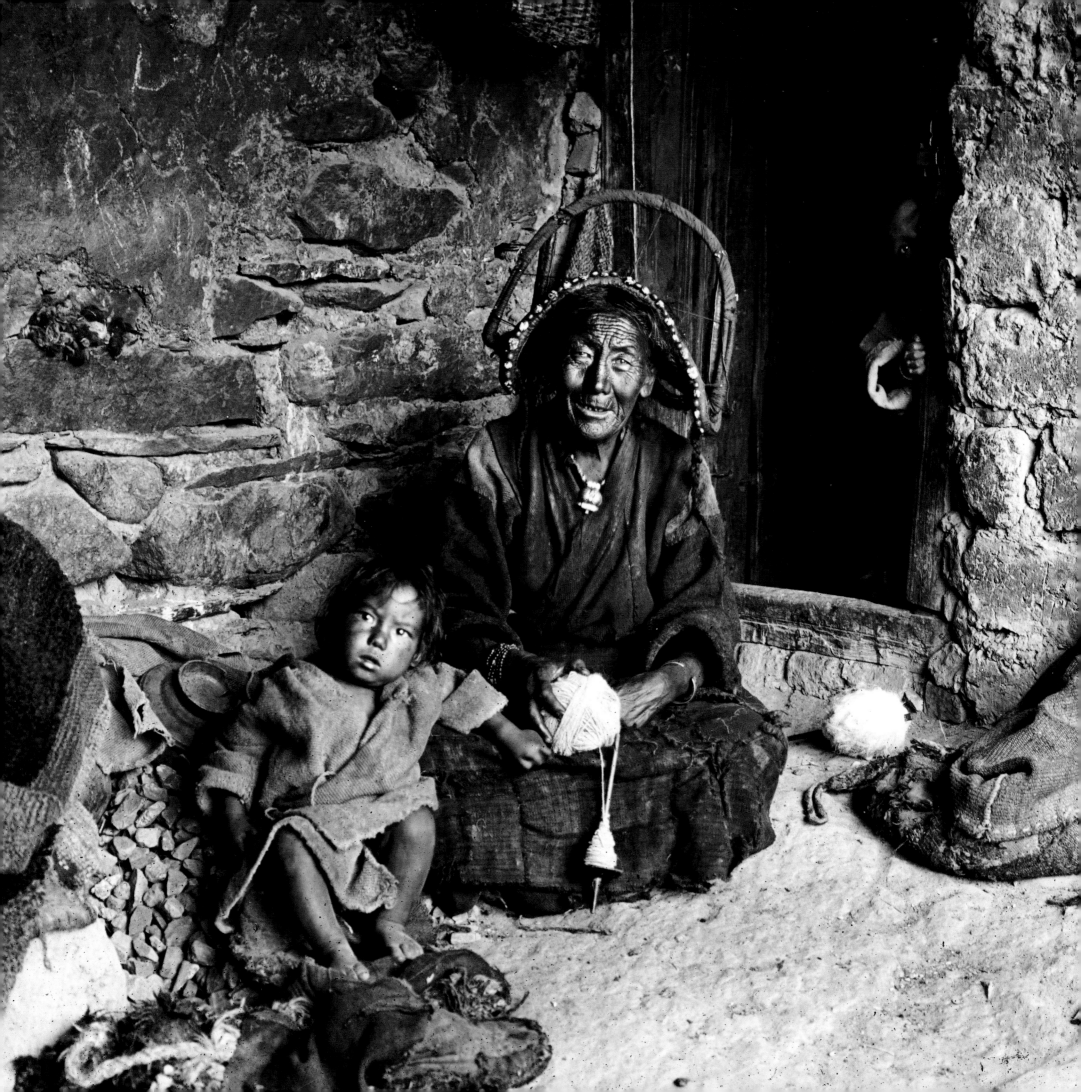

Relief map of Mount Everest at a scale of 1:100,000 compiled and drawn by the Royal Geographical Society in 1975.

Jung-mo's mind's eye travels over the mountainsides and lakes, the caves and forests that make up the landscape where she has spent her summers. She will mark the sacred places with bundles of bamboo, or with the prayer flags that the Tibetans call "wind-horses," carrying prayers to heaven for the good of all sentient beings. The monasteries on the Tibetan side of Everest may have been almost completely wiped out, but local attention to the holy places—caves, lakes, passes, even boulders—has been maintained.

DIVINING FROM GEOGRAPHY

Geomancy, the art of divination from the shape or relationship of geographical features, is a deep current in Tibetan Buddhism. Spirits and ghosts, gods and goddesses are embodied in the mountains and lakes, connecting each new generation with the legends of its ancestors. One of these strands is the idea of sacred valleys, the *beyuel*. These are places of deep spirituality and power, the goal of pilgrims, and a sanctuary in times of war and disaster. They are intimately connected to the idea of nirvana, fragments of heaven on earth. Some of these valleys are known, some remain undiscovered, waiting for the appropriate master to "open" them.

The Kama Valley lies at the heart of Beyuel Khembalung and is used by the people of the Kharta Valley to the northeast across the Shao La as summer pasturage for their yaks, a source of medicinal and other plants for food and fuel, and a place of pilgrimage. The stories of the people here reflect their intimate connection with the landscape.

More than a thousand years ago, Tibet's great Buddhist king, Trisong Detsen, ascended the throne. At the age of 21, he invited several Buddhist masters to help extend the influence of their religion in Tibet, founding the first of the monasteries that would shape Tibetan life until the Cultural Revolution in 1966. One of these teachers was Padmasambhava, known as Guru Rinpoche, "the lotus-born." He revealed to Trisong Detsen the existence of a *beyuel* called Khembalung, which had formed when a lotus flower fell to earth, a gift from the king of the gods that went astray. He prophesied that it would be a heavenly refuge during times of war and catastrophe in Tibet, when the *dharma*—religion—was under threat.

Shepherds and porters rest on a slope below the Langma La, in the Kama Valley. Chomolönzo rises spectacularly above them in the distance.

PHOTO: LT.-COL. HOWARD BURY, 1921

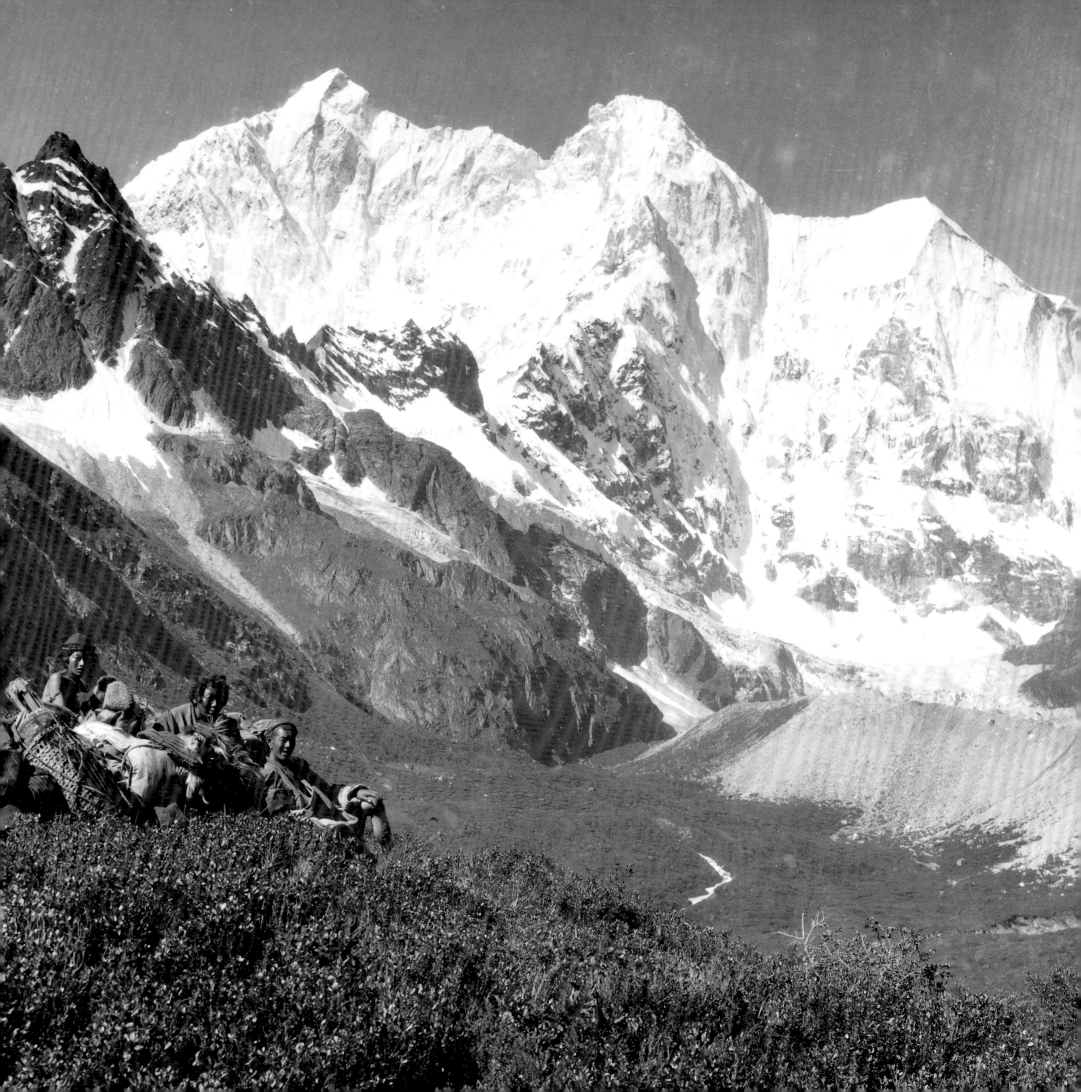

The Kama Valley—fertile, verdant, and one of the most beautiful valleys in the world, lies at the heart of the Beyuel Khembalung. In Tibetan Buddhism, beyuels *are places of deep spirituality and power.*

PHOTO: STEPHEN VENABLES, 1988

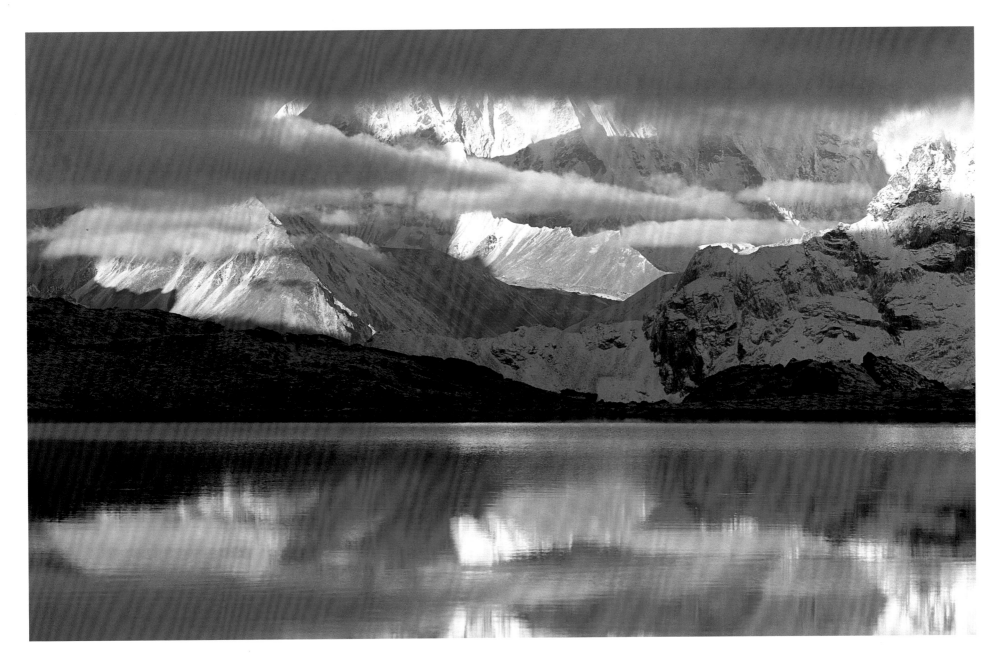

Here the Bhong Chu, a river older than the Himalayas themselves, turns sharply south, dropping steeply toward the Gangetic plain in Nepal where the river is called the Arun. The gorge is so deep that monsoon rains penetrate along its course deep into the mountains, almost to the foot of the East Face of Everest itself. Consequently, the valley is fertile and verdant, a contrast to the arid Tibetan plateau. It is one of the most beautiful valleys on earth, surrounded by gigantic mountains, their fluted ridges silhouetted against a crystalline sky or looming through gaps in heavy gray clouds. The lower hillsides are blanketed with juniper and silver firs, mountain ash and birch, willows and vast rhododendrons. Plants and flowers, many of them used in Tibetan medicine, are spread across the higher, treeless slopes in summer, chief among them the red and blue poppies of the genus *Meconopsis*—*upa mendog* in Tibetan—the very lotus flower that the king of the gods had let fall to earth.

The first European to explore the valley was Lt.-Col. Charles Howard Bury, the leader of the 1921 Everest Reconnaissance Expedition. He described it thus: "We had explored many of these Himalayan valleys, but none seemed to me to be comparable with this, either for the beauty of its Alpine scenery, or for its wonderful vegetation. We shall not easily forget the smiling pastures carpeted with gentians and every variety of Alpine flower that rise to the very verge of icebound and snow-covered tracks, where mighty glaciers descend among the forests which clothe the lower slope."[1]

Dawn in the Beyuel Khembalung. The great fluted wall of Shartse-Lhotse is reflected in one of the lakes near Tso-sho-rimi, the "lama's throne." This may be the Tso-me-lung where "people can see their future."

PHOTO: STEPHEN VENABLES, 1988

A cairn of mani stones (above). Local attention to rituals and holy places such as caves, lakes, and boulders plays an important role in Tibetan Buddhism.

PHOTO: BENTLEY BEETHAM, 1924

On a barren hill-side, a porter (right) sits next to a cairn of boulders topped by a mani stone inscribed with a sacred text.

PHOTO: FRANK SMYTHE, 1933

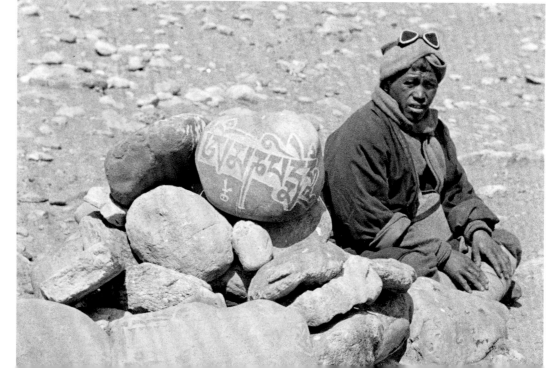

At a mani boulder (opposite), just near Traksindhu on the approach march to Everest. Tibetan and Nepalese Buddhists inscribe religious texts and phrases such as "Om Mani Padme Hum" on rocks, which are left in sacred spaces. Tibetans believe these words create good karma for the person who created the stone.

PHOTO: CHARLES WYLIE, 1953

A *Buddhist priest, obscured from view, sits meditating in a rock cell near Rongbuk monastery (left). At the time this photograph was taken, he had already lived in isolation for 15 years, with only a monk to bring him his daily water and bread.*

PHOTO: CAPT. J. B. NOEL, 1922/24

Each *beyuel* has a guide-text or *neyig*, and Khembalung is no exception. It was "opened" in the fourteenth century by Rindzin Godem, who discovered its guide-text near the monastery of Sangsang Lhabrag, in a rocky peak shaped like a heap of poisonous snakes. He thus earned himself the title of *tertoen*, or discoverer. Since then, mystics from beyond the region have traveled to these remote places, living at altitudes of 17,000 feet (5180 m) through the long, bitter winters, abandoning society and its conventions to experience a simple but harsh relationship with nature. And so local traditions, centered on the cycle of farming and nomadism that sustains the villages in the Kharta Valley, have blended with Buddhism to create a complex cultural mixture.

Before Buddhism, and before the Bon faith with which Buddhism competed and coexisted, there was an animist tradition in Tibet that is preserved in these remote valleys, subsumed into Buddhism in the same way that pagan traditions have been absorbed into Christianity in Europe. A good illustration of this is the legend that surrounds Everest itself, the mountain Tibetans call Chomolungma.

THE GODDESS ON EVEREST

The goddess said to inhabit the slopes of Chomolungma is Miyolangsangma. She is one of five sisters who are associated with mountains, often above sacred lakes, along the Nepali-Tibetan frontier. The leader of these five sisters is called Tashi Tseringma, whose home is Gaurishankar to the west, a stunning peak that is sacred to Hindus as well, especially in Kathmandu. The "Five Sisters of Long Life," as they are known, are only minor deities; the peak Khumbila, for example, is far more important to the Sherpas of Khumbu as the home of their patron deity Khumbu'i Yulha, literally the "Home God of the Khumbu." This peak sits at the heart of Khumbu, a hub whose spokes are the valleys that radiate out from it.

A *mani wall (opposite) with prayer wheels in the Kharta district of Tibet. Early expedition members were amazed by the number of religious buildings and stones they came across as they walked through Tibet. Chortens and mani walls are often erected in places where a person has had some kind of fall or injury.*

PHOTO: CAPT. J. B. NOEL, 1922/24

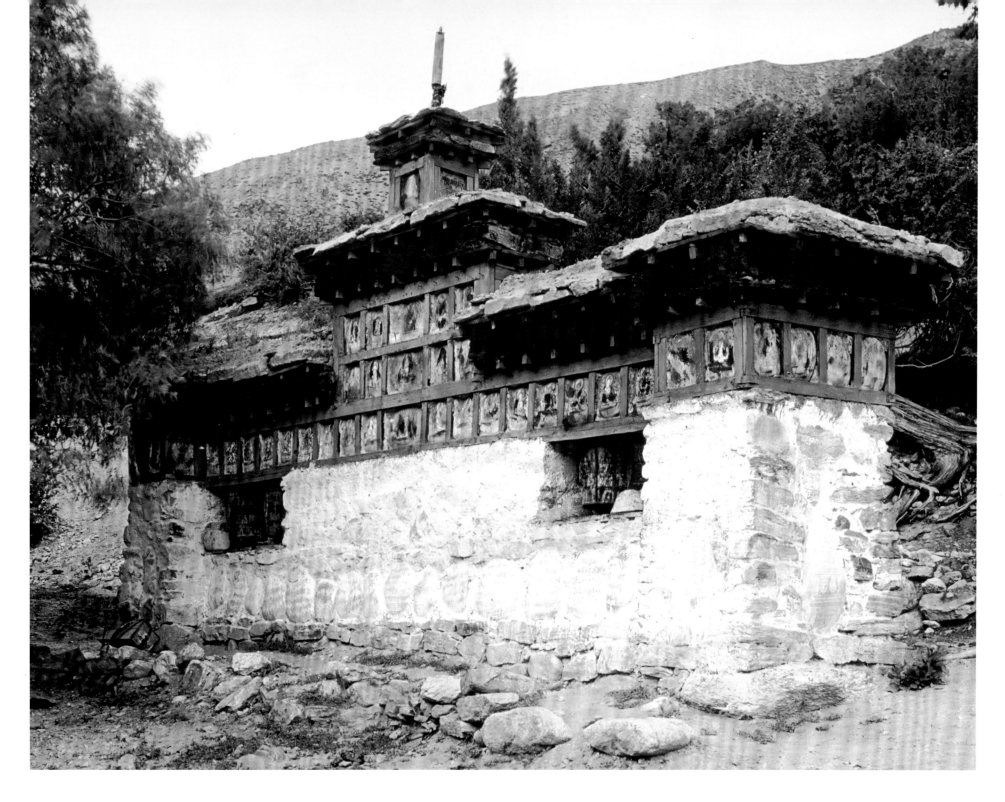

This mountain, in a way, holds the collective soul of the Sherpas, a repository for their sense of identity.

According to legend, Miyolangsangma was one of a group of wrathful Bon deities, the *srungma*, who was subdued by the evangelizing zeal of Guru Rinpoche to act as a servant of Buddhism. Miyolangsangma's character became that of a generous benefactor and she is always depicted in the act of giving. Sherpas on Everest go out of their way to keep on her good side; offensive smells, such as roasting meat or burning garbage, and morally questionable behavior can provoke her wrath. Before every expedition they will hold a *puja*, building a *lhap-so*, which is a kind of altar, and stringing up lines of prayer flags to bring good luck.

Murals at monasteries on either side of the mountain show Miyolangsangma as a golden goddess riding a tiger and holding a bowl of *tsampa* and a mongoose that spits jewels. Her role as a bringer of wealth or resources to those who honor the mountain is clear. The translation of her name is less absolute. The scholar Edwin Bernbaum translates it as the "Unmovable Goddess Who Is a Benefactress of Bulls," the bulls being yaks.

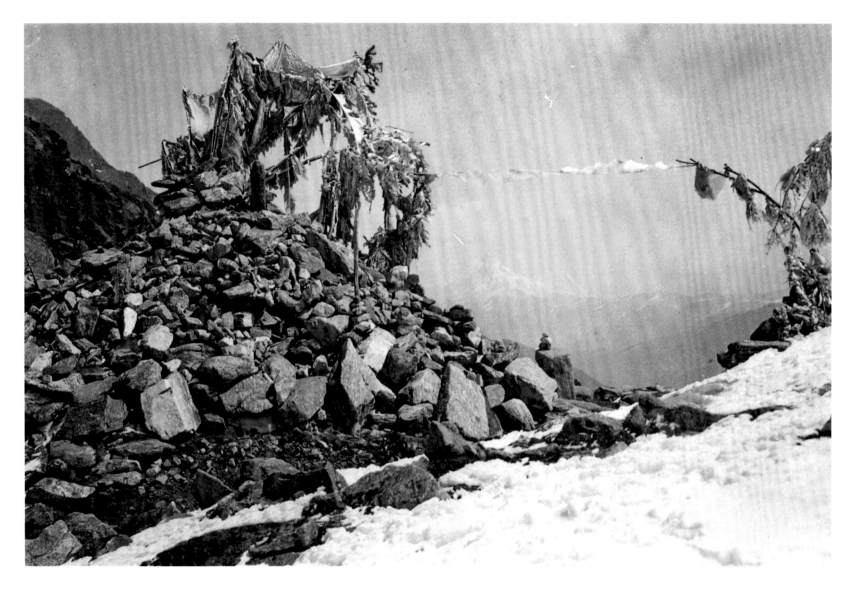

Prayer flags tied to a cairn on top of the Natu La (left). Even today, prayer flags are strung up by Sherpas prior to any expedition and are thought to bring good luck to expedition members.

PHOTO: FRANK SMYTHE, 1933

Trulshik Rinpoche, the former head lama of Rongbuk now in exile at Thupten Choeling near Junbesi in Solu Khumbu, says her name means the "Unshakeable Good Elephant Woman." It will be interesting to see if the role of Miyolangsangma increases in importance as she becomes more "famous" among Sherpas, Tibetans, and Westerners alike. In the past, her role as the deity of Chomolungma was purely symbolic: a wealth-giver. There are legends of how the people around Everest suffered because they failed to pay her due attention. Now, Everest is a workplace offering employment to the Sherpas who carry loads on the mountain and income to the tourist businesses that have sprung up to service the trekking industry.

From being a symbol of wealth, Chomolungma has become the real source of that wealth, replacing, to an extent, the trade and agriculture that sustained the Sherpas before the Chinese invaded Tibet and curtailed activity across the border.

Perhaps in the future Khumbu'i Yulha, the patron god of the Sherpas, will have a rival in the once obscure but now revered Miyolangsangma. Religion in this part of the Himalayas has grown organically, blending the old and the new, mixing the practices of competing traditions and faiths as the wheel of history turns. The tourist dollar, like the barley crop or the yak herds, is just one more resource for which Sherpas are grateful, and it is Miyolangsangma herself who has given them this.

More controversially, Miyolangsangma has been offered as a root of the name Chomolungma. Edwin Bernbaum, who transcribes the name as Jomolangma, writes: "The Tibetan language has a tendency to condense long words and phrases into one or two syllables that can be difficult to decipher. Langma in Jomolangma is probably short for Miyolangsangma, making the Tibetan name of Mount Everest a cryptic reference to the goddess of the mountain as the 'Lady Langma.'"[2]

A small cairn of stones, behind the resting figure, marks the site of a high mountain pass (opposite).

PHOTO: T. A. BROCKLEBANK, 1933

Monasteries dominated Tibetan life until the Cultural Revolution in 1966. Shegar Dzong (right), a familiar landmark for the 1920s and 1930s Everest expeditions, was for Capt. J. B. Noel a stupendous sight, rising off the Tibetan plateau at 15,000 feet (4570 m). He later wrote that: "They are Dream Towers of the air, and at times, caught in the light of dawn or at sunset, are unbelievably beautiful."

PHOTO: CAPT. J. B. NOEL, 1922/24

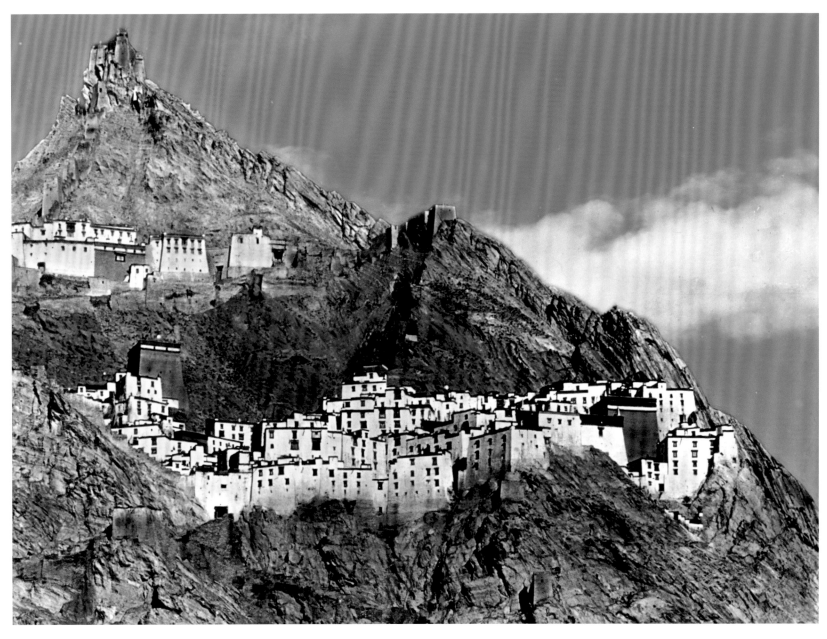

At a rest stop (opposite) on the way up to the Kharta Glacier, the local Tibetan porters indulge in some competitive cairn-building. Lt.-Col. Howard Bury noted that the local people would invariably shout "Lha-gyal-lo" ("Victory to the Gods") as a term of respect. These and other signs of passage can be found throughout the Himalayas, but they are always erected in a spirit of reverence.

PHOTO: GEORGE MALLORY, 1921

A ceremonial wooden horse (left) inside Shegar Dzong monastery.

PHOTO: C. J. MORRIS, 1922

Stuffed yaks (right) hanging in the entrance to Gyangtse monastery. During the 1922 expedition, Noel made a specific detour to Gyangtse to record aspects of Tibetan life and culture.

PHOTO: J. B. NOEL, 1922

The monks and an administrator at Shegar Dzong monastery. Before the 1950 Chinese invasion of Tibet, more than a third of the population resided in monasteries as monks or nuns.

PHOTO: LT.-COL. HOWARD BURY, 1921

An image of a Buddha (below) in one of the many monasteries that Captain Noel visited in Tibet. Many of these icons were subsequently destroyed by the Chinese in the 1950s and these photographs are the only record of what was once there.

PHOTO: CAPT. J. B. NOEL, 1924

A group of Buddhas (left) sit in a dark recess of Shegar Dzong monastery. In front sits a line of offering bowls filled with water and lighted butter lamps. Offerings are an important part of the ritual of Tibetan Buddhist belief.

PHOTO: C. J. MORRIS, 1922

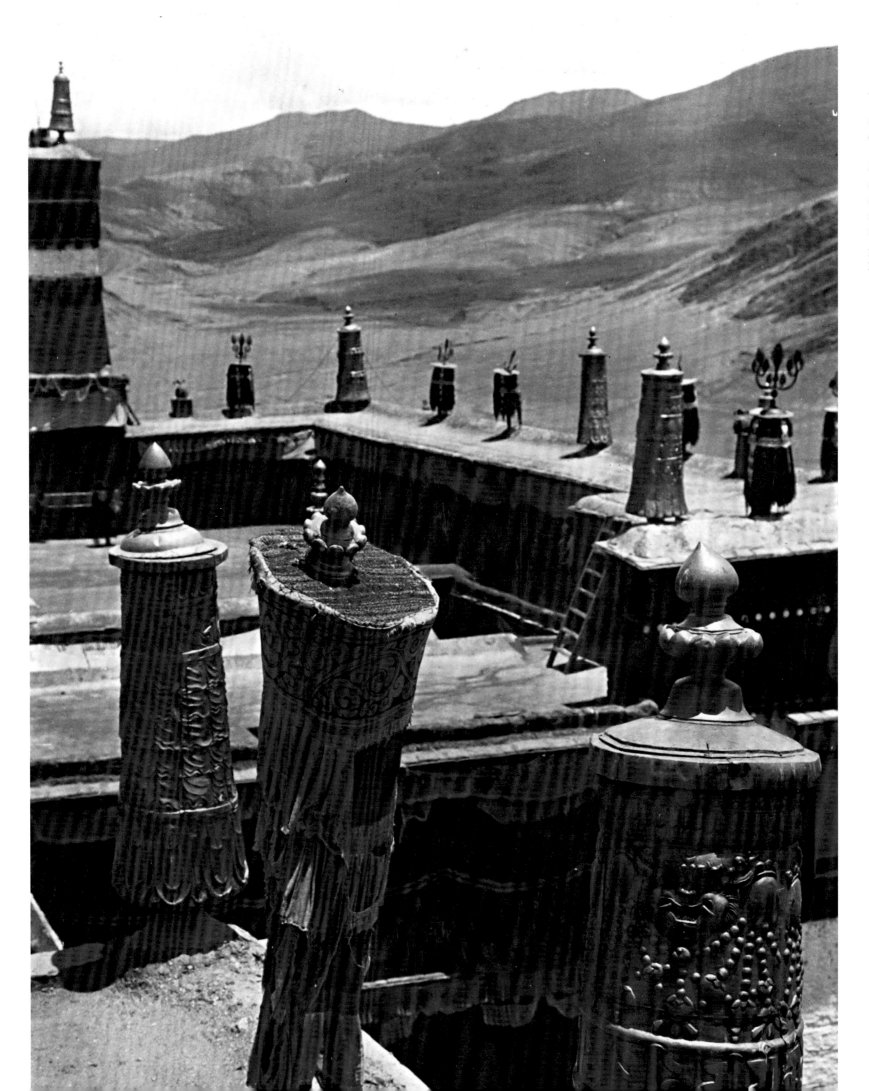

View from the monastery rooftop at Shegar Dzong. Tibet, a mysterious land ruled by a god-king and populated by monks, was for many years closed to foreigners.

PHOTO: BENTLEY BEETHAM, 1924

Tibetan Buddhist monks at Shegar Dzong monastery hold up thangkas, specially painted religious banners that told important Buddhist stories and provided inspiration to practitioners on their path toward enlightenment.

PHOTO: CAPT. J. B. NOEL, 1922

The translation of the word Chomolungma, the true meaning of the Tibetan name for Everest, is something of a Holy Grail for travelers and anthropologists who study the region— mythical, tantalizing, and probably nonexistent. Another name for Everest, the Nepali term Sagarmatha, which translates as "Brow of the Sky," is modern, having been invented after Everest was identified as the highest mountain on earth. Nepal suddenly needed—for political reasons—its own, non-Tibetan name, because the mountain straddles a disputed border. For their part, the Chinese have their own distinctive transliteration of the Tibetan name, Qomolangma.

Chomolungma is often translated as "Mother Goddess of the Earth," which isn't correct; it is more a translation of what we expect from the world's highest mountain. The issue is complicated by evidence suggesting that the pronunciation of the name differs depending on who and where you are. As an example, the passports issued in Lhasa for the 1920s

expeditions refer to Everest as Kang ("snow mountain") Cha-ma-lung. The Tibetologist and diplomat Sir Basil Gould translated Cha-ma-lung as "Land of the Hen Birds." However, in the region around Everest itself, the name appears differently. In the guide-text to the Beyuel Khembalung presented to the 1936 expedition by the head lama at Rongbuk, Dzatrul Rinpoche, the name appears as Chha-mo-lang-ma, pronounced and transcribed elsewhere as Jomolangma. It all comes down to the difference in pronunciation, if any, between two syllables, "lung" and "lang." There hardly seems to be any difference, but to a Tibetan they mean very different things. Is the "lang," as Bernbaum suggests, a compression of the goddess Miyolangsangma? Or is it "lung," a "place," or a "broad valley"? In one rather prosaic translation, Chomolungma simply means "The Peak Above the Valley," and looking south from Rongbuk monastery to where Everest fills the head of the wide Rongbuk Glacier, this translation makes perfect sense.

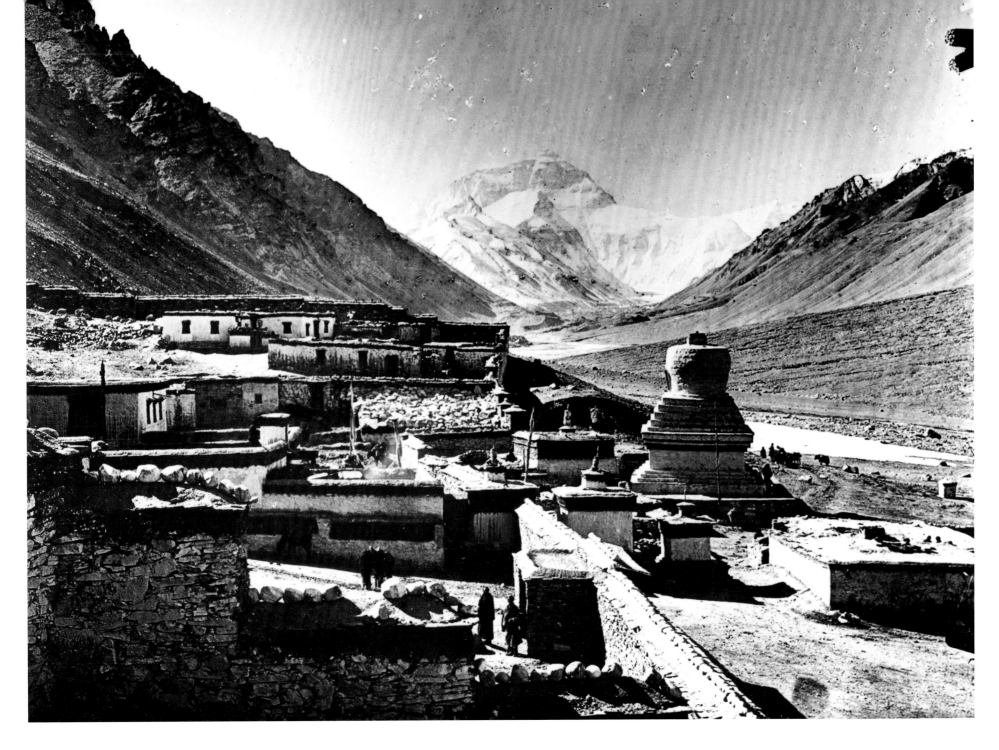

It is often the case with mountains all over the world that they are given a rather dull name with a purely descriptive function—the Matterhorn is simply "The Peak Above the Pastures"—but which is subsequently invested with a whole range of meanings that can be altered to suit changing circumstances or influences. Chomolungma (the "lung" rhymes with "put") might be an ancient word from an age before Guru Rinpoche lived and which, like the shamanistic practices and legends of long ago, has been subsumed by the Buddhist tradition and given a different, more religious spin.

You would imagine that the argument could be solved by simply asking lots of people who live around Everest what the

name means. Often the reply you get involves birds. I had this exchange with a nomad in the Kama Valley.

> "What does Chomolungma mean?"
> "Hen."
> "Hen?"
> "Yeah, but a big hen, with all its feathers puffed out. So it looks fat."
> "Big fat hen?"
> "Yes, big fat hen."

Tenzing Norgay, who was born in the Kama Valley and later migrated to Khumbu before settling permanently in

Tibetan ingenuity: A climber's discarded oxygen cylinder hangs in Thyangboche monastery. Retrieved from the prewar expeditions, it was used as a gong to signal to all women to leave the monastery at 5:00 p.m. each day.

PHOTO: UNKNOWN, 1951

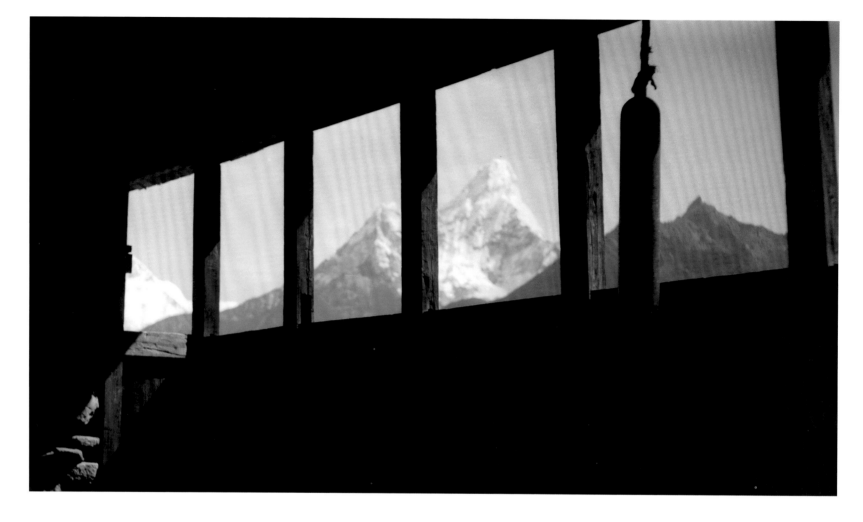

Darjeeling, said his mother translated the name as "The Mountain So High No Bird Can Fly Over It," and all these names that refer to birds fit in with the Lhasa version, which Gould translated as "Land of the Hen Bird." However the word Chomolungma is translated, the important issue at stake is not what it means but the thing to which it refers, because within that difference we see just how fundamental the divide is between Western attitudes to Everest and the role of Chomolungma in the lives of those Tibetans and Sherpas who live on the mountain's slopes.

In 1921, George Mallory and Guy Bullock became the first Europeans to enter the Kama Valley, on the east side of Everest. They were searching for a likely route to the summit and while there was some information about the geography of the mountain, they relied heavily on the local population for knowledge of exactly how to approach its different aspects. They understood that trekking to the great East Face above the Kangshung Glacier required them to cross from the villages of Kharta over a high pass and into the Kama Valley, but they were

bemused to be traveling in a southwesterly direction when they had imagined the mountain was due west. Where was Chomolungma? they asked again and again. "We were more than ever mystified," Mallory wrote. That evening, on the shore of Tso-sho-rimi, he and Bullock convened a conference: "In the Sahibs' tent that night there took place a long and fragmentary conversation with the head-man, our Sirdar acting as interpreter. We gained one piece of information: there were two Chomolungmas. It was not difficult to guess that, if Everest were one, the other must be Makalu."[3]

It may simply be that both Makalu and Everest were called by the same name; mountains are commonplace in the Himalayas and often have similar names. Or else the whole massif of the Everest region is known as Chomolungma, not just the peak of Everest. Either way, it reveals how differently the mountain's people viewed their giant neighbors. You can't farm on them, you can't graze yaks on them, and they are inherently dangerous. We tend to judge myths as being stories that explain the unexplained, but myths also offer useful advice

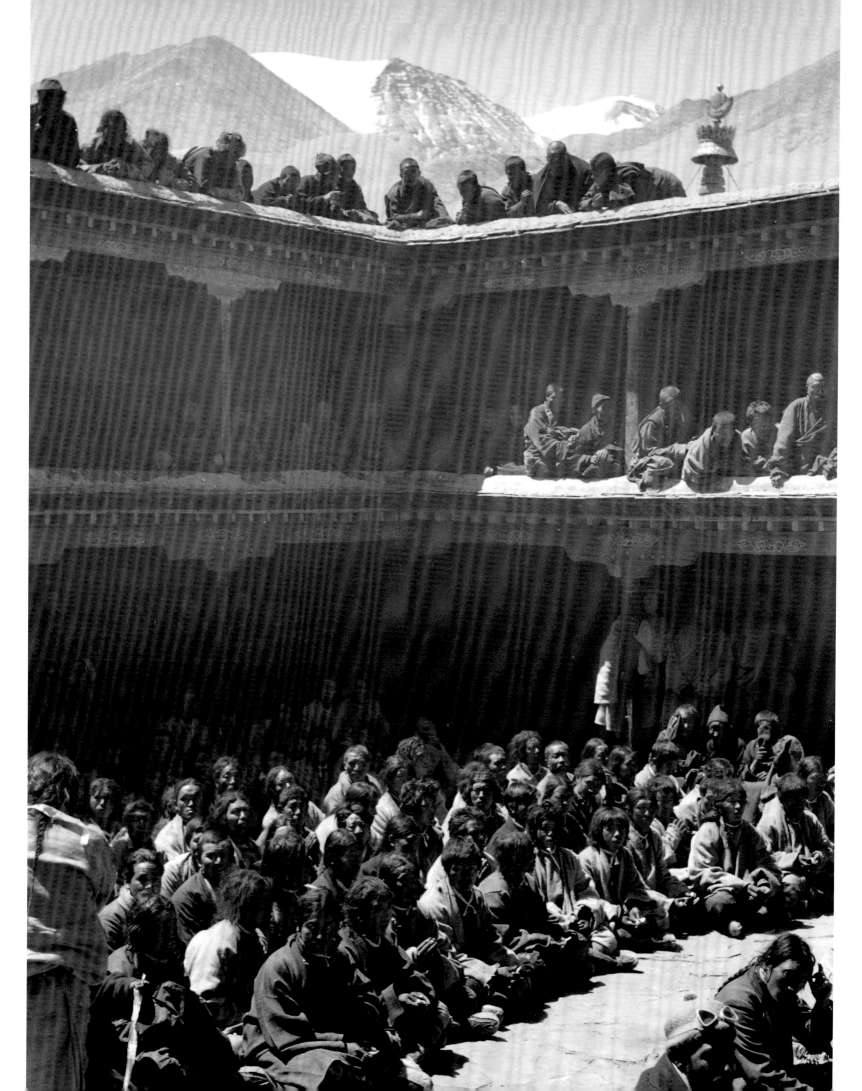

Prior to contact with Westerners, the idea of climbing mountains, let alone reaching Chomolungma's summit, was unheard of for Tibetans. However, for those Sherpas who joined the expeditions as porters, a blessing was always sought first. Here, the head lama at Rongbuk monastery blesses the 1936 expedition porters. Ruttledge commented that the porters sought to wear the best clothes they could find for the occasion, and would make a small offering, prostrate themselves, and then give a white scarf or katak to the lama as a sign of reverence.

PHOTO: FRANK SMYTHE, 1936

that gives individuals an advantage. The Tibetan myths about mountains are populated with wrathful deities, ghosts, or terrible creatures such as the yeti. They are warnings to stay away, just as myths about snakes tell us that they can be dangerous.

The notion of climbing a mountain was utterly foreign to those nomads grazing their animals on the pastures below Everest. Why expose yourself to unnecessary risks when life is already full of them? They didn't even have a word for the apex of a mountain; the summit that George Mallory was trying to reach didn't exist for them. Mallory had his own myths—that reaching the summit was a worthwhile goal expressing a basic human desire to explore—but he missed the myths of the people already living there.

PEAK OF CONSCIOUSNESS

If the many stories of fabulous creatures and gods made up one vision of the mountains, then Buddhism, like Hinduism, saw the mountains as something else again, the zenith of consciousness: the physical expression of a higher state of being that exists beyond or outside time and space, a kind of pure understanding. This is why the caves around Everest were full of hermits. Mountains feature at the center of mandalas for the same reason, and can sometimes become a metaphor for this higher plane of spiritual insight. The guru Chogyal Namkhai Norbu, in his book *The Crystal and the Way of Light*, quotes this tantra from the Dzogchen tradition:

> *Knowledge of Dzogchen*
> *is like being on the highest*
> *mountain peak;*
> *no level of the mountain remains*
> *mysterious or hidden,*
> *and whoever finds themselves*
> *on this highest peak*
> *cannot be conditioned*
> *by anyone or anything.*[4]

Perhaps this was the kind of freedom that George Mallory was looking for on Everest; certainly climbers such as Marco Pallis believed that there were spiritual insights to be gained from their rather eccentric sport.

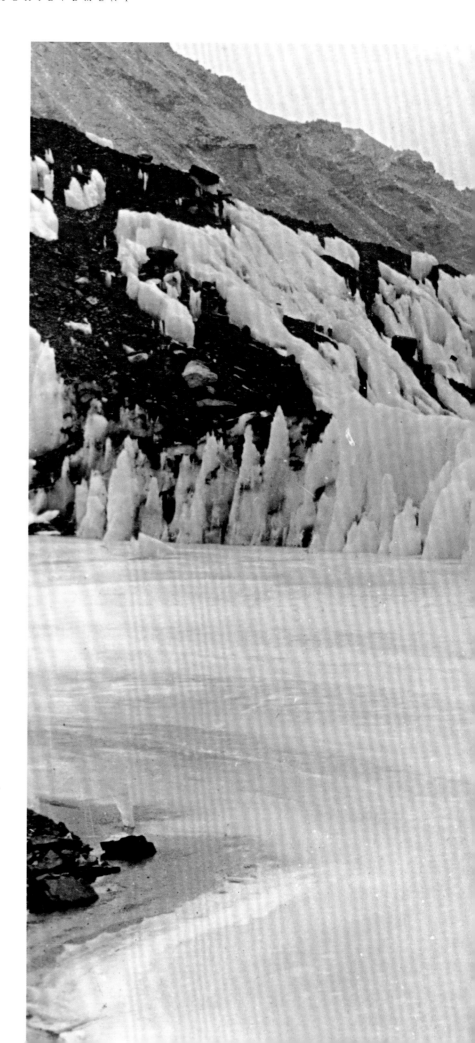

A *team member gazes out in wonder at the ice corridor and pinnacles of the Rongbuk Glacier.*

PHOTO: CAPT. J. B. NOEL, 1924

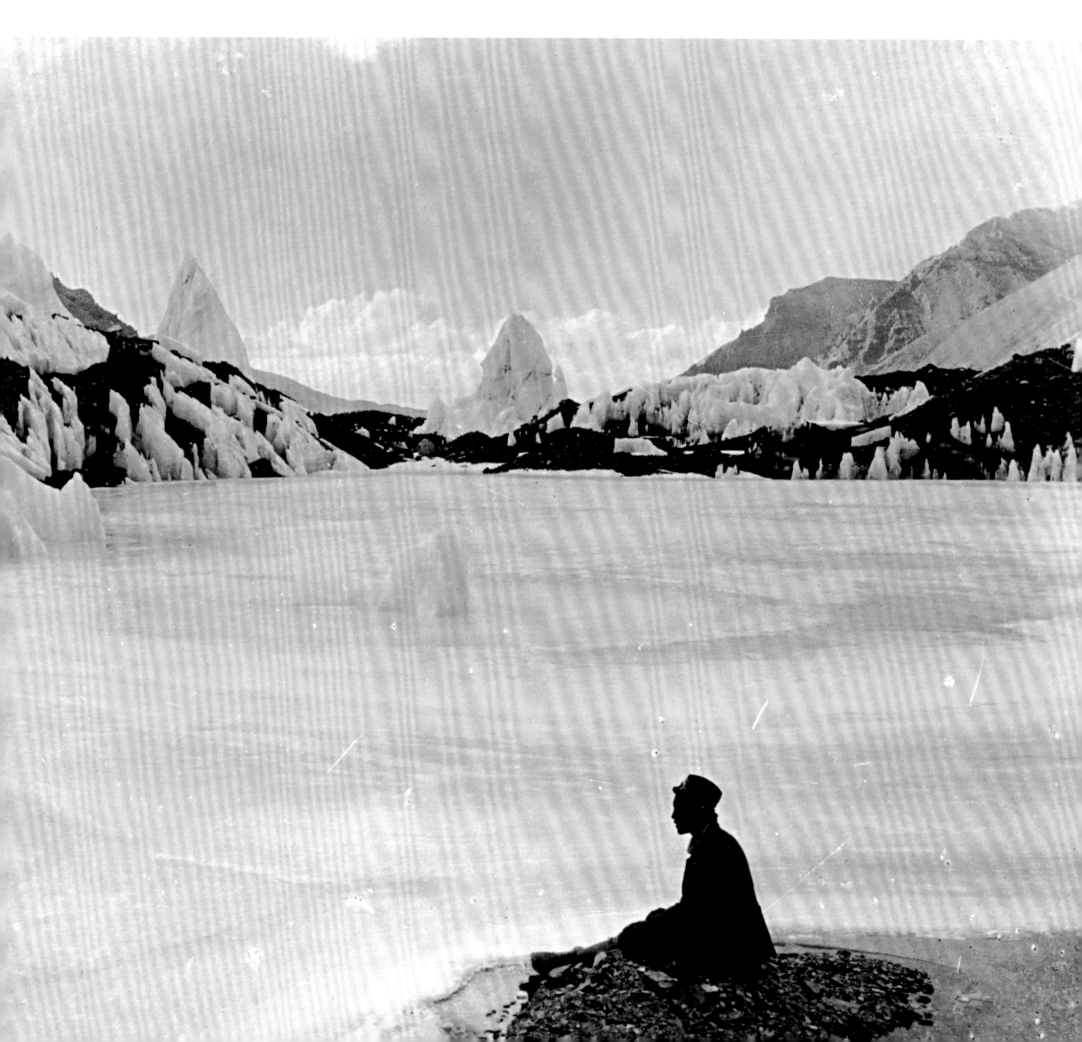

64

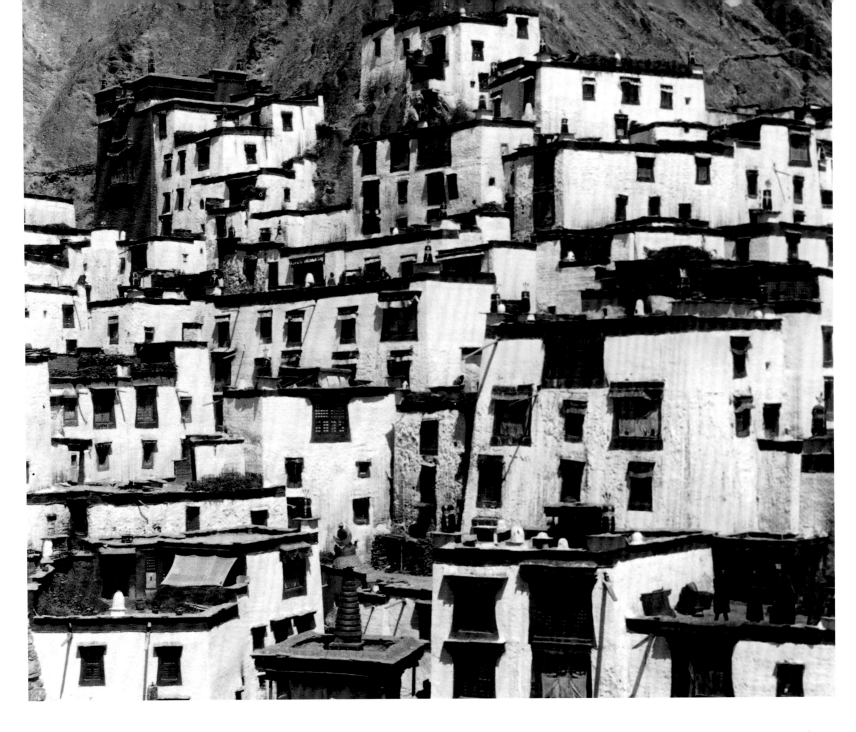

The buildings
of Shegar Dzong
monastery were
painted a brilliant
white, giving the
village and its
monastery the
name "Shegar,"
which means
"Shining Glass."

PHOTO: GEORGE
MALLORY, 1922

For the nomads in the Kama Valley and the monks at Rongbuk monastery, the motivation for those attempting Everest was obscure. Nawang Gombu, the first man to climb the mountain twice, was a novitiate monk at Rongbuk in the late 1940s before he ran away to follow his uncle, Tenzing Norgay, into the expedition game. The legends about the strange foreigners, or *chilina-nga,* who had traveled so far to climb Chomolungma, were still fresh; Trulshik Rinpoche was 14 when the last prewar expedition arrived at Rongbuk in 1938. ("I knew you were English," he said when I interviewed him about Chomolungma. "I remember the way the English talked when they came. You are like them.") Gombu asked the monks what the English were looking for on the summit of the mountain.

The monks told him that there must be a golden cow up there and they wanted to take it home. In a way, they were proved correct. Several climbers have become millionaires from lecturing and writing about their experiences on Everest.

Trulshik Rinpoche became head lama at Rongbuk after the death in 1940 of its founding monk, Dzatrul Rinpoche. In 1921, Dzatrul had been on retreat and did not wish to see the climbers who arrived with their passport from the 13th Dalai Lama. The following year, during the first full attempt on the mountain, Dzatrul was in residence and received the leader of the expedition, Brig.-Gen. Charles Bruce, who later described the lama thus: "[He] was beyond question a remarkable individual. He was a large well-made man of about sixty, full

of dignity, with a most intelligent and wise face and an extraordinary attractive smile. He was treated with the utmost respect by the whole of his people."[5]

Dzatrul Rinpoche was a great religious leader not just on the Tibetan side of Everest but also in Khumbu, across the Nangpa La, in Nepal; in 1902 he founded the current *gompa* at Rongbuk. Before then, Trulshik Rinpoche told me, there had been just a few hermits living where the current Base Camp is located below the Rongbuk Glacier. In 1916, Dzatrul was also the guiding influence in the foundation of the exquisite monastery at Thyangboche on the southern approach to Everest. Born in 1866, he was the driving force of religious reform in the area, raising funds among rich traders at Dingri for these new institutions. The Khumbu Sherpas had become rich through trade across the Nangpa La, and their newfound wealth allowed Dzatrul to lead a rebirth of Buddhism in Khumbu, turning back the encroaching tide of Hinduism that was altering the intrinsically Tibetan culture of the Sherpas.

"When the thirteenth Dalai Lama gave the first permission to climb Chomolungma, he said that they could come as long as they didn't bring guns and kill any of the animals living there. We didn't mind them to climb the mountain. That was okay. We just didn't want the animals to be killed."[6] Many travelers and mountaineers noted how tame the creatures living in Beyuel Khembalung were, a consequence perhaps of never having been hunted by human beings. (To the Tibetans, one of the most offensive things the Chinese did during the Cultural Revolution was to hunt indiscriminately, often with automatic weapons.) According to Dzatrul's own autobiography, Bruce took out his penknife and promised the lama that it was the most lethal weapon he owned and they wouldn't harm the creatures they encountered.

Alas, Bruce could offer no guarantees for the lives of the Tibetans and Sherpas who worked as porters or "coolies" on the expedition. In 1922, seven of them were swept to their deaths by an avalanche on the slopes leading to the North Col. "I was filled with compassion for their lot who underwent such suffering on unnecessary work," Dzatrul Rinpoche wrote. The lama also forbade the local population from visiting the camps the British had used to recover any abandoned food or equipment. The temptation, however, proved too great, and

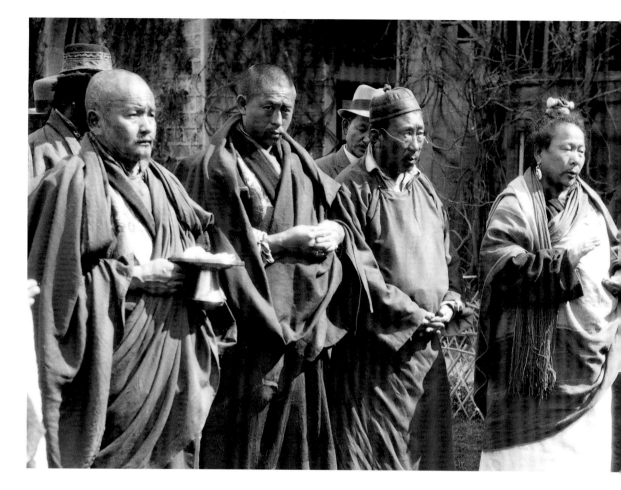

Lamas of the Ghoom monastery in Darjeeling, India, offer a blesssing to the 1933 expedition team before they set off on their long journey to Mount Everest.

PHOTO: FRANK SMYTHE, 1933

about 20 young men and women slipped past the monastery at night and made their way on to the East Rongbuk Glacier. "From a cleft in the nearby scree, seven bears came out. Whatever their hope when they saw the supplies, in a great panic, they all ran away."[7]

The way in which these deaths were woven into a kind of spiritual narrative is fascinating. Myths could be generated about Europeans, too, as John Noel discovered just before the disappearance of George Mallory and Andrew Irvine in 1924 when the expedition called at the Rongbuk monastery on its way to Base Camp: "One of the lamas, an old man with a gnarled face and only two teeth in his head, shuffled over the courtyard wrapped in his maroon gown, and led me to the temple entrance, where on an inner wall, so dark that at first I could not distinguish it, he showed me a freshly executed painting. Looking at it carefully I saw it was a picture of the speared white man lying below Mount Everest surrounded by guard dogs and Sukpas [yetis] and horned demons."[8]

Whether the punishment depicted was for the unnecessary deaths of the porters or for daring to set foot on the mountain

isn't clear from Noel's description, but the influence of foreigners—Nepalis, Chinese, British—was resented in Tibet. If you mess with mountains, the mural was telling him, then disaster will follow. For Dzatrul Rinpoche, the Everest expeditions were an unwelcome diversion from his more serious work of strengthening the *dharma* and giving spiritual guidance to those around him. That Chomolungma was the highest mountain on earth was of little consequence to him.

Gradually, however, the myth of Everest—as opposed to the myths of Chomolungma—has come to dominate the lives of those who live around the mountain. In economic terms, the peak has proved a gigantic money-spinner, and one that, if managed correctly, promises to sustain the Tibetans and Sherpas who live there. Each year, as many as 25,000 trekkers walk through Khumbu to Everest's southern Base Camp and this huge influx has inevitably had consequences on life in the villages around it. Jamling Tenzing Norgay, the second son of the Everest climber, recalls a conversation he had with a Sherpani in Namche Bazar, the Sherpa capital. She said: "Mikaru [literally "white eyes," or Westerners] are much like cattle. They are happy wandering about aimlessly all day long, they are constantly getting sick, and you have to lead them by the nose over difficult terrain or they'll fall off the trail. But if you feed them well, they'll produce a lot of rich milk for you."

Plenty of writers and environmentalists have bemoaned the degradation of the "pristine" environment that once surrounded Everest. Perhaps the corrupting influence of the West is one of our strongest myths; for some reason we need to believe that we inevitably undermine the things we most love. The truth is more complicated. During the 1970s and early 1980s, when the number of trekkers was comparatively small, it was clear that environmental and cultural problems were increasing at an alarming rate. This led to the formation of the Sagarmatha Pollution Control Committee (SPCC), whose leader was the abbot at Thyangboche monastery, Ngawang Tenzin Zangbu, commonly called Thyangboche Lama. Working with the conservation agency the Worldwide Fund for Nature, the SPCC has gone a long way toward helping to halt and reverse the damage done by mass tourism even as the number of trekkers steadily increases. The huge comparative wealth that tourism has generated continues to pose a threat to the culture

Everest (left) and Lhotse loom behind a raven perched atop a prayer flag. Tibetan Buddhists believe that these flags hold the prayers of a person, and that when blown by the wind the prayers pass into the world bringing good to everyone.

PHOTO: JEFF HALL, 1999

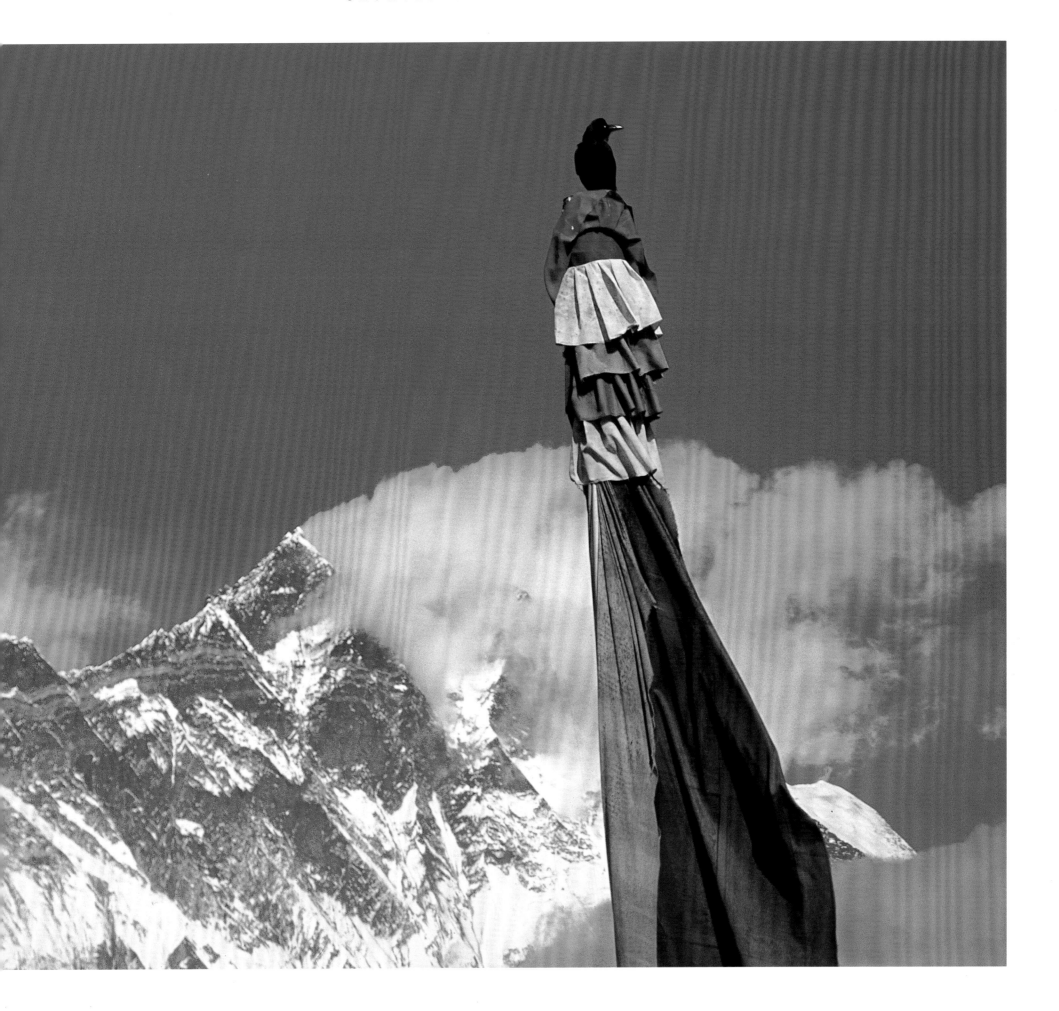

that has developed on the slopes of Everest; many Sherpas have moved to Kathmandu where life is much easier. But the money has also underpinned the cultural framework that supports the Sherpa way of life. Thyangboche Lama has overseen a program to control garbage and the use of firewood. Some more traditional monks and older Sherpas criticized him for his forays into the world of politics and everyday affairs, but his intervention, applying Buddhist principles that are rooted in the landscape around Everest, has helped to defend the environment that all Sherpas rely on.

PRESERVING THE SHERPA CULTURE

When I interviewed Thyangboche Lama in Kathmandu he was busy preparing with other monks for the celebration of Losar, the Tibetan New Year. My mind was full of policy initiatives, of practical steps that could be taken to ameliorate the impact of tourism. He agreed with me about some of these issues, for example, the need for more of the money generated by peak royalties charged by the government in Kathmandu to be used in maintaining Khumbu's environmental integrity. There had been too much focus on the mountain itself, he said, and not enough on the communities around it. But then he lost patience a little with such technical ideas. "Look," he said, "the most important way to protect Khumbu is to pray for the whole world." At first, I didn't really understand his answer. It seemed like a standard Buddhist response, and I tried to return to my earlier line of questioning. "No," he said, "you're missing the point. Only by changing the minds of those who come to Khumbu will we be able to stop the bad effects of tourism."

Everest, he seemed to be saying, may once have been an isolated and remote mountain far from the concerns of the wider world, but that had changed forever. The wider world, its politics and economics, mixes in a strange blend with the centuries-old way of life of men and women such as Jung-mo. In Khumbu it is the consumerist West that is the problem, while on the Tibetan side of the mountain it is totalitarianism and Chinese-style consumerism that threaten to undermine the culture that has grown over thousands of years around Everest. Trulshik Rinpoche fled Rongbuk in 1959, and he doubts that he will ever return. "Over the years 1959, 1960, and 1961 the monastery was destroyed and no one lived there,"

The wealth generated by tourism has had an inevitable impact on traditional life and skills. The carved guardian figure on this water spout is reminiscent of similar wooden sculptures throughout the Himalayas; but with the increase in piped water, electricity, and other conveniences, there is a possibility that this kind of ornamentation may die out.

PHOTO: ALFRED GREGORY, 1953

Trulshik said. "Then, many years later, foreigners started coming and looked at the monastery. They were very interested. And so the Chinese thought, 'We can bring more tourists,' and they said to some local people that they could come and live there." Trulshik met some of these monks at his monastery at Thupten Choeling, but the Chinese authorities have now banned these meetings and consistently refuse Trulshik a visa to visit Tibet.

At the time of writing, the Chinese were in the process of building a much-improved road to the Base Camp on the northern side of Everest so that they could ferry in more tourists. This will inevitably have an impact on the lives of ordinary Tibetans and on the increasing number of Han Chinese immigrants. The many legends and myths that surround Chomolungma and the goddess who lives there are an expression of a way of life that is now under intense pressure. It may be that this way of life will be preserved only as colorful stories to entertain tourists as the packaging of the mountain gathers pace. Ultimately, Thyangboche Lama will be proved correct. What we see in the mountain is no more and no less than that which we ourselves bring to it.

Porters loaded with supplies make their way past the white wall of Changtse toward the North Face of Everest, which looms behind. Already in 1933, when this photograph was taken, Chomolungma, the abode of deities, was becoming a source of economic wealth for a few select high-altitude porters. The more recent advent of mass mountain tourism has increased and spread that wealth—among both foreign operators and local Sherpas— but some people find it hard to reconcile such blatant commercialization with the traditional reverence for the mountain.

PHOTO: FRANK SMYTHE, 1933

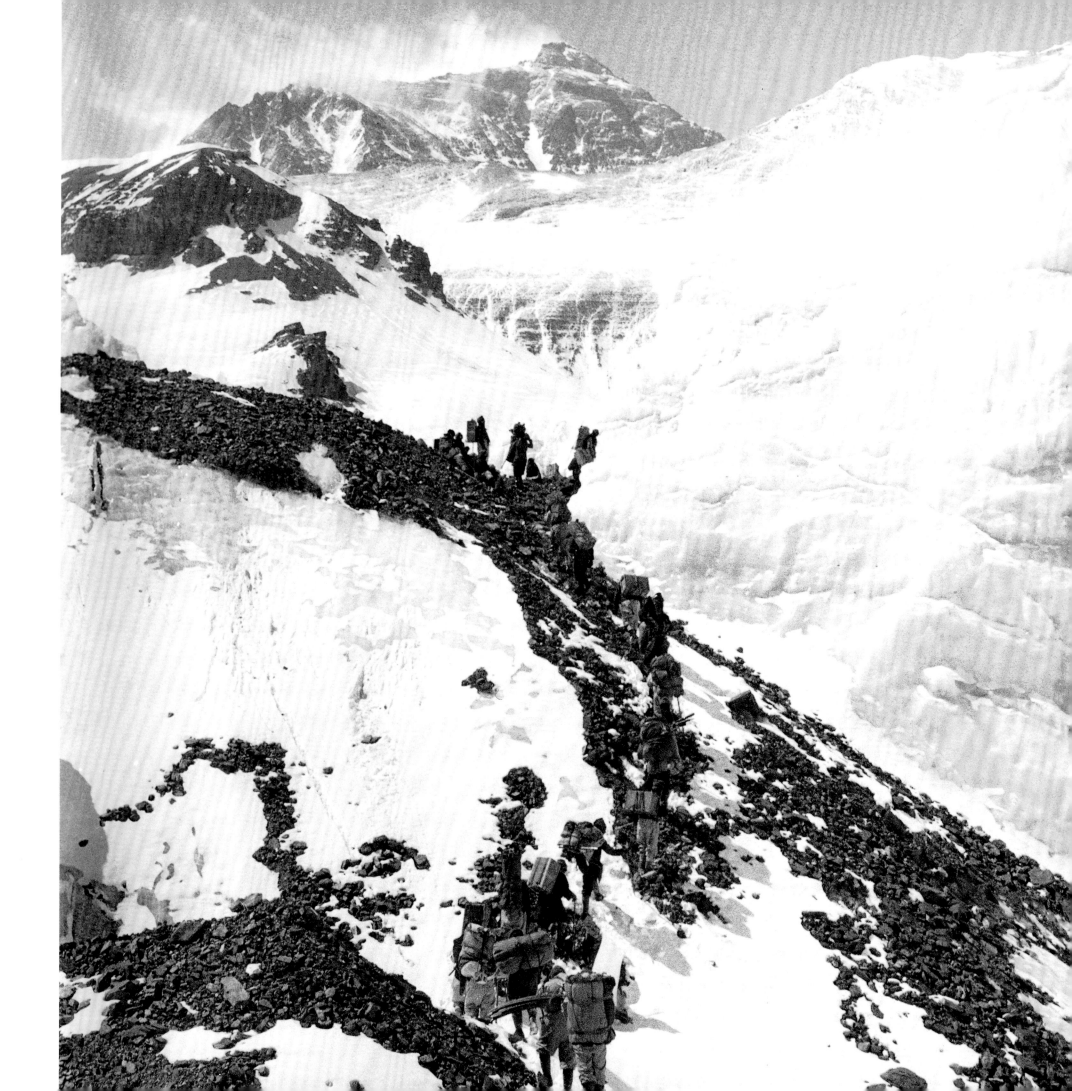

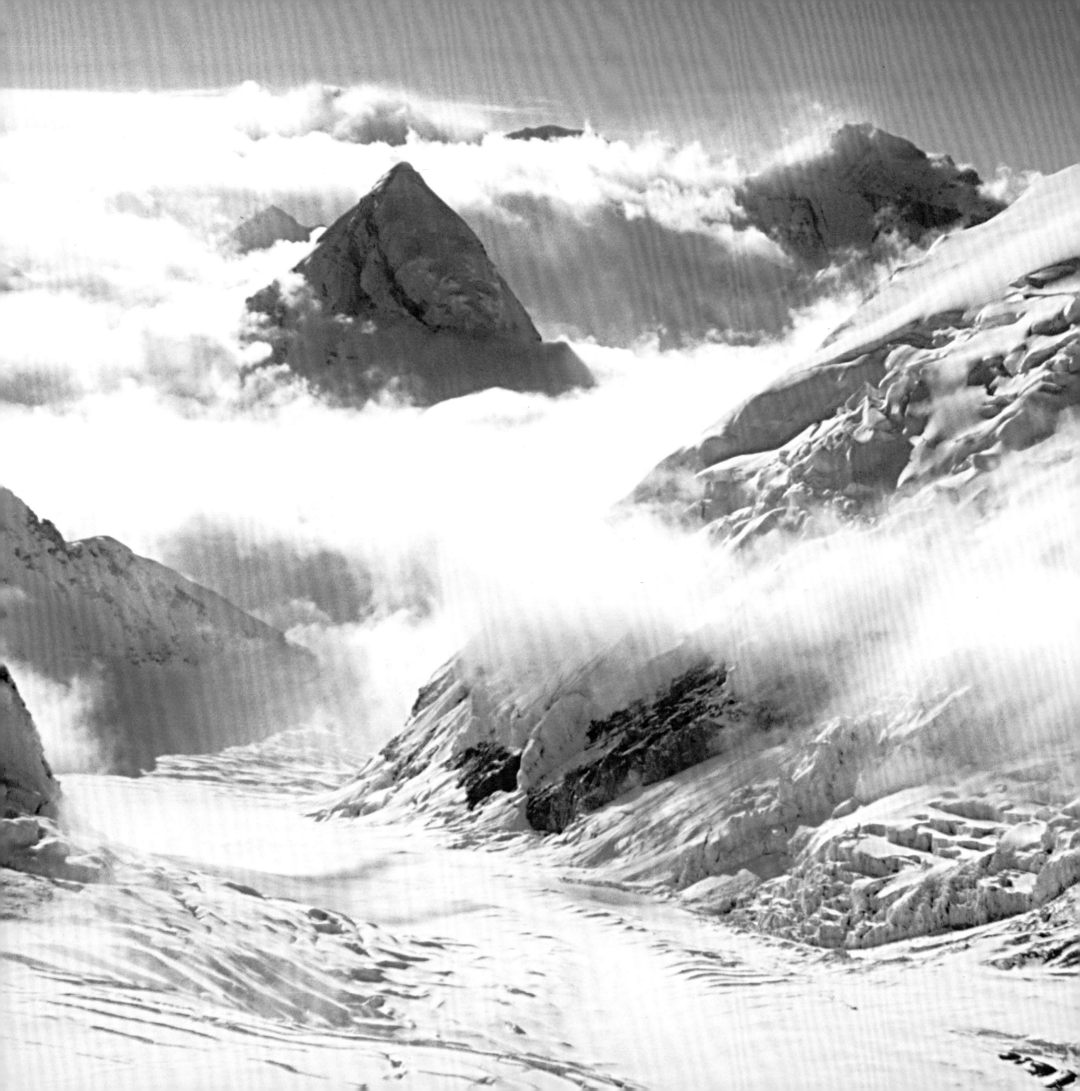

Long ascent
· inferental

THE LONG ASCENT, 1921–1953

"As the clouds rolled asunder before the heights, gradually, very gradually, we saw the great mountainsides and glaciers and ridges, now one fragment, now another, through the floating rifts, until, far higher in the sky than imagination dared to suggest, a prodigious white fang—an excrescence from the jaw of the world—the summit of Everest appeared."[1]

STEPHEN VENABLES

AT 11:30 A.M. ON MAY 29, 1953, Edmund Hillary and Tenzing Norgay embraced on the summit of Everest. Soon they would descend to earth, to fame, adulation, and the tumultuous press of the crowds. But for the moment no one in the world—not even their fellow expedition climbers—knew precisely where they were. No other human being knew that Everest had been climbed and for half an hour or so the summit was theirs alone—a moment of private joy, the culmination of long-nurtured dreams.

It was a supreme moment of personal triumph, but both men were quick to acknowledge that they had not climbed Everest alone. Thousands of feet below them, waiting anxiously at different camps, were over 30 British, New Zealand, and Nepalese climbers. All of them had played their part in getting the two men to the summit, vindicating their leader's belief in the value of teamwork. But beyond that immediate debt to their teammates, Hillary and Tenzing knew that their success was built on the efforts of many, many other individuals, the culmination of a long journey started 32 years earlier.

Few people realized at the start of that journey quite how long and difficult it was going to be. For all of us now that is what makes the journey so fascinating: If the summit had been won too easily there would be no tension, no drama, no sense of wonder. Everest posed all manner of problems—political, geographical, and physiological. Just to reach the bottom of the mountain was a major undertaking. Then there was the job of finding a feasible route to the summit. There was also the apparently intractable problem of how to cope with the final steep, hazardous, diagonal traverse toward the summit, at an altitude where human survival is at best tenuous. Time after time, climbers were rebuffed by those final 1000 feet (300 m) or so of snow-encrusted limestone. Then World War II and the subsequent redrawing of the political map of Central Asia changed everything for mountaineers, sending them back to the drawing board to grapple with a new set of problems on the south side of the mountain.

The quest to solve those problems became an obsession for some of the twentieth century's finest mountain explorers. Their story is an odyssey, with all the twists and turns, delays, frustrations, diversions, and challenges that that name implies. It is also an inspiring story of discovery—both of the mountain and of what can be achieved by the human spirit.

Looking down into the unique formation known as the Western Cwm from the Lhotse Face. PHOTO: GEORGE LOWE, 1953

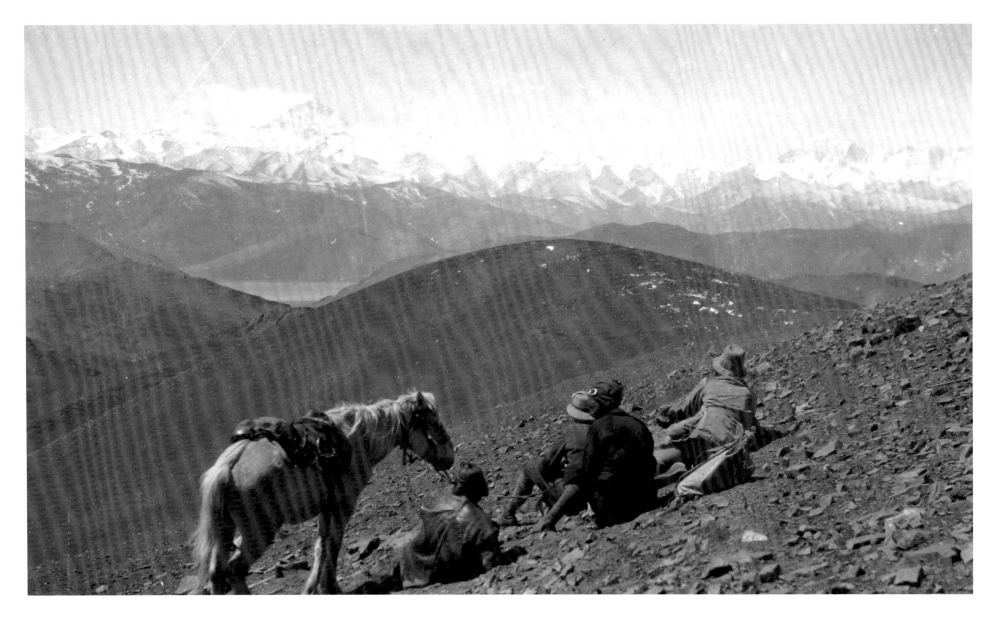

1921—THE FIRST RECONNAISSANCE

It was June 13, 1921, two months since George Mallory had set sail from England with the Everest Reconnaissance Expedition. Now, staring through field glasses from a rocky hill rising above the Tibetan plateau, gazing at the immense icy curtain of the East Face of Everest still nearly 100 miles (160 km) away in the distance, he began for the first time to thrill unequivocally to the challenge of unlocking Everest's secrets—"to piece together the fragments, to interpret the dream." Mallory and his companion Guy Bullock lingered for a while on the hilltop, soaking up the glorious vision before hurrying down to join the expedition caravan as it continued toward yet another overnight camp on its long, dusty journey into the unknown.

It is that sense of solving a puzzle, of revealing the secrets of a previously forbidden landscape, that makes the 1921 reconnaissance the most inspiring of all the seven British expeditions that made the journey across the Tibetan plateau, before World War II finally brought a long halt to such innocent pastimes. Nominated by the Mount Everest Committee of the Alpine Club and Royal Geographical Society, the 1921 team represented the rump of an imperial world shaken by the carnage of World War I. The leader, Lt.-Col. Charles Howard Bury, was no climber, but he had made some adventurous private journeys in Central Asia before serving on the Western Front. In charge of his survey was Maj. Henry Morshead, at 39 a veteran explorer most famous for his journeys to the Yarlung Zangbo Gorges in eastern Tibet, and also an experienced mountaineer. His assistant, the Canadian-born Oliver Wheeler, was seconded to the expedition by the Survey of India, as was Alexander Heron by the Geological Survey. The expedition

The Pang La was an important mile-stone on the journey to Everest. After three weeks on the Tibetan plateau it was a useful point to test acclimatization and also to see the magnificence of the Himalayan range, with Mount Everest just 35 miles (56 km) away.

PHOTO: NOEL ODELL, 1924

doctor, Alexander Wollaston, was a seasoned explorer who, among other things, had explored the jungle approaches to the Carstenz Pyramid in New Guinea; like Howard Bury he was a keen naturalist and photographer. The official climbing leader, Harold Raeburn, despite a fine record, was prematurely aged at 56, and now proved a crusty individual unequal to the rigors of high altitude. As for the most experienced Himalayan mountaineer on the team, Dr. Alexander Kellas, at 52 he too was worn and stressed and was to fall ill and die before even reaching the mountain. That left just the comparatively youthful 34-year-old George Mallory, whose mountaineering skills were undisputed, and Guy Bullock, whose main recommendation was that he had been at school with Mallory.

It is easy now to scoff at the apparent amateurism of this *ad hoc* band cobbled together through the old-boy network. But, as we jet our way to Kathmandu to join the modern package tours driving over the Nepalese frontier to Tibet, armed with our definitive maps and satellite photos, we ought to remember that in 1921 Nepal was forbidden territory, and the only approach was a month-long journey through Tibet by foot and pony all the way from Darjeeling. Apart from one distant photograph taken during Francis Younghusband's 1904 mission to Tibet, and the account of Capt. John Noel's solo journey in 1913, nothing was known of Everest except that its summit was the highest on earth (a fact deduced by trigonometric observations from great distances away in India). And that represented the other great unknown: No one actually knew whether, if a theoretical route to the summit were found, it would be physiologically possible for a human being to follow that route to 29,002 feet (8840 m) above sea level (the then calculated height of Everest).

In 1921, the human altitude record stood at about 24,600 feet (7500 m)—the height attained by the Duke of Abruzzi's team when they attempted Chogolisa, in the Karakoram Range of Kashmir, in 1909. The highest actual summit attained was Trisul, the 23,385-foot (7128-m) peak near Nanda Devi, which Tom Longstaff's team had climbed in 1907. But no one had any idea whether the human body

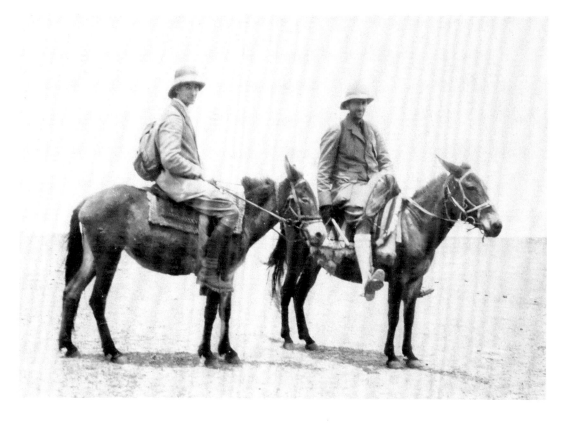

could push itself to nearly 9000 m above sea level, or what would actually happen when climbers tried to sleep at extreme altitude—as they would presumably have to if they were to place their highest camps within reasonable reach of the summit.

By a strange irony, Alexander Kellas, the Scottish doctor who was to die during the 1921 approach march, did have some very sound theories about altitude. He was probably the most experienced Himalayan climber of his day and had made first ascents of Chomiomo (22,404 feet/6829 m), Kangchenjau (22,702 feet/6920 m), and Pauhunri (23,375 feet/7125 m) in Sikkim, coming within a whisker of Longstaff's record climb. His only companions on these fantastic adventures were Sherpas, the Nepalese people of Tibetan origin who were later to become synonymous with Everest. Working from his personal experience in the field and from empirical calculations in the laboratory, he calculated that the maximal rate of oxygen consumption of an unaided climber near the summit would be just under 1.75 imperial pints (one liter) per minute—slightly less than

George Mallory and Guy Bullock (above) leaving for Phari Dzong, a Tibetan town near the Sikkim border. It was from near here that they got their first distant view of Everest on the long approach march.

PHOTO: A. F. R. WOLLASTON, 1921

Headstone marking Dr. Alexander Kellas's grave at Kampa Dzong. Dr. Kellas's death on the 1921 Everest Expedition was a great setback both to that expedition and to future Everest expeditions because they lost his invaluable knowledge of altitude climbing and his belief in the use of oxygen.

PHOTO: A. F. R WOLLASTON, 1921

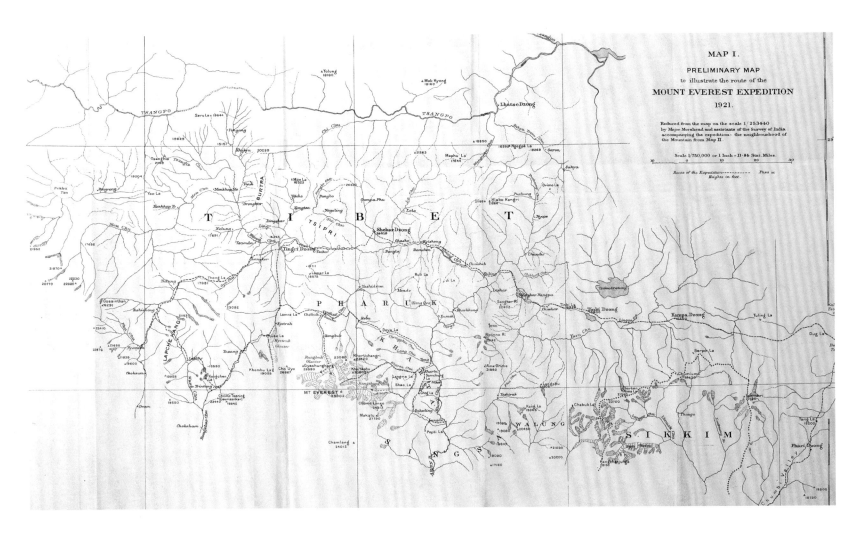

"Map 1. Preliminary map to illustrate the route of the Mount Everest Expedition, 1921," published in the Geographical Journal, 1922. The broken line on this historic map marks the route of the various members during their reconnaissance of the area. The map's enormous scope and detail, all achieved on foot and on horseback, over an area never surveyed in detail before, is astonishing.

A REDUCTION OF THE MAP DRAWN BY MAJ. HENRY MORSHEAD AND ASSISTANTS OF THE SURVEY OF INDIA

the figure now accepted. He thought that, if the terrain were extremely strenuous, climbers would need to carry supplementary oxygen. However, he also postulated that, if the terrain allowed, it should be possible for very fit climbers to reach the summit of Everest without any artificial support, managing a maximum ascent rate on the final section of about 330 feet (100 m) per hour. This is exactly what Peter Habeler and Reinhold Messner were to achieve 57 years later when they made the first oxygenless ascent in 1978.

In 1921, all of that remained conjecture as the expedition caravan set off from Darjeeling. For Kellas, the first part of the journey through the steamy jungle of Sikkim was familiar terrain. For the keen amateur botanist Howard Bury, the fantastic, epiphytic profusion of ferns, mosses, and orchids dripping from the rainforest, changing gradually to alpine vegetation as they climbed up through the greatest mountain range on earth, must have been a delight. Then they crossed the Jelep La and descended into the Chumbi Valley, a finger of Tibetan territory pointing down between Sikkim and Bhutan,

where the hillsides were cloaked in rhododendron and open glades were carpeted with primulas. It was only after climbing further north that the caravan entered more typically Tibetan terrain—a landscape of open plains and rolling hills, where the vegetation is a microscopic incidental detail amid the browns and ochers of geology laid bare to the wind and the brilliant luminosity of clear blue skies.

On they marched, puzzling local Tibetan farmers and nomads with their great caravan of pack animals, servants, tents, provisions, stoves, tables and folding chairs, theodolites, plane tables, telescopes, and mahogany-and-brass plate cameras. The wind, the thin air, and the indifferent food took their toll on the expedition. Raeburn had to return to Sikkim, stricken with dysentery. And then Kellas, weakened by diarrhea, developed complications in the thin cold air and died. He was buried near Kampa Dzong, only a short way north of the Sikkimese mountains that he knew so well. Later, Francis Younghusband, the *éminence grise* behind the early Everest expeditions, would write in his potted history *The Epic of Mount Everest*: "We like

Looking south from near the Chog La. This image was taken by expedition member Alexander Wollaston, a medical doctor, botanist, and naturalist, who spent many days recording and collecting plants and animals in Tibet. He found giant rhubarb (Rheum nobile) growing at 16,200 feet (4940 m), the height from which he took this photograph.

PHOTO: A. F. R. WOLLASTON, 1921

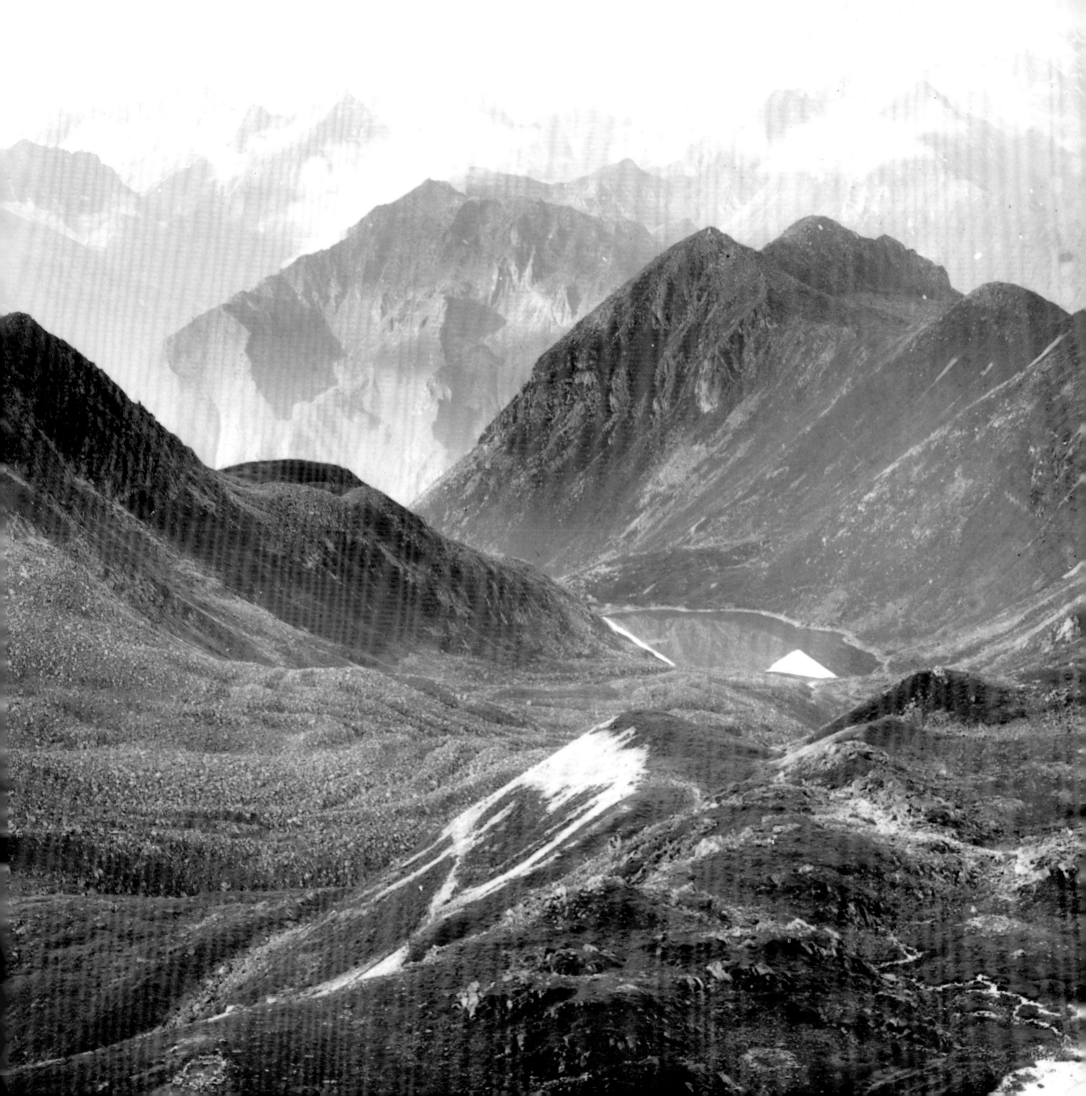

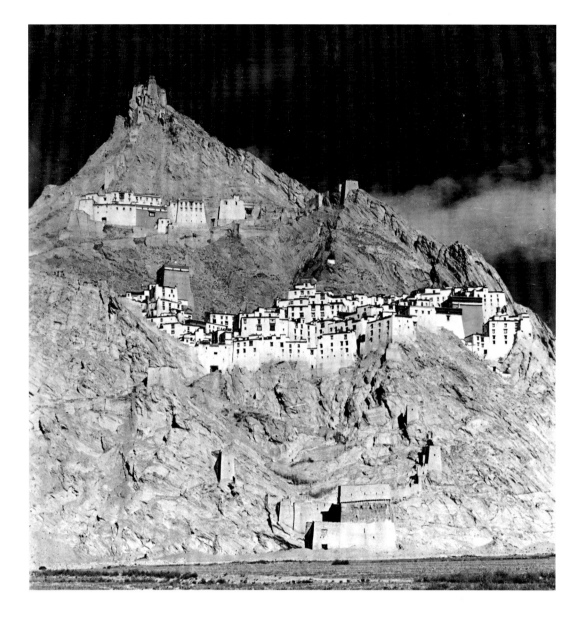

*Shegar Dzong.
Captain Noel thought
Tibetan architecture
the best in Asia and
writes of the settlement
of Shegar Dzong,
"Constructed of
nothing more than
mud and stones,
yet what an aspect of
solidity they present!
They seem to have
grown from the very
rocks upon which
they stand."*

PHOTO: CAPT. J. B.
NOEL, 1924

structure of Everest's North Face, towering just 50 miles (80 km) to the south, above an intervening ridge. Even with a plastering of monsoon snow, the North Face clearly displayed its distinctive bands of sedimentary rock, laid down in some primeval ocean long before the Indian subcontinent collided with Asia. The mountaineers could see the prominent gash of the Great Couloir cutting vertically through the horizontal bands. They could now begin to gauge the daunting length of the pyramid's left-hand edge—its Northeast Ridge—but they could also make out the hopeful-looking subsidiary arm of a North Ridge descending toward them from the shoulder of the Northeast Ridge.

Over the next few weeks, this naming of parts would continue as Mallory and Bullock pieced together the world's most prestigious mountain jigsaw. While they evaluated the mountain with alpinists' eyes, their colleagues were busy mapping, botanizing, and geologizing. The sheer scale of the surveying—and the accuracy of the resulting map—make a mockery of most modern expeditions. This and all future Everest expeditions would suffer to some extent from an enduring conflict of interest between scientists and mountaineers, with the Royal Geographical Society tending to be scornful of such frivolities as mere climbing. As Younghusband put it: "This narrow view of the functions of the society was strongly held by some Fellows—even by an ex-President. It was a survival from times when the making of a map was looked upon as the be-all and end-all of a geographer. But it was now laid down from the very first that the attainment of the summit of Mount Everest was the supreme object of the expedition and all other objects were subsidiary to that."

to know that his eyes had last rested on the scenes of his triumphs. The mighty Pauhunri, Kangchenjau, and Chomiomo, all three of which he—and only he—had climbed, rose before them on his last day's journey."[2]

The survivors continued sadly eastward and eventually reached Shegar. They were the first Europeans ever to reach this monastic hill-fortress complex, where they paid their respects to the dzongpen, the local administrator for the Everest region, through whose offices this and future expeditions would negotiate the hire of local people as porters.

For Mallory and Bullock, spearheading the search for a route to the summit now that Raeburn and Kellas were gone, the real business of converting the dream to reality had begun. From the magnificent citadel summit of Shegar—which means the Crystal Fort—they could begin to discern the pyramidal

From Shegar the expedition marched to the village of Tingri and then to Rongbuk, the highest monastery in the world, standing at 15,740 feet (4800 m) in the bleak, stony valley carved by Everest's northern glacier. On clear evenings the prayer flags strung from the monastery's great domed stupa were silhouetted against the rockbands at the head of the valley, glowing blood red, then violet, then fading through blue to darkness. For the lamas who had chosen to live in this bleak spot, the pyramid that dominated their world was not Everest but Chomolungma, the Mother Goddess of the Earth.

(Whether that is what the word actually means is a question considered in Chapter Two.) Time and time again the lamas would be mystified by the tweed-suited Englishmen who strove so tirelessly toward its summit. Some wondered whether there must be precious treasure hidden up there. Brig.-Gen. Bruce, leader of the 1922 expedition, came closest to the truth when he explained that his companions were members of an obscure English sect who worshipped mountains. Younghusband, ever determined to put a noble gloss on the activities of his Everesters, in particular the questing Mallory, described it as "the quickening of the human spirit."

For Mallory in 1921 the most immediate quest was practical: to find a feasible climbing route. In a glorious festival of mountain vagabondage he and Bullock climbed 5575 feet (1700 m) in a single day to the summit of Ri Ring. They trekked up the Rongbuk Glacier to stand right beneath the North Face of Everest itself towering 8500 feet (2600 m) above them. They explored the western branch of the glacier to a

A group of Tibetans at Gyangkar Nangpa's, the country residence of the dzongpen (governor) of Phari. Here, the 1921 expedition was given dumplings, tea, and milk during the approach to Everest. They reciprocated as best they could by providing a European meal from their own food supplies.

PHOTO: LT.-COL. HOWARD BURY, 1921

Tibetans have traded for thousands of years over the Himalayan passes that would soon become familiar to expeditions of the 1920s and 30s. Here, bales of wool are being loaded for transport to Sikkim from Tibet.

PHOTO: LT.-COL. HOWARD BURY, 1921

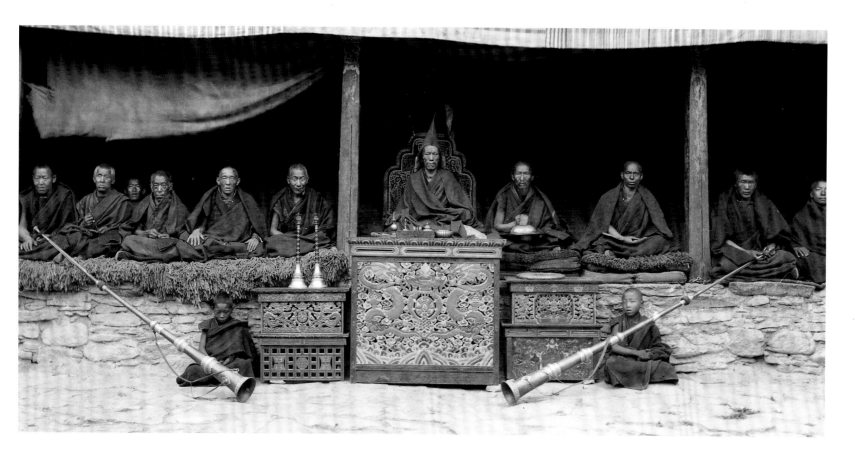

The lamas of Kharta monastery, mindful of their prayers and meditation to Lord Buddha, sit crosslegged. This monastery was founded by a saint after a great flood. In Tibetan mythology, frogs represent the water god and are believed to cause floods. The saint caught and buried a frog at the site of this monastery to protect the area from further floods.

PHOTO: LT.-COL. HOWARD BURY, 1921

high pass on the frontier, and stared down a great precipice into Nepal, as Bullock also did from the Lho La. They glimpsed the great cataract of ice tumbling out of what they called the Western Cwm, never imagining it would be the route eventually followed to the summit (cwm is the Welsh word for an amphitheater-shaped hollow scooped out by glaciation). Homesick perhaps for his daughters Berridge and Clare, Mallory named one particularly beautiful summit Pumori (Daughter Peak). More prosaically, the jagged summit across the Western Cwm in Nepal was named Nuptse (West Peak), and the huge bulk blocking all view of the lower part of Everest from Rongbuk was called Changtse (North Peak).

Mallory correctly ruled out the West Ridge of Everest as too complex and the North Face (possibly incorrectly) as too difficult. It seemed that his original hunch about the North Ridge was correct and that it had to be attained from the North Col between it and Changtse. The western side of the col looked steep and dangerous, so he decided to find a way to the east side. In searching for the east side he embarked on one of the most circuitous red herrings in the history of mountain exploration, making a long journey to the Kharta Valley, where Howard Bury and the rest of the team were now based.

In Kharta, Howard Bury had already photographed the local dzongpen and his wife, dressed magnificently in their ceremonial robes. The dzongpen presided over a cluster of villages that still line the banks of the Kharta river. Now, there is no dzongpen and the monasteries have all been destroyed. But the same terraced barley fields, threshing floors, water mills, and yak enclosures remain, as do the houses of mud and stone sandwiched between wooden beams. In one of the villages, Moyey, a young boy called Tenzing Norgay might have seen the Englishmen walking through on their way to the high passes that lead to the neighboring Kama Valley. Howard Bury took the longer route by the Shao La. Mallory and Bullock crossed the higher and more direct Langma La before descending into the lushest country they had seen since leaving the Chumbi Valley weeks earlier. In the lower Kama Valley, Howard Bury photographed immense trunks of cedar and juniper. Higher up, the party found the most exquisite meadows brimming with alpine flowers. From above these meadows they took magnificent photographs of the world's fifth highest mountain, Makalu, and its sister peak Chomolönzo. Later, in the official expedition book, Mallory wrote: "When all is said about Chomolungma, then Goddess

The dzongpen of Kharta and his wife, posing in front of a ceremonial tent. Dzongpens were local administrators appointed by Lhasa to collect taxes and maintain order. All expeditions that passed through Tibet paid their respects to the dzongpens.

PHOTO: LT.-COL. HOWARD BURY, 1921

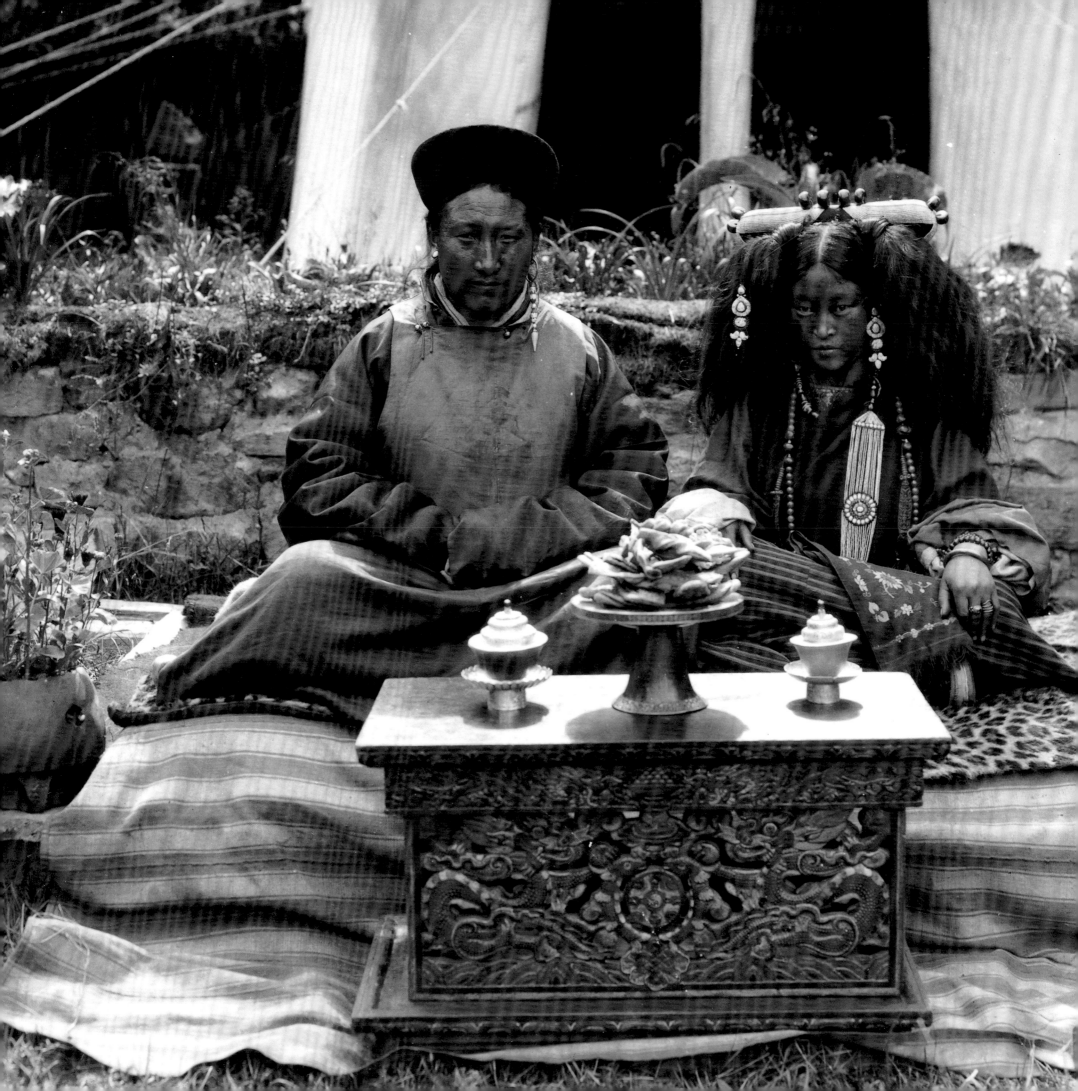

Mother of the World, and about Chomo Uri [Lonzo] the goddess of the Turquoise Mountain, I come back to the valley, the valley bed itself, the broad pastures … the little stream we followed … the few rare plants, so well watered here, and a soft, familiar blueness in the air which even here may charm us. Though I bow to the goddesses I cannot forget at their feet a gentler spirit than theirs, a little shy perhaps, but constant in the changing winds and variable moods of mountains, and always friendly." For future British Everest expeditions this eastern side of the mountain would be a place of recuperation. But for now, for all his engaging ambivalence, Mallory still had a reconnaissance to complete.

When the monsoon clouds lifted, there at the head of the Kama Valley was revealed a mountain wall more forbidding than anything Mallory had ever seen before—Everest's Kangshung Face, some 10,500 feet (3200 m) high, an immense

sheet of hanging glacier draped menacingly over a base of almost vertical rock buttresses. On the left, it curved round to an even more impregnable wall, dropping sheer from Lhotse, the South Peak, fourth highest mountain in the world. Between Lhotse and Everest lay the high saddle of the South Col, with the promising-looking Southeast Ridge rising to Everest's summit. But, as Mallory had already noted, the wall on this side of the col looked out of the question and the far side lay in Nepal, forbidden to Westerners, and in any case guarded by the fearsome icefall he had already seen.

Mallory and his team escaped northward, climbing out of the Kama Valley and across to the head of the parallel Kharta Valley. With one of the porters, Nyima, he climbed the exquisite peak of Khartse for a fine view of Everest's Northeast Ridge, which was clearly blocked halfway up by a great uprearing of awesome pinnacles. Mallory realized that they

would have to get on to the Northeast Ridge above those pinnacles, and to do that they still had to find that North Col access to the North Ridge.

At last, through a process of elimination, Mallory found his North Col. It was now late in the season and autumn was approaching as the expedition reached a windswept col, the Lhakpa La, at the head of the Kharta Glacier, and looked across the smooth upper snowfield of the previously unseen East Rongbuk Glacier. And there, on the far side of the snowfield, was an icewall 980 feet (300 m) high, looking steep but climbable, leading to the holy grail of the North Col.

It had been stressed repeatedly that the 1921 expedition was a reconnaissance, not a full-scale climbing attempt. Nevertheless, Mallory did lead a party down on to the East Rongbuk Glacier to the site of what would be Camp III, or Advance Base, for future expeditions. From there, he cut steps up the hanging glacier wall above, leading Bullock, Wheeler, and three porters up to the broad, level snow ridge. At last, on the morning of September 23, 1921, they had reached the elusive North Col. Behind them the ridge reared up toward Changtse. Ahead, the snow tongue extended upward to merge into a broad rocky ridge leading with no apparent obstacles all the way up to the great shoulder on the Northeast Ridge. And it appeared that, apart from one or two little steps, the ridge led with reasonable ease directly to the summit of Everest.

From Mallory's foreshortened viewpoint the summit looked so close, so attainable. In fact, it was still 6000 feet (1800 m) above him. And, for the first time, he felt the cutting force of the westerly wind, blasting across the huge, tilted expanse of the North Face, and realized that with winter approaching and the expedition over-extended, any serious climbing would have to wait until the following spring.

"Windy Col Camp" at 22,500 feet (6860 m) on the Lhakpa La, from which Mallory finally looked down on the East Rongbuk Glacier. Beyond it, a 1000-foot (300-m) slope led to the North Col. The col is just out of the frame to the right, but the North Ridge can be seen sweeping up leftward to the Northeast Ridge. Over a mile of difficult terrain separates the top of the North Ridge from Everest's summit.
PHOTO: LT.-COL. HOWARD BURY, 1921

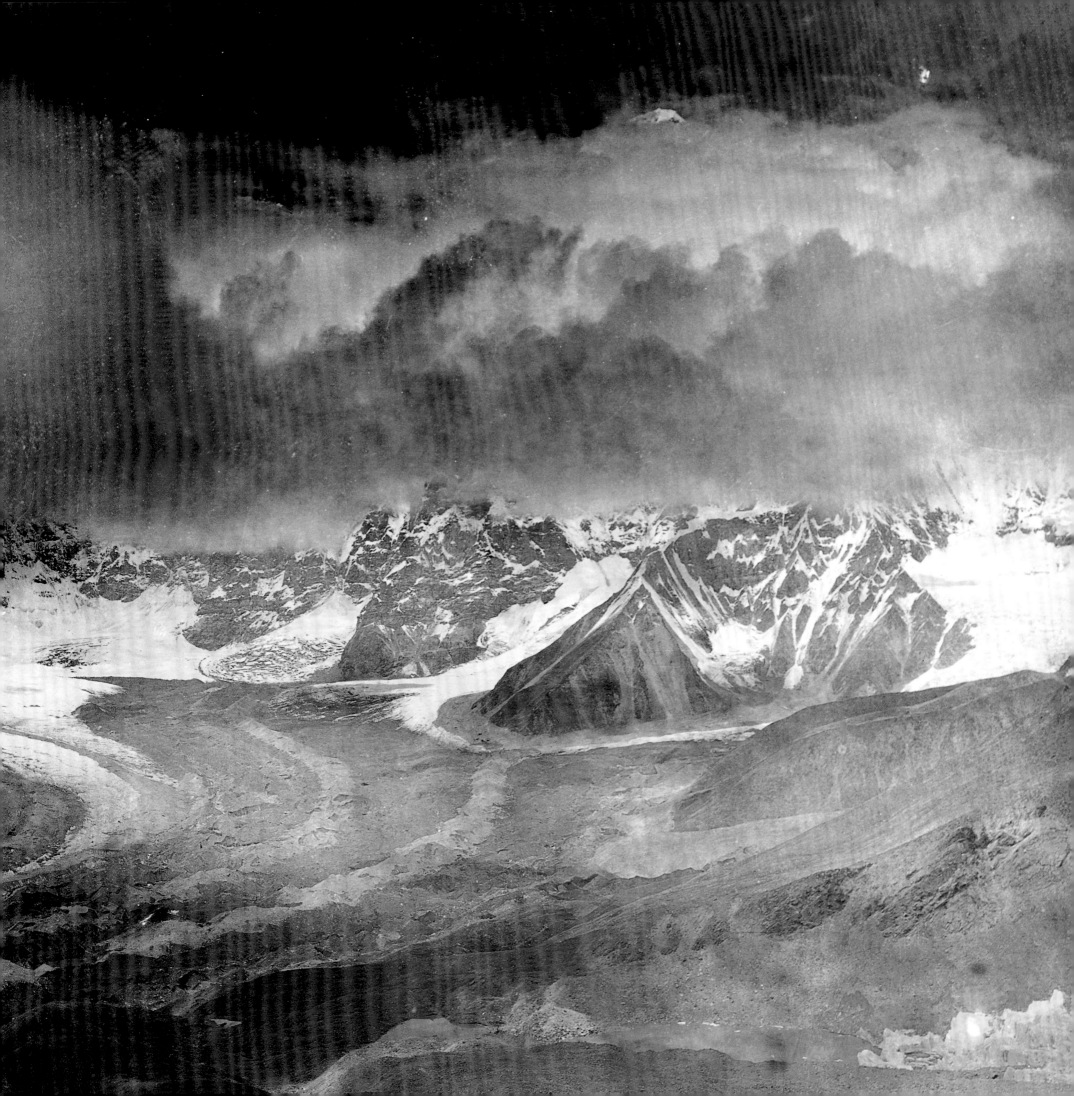

Capt. John Noel, dubbed by Brig.-Gen. Charles Bruce "St. Noel of the Cameras," cinematographing at Base Camp on the Rongbuk Glacier. In a letter to Hinks reporting on team members, Bruce wrote of Noel "He is an R.C. Please approach the mountaineering pope for his benefaction during lifetime."

PHOTO: CAPT. J. B. NOEL, 1922

The Kangshung Glacier, with the top of Mount Everest just appearing above the clouds. This was the sight that met Lt.-Col. Howard Bury when he, Ang Tenze, and Nyima Tendu (who carried the cameras!), climbed the slopes above the glacier to try and get a view of Everest's East Face.

PHOTO: LT.-COL. HOWARD BURY, 1921

1922—DEATH ON THE MOUNTAIN

It was the last week of April 1922. Beneath the whitewashed monastic houses clustered on the cliff face of Shegar Dzong, Capt. John Noel had set up his tripod and plate camera. In the foreground he had erected a magnificent Tibetan ceremonial tent. Later, he would hand-tint the photo to reproduce the tent's brilliant red, green, yellow, and blue decorative border. Along with still cameras, he had brought his "kinematograph" to make a Himalayan movie. The long story of Everest's commercialization had just begun.

For Captain Noel, the expedition was a chance to carry on where he had left off with his clandestine reconnoiter of 1913. In 1921, the army had refused his request for leave to join the reconnaissance; now, determined to put Everest first, he had resigned his commission. Many of his companions on the 1922 expedition also seemed predestined for Everest. Mallory, now firmly associated in the public mind with the mountain, was

back again, dressed at Shegar in jacket and tie for an official audience with the dzongpen. The only other member of the 1921 team was the phenomenally tough, stocky, bullet-headed Morshead. Key new members of the climbing team were Col. Teddy Norton and Howard Somervell, both stationed in India, and Capt. George Finch. Finch was a very experienced and ambitious mountaineer, with many fine alpine ascents to his credit. He had been part of the initial selection the previous year, telling Younghusband, "Sir Francis, you've sent me to heaven!,"[3] only to be informed a few days later that he had failed his medical. (In fact it is questionable whether there was actually anything wrong with him, but the prewar Everest expeditions were rife with spurious medical assessments.)

In charge of the whole enterprise was the man originally intended to lead the 1921 expedition, Brig.-Gen. Charles Bruce. Unlike Howard Bury, whom Mallory loathed, Bruce had the common touch. Younghusband wrote, "Bruce is a kind

Brig.-Gen. Charles G. Bruce, wearing the obligatory dress of imperial soldiers in hot climates—long socks, shorts, and pith helmet—drinks chang at a rest stop en route for Everest. Chang is an alcoholic drink made from fermented barley, which is stuffed into a wooden container, and to which hot water is added. It is drunk through a straw.

PHOTO: BENTLEY BEETHAM, 1924

of benevolent volcano in perpetual eruption of good cheer. And of such irrepressible fun that no amount of misfortune can ever quell him."[4] He had spent much of his professional life in northern India, commanding the Gurkha soldiers recruited from Nepal, and in 1895, along with Albert Mummery, he had organized the first modern Himalayan climbing expedition—to Nanga Parbat. For years this huge, energetic, generous-spirited man had dreamed of Everest, and now at last he was at the mountain's threshold, organizing 160 local porters for the final march over the Pang La to the Rongbuk Base Camp, which was reached on May Day.

Nowadays, expeditions reach the mountain a month earlier to allow plenty of time before the arrival of the wet warm monsoon, which usually reaches the Himalayas some time between late May and mid-June. In 1922—and on most subsequent prewar attempts—the long approach march across the bleak Tibetan plateau, unthinkable before the end of winter, dictated a more rushed attempt on the mountain.

That limited window of opportunity was just one of several dilemmas never fully solved during repeated unsuccessful attempts. Nevertheless, despite the problems and the failure to attain the summit, the mitigating triumphs were legion, starting in 1922 with a leap into the unknown almost as spectacular as the previous year's reconnaissance.

Base Camp was in the comparatively comfortable flat bed of the valley, with plentiful fresh water, up against the first rubbly mounds of the Rongbuk Glacier's terminal moraine. Instead of 1921's circuitous, trial-and-error approach from Kharta, this year the expedition marched straight up the previously ignored East Rongbuk stream and glacier to Advance Base. But it was still a long journey, with two intermediate staging camps. Food, fuel, tents, climbing gear, and oxygen equipment were ferried up in stages by local porters, many of them women and youths. Attempts by the "sahibs" to make sure that the men got the heaviest loads proved fruitless. And, on top of their loads, some of the women were carrying young children! Without the hard work of these incredibly tough people, most of whom have been consigned to anonymity, this and nearly all subsequent Everest expeditions would never have got off the ground.

The strongest porters, mainly Sherpas who had come all the way from Darjeeling, would end up carrying supplies to the North Col and beyond. With the weight of equipment in those days, it was unthinkable that the sahibs could carry all their own gear, particularly if they were going to be in a fit state to continue to the summit. There was also the oxygen equipment. At this stage, most of the team were at best ambivalent about the merits of sucking oxygen through a rubber tube attached to an unwieldy packframe of heavy metal cylinders. Even if oxygen proved beneficial (about which they were skeptical), using it was highly questionable on ethical and on esthetic grounds.

In the end, two rushed attempts were made in 1922, one with and one without supplementary oxygen. Viewed in retrospect, both were doomed to failure; nevertheless, each was a triumphant step into the unknown. The first, oxygenless team of Mallory, Morshead, Norton, and Somervell, set off at 7:00 a.m. from Camp IV on the snow shelf in the immediate lee of the North Col. Accompanying them were five porters

The Arun river is one of the principal tributaries of the Kosi Ri and is known as the Bhong Chu in Tibet. During the 1922 expedition, John Morris and a Sherpa guide provide a height rule for 6-feet (nearly 2-m) high white lilies, found during a foray into the Arun Valley. Morris and Captain Noel thought the lilies a good reward for having had to fight their way through thick forest.

PHOTO: CAPT. J. B. NOEL, 1922

A *handful of porters sit with the baggage, including skis, of the 1922 Everest Expedition at Tingri Dzong. It took 350 yaks and 50 porters to carry all these loads to Base Camp.*

PHOTO: CAPT. J. B. NOEL, 1922

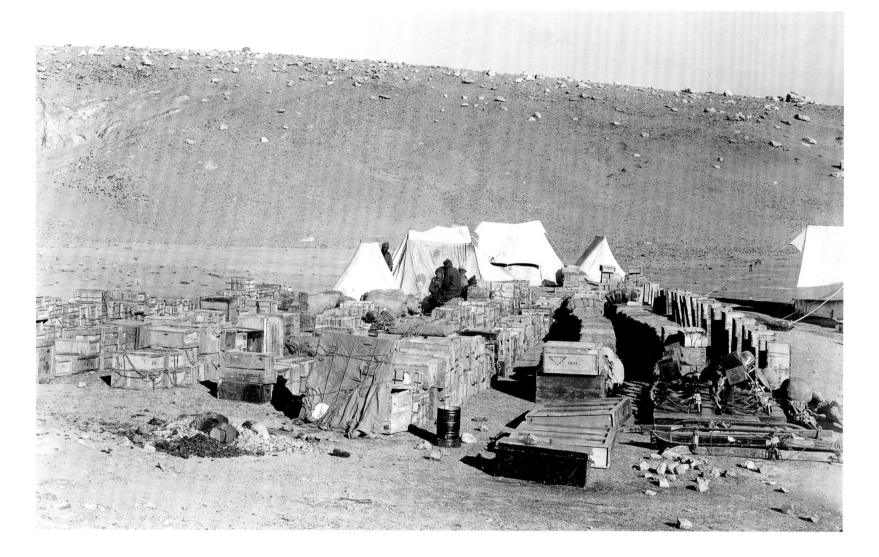

A *Tibetan receipt for the supply of ponies from Shegar Dzong to Tingri Dzong on the 1921 Mount Everest Expedition.*

carrying the equipment for Camp V. Right from the start, they were plagued by the icy wind, which blasts across the huge tilted slab of the North Face from Nepal, concentrating all its malignant force onto the crest of the North Ridge. The sahibs wore layers of wool and tweed, with several pairs of socks inside their overlarge leather nailed boots. They also had windproof suits of cotton, but Morshead neglected to put his

on that day, getting dangerously close to frostbite. The porters were less well equipped. Nowadays all the party would be wearing crampons to claw easily up the initial tongue of hard-packed snow. In 1922, Mallory had to wield his long, heavy ice-ax, chopping steps at an altitude where already the air pressure was less than half that at sea level.

The plan was to climb right up to 27,000 feet (8230 m) that day and set up camp there. In the end, with all the men—particularly the porters—weakened and chilled by the wind, they had to stop and send the porters back from 25,000 feet (7620 m), where the sahibs pitched the two tents on uncomfortable sloping ledges in a sheltered hollow on the east side of the ridge.

They were now higher than any man had been before—and they were spending the night there! Sleep does not come easily at that altitude. Nor does the grim business, not yet fully understood in 1922, of forcing enough liquid into one's

dehydrated body. This has to be done by melting snow and ice over a stove—usually, in those days, an unsatisfactory arrangement using solid fuel tablets. Despite all that, Mallory, Somervell, and Norton managed to get away by 8:00 the next morning, leaving behind in their overnight camp Morshead, who felt he would slow them down.

The three continued upward into what is now often called the Deathzone. For men accustomed to the joyful, agile, liberating movement of alpine climbing this was a travesty. The terrain was not particularly steep, yet steep enough that an unchecked slip could result in a fatal plunge of several thousand feet. It was not technically difficult—just awkward, with new snow lying on sloping, often loose rocks. With one hand resting on rocky outcrops, the other clasping a long ice-ax, each man stopped every few steps to gasp at the thin air, trying desperately to suck more oxygen into his lungs and restore some strength to leaden legs. There was a feeling of helpless lethargy worse than anything they had experienced before, with their goal, the great shoulder on the Northeast Ridge, never seeming to get any closer.

At 2:00 p.m., bravely determined to return to Camp V and escort Morshead safely back down to the North Col, they turned around. Their highpoint was later calculated at 26,985 feet (8227 m)—almost 2400 feet (732 m) higher than anyone had been before them.

One incident on the descent highlighted the skill and competence of those early climbers, who managed without the fixed ropes modern expeditions drape all over the mountain. As the four men were descending from Camp V, all roped together and moving simultaneously, the man at the back slipped, dragging two of the others with him. Mallory, descending first in line, had time to react, plunging his ice-ax into a snowpatch, whipping the rope around it and checking the others' fall. Photographed two days later enjoying one of 17 cups of tea he drank back down at Advance Base, he looks understandably pleased with himself.

As Mallory's team descended, they met George Finch on his way up. Thoroughly

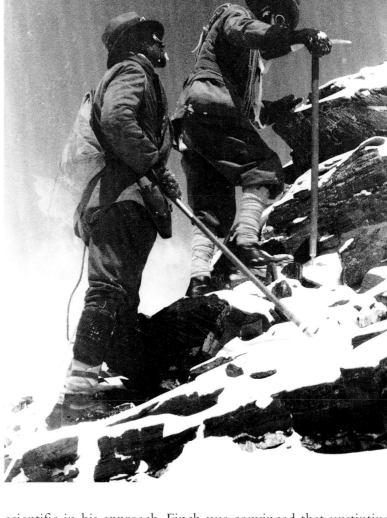

George Mallory and Edward (Teddy) Norton approach their high point, setting a new world altitude record of 26,985 feet (8227 m) on the North Face of Everest.

PHOTO: E. H. SOMERVELL, 1922

scientific in his approach, Finch was convinced that unstinting use of supplementary oxygen was the key to success. Faced with a shortage of available fit climbers (sore throats and other high-altitude illnesses tend to decimate Everest teams), he had recruited Capt. Geoffrey Bruce, the leader's nephew, who was not even a member of the official climbing team. However, young Bruce was fit, keen, and willing, as was a young Gurkha soldier, Tejbir. With help from Sherpas, they succeeded in establishing a new Camp V, some 500 feet (150 m) higher than Mallory's. Then a storm struck, pinning them down in their tiny tent for a night and most of the next day. That evening, in one of many extraordinary displays of generous loyalty, a team of Sherpas climbed all the way up from the North Col

Cover of the program to the 1922 Mount Everest Expedition film made by Capt. J. B. Noel.

A *view from the 1922 high point. The terrain underfoot is easy and in the thin air the summit seems tantalizingly close. In fact, it is some 4900 feet (1500 m) distant and about 1970 feet (600 m) higher. And, as later expeditions would discover, the terrain becomes steadily more difficult above this point.*

PHOTO: T. H. SOMERVELL, 1922

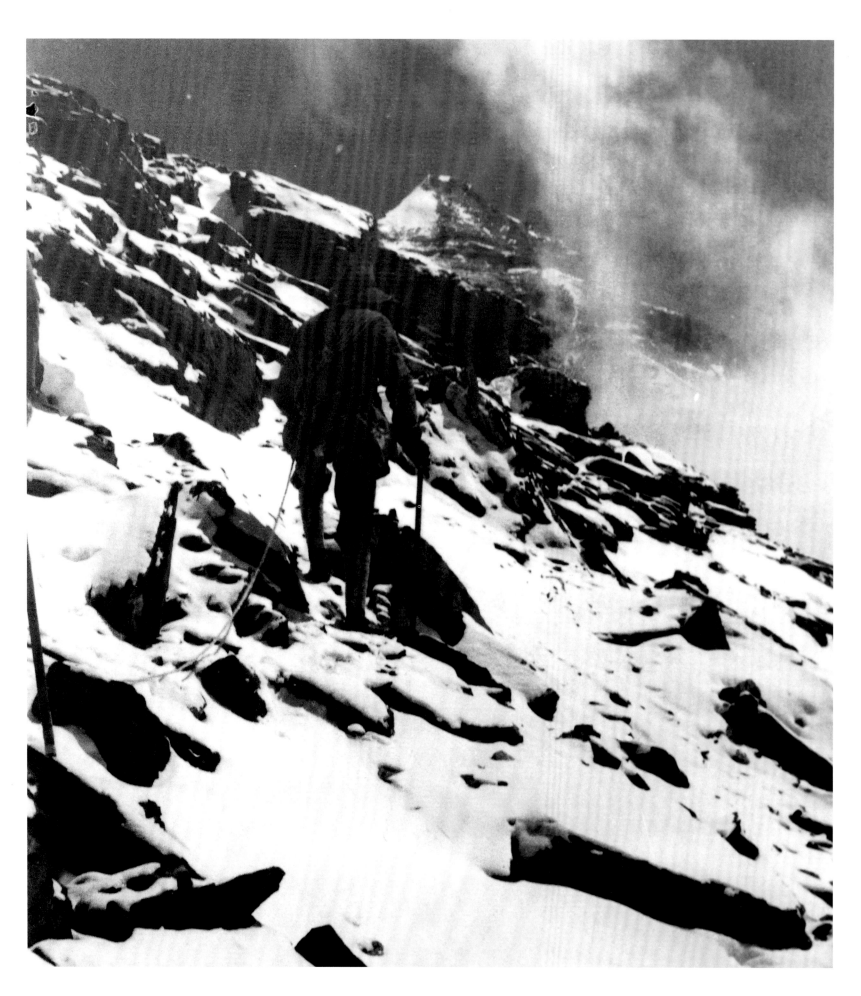

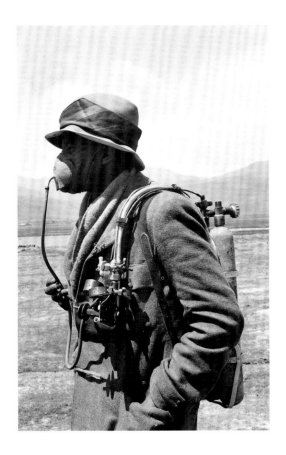

George Finch trying out the oxygen apparatus that he worked tirelessly to improve. On his record-breaking summit attempt with Geoffrey Bruce he showed how oxygen could benefit climbers at high altitudes. However, many colleagues remained skeptical about the heavy, cumbersome, and frequently unreliable equipment.

PHOTO: CAPT. J. B. NOEL, 1922

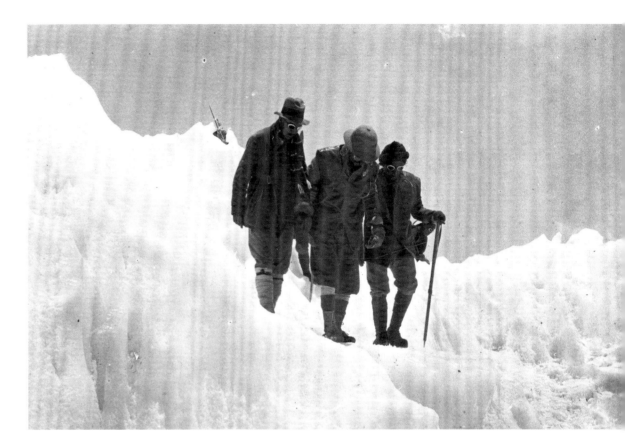

with thermos flasks of hot tea and Bovril. Meanwhile, Finch had been staving off the effects of altitude with regular gasps of oxygen—between puffs on a cigarette! After two nights at the high camp, he set off for the summit with young Bruce and Tejbir. The latter became exhausted and turned back, but Finch and Bruce continued.

Their climb turned into one of the most bizarre feats in mountaineering history—with a complete novice, Bruce, unroped but guided by his mentor Finch, pioneering a new route up Mount Everest and establishing a new altitude record. As Reinhold Messner was to do 58 years later, Finch cut diagonally across the North Face, heading for the deep cleft of the Great Couloir, gaining vital horizontal distance as well as height. It is just conceivable that if he had been alone he might have reached the summit that day. However, even with his impressive alpine experience, he seems to have underestimated the difficulties he would have faced on the final pyramid. As it was, after a brief panic at midday when Bruce's oxygen supply became blocked, Finch decided to turn around. Even with his oxygen reconnected, it was obvious that Bruce was dangerously tired. To have continued would almost certainly have meant never returning.

So the oxygen protagonist and the novice turned around from a high point of 27,300 feet (8323 m). By 5:30 that afternoon they were back down at Advance Base, having descended over 6000 feet (1800 m). Finch put their phenomenal performance down to oxygen equipment and Mallory was so impressed that he decided he should abandon his purist ideals and try using what the Sherpas called "English Air." It was while heading back up to the North Col for one final attempt that he witnessed the first disaster on Everest.

Everyone knew that the snow slopes leading up the east side of the col were avalanche prone. They also knew that conditions were becoming more unstable with the monsoon approaching. Yet, as so often happens in the inexact science of avalanche prediction, they allowed ambition and enthusiasm to get the upper hand and persuade themselves that the slope was safe. Mallory, Somervell, and Colin Crawford (the expedition's transport officer) were leading a party of 14 porters when a slab broke away with a loud bang, gathering momentum and sweeping the final rope of nine porters over a cliff and into a crevasse. Seven of the men were killed. Somervell, in particular, was stricken by a guilty sense of grief: "Why, oh why could not one of us Britishers have shared their fate?"

Capt. Geoffrey Bruce, exhausted and frostbitten after his astonishing high-altitude debut with Finch, is escorted down from the North Col.

PHOTO: GEORGE FINCH, 1922

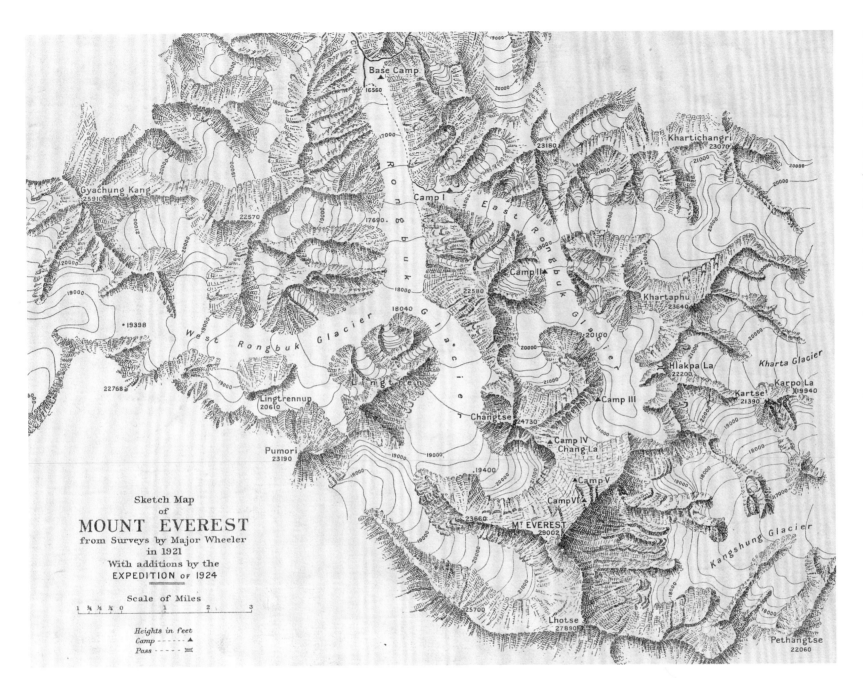

Sketch Map
of
MOUNT EVEREST
from Surveys by Major Wheeler
in 1921
With additions by the
EXPEDITION of 1924

Scale of Miles

Heights in feet
Camp - - - - - ▲
Pass - - - - - ≍

"*Sketch map of Mount Everest from surveys by Major Wheeler in 1921 with additions by the expedition of 1924,*" published in the Geographical Journal, *1924. This detailed map shows the glaciers that surround Mount Everest on the Tibetan side. It also marks the camps established by the 1924 expedition from the Rongbuk Glacier, into the East Rongbuk Glacier, curling up on to the Chang La or North Col, from where the fatal attempt on the summit was made by Mallory and Irvine.*

1924—INTO THE CLOUDS

Two years later, the Britishers made amends for any lingering guilt they may have felt over the deaths of the porters. It was 1924 and another attempt, surely bound to be successful this time, was building on the lessons of 1922. But once again, the expedition turned into a race against time and, even worse, the weather wreaked havoc with all the team's well-laid plans. At Advance Base the temperature dropped to –20° F (–2° C). As the wind shrieked across the East Rongbuk Glacier, the morale of the Tibetan porters wilted. Even down at Camp II, inadequately equipped, they were getting dangerously close to hypothermia. It was then that Norton, acting leader since

Brig.-Gen. Charles Bruce had been forced to retire to Darjeeling with malaria, took command, breaking up all the carefully packed high-altitude tents and clothing packs and distributing them among the porters. Later in the expedition, when the team had regrouped and forced a route up to the North Col, four Sherpas got stranded at the col, unwilling to descend a frightening snow slope immediately beneath it. Despite being ill, tired, and worried about bad weather, Norton, Somervell, and Mallory forced themselves to climb all the way up to the col and rescue the Sherpas.

The sahibs showed responsible concern for their employees and the Sherpas certainly responded heroically, particularly

Norbu Yishang, Lhakpa Chedi, and Semchumbi, without whose great efforts Norton and Somervell would never have established their Camp VI at an incredible 26,800 feet (8171 m). Captain Noel included the three Sherpas, dressed in cotton windsuits tinted green to look like surgeons' outfits, in a photo with Somervell and Norton sitting in camp chairs, Somervell in a heavy cotton coat, Norton in his trademark striped, belted Norfolk jacket. The Sherpas look proud and fit, seemingly unaffected by their efforts. The two sahibs look more drawn, but still with strength in reserve. Like so many of those climbers on the prewar expeditions, they were highly civilized, talented individuals. Somervell, a medical missionary who spent much of his life in India, was a fine painter and musician; he had arranged the Tibetan music for Noel's Everest film when it was shown in London. Norton painted some brilliant watercolors during his two Everest expeditions.

Although he was now official leader in 1924, Norton made Mallory "climbing leader." Both men knew that they were top contenders for the summit, yet there existed a high regard between them. Mallory, careless at times, recognized that Norton, the professional soldier, had a firm grip on logistics and was universally liked. Norton in return praised Mallory's "unique" effortless grace as a climber—and no doubt warmed to the man's literary and intellectual tastes. As a schoolmaster at Charterhouse, Mallory's idealism had impressed one of his pupils, Robert Graves, who wrote in *Goodbye to All That*: "[He was] so youthful-looking as to be often mistaken for a member of the school. From the first he treated me as an equal, and I used to spend my spare time reading in his room, or going for walks with him in the country. He told me of the existence of modern authors. My father being two generations older than myself and my only link with books, I had never heard of people like Shaw, Samuel Butler, Rupert Brooke…."[5]

Literature, art, music, philosophy … the civilized things of life, together with their shared passion for high mountain country, must have helped sustain those pioneers in their isolation, 5000 miles from home. But in the end, their wild dream was only going to be realized through brutish hard labor. After all the delays and much reworking of plans, two summit attempts were staged far later than planned at the end of May. The first attempt, without oxygen, was made by

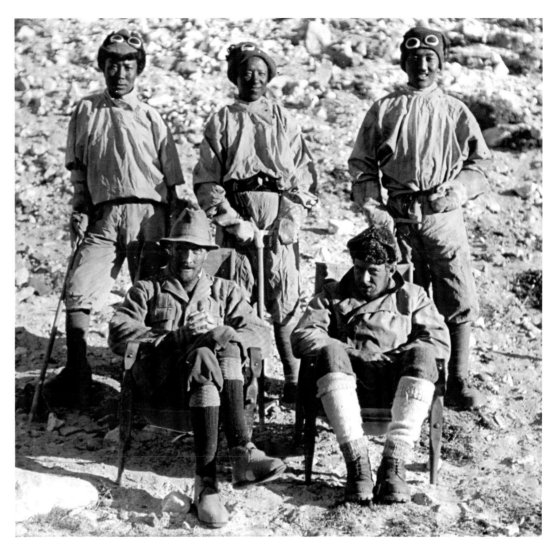

On the slopes of the North Col, Mallory, Norton, and Somervell had to rescue several porters who had been unwillingly abandoned. Namgya (left), one of the porters, suffered terribly in this ordeal and shows his severely frostbitten fingers to Beetham's camera.

PHOTO: BENTLEY BEETHAM, 1924

Norton and Somervell with the Sherpas Norbu Yishang, Lhakpa Chedi, and Semchumbi (above), who established Camp VI at 26,800 feet (8171 m) in 1924.

PHOTO: CAPT. J. B. NOEL, 1924

Somervell and Norton. Setting out this time from a realistically high sixth camp, they had some chance of success. Rather than head straight up to the Shoulder, they realized that the correct route to the Northeast Ridge led diagonally rightward. In fact, Norton had decided to avoid the skyline completely and, after climbing through the yellow band, to follow a grayer band of rock horizontally rightward, staying well below the two obvious steps on the skyline.

Somervell and Norton began their climb to the summit on the morning of June 5, 1924. The scenery around them was overwhelmingly impressive. Looking north along the Nepal–Tibet border they saw the Rongbuk Glacier dizzyingly far below. Even great peaks such as Gyachung Kang and Changtse were a long way below the climbers. Somervell was forced to stop, unable to go any further because of a constriction in his throat. Norton continued alone, his tall figure stooped to hold out a steadying hand on the perversely sloping tiles of Everest's immense tilted roof. Immediately above him, vertical crags barred access to the Northeast Ridge. But straight ahead the strata led inexorably into the gash of the Great Couloir and, beckoning just beyond, seeming so tantalizingly close, was the final summit pyramid.

Alone and without bottled oxygen, Norton reached the Great Couloir and attempted to climb the now steeper, snow-covered rocks on the far side. It was precarious and he was acutely aware of the 8000-foot (2440-m) precipice beneath his feet. He also knew that if he were to push on to the summit his chances of returning before dark were almost nil. We now know that human beings can survive a night in the open on top of Everest. Even without goosedown insulation (only George Finch, the sole scientific voice in the wilderness, had experimented with it, in 1922) and relying only on his many layers of cotton and wool, Norton might have survived a bivouac. But that kind of risk-taking was anathema in 1924, and at 1:00 p.m. he turned around. He had reached a point later calculated at 28,126 feet (8575 m)—a record for oxygenless climbing that was to remain unbeaten for 54 years. On one point he was adamant—he felt capable, despite the lack of oxygen, of climbing the remaining 902 feet (273 m).

The decision to turn around was quickly vindicated. Reversing the dicey traverse, he ended up calling to Somervell

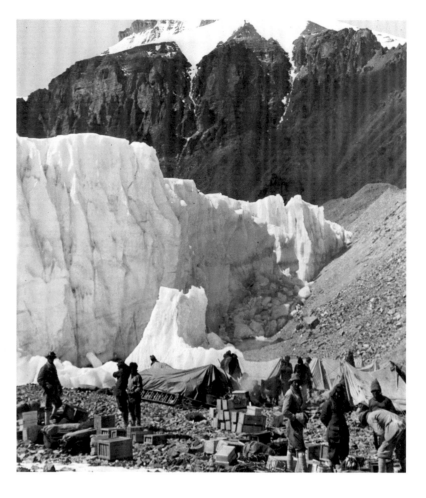

Mallory, wearing a hat and looking at the camera, stands in the foreground of Camp II on the East Rongbuk Glacier. Above the camp rises Mount Kellas, named after Dr. Alexander Kellas, who died on the 1921 expedition.

PHOTO: BENTLEY
BEETHAM, 1924

to throw the rope to him. Weakness was compounded by his failing vision—he had taken off his snow goggles earlier, mistakenly assuming that they were not necessary on the mainly rocky terrain. Somervell also was suffering from his painfully constricted throat. As they climbed back down to Camp VI and continued toward the North Col, Norton drew ahead. At one point he noticed that Somervell had stopped behind him. Later he explained that he thought Somervell had stopped to do some sketching high on the North Face of Everest, having just helped establish a world altitude record! It speaks volumes for Norton's anti-heroic nonchalance, but also for the delusions of hypoxia. Somervell was actually fighting for his life, coughing up the mucous lining of his larynx. Luckily the blockage was evicted and now breathing more freely Somervell hurried to join his companion. Darkness fell as they staggered toward the North Col shouting for help. Someone offered to bring up oxygen and Norton shouted "We don't want the damn oxygen; we want drink!"

Exhausted and snowblind, Norton now heard Mallory outline plans for the second attempt. Desperate to finish the

Team members start the climb up the 1000-foot (300-m) wall of snow and ice leading to the North Col. Establishing a camp at the North Col was a vital requirement of any expedition to the North Ridge of Everest. A summit attempt was made from this camp once it was established.

PHOTO: BENTLEY
BEETHAM, 1924

MALLORY AND IRVINE—THE MYSTERY CONTINUES

The famous last image of George Mallory and Sandy Irvine taken before they set off from the North Col of Everest. Three days later, the two men disappeared into the mists never to be seen alive again. The question of whether or not they reached the summit has still not been answered.

PHOTO: NOEL ODELL, 1924

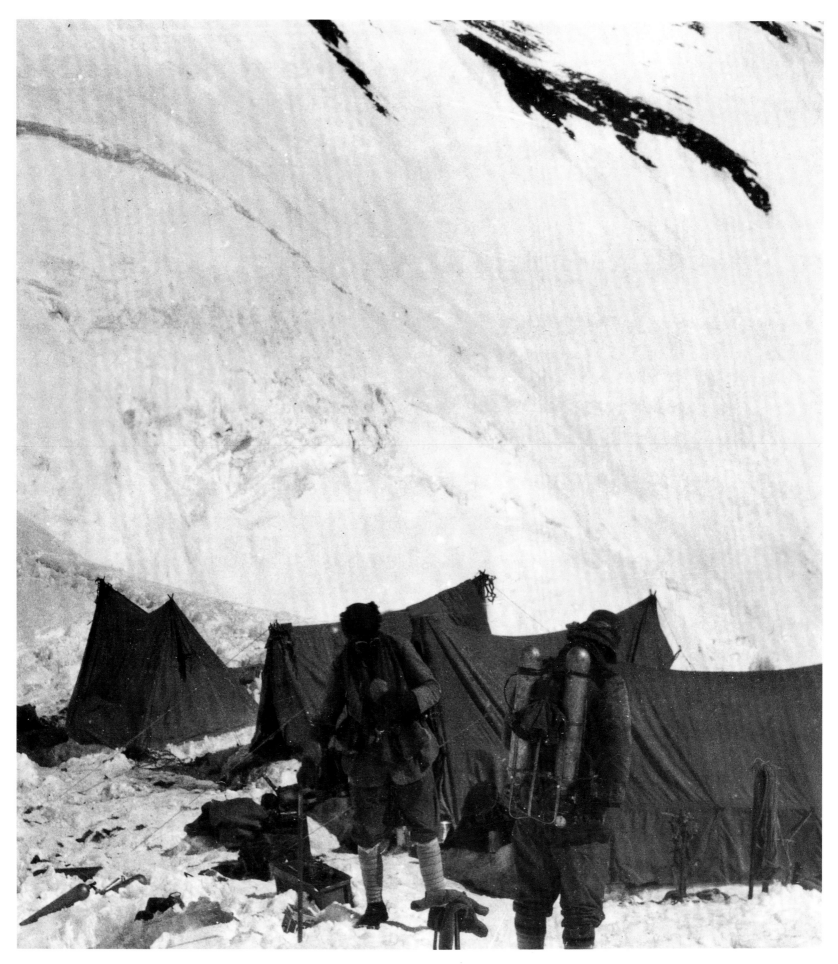

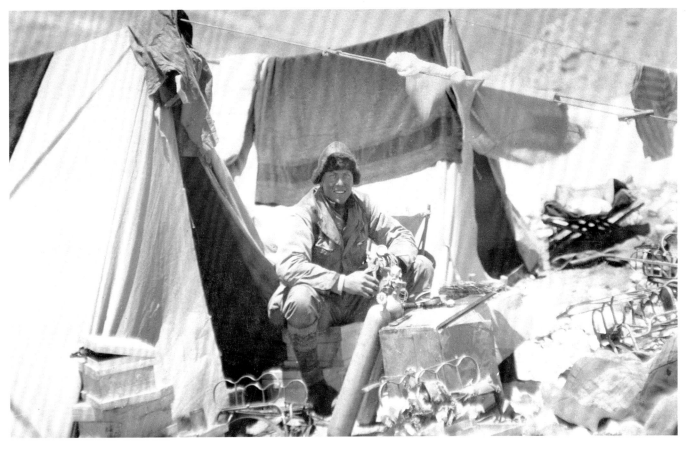

Sandy Irvine (left) fixes an oxygen cylinder. Irvine had shown great engineering flair, finding a solution to any mechanical problem. It was this ability to adapt and repair equipment— particularly oxygen equipment—with the smallest of resources that probably led to his being selected by Mallory for the second attempt on the summit.

PHOTO: BENTLEY
BEETHAM, 1924

Norton's coded telegram (below) taken by runner from Rongbuk Base Camp to Phari Dzong. From there it was relayed to London, arriving on June 19, 1924. It reads "Mallory Irvine Nove Remainder Alcedo," which, decoded, translates as "Mallory and Irvine killed in last engagement, arrived here, all in good order."

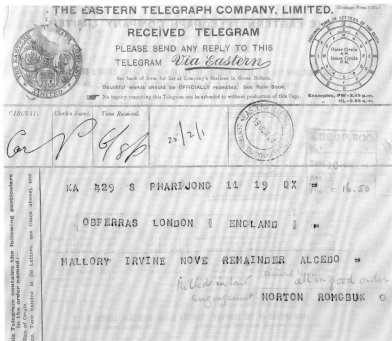

Diagram on the back of a letter to Hinks (right) written by Norton in Darjeeling. It shows Mount Everest and the heights reached by various team members, including Mallory and Irvine.

MANUSCRIPT: COL. E. NORTON, 1924

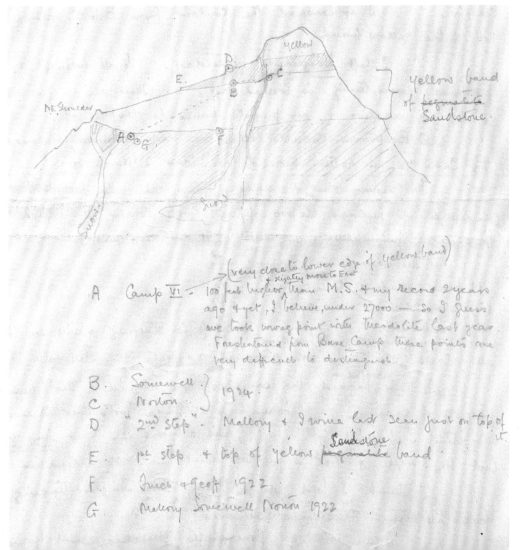

witnessed the final, mist-wreathed moments of tragic drama. On the afternoon of June 7 he arrived at Camp V to meet Sherpa Lhakpa descending from Camp VI, where he and three of his colleagues had just installed Mallory and Irvine for their summit attempt. He showed Odell two notes from Mallory—one for Odell and one to be taken on down to Captain Noel, who was stationed on a rocky perch above Advance Base with his cine camera trained on the upper slopes of the North Face.

That now-famous note, Mallory's last message to the outside world, read as follows: "Dear Noel, We'll probably start early tomorrow (8th) in order to have clear weather. It won't be too early to start looking for us either crossing the rock band or going up skyline at 8.00 pm. Yours ever, G. Mallory."

Eight p.m. was a careless, hypoxic error: He clearly meant eight in the morning. On precisely which rock band and at which point on the skyline Mallory intended Captain Noel's telephoto lens to immortalize himself and Irvine in celluloid, remain the subject of endless conjecture and speculation, as does exactly where Odell saw two figures appear briefly before clouds swirled in to hide them, as he climbed up from Camp V on that morning of June 8. Thousands and thousands of words have been—and will continue to be—written on the subject, but we still do not know exactly what happened. All they knew in 1924, when Odell returned a second time to Camp VI on June 10 to find it exactly as he had left it two days earlier, was that Mallory and Irvine had disappeared.

Now we have more clues. In 1933, Percy Wyn-Harris found Irvine's ice-ax lying on a slab a short way below the crest of the Northeast Ridge. In 1991, two of Mallory's or Irvine's abandoned oxygen bottles were found a little further on, toward the first obvious bump on the skyline known as the First Step. And in 1975, a Chinese climber, Wang Hong-Bao, reported seeing an "English dead" lower down, approximately level with Camp VI. Finally, in 1999 an American research expedition found and photographed the almost perfectly preserved, bleached body of Mallory lying face down in the rubble, his right leg badly broken, in the same area where Wang had reported a corpse.

For some reason, the mountain sleuths had always assumed that the body found by Wang must be Irvine, not Mallory. When it was finally identified as Mallory in 1999, they then

job once and for all, Mallory had decided to boost his chances with oxygen. Aware of his shortcomings in handling machinery, he had decided to take with him the youngest member of the team, 22-year-old Sandy Irvine. Still an undergraduate at Oxford, Irvine had a pitifully meager climbing record but he had abundant enthusiasm and had proved brilliant at coaxing the temperamental oxygen sets into working. He had been invited to join the 1924 team at the suggestion of the older, more experienced Noel Odell, a geologist.

Odell must have been surprised and disappointed not to be chosen for the summit attempt himself, but any bitterness was subsumed in a heroic display of support over the next few days. Climbing up and down the North Ridge with apparently effortless ease, geologizing as he went, he showed an aptitude for altitude that has rarely been matched. And it was he who

suggested that this must be a different body, because the 1975 report referred to a corpse in a sitting or sleeping position with a hole in his face. In other words, they said, Irvine's body must also be somewhere in the vicinity. However, Wang's sighting in 1975 only became more widely known in 1979, after he told the story to a Japanese colleague, Hasegawa Ryoten Yashimoro, on a joint Sino-Japanese reconnaissance expedition. All this was done four years after the actual discovery, in sign language (neither spoke the other's language, though some written communication was possible by writing in the snow with an ice-ax because both languages use the same Chinese characters), but the following day Wang was killed in an avalanche before a Sino-Japanese interpreter could question him more closely. It was hardly the kind of evidence on which to base the precise identification of a corpse.

Perhaps Irvine's body really is somewhere nearby on those bleak scree slopes. However, the discovery of Mallory's body has already told us a lot. As well as a severe fracture to his right leg, Mallory seems to have suffered injuries to his right elbow, shoulder, and head. Clearly, he had a bad fall. The position of the body, with the unbroken leg resting over the broken one and the hands stretched out as if grasping the scree slope, suggests that he may still have been alive, but horribly injured, when he came to a stop. The climbing rope was still tied round his waist and tangled around his shoulders, as often happens in a big fall. Bruising on the ribs, preserved perfectly after 75 years, indicated the vicious tug as the rope came tight before it snapped about 10 feet (3 m) from his waist.

That vital discovery of the snapped rope scotched all the previous elaborate theories that Mallory might have left Irvine and carried on alone to the summit. Whatever happened on that day in 1924, both men were roped together and died either during or after Mallory's battering fall, probably from somewhere up in the Yellow Band. Whether or not both men fell to their deaths, or Irvine was left stranded but uninjured after Mallory fell and snapped the rope, remains unknown.

The researchers in 1999 had hoped to find the Kodak vestpocket camera that Somervell had carried on his own summit attempt and had lent Mallory afterward. If a camera could be found, perhaps it would contain incontrovertible proof that Mallory and Irvine reached the summit before dying. There was sadly no camera; perhaps it is still waiting to

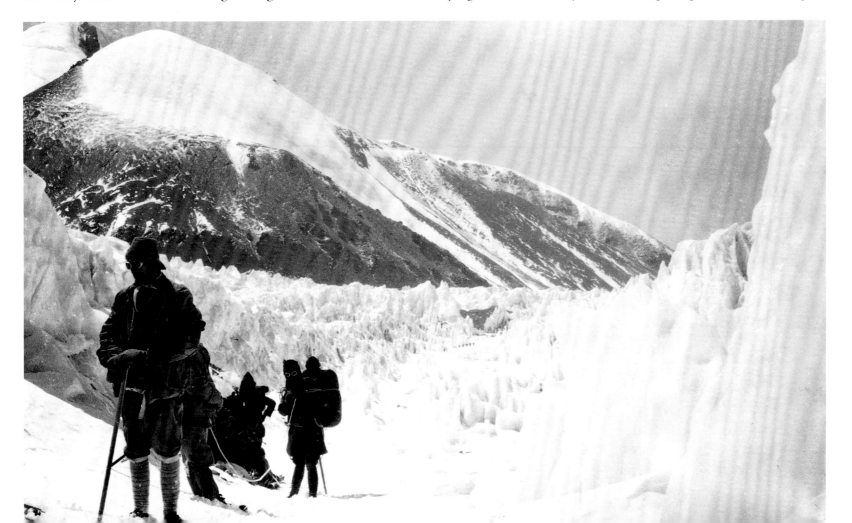

One of a handful of photographs taken by Sandy Irvine before he disappeared with Mallory on Everest. Here, a party can be seen resting—and another party following in the distance—up the "trough," which provided a fortuitous highway between the ice pinnacles of the East Rongbuk Glacier.

PHOTO: A. C. IRVINE, 1924

be discovered with Irvine's corpse. Undeterred, the amateur detectives continued to construct elaborate hypotheses for proving that Mallory did indeed reach the summit. Much was made of the fact that Mallory's goggles were stowed away in a pocket, this being proof, apparently, that the accident must have happened after nightfall and therefore—by several leaps of faith—on the way back from the summit.

Nonsense. First, he could well have taken off his goggles when they became iced up during the brief storm that Odell reported on the afternoon of June 8, and which might well have prompted Mallory to turn around. Second, even if the accident happened after dark, which is entirely plausible, that is no proof that it was on the way back from the summit. (It could even have happened the next morning, although a bivouac near the top of Everest would probably have resulted in frostbite—something there is no sign of on the preserved hands and feet of the corpse.)

All such theories dressed up as empirical deduction are actually sustained by huge dollops of wishful thinking. There is an assumption, based on the ambiguous evidence of Odell's rather vague reports on where he saw the two men before they disappeared into the clouds, that they must have followed Mallory's intended route up the crest of the Northeast Ridge, taking in the formidable prow of the notorious Second Step. If they did reach the summit, however, it seems far more likely to me that, faced with the true reality of the ridge's difficulties, they would have sidled off sideways (as the 1933 team was to do) and joined Norton's easier traverse line. Then, perhaps, sustained by that great leap of the human spirit that causes men to burn bridges and cross barriers, they might have forced themselves on up the final pyramid—driving themselves up to the summit, then making a desperate retreat back down, running out of oxygen, continuing into the darkness until the almost inevitable mistake by one of them pulled them both off the precarious sloping ledges to crash to their deaths.

All that is theoretically possible. The more likely scenario is that all manner of problems, technical and emotional—not least the inexperience of his companion—forced Mallory to make the painful decision to abandon his dream and return empty-handed to Camp VI. Perhaps that decision was forced on him by the verticality of the Second Step. Or perhaps, like Norton,

he followed the lower traverse line and also ran out of time. But nothing will alter the awful reality of two men suffering a lonely, violent death. Much was made of the fact that, among the various bits of memorabilia found in Mallory's pockets in 1999 were scribbled notes detailing his calculations for oxygen consumption and proving how seriously he planned the summit attempt. Far more poignant was the unpaid bill for two pairs of Fives gloves. What a touchingly incongruous memorial, thousands of miles from the leafy Surrey public school where, when he was a master, Mallory must have played the esoteric, quintessentially British game of Fives.

Many of his friends, particularly his mentor Geoffrey Winthrop Young, consoled themselves with the belief that George Mallory must have reached the summit; but for the mother of his three children, Ruth, writing to Young, that was irrelevant: "I don't think I do feel that his death makes me the least more proud of him, it is his life that I loved and love," she wrote. "I know so absolutely that he could not have failed in courage or self-sacrifice. Whether he got to the top of the mountain or did not, whether he lived or died, makes no difference to my admiration for him. I think I have got the pain separate. There is so much of it, and it will go on so long, that I must do that … Oh, Geoffrey, if only it hadn't happened! It so easily might not have."[6]

THE CONTINUING STRUGGLE

In the long saga of man's involvement with Everest, politics has rarely been far beneath the surface. That British explorers were allowed access to the mountain in the first place was only as a result of Britain's unique leverage on the Tibetan government. Yet, for all its apparent bullying, the British empire was run by bureaucrats fearful of upsetting the delicate diplomatic balance.

The key link between Britain's India Office and the government of Tibet was the Political Officer in Sikkim, an office held from 1921–28 by Lt.-Col. Frederick Bailey. Despite having been Morshead's companion on the great exploration of the Yarlung Zangbo Gorges, he seems to have acquired all the cautious intransigence of the true bureaucrat determined not to upset the apple cart. He did everything he could to thwart attempts on the mountain, seizing on any perceived breach of conduct as an excuse to ban future expeditions.

Captain Noel's atmospheric photo captures all the dangerous allure of the world's highest mountain. It shows the lower part of Everest's Northeast Ridge and evokes the conflicting emotions of admiration and regret inspired by Mallory's and Irvine's summit quest. Two days after his last sighting of the men, Noel Odell climbed a second time, alone, to Camp VI to search for them. Finding nothing there, and seeing no sign of them above, he arranged two sleeping bags in a "T" as a signal for Hazard, who was waiting down at the North Col. Hazard in turn arranged six sleeping bags in the shape of a cross—the code agreed beforehand with the rest of the team at Advance Base Camp, signifying "Death."

PHOTO: CAPT. J. B. NOEL, 1924

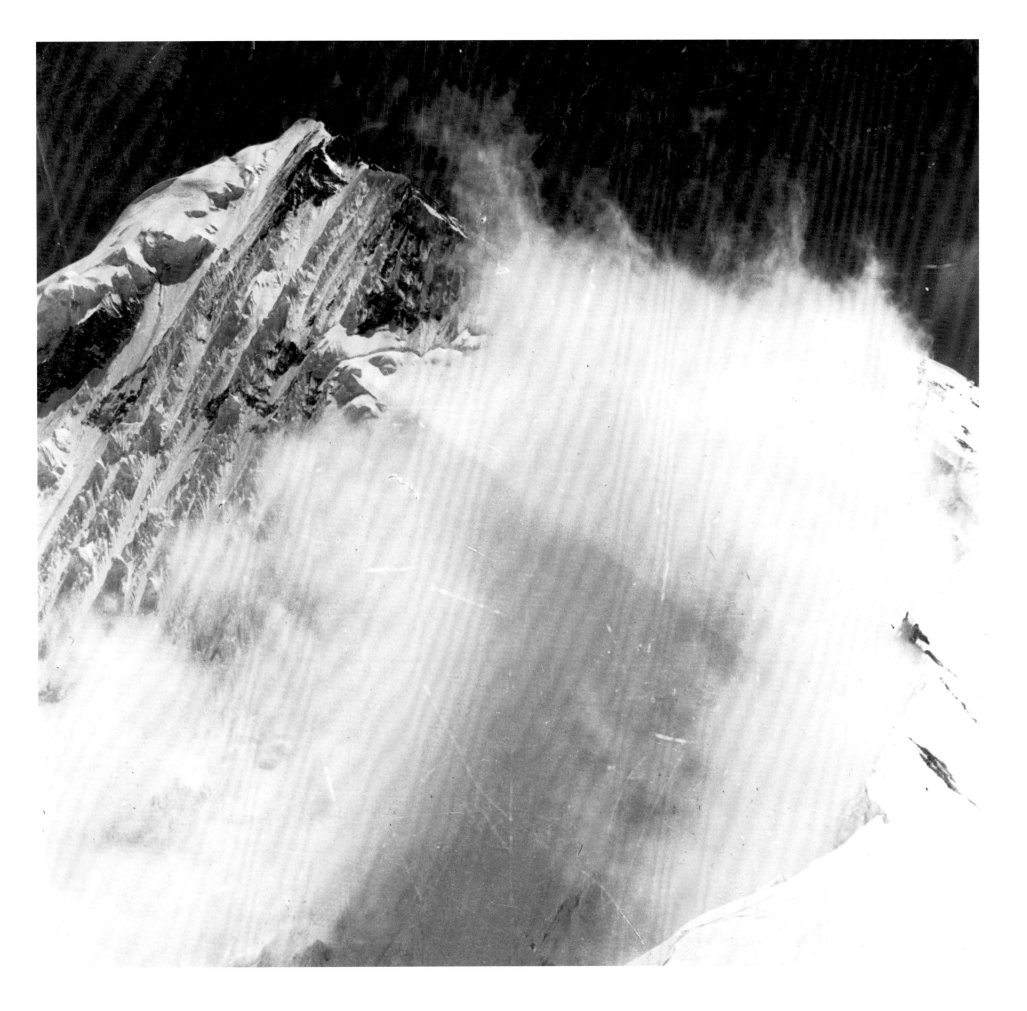

Tibetan notice for the 1921 Mount Everest Expedition, to ensure that they were given any assistance necessary by the Tibetans. The notice reads: To: The Dzongpens and Headmen of Phari, Tingri, Kampa, and Kharta. You are to bear in mind that a party of sahibs are coming to see the Chomo Lunma mountain and they will evince great friendship toward the Tibetans. On the request of the Great Minister Bell, a passport has been issued requiring you and all officials and subjects of the Tibetan government to supply transport, e.g., riding ponies, pack animals, and coolies as required by the sahibs, the rates for which should be fixed to mutual satisfaction. Any other assistance that the sahibs may require either by day or by night, on the march or during halts, should be faithfully given, and their requirements about transport or anything else should be promptly attended to. All the people of the country, wherever the sahibs may happen to come, should render all necessary assistance in the best possible way, in order to maintain friendly relations between the British and Tibetan Governments. Dispatched during the Iron-Bird Year (1921) Seal of the Prime Minister.

There were several "breaches" that Bailey could frown upon. In the aftermath of the 1924 expedition it transpired that one of the surveyors, John Hazard, had traveled way beyond the regions permitted in the expedition "passport." There were also doubts about the legitimacy of Norton's decision to lead the team to the beautiful Rongshar Valley to recuperate before the long march home. More seriously, Bailey managed to winkle out irregularities in the paperwork relating to the several Tibetan lamas whom Captain Noel, ever the entrepreneur, enticed back to Britain to perform traditional dances to enliven showings of his film. As far as the officials were concerned, individualism and crass commercialism were threatening Britain's delicate relations with the Dalai Lama.

So there were to be no more expeditions for a long time. Not until 1931 did the India Office once again begin to countenance the idea, finally obtaining permission for an expedition in 1933. As it turned out, this would be the first of no fewer than four official expeditions to attempt Everest before the end of the decade. None succeeded in bettering Norton's high point of 1924. However, although no apparent progress was made on Everest itself, this turned out to be a fascinating period for Himalayan exploration in general and Everest inevitably attracted some of the most talented mountain explorers, some of whom would play a key role in the subsequent chapter of the story after World War II.

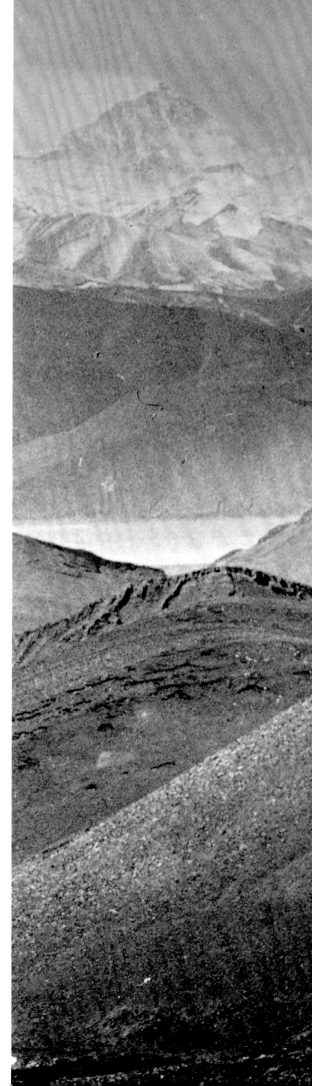

From the dry slopes of the Pang La, the snow-covered peaks of the Himalayas, including Mount Everest, can be seen stretching out like a long wall separating the Tibetan plateau from the Indian plains.

PHOTO: BENTLEY BEETHAM, 1924

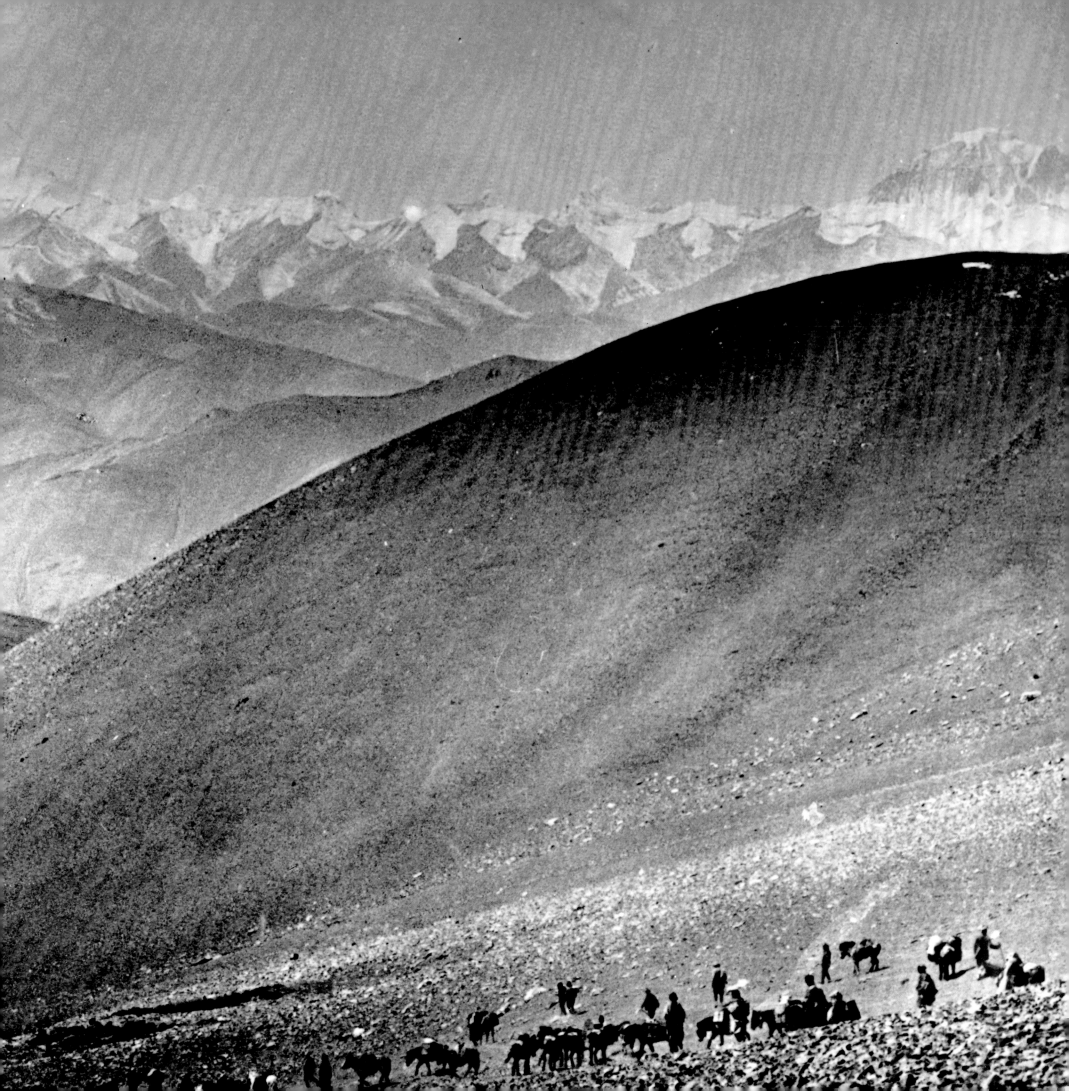

ALBUM: THE 1920S EXPEDITIONS

Major Wheeler's Photographic Survey Party (right). Using photo-topographical surveying instruments, Oliver Wheeler with his two assistants methodically photographed and mapped the Everest region. Wheeler had learned this surveying method in Canada, where it had been extensively applied.

PHOTO: A. F. R. WOLLASTON, 1921

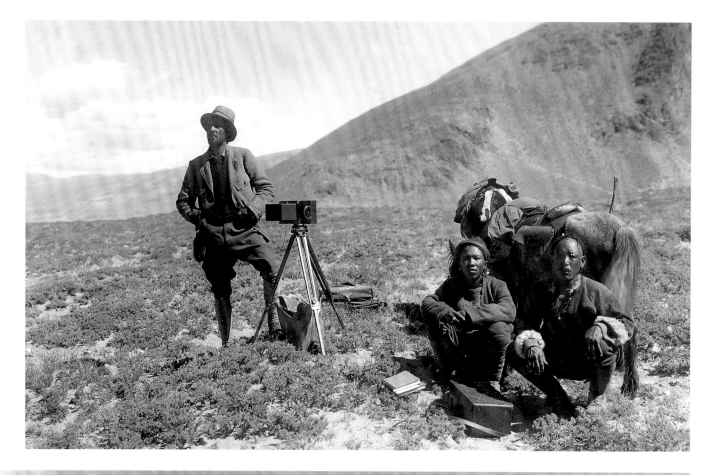

Maj. H. T. Morshead and Gujjar Singh (opposite) plane tabling at 17,000 feet (5180 m) for the Survey of India while on the 1921 Mount Everest Reconnaissance Expedition. Some 12,000 square miles (31,000 square km) of totally unexplored country in the Everest region was mapped.

PHOTO: LT.-COL. HOWARD BURY, 1921

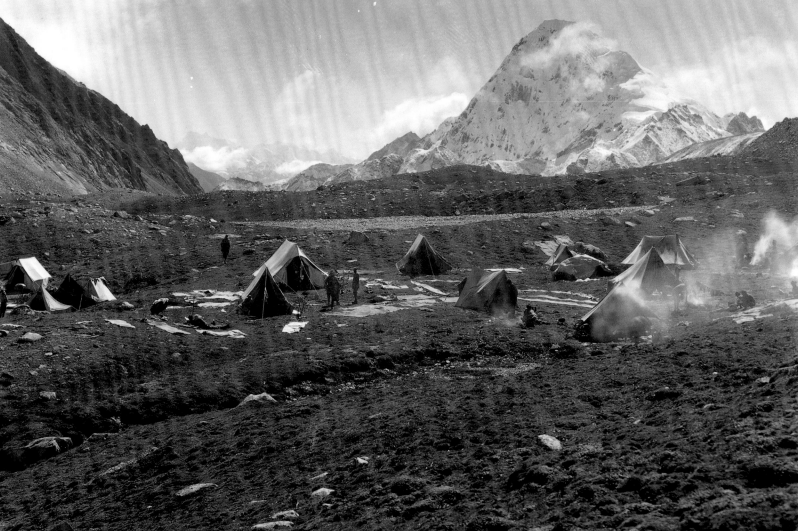

The Reconnaissance Expedition Advance Base Camp (left) in the Kharta Valley. It was during the first two expeditions that many lessons were learned with regard to equipment; from where to buy it to how long it would last. In 1924, Capt. Geoffrey Bruce suggested buying tents from Elgin Mills at Cawnpore because he felt it was not advisable to bring porters' tents back after an expedition as they were usually blackened with smoke.

PHOTO: LT.-COL. HOWARD BURY, 1921

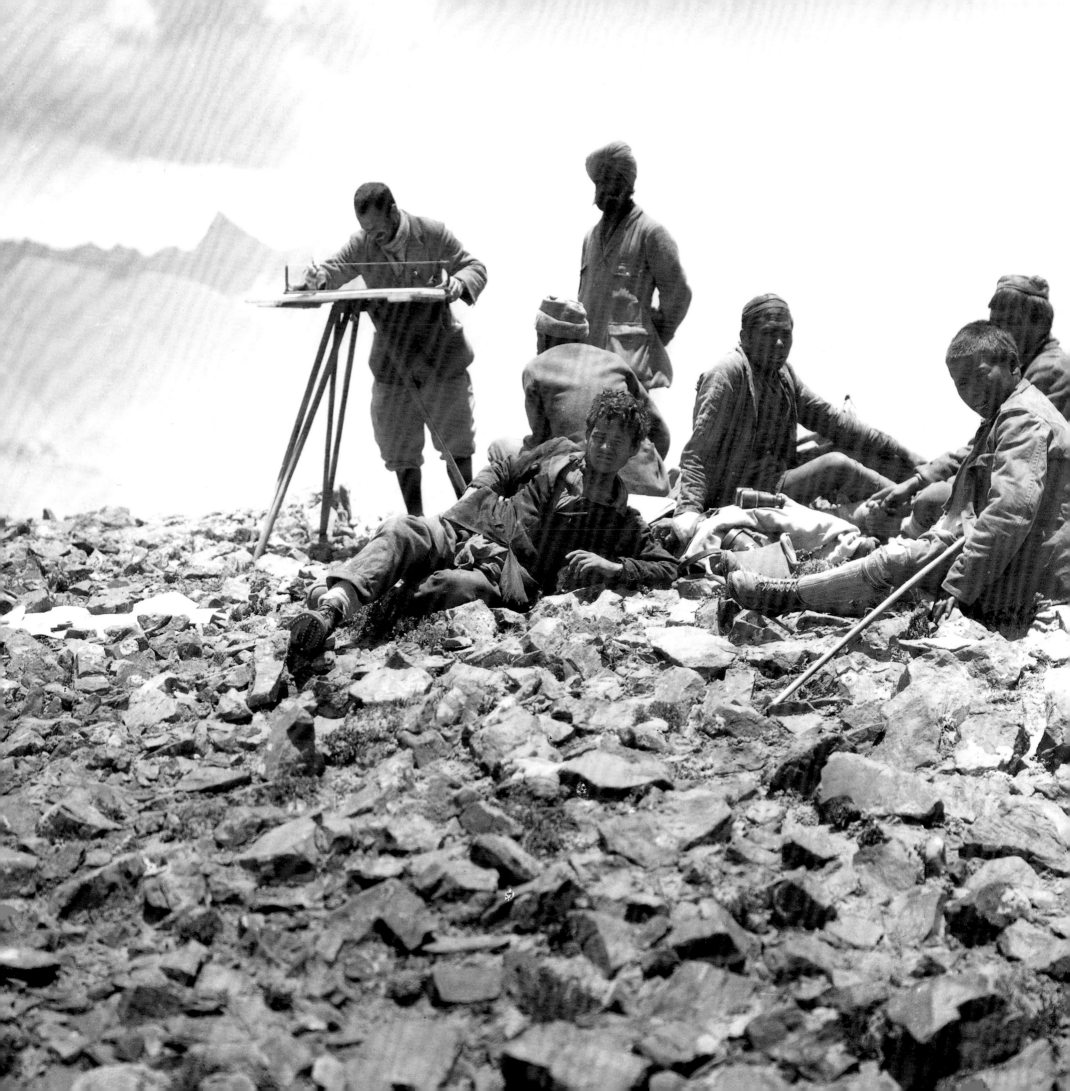

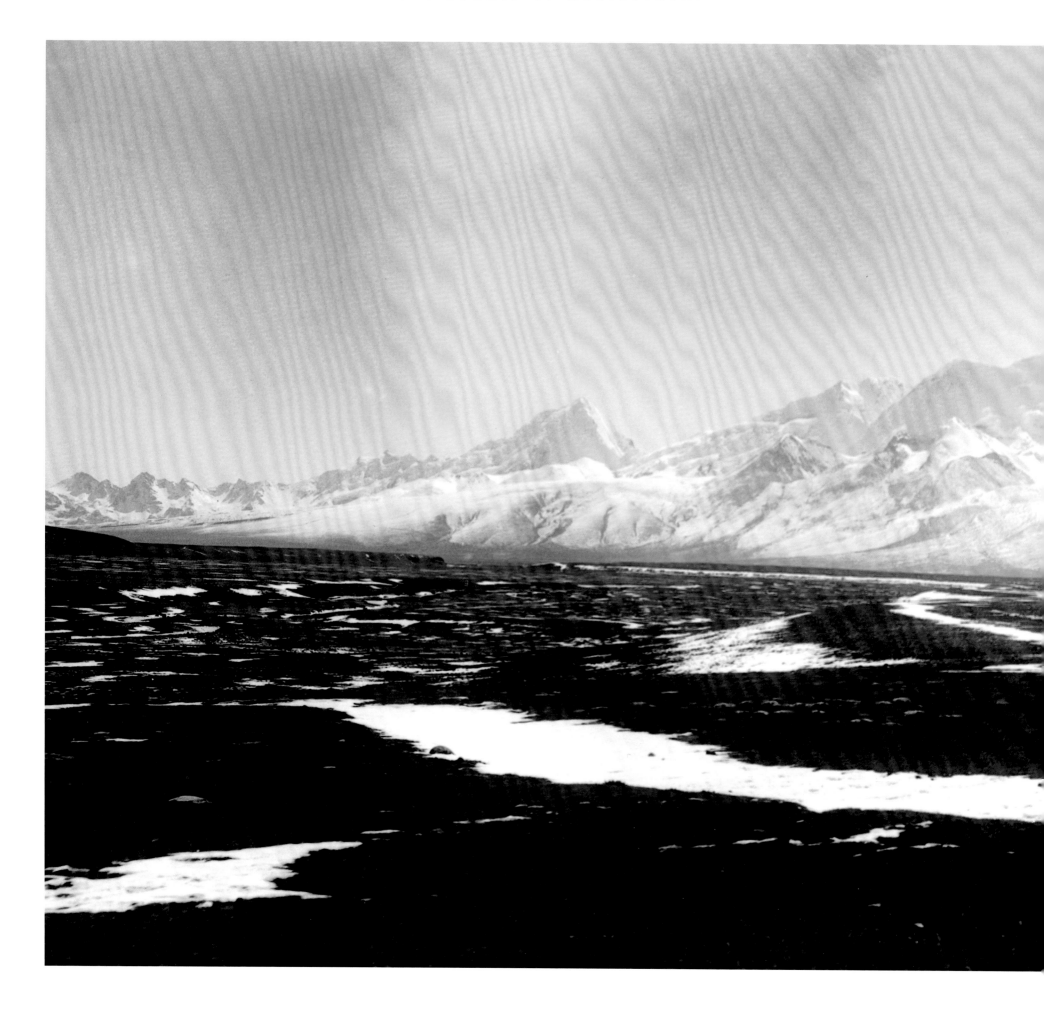

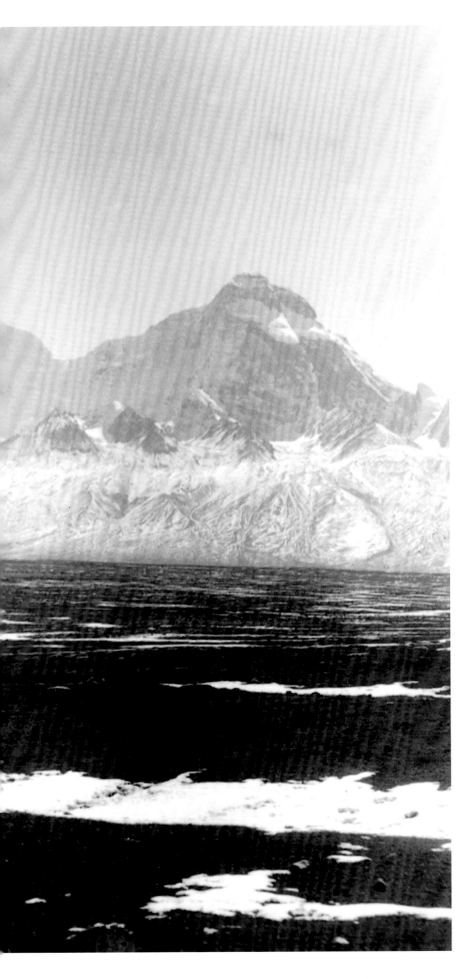

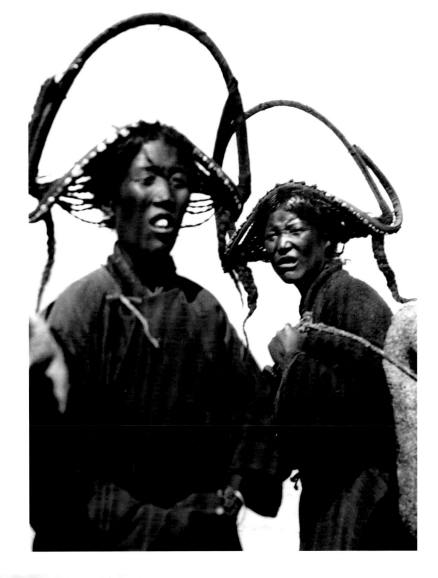

Chomolhari (Mountain of the Goddess), 23,997 feet (7314 m) high, rises above the plateau on the Tibet-Bhutan border (opposite). The mountain is sacred to Tibetan Buddhists, and every year pilgrims assemble in the town of Phari Dzong, 10 miles (16 km) distant, and walk in procession to the mountain.

PHOTO: A. F. R.
WOLLASTON, 1921

A pair of Tibetan women (right) wearing hooped wooden headdresses.

PHOTO: A. F. R.
WOLLASTON, 1921

A yak (left) carrying supplies for Everest. Pack animals were the only means of transport across Tibet. Some ponies were used, but on the rougher terrain only yaks could cope.

PHOTO: BENTLEY
BEETHAM, 1924

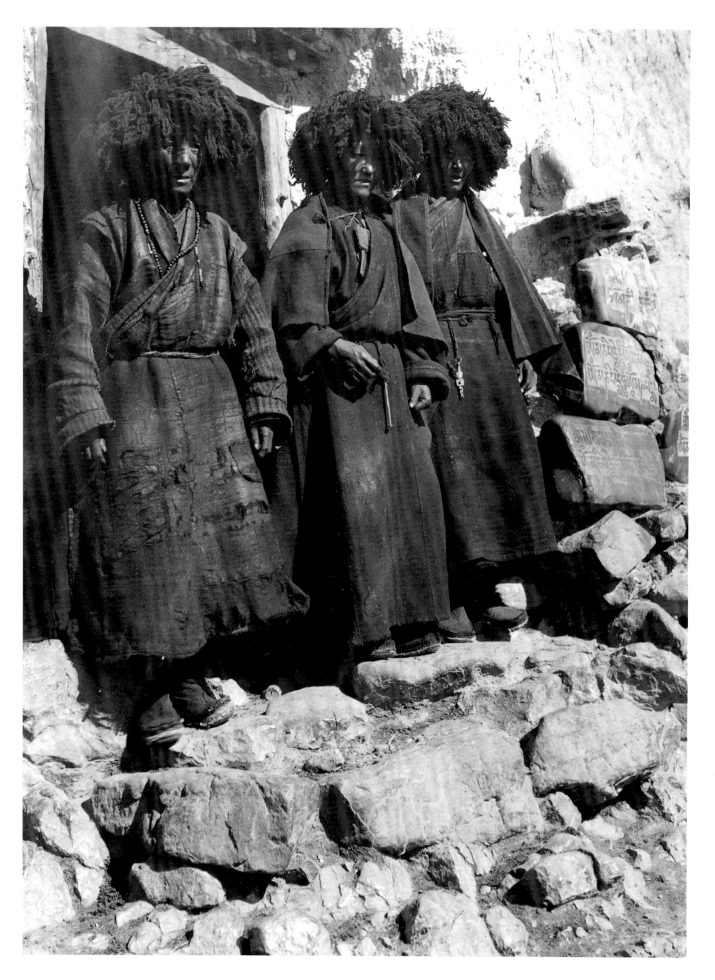

The nunnery of Tatsang was first visited during Younghusband's British Mission to Tibet in 1904. The nuns (ani) are wearing wigs made from yaks' hair to emulate their religious guru, or Rinpoche, who had long, dreadlocked hair.

PHOTO: LT.-COL. HOWARD BURY, 1921

Gyalzen Kazi (above, left) from Gangtok in Sikkim and Chheten Wangdi (above, right), a Tibetan who had fought with the Indian army in Egypt, were interpreters on the 1921 expedition. Only Maj. H. T. Morshead spoke a little Tibetan, so the employment of interpreters was vital.

PHOTO: A. F. R. WOLLASTON, 1921

The dzongpen or governor of Kharta, with his wife and son (opposite). On meeting the governor, the 1921 expedition asked about the possibility of renting a house so they could have a storeroom and set up a darkroom. A house was located with a pleasant garden of poplars and willows, and they were charged one trangka a day.

PHOTO: A. F. R. WOLLASTON, 1921

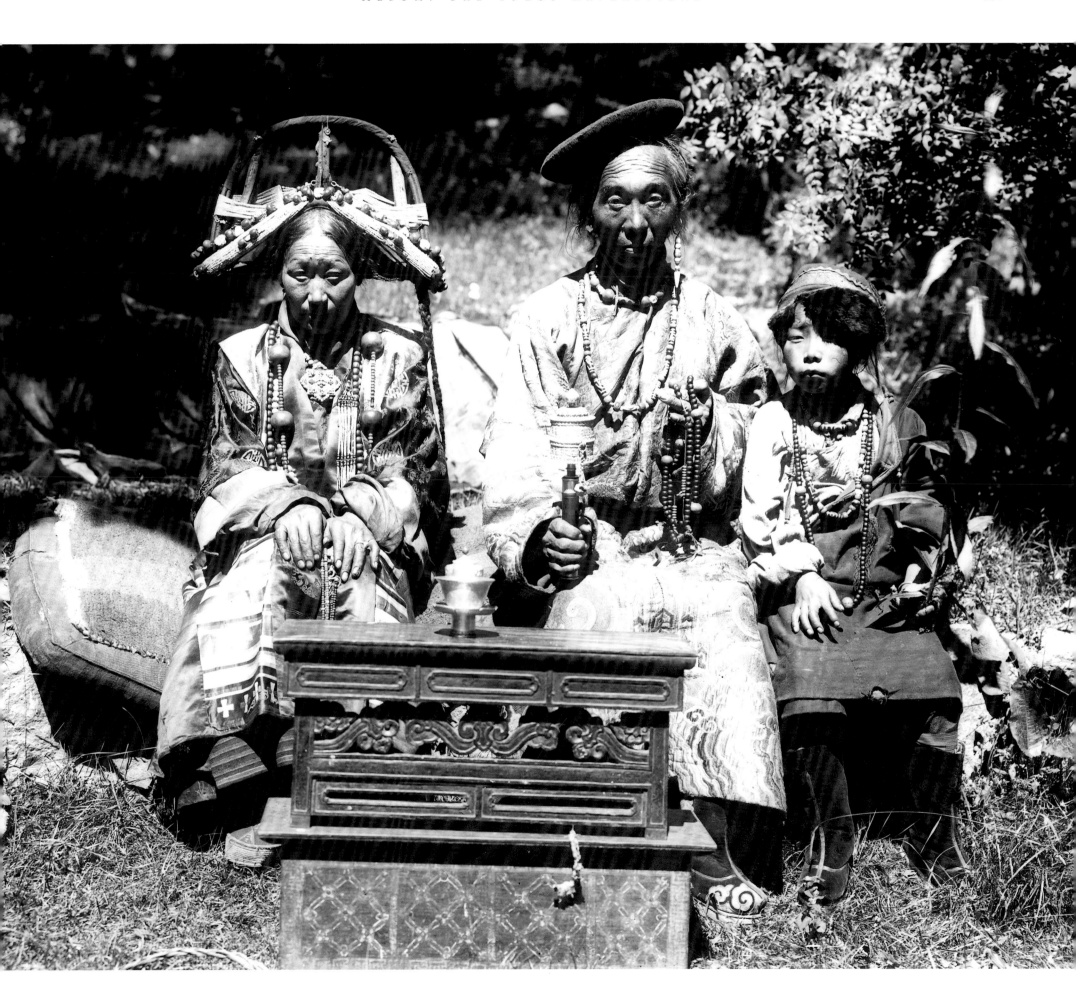

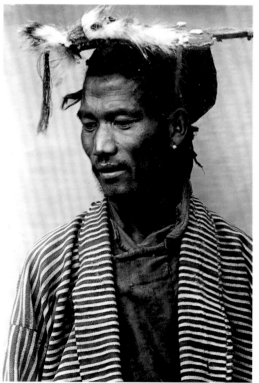

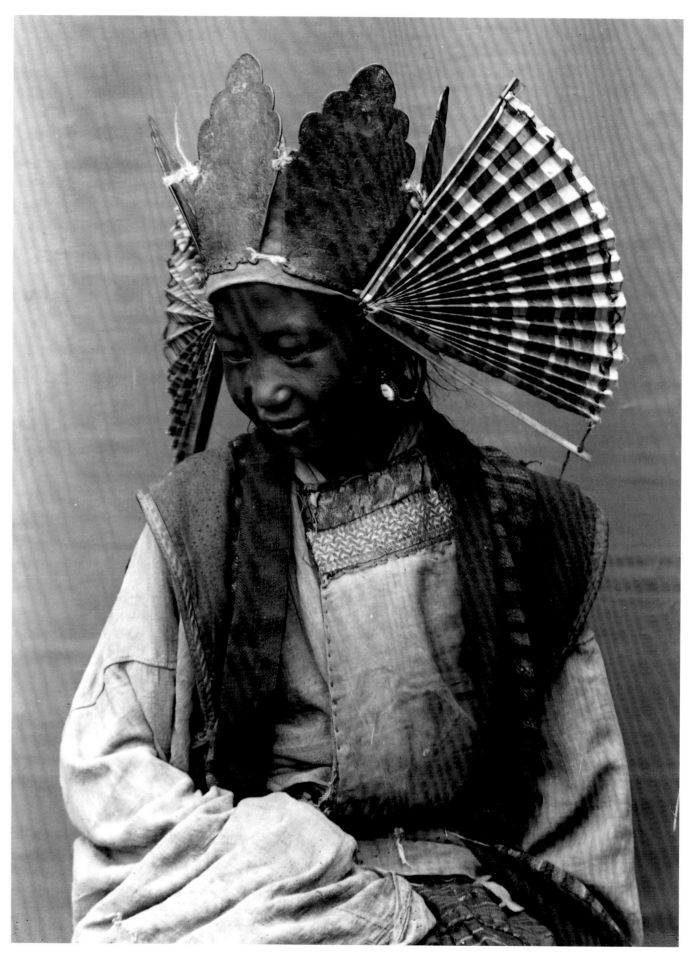

Tibetan dancing man, with (top) and without (above) mask.

PHOTO: CAPT. J. B. NOEL, 1922

Tibetan dancing girl (right), wearing an elaborate headdress.

PHOTO: CAPT. J. B. NOEL, 1922

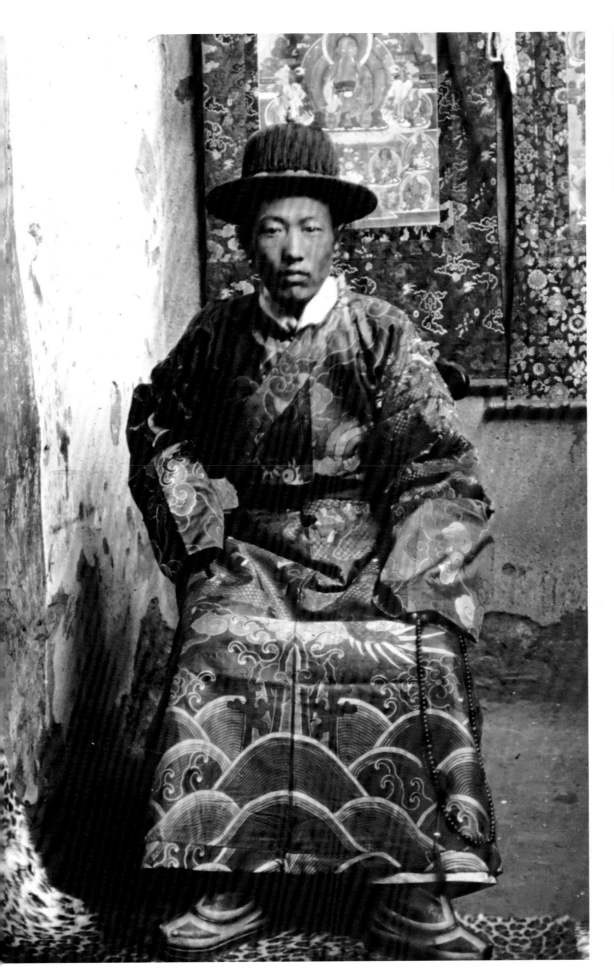

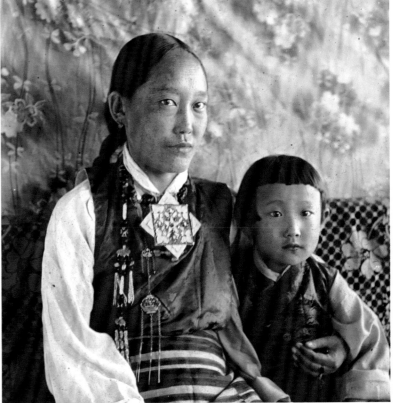

Portrait of a Tibetan mother and child (above). The mother is wearing a silver and turquoise amulet, which holds sacred prayers to protect her against evil spirits.

PHOTO: CAPT. J. B. NOEL, 1922/24

The dzongpen or governor (left) at Phari. Noel noted that the dzongpen would wear flowing robes of Chinese silk embellished with embroidery. Long sleeves and manicured nails were other outward signs of his higher social status.

PHOTO: CAPT. J. B. NOEL, 1922/24

A pair of red Tibetan shoes (above) worn by a Tibetan woman (top, left), who is also wearing a striped apron. The apron denotes the woman's married status.

PHOTO: CAPT. J. B. NOEL, 1922/24

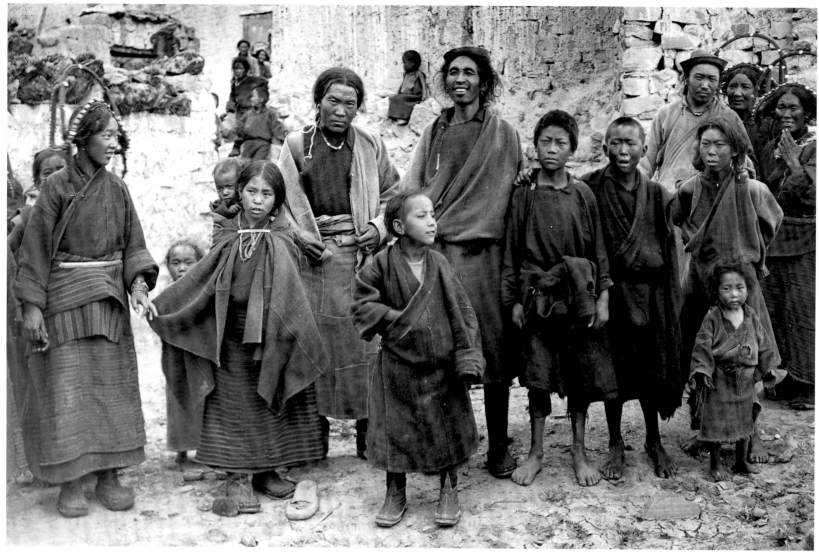

A group of Tibetans (left). It was common practice on the Tibetan-Nepali border for a woman to marry several brothers simultaneously. This practice of polyandry was an effective method of population control.

PHOTO: CAPT. J. B. NOEL, 1922

A group of monks gather at the entrance of Shegar Dzong (opposite), the simple but impressive entrance to the monastery.

PHOTO: C. J. MORRIS, 1922

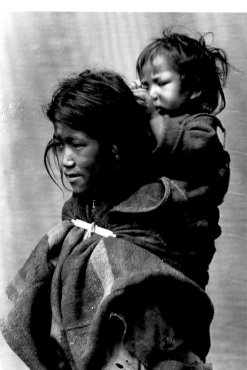

Tibetan girl and young child (left). The typical way of carrying a baby in Tibet was in a blanket tied to the mother's back.

PHOTO: CAPT. J. B. NOEL, 1922

Group of ani (nuns) at a nunnery at Gyangtse (right). At the time, Gyangtse was Tibet's third largest town and was watched over by a monastery of several thousand monks and nuns.

PHOTO: CAPT. J. B. NOEL, 1922

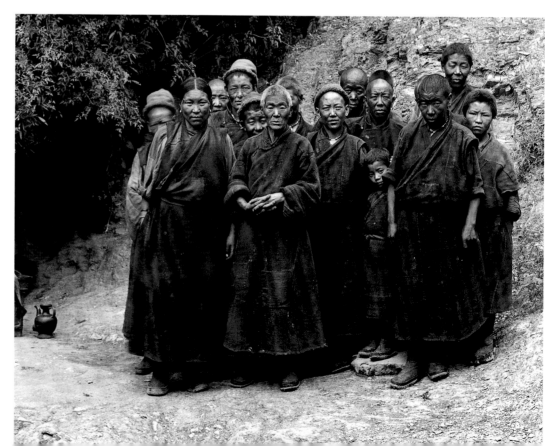

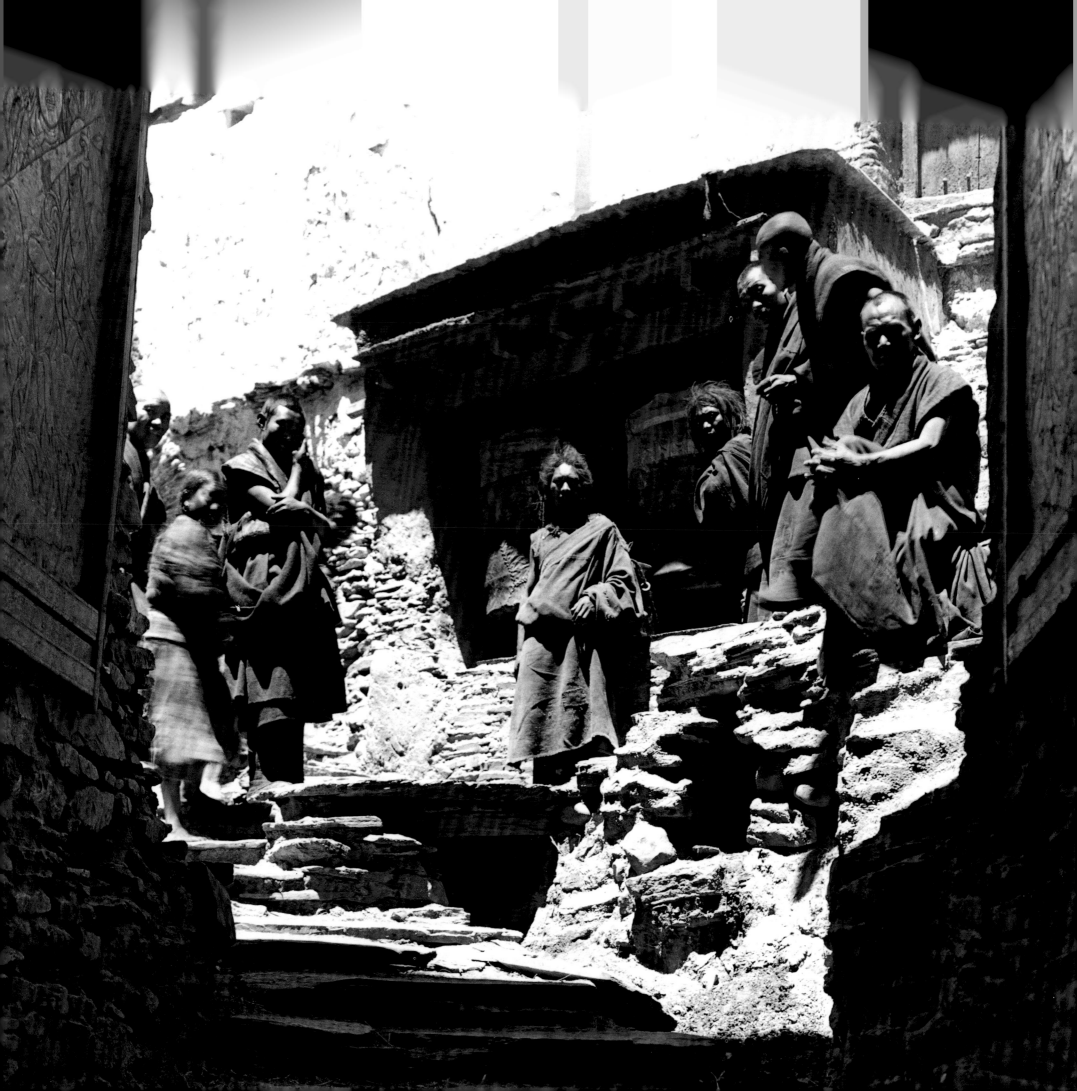

Part of the Great Pagoda at Gyangtse monastery (left), a massive chorten temple built in the fifteenth century by Nepalese craftsmen and one of the very few religious buildings still standing after the Cultural Revolution.
Chortens are highly symbolic. The five levels represent the four elements and eternal space, the square base symbolizes earth; the dome, water; the spire, fire; and the top, moon and sun, air and space.

PHOTO: CAPT. J. B. NOEL, 1922/24

A beautiful Tibetan ceremonial tent at Shegar Dzong (opposite). Unlike the densely woven everyday tents, these purely ceremonial tents were not waterproof, as the 1921 expedition found out. Kindly given one, the men in it were forced to put their macintoshes on to keep dry when it rained during the night.

PHOTO: CAPT. J. B. NOEL, 1922/24

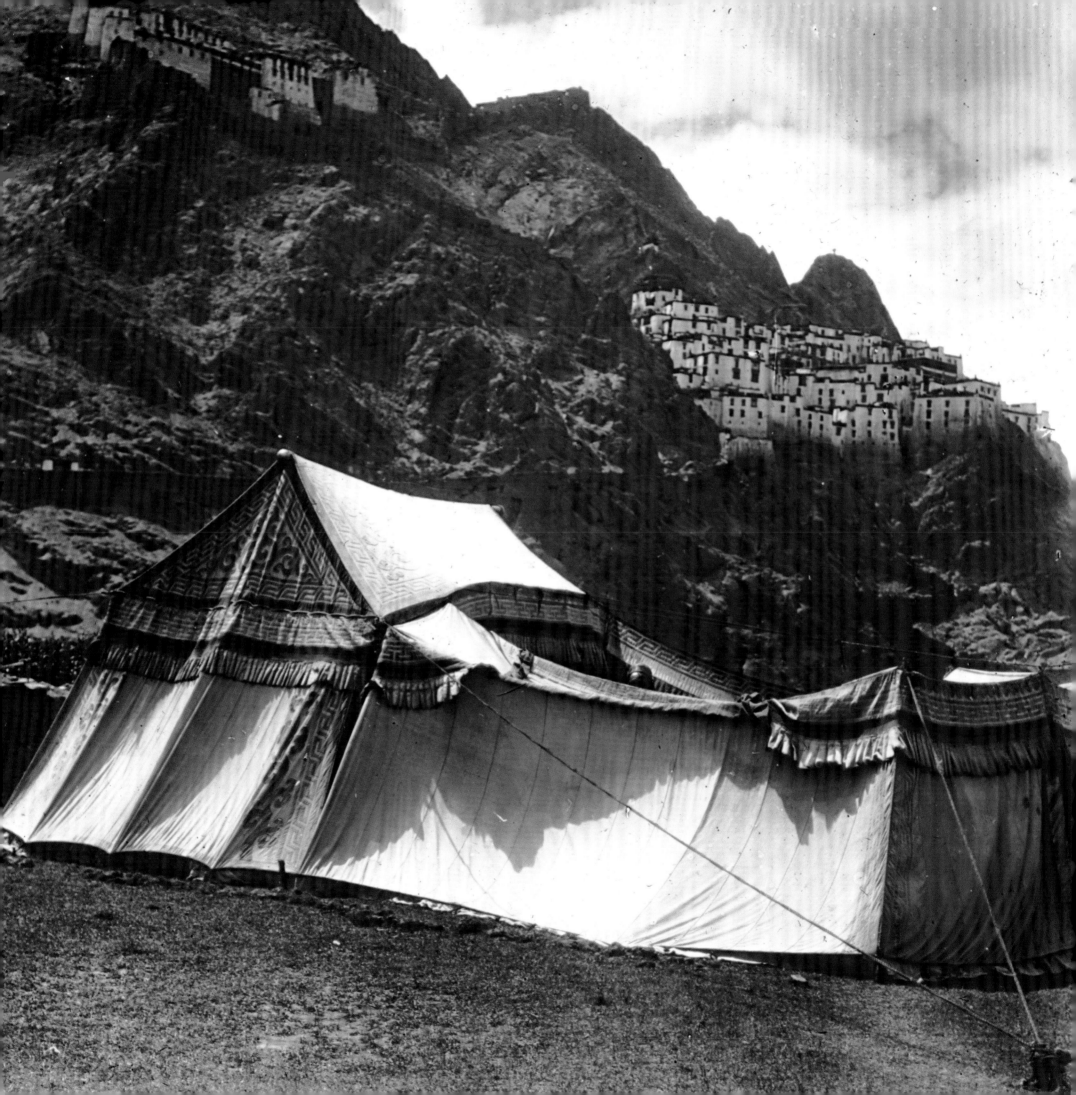

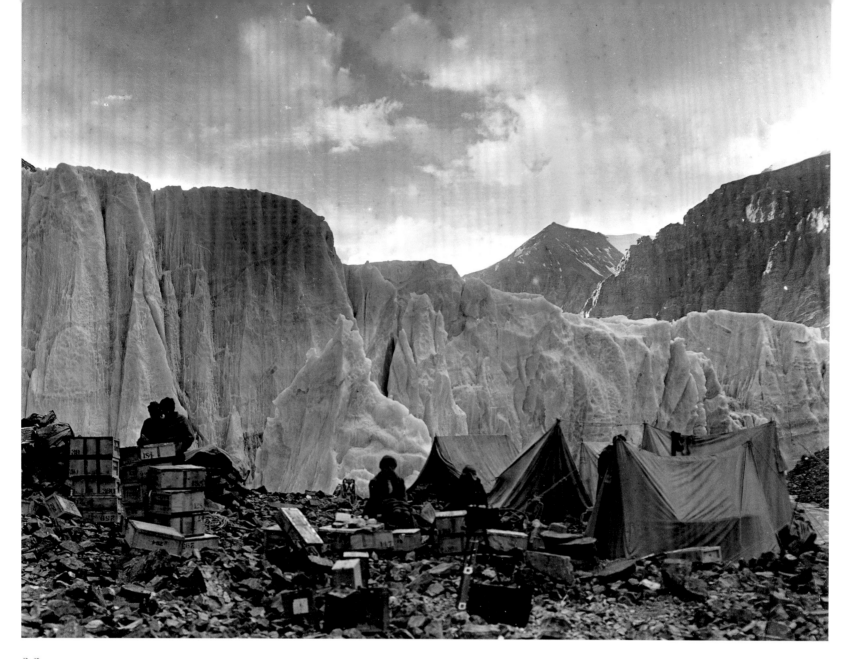

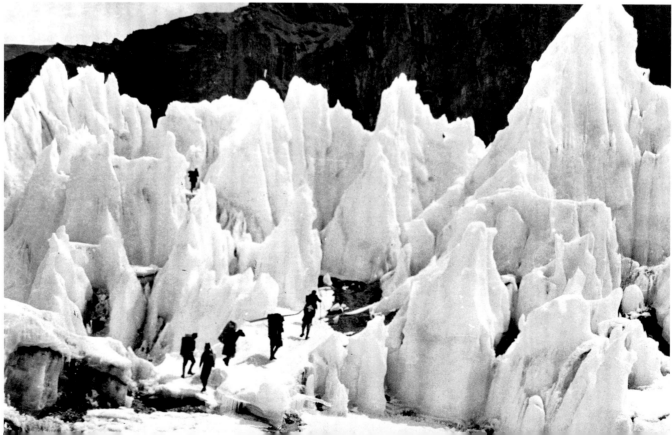

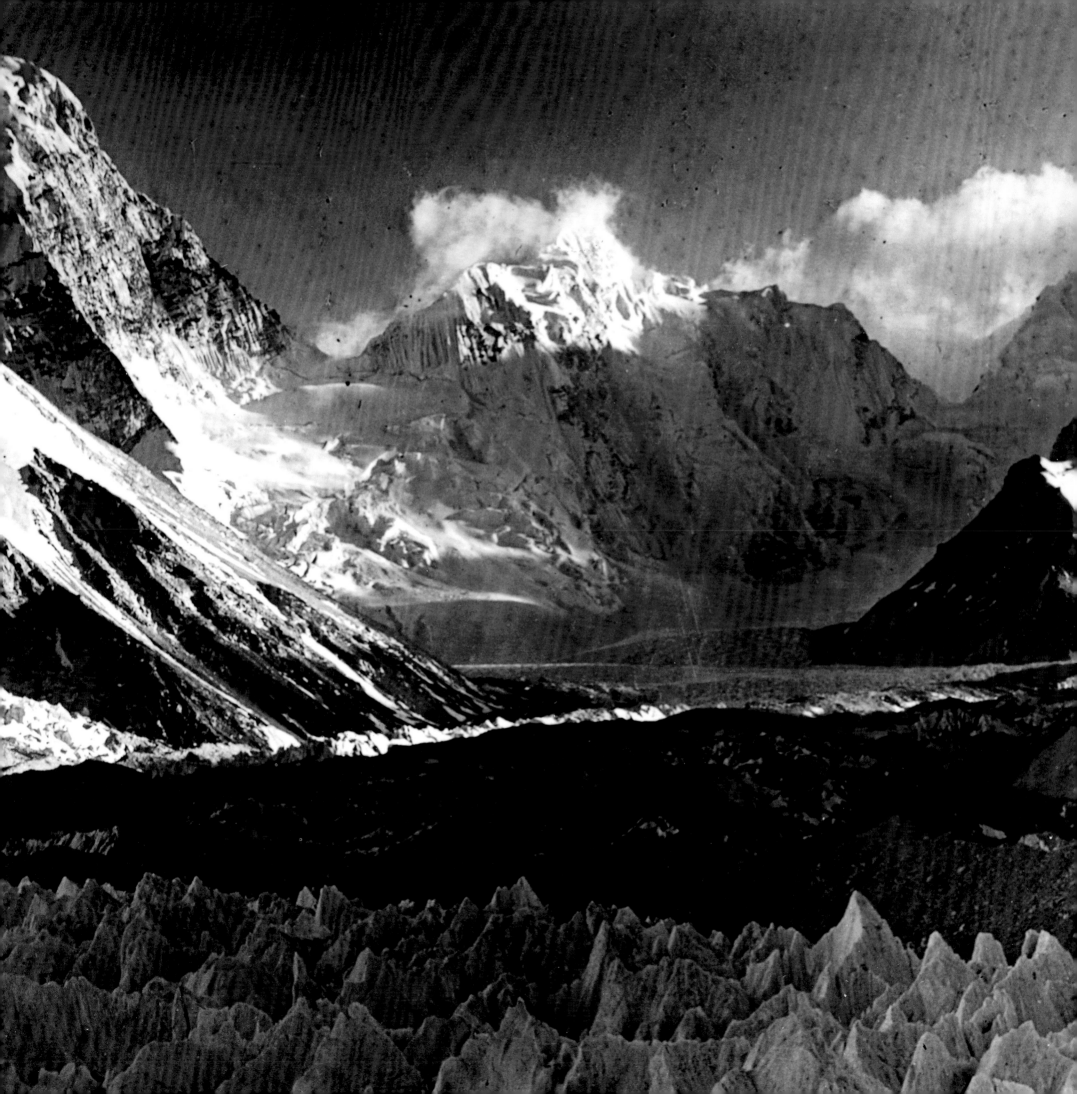

A *rope bridge in the Chumbi Valley. The Everest expeditions of the 1920s and 1930s had to pass through Sikkim and the Chumbi Valley. The many rivers in both areas were crossed using suspension bridges made of wire or rope. They were often frail structures that swung and lurched from side to side.*

PHOTO: CAPT. J. B. NOEL, 1922/24

This *hand-painted lantern slide (opposite) brings to life a meadow of irises surrounded by the abundant forests of the Himalayas' lower elevations.*

PHOTO: CAPT. J. B. NOEL, 1922/24

Howard *Somervell (left) without trousers, Arthur Wakefield (center) carrying boots, and George Mallory (right) naked after fording a stream en route to Everest. Mallory was known by team members to favor nude bathing!*

PHOTO: GEORGE FINCH, 1922

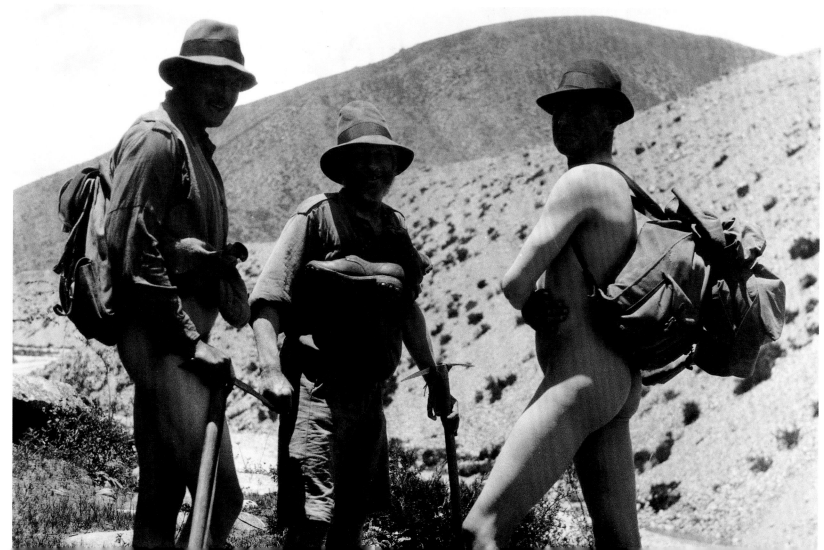

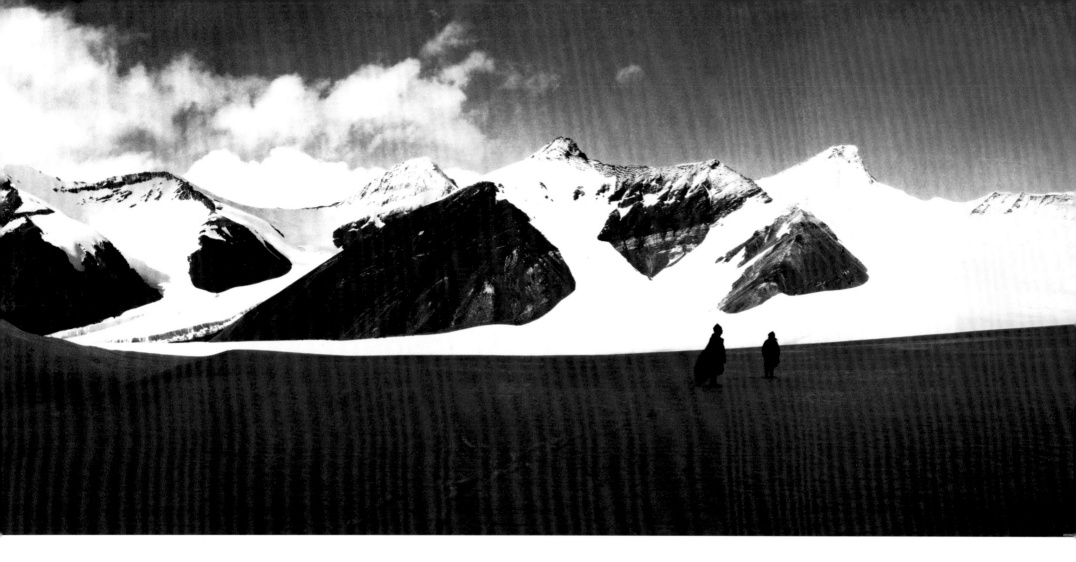

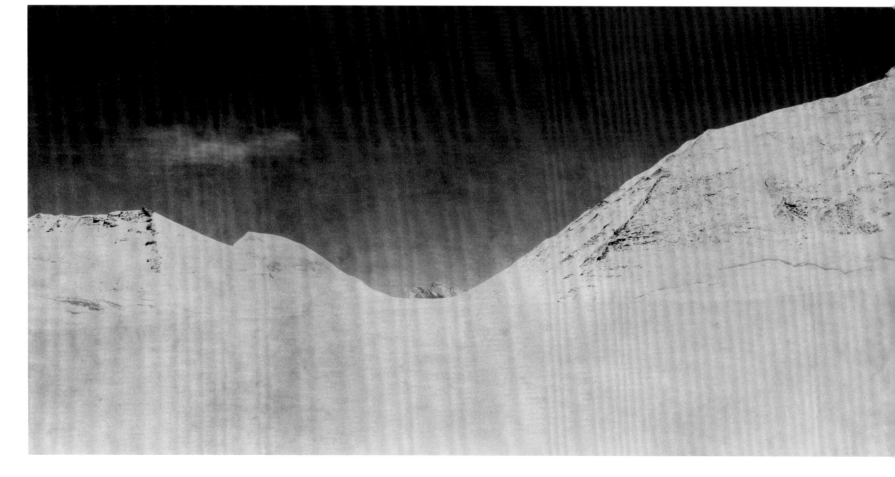

This rarely seen 180° panorama (above) shows the vast white sweep of the head of the East Rongbuk Glacier. Two lonely figures give a sense of the scale of the glacier. On the right is the lower part of Everest's immense Northeast Ridge.

PHOTO: UNKNOWN, 1922

On the extreme right, Camp III (Advance Base) nestles under the cliffs of Changtse with the icewall of the North Col behind and the North Ridge of Everest rising up to meet the Northeast Ridge.

PHOTO: UNKNOWN, 1922

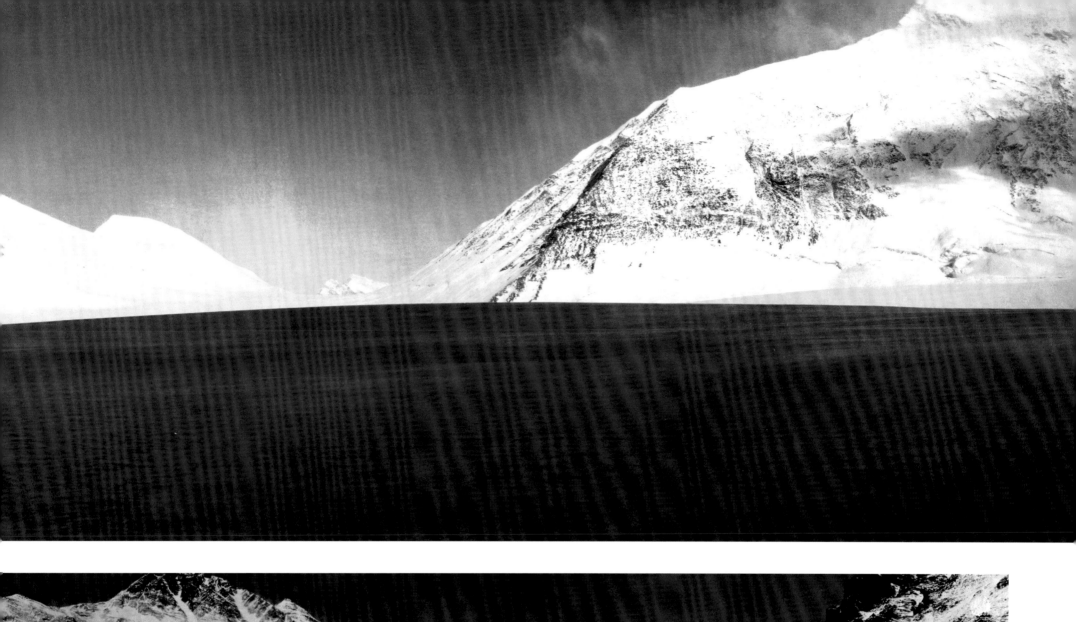
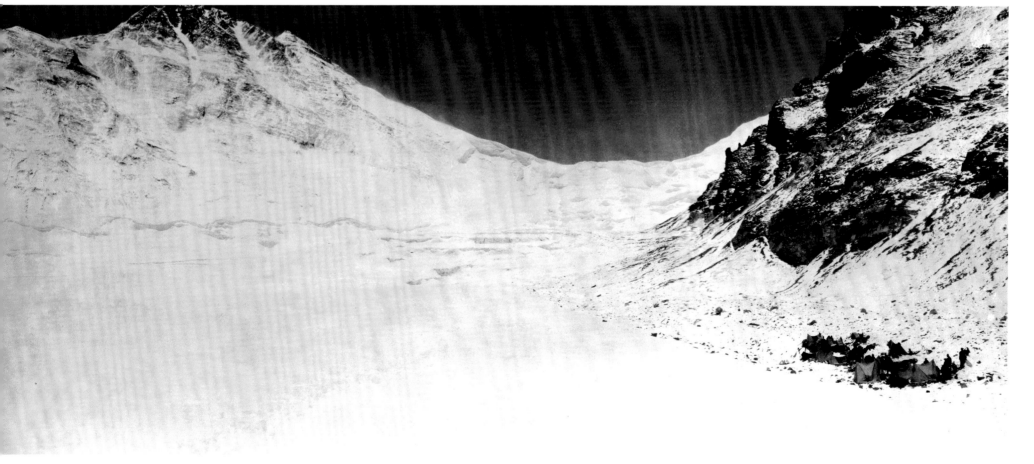

George Mallory took this telephotograph from the upper Kharta Glacier during the search for a potential route to the summit. The photo shows the immense sweep of the upper Kangshung Face, bounded on the left by the Southeast Ridge and the prominent bump of the South Summit, which would not be attained for another 32 years. Descending toward the camera is the daunting Northeast Ridge. From this viewpoint it was immediately obvious that the Pinnacles, halfway up the ridge, would pose a very formidable obstacle, hence the need to find a way onto the North Ridge, out of shot to the right, which avoids this obstacle.

PHOTO: GEORGE MALLORY, 1921

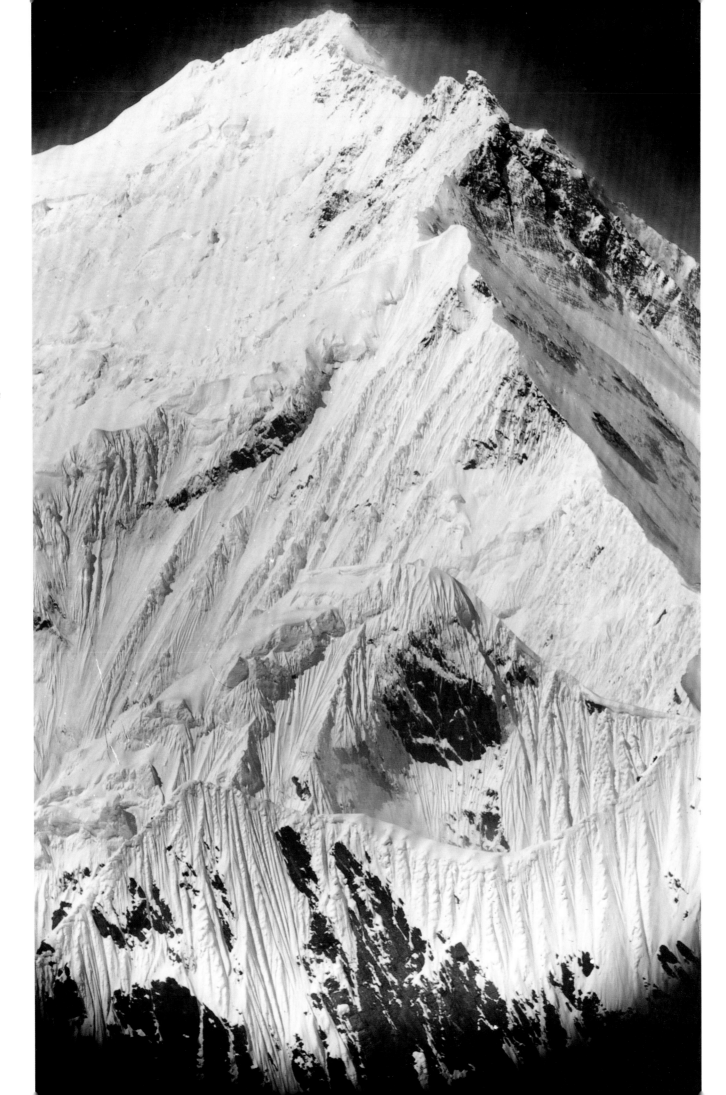

The ant-like figures of members of the 1924 expedition (opposite) emphasize the scale of the 1000-foot (300-m) icewall leading to Camp IV on the North Col.

PHOTO: BENTLEY BEETHAM, 1924

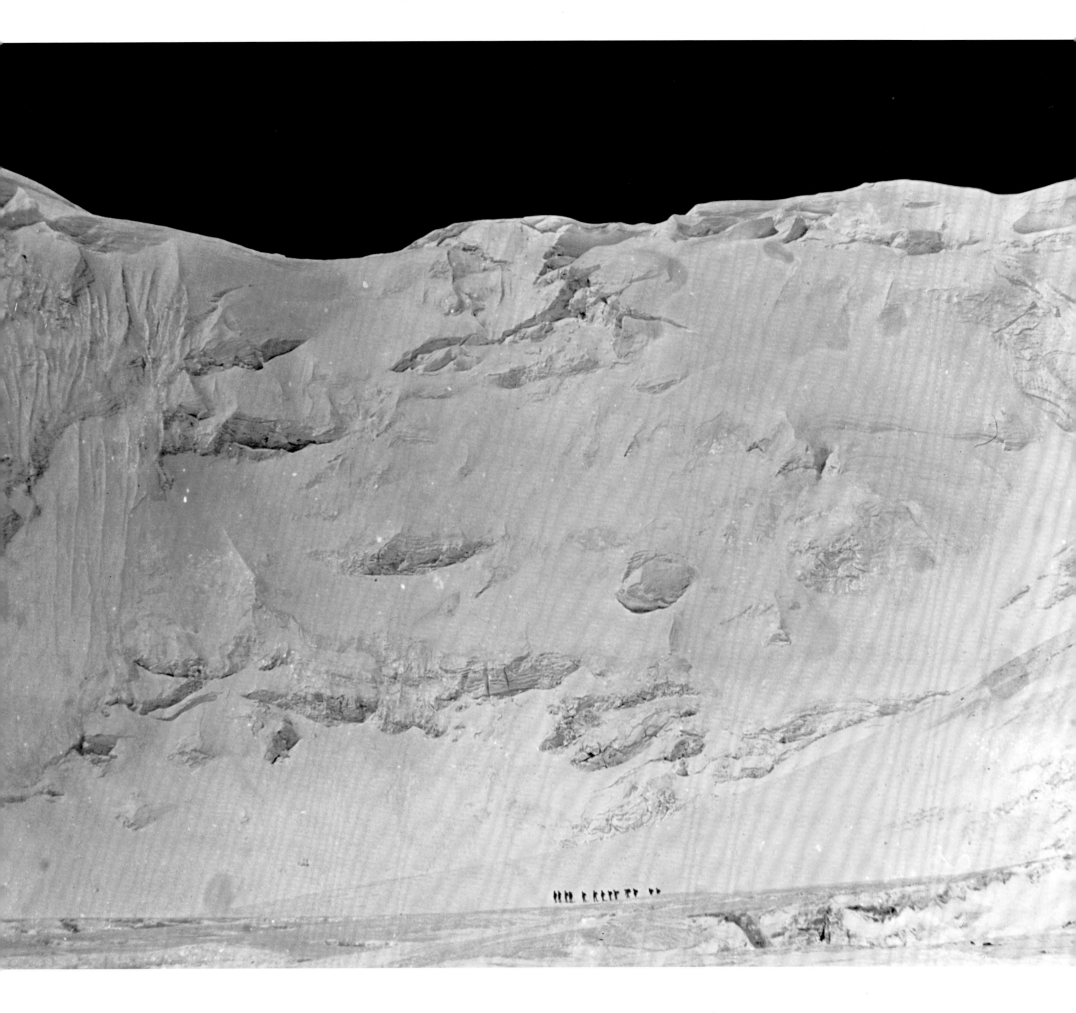

THE EXPEDITIONS: 1933, 1935, 1936, AND 1938

The 1933 expedition was a lavish affair organized on the same grand scale as its precursors. But whereas Brig.-Gen. Charles Bruce had been a larger-than-life extrovert, Hugh Ruttledge was a rather mild, self-deprecating man, whose main virtue was the kind of steady colonial background so dear to the Everest Committee. Although not a soldier, his approach—and the prevailing approach—was conservatively military, prompting the outspoken veteran of 1922, George Finch, to write: "You cannot apply the military method of Staff control under conditions when the leader cannot be expected willingly to risk the lives of others. The instruction 'must not take any risks' is tantamount to saying that you must not get there. On the other hand, a climbing leader is always in a position to ask others to take the same risks that he is himself taking. Thus, a forceful personality and strong character, not 'compatibility of temperament,' are the qualities needed … In a venture of this kind personal ambition is a valuable quality."[7]

Not all of the climbers on the 1933 expedition would necessarily have agreed, but they were certainly a colorful, and talented bunch, representing a whole new generation of mountaineers, who converged on Everest from many different directions. Two of the leading players first roped together at Easter 1928 on the then virtually unexplored precipice of Clogwyn d'ur Arddu in North Wales. Rain defeated their attempt at the first ever ascent of the West Buttress, but they returned at Whitsun to complete what became known as Longland's Climb. Jack Longland was probably the most forceful and athletic of his generation of mountaineers at

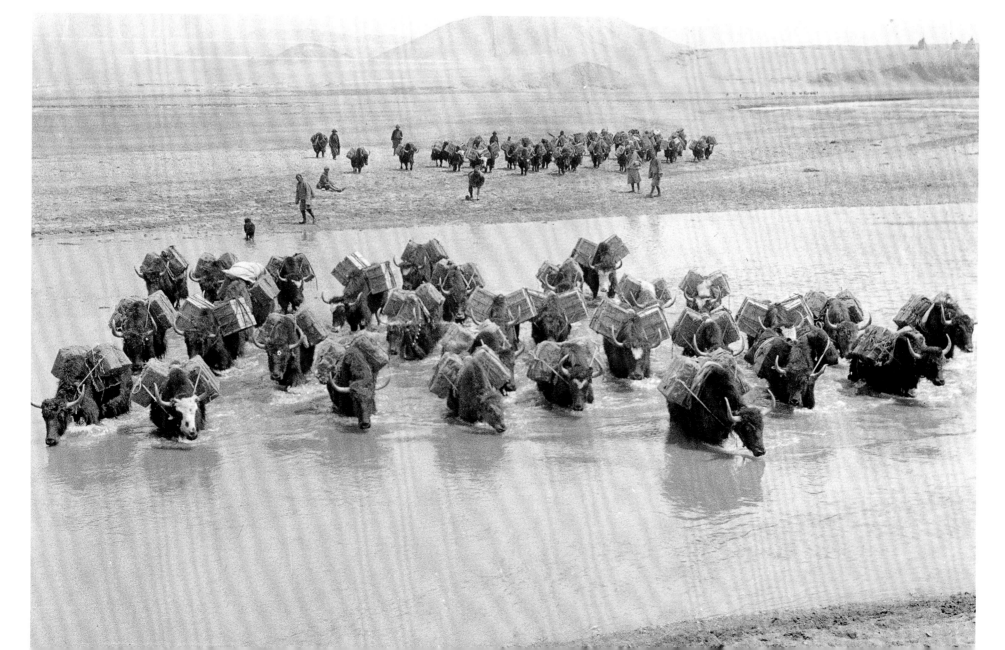

A pack train of yaks laden with expedition supplies fording the Yaru river near Mende.

PHOTO: FRANK SMYTHE, 1933

Cambridge University. The other future Everester on "Cloggy" that day was Frank Smythe.

Smythe, like Finch before him, nurtured his mountain passion in Europe—in Corsica and the Alps. Already in 1927, with Dr. Graham Brown, he had made the first ascent of Sentinelle Rouge on the massive Brenva Face of Mont Blanc. Shortly after the success in Wales, he was back in the Alps with Brown to pioneer another great line up Europe's highest peak—the Route Major. Almost uniquely among British mountaineers at that time, Smythe came quite close to rivaling the achievements of his continental contemporaries and in 1930 he was invited to join the prestigious international expedition to the world's third highest peak, Kangchenjunga, led by Gunther Dyhrenfurth, whose son would much later lead America's triumphant 1963 Everest Expedition.

Kangchenjunga was not climbed, but for Frank Smythe the expedition was a revelatory induction to the Himalayas. Although a very successful mountaineer, he was no flashy gymnast, nor was he obviously fit. In fact, he had been invalided out of the Royal Air Force after failing a medical. But, like so many successful mountaineers, Smythe succeeded through passion and determination, and a recognition that the appeal of mountain climbing goes far beyond mere sport. His romantic, almost mystical, approach to mountaineering infused his prolific output of books, which, with his photography, lecturing, and broadcasting, provided his entire income. He was one of the very first professional mountaineers.

While Longland and Smythe were grappling with Clogwyn d'ur Arddu in 1928, Eric Shipton, a dyslexic who had just failed to get into Cambridge, was sailing to Africa to try his hand at coffee planting. Before embarking for Kenya, he had done some climbing in Britain and the Alps, and ever since he was a young boy he had loved to wander in mountain country, dreaming always of the view over the next ridge. In Kenya he introduced himself to the Assistant District Commissioner of Kakamega, Percy Wyn-Harris, another alumnus of the Cambridge University Mountaineering Club. Hugely resourceful, the two men managed to negotiate their way through the equatorial forest to Mount Kenya, which had only been climbed once before, in 1899. In the course of the second ascent, Shipton and Wyn-Harris put up a new rock

Jack Longland pole vaulting at Tingri Dzong. Hugh Ruttledge wrote of this occasion, "A great afternoon's sport ended with an exhibition of pole jumping by Longland, using a long bamboo. This took on at once, and as neither Sherpa nor Tibetan is content with the role of passive spectator, some very remarkable jumping, or rather falling was observed. But these men are unkillable."

PHOTO: FRANK SMYTHE, 1933

route and took in the previously unclimbed lower twin summit, Nelion. Shipton's subsequent article in the *East Africa Standard* attracted the attention of another coffee planter with a yearning for mountains, Bill Tilman. Shipton and Tilman struck up a partnership and later made the first ascent of Mount Kenya's very difficult West Ridge, followed by climbs in Uganda's Ruwenzori mountains that for sheer speed and daring have never been matched.

Tilman would also later become a key player in the Everest saga, but Shipton was the first to realize the dream of visiting the greatest mountain range on earth. In 1931 he was invited to join Frank Smythe's Kamet expedition. Shipton, Smythe, and Raymond Greene (novelist Graham Greene's brother and future doctor to the 1933 expedition) were among the group

*R*aymond Greene, brother of the novelist Graham Greene, shaving with the aid of a makeshift mirror. Greene was Chief Medical Officer for the 1933 expedition.

PHOTO: FRANK SMYTHE, 1933

*T*he barber's shop, Base Camp. The journey to and from Everest in 1933 lasted from March to July, and as a barber's shop was nowhere to be found, the team relied on each other for their beauty treatment.

PHOTO: FRANK SMYTHE, 1933

which reached the summit of Kamet, a mountain that had eluded Kellas and Morshead back in 1920 and which now, at 25,446 feet (7758 m), represented the highest actual summit attained by man. Also in the summit team was Sherpa Nima Tendrup, veteran of three Everest expeditions, those of 1921, 1922, and 1924.

Shipton took to the Himalayas like a duck to water. Above all it was the exploration—the diversity and movement and delicious surprise of unlocking the landscape's secrets, rather than merely bagging a summit—that appealed most to him. Nevertheless, he could not help but be thrilled when, along with Smythe, he was selected for the following year's summit campaign on Everest.

Shipton, Smythe, Wyn-Harris, and Longland all played pivotal roles in the 1933 attempt. It was Wyn-Harris who, with

Lawrence Wager, found Irvine's abandoned ice-ax near the crest of the Northeast Ridge. This time, the expedition had managed to place the top camp even higher—halfway up the Yellow Band at 27,400 feet (8354 m)—giving the summit teams a more realistic chance of success. It was while he was escorting down the Sherpas who had established this vital camp on May 29 (20 years to the day before Everest's eventual first ascent) that Jack Longland found himself forced to draw on all his reserves of mountaineering judgement:

"Without any warning that I remember a storm blew up out of the west. There were no more distant horizons—the most I could see was a snow-swept circle of 20 or 30 yards. A mountain storm is always unnerving, but its effect at 27,000 feet on cold and exhausted men is devastating. Worst of all I was responsible for the safety of eight men who had

*E*ric Shipton in the "trough" of the East Rongbuk Glacier (opposite). "Photography can give no true picture of the ice scenery of the East Rongbuk Glacier," wrote Hugh Ruttledge. "It can but show the outlines and mass of the pinnacles, not their graduations of blue, green, and grey, and their transparent loveliness."

PHOTO: FRANK SMYTHE, 1933

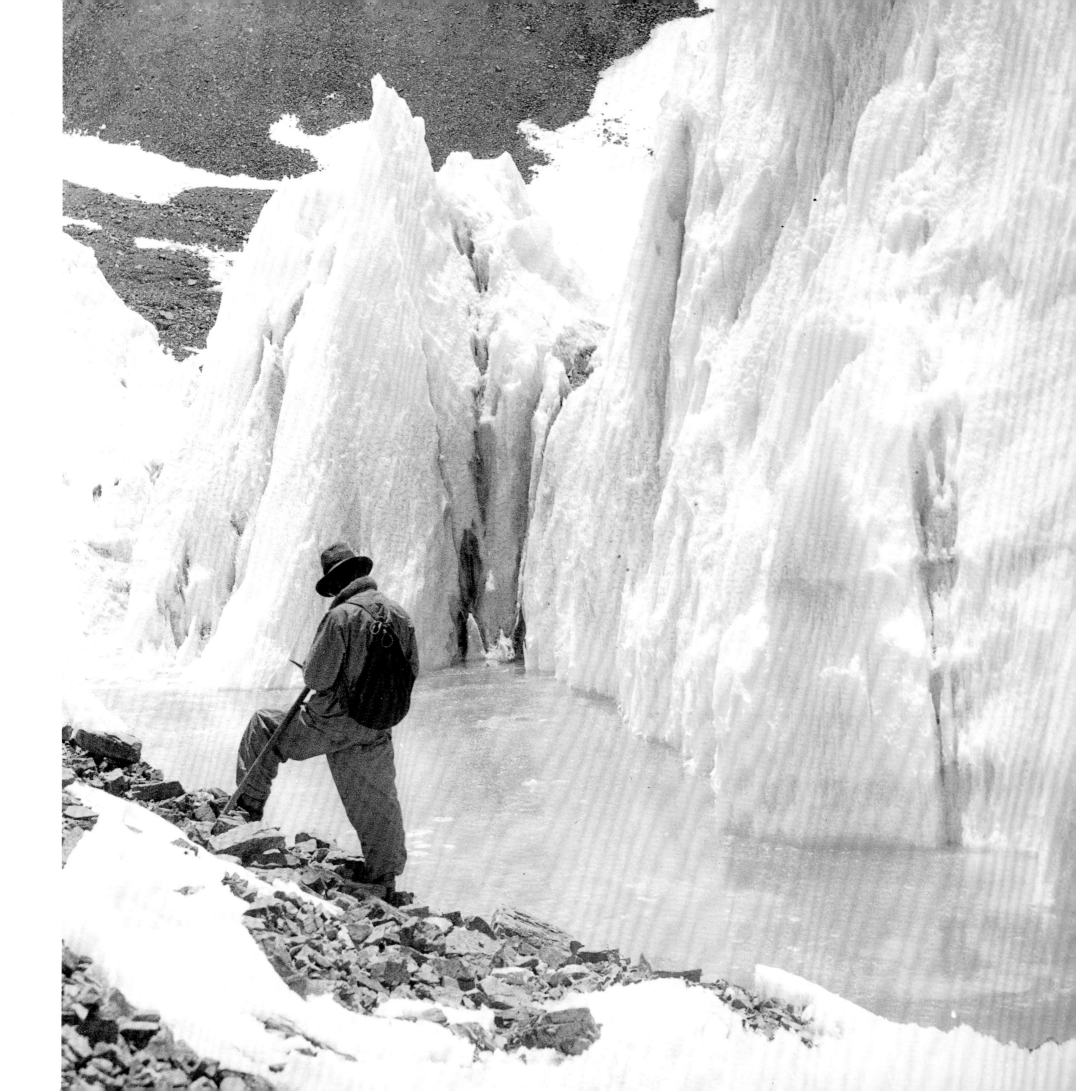

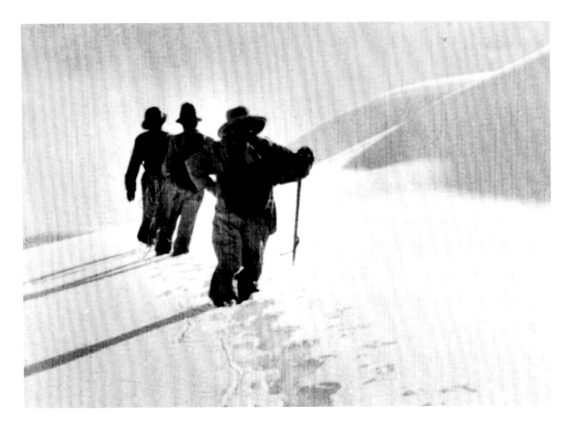

Team members plodding through deep snow. Hours were spent breaking trail and, on steeper terrain, cutting steps, only for them to be filled in by new snowfall. This constant remaking of steps is one of the unavoidable themes of expedition life and can be very dispiriting to climbers who are trying to conserve energy.

PHOTO: FRANK SMYTHE, 1933

trustingly followed us to this height and who had somehow to be got safely down."[8] For two hours he struggled to lead and cajole his men through the maelstrom, relying on sheer instinct and a photograph to navigate through the featureless rubble of Everest's North Ridge. At last the green tents of Camp V appeared; "less than three hours since I'd left Wager and Wyn-Harris at Camp VI, but I seemed to have crowded a lifetime of fear and struggle and responsibility into that short time."

That masterful care shown to the Sherpas contrasts sharply with today's role reversal, where Sherpas are so often taking the sahibs by the hand. In 1933, the sahibs were still very much the driving force and the next morning Wager and Wyn-Harris were on their way up the summit ridge. They left at 5:40 a.m., after the usual numb-fingered, short-breathed struggle to cook a travesty of breakfast, thaw out frozen leather boots, and lace them over several pairs of woolen socks. The North Face was still in shadow as they set off, nailed boots scratching clumsily on the shattered rock, throats rasping on the thin cold air. Then there was the glorious, life-affirming explosion of light and a hint of warmth, as the sun burst over the Northeast Ridge just above them. It was then that they found the ice-ax. They continued diagonally upward, but at the First Step, seeing how awkward the actual ridge crest looked, they decided to

remain on the face, following the ledge between the top of the Yellow Band and steeper gray rock above. Traversing west, they found themselves unable to attain the Second Step, which reared up with horrible steepness, and they found themselves committed to the traverse, eventually joining Norton's route into the unnervingly loose powder snow of the Great Couloir. And, like Norton before them, soon after midday, they found themselves on the steeper, scarier far wall of the couloir, unwilling to push on and risk benightment.

Back at Camp VI they paused to chat with Frank Smythe and Eric Shipton, both ensconced for the second attempt. Bad weather kept Smythe and Shipton pinned down the next day, yet they still found the strength after two nights at 27,400 feet (8354 m) to mount a summit bid. Shipton ground to a halt near the First Step and returned to the tent, but Smythe continued, reaching about the same point as Wager and Wyn-Harris. Later, he wrote about the huge psychological barrier faced by the solo climber at extreme altitude: "I was a prisoner, struggling vainly to escape from a vast hollow enclosed by dungeon-like walls. Wherever I looked hostile rocks frowned down on my impotent strugglings, and the wall above seemed almost to overhang me with its dark strata set one upon the other, an embodiment of static, but pitiless, force."[9]

Smythe also wrote about turning around to hand a piece of chocolate to a non-existent companion, and he described seeing strange, dark, pulsating objects hovering in the sky near Camp VI—either an authentic UFO sighting or further evidence of the mind-warping effects of hypoxia. Raymond Greene called them "Frank's pulsating teapots." Teapots notwithstanding, Smythe, like Norton, Wager, and Wyn-Harris, had managed to climb to over 28,000 feet (8530 m) without oxygen equipment and, to cap it all, now spent a third night at the miserable ledge of Camp VI while Shipton descended to the comparative luxury of Camp V.

Frank Smythe later described the retreat from the North Col on June 3, 1933, as "a descent of broken men." Although another attempt was made on the mountain, by the time everyone had recouped at Base Camp the expedition was effectively over, defeated by the cumulative effects of altitude and the inexorable advance of the monsoon. Once again Mount Everest had won.

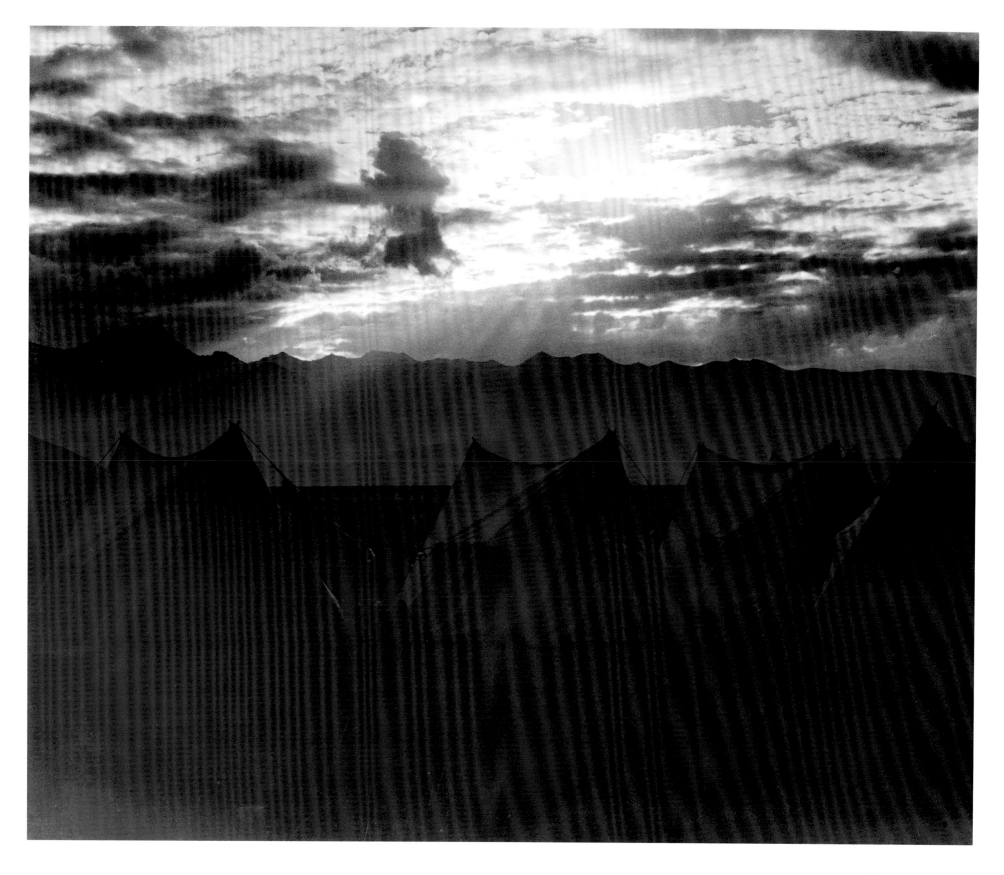

The sun sets over tents at a camp en route to Everest.

PHOTO: FRANK SMYTHE, 1933

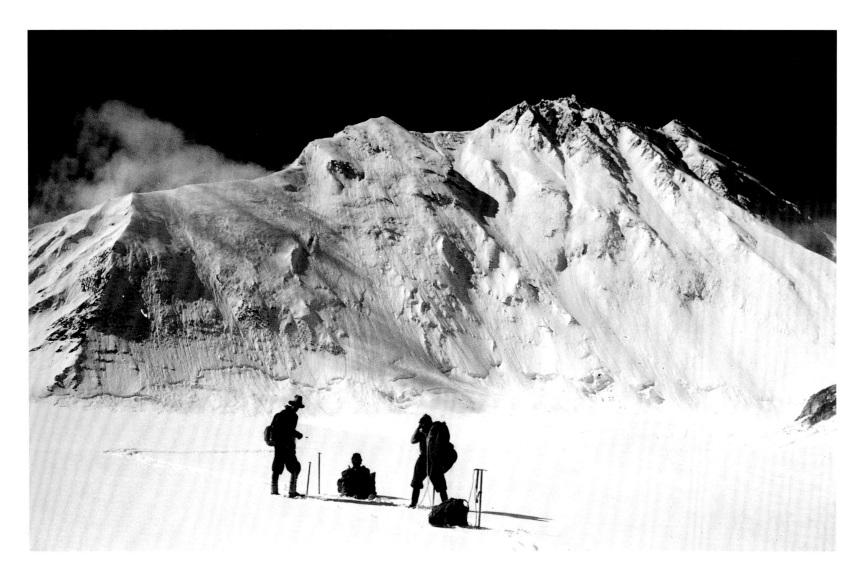

Members of Eric Shipton's 1935 expedition (left) pause for a rest on the great snowfield of the upper East Rongbuk Glacier. Stretched out above them is the full length of Everest's Northeast Ridge, with the North Ridge slanting up from the right. The summit is set back a long way, at least 4920 feet (1500 m) horizontally. The whole mountain is blanketed white with monsoon snow.

PHOTO: L. V. BRYANT, 1935

The fight continued through the 1930s but no one got anywhere near the high point of 1933. Despite criticism of his handling of the 1933 expedition (too much dithering, in the view of some of his juniors), Hugh Ruttledge was asked to lead the full-scale campaign of 1936 at a cost of £10,000. Far more interesting was Shipton's reconnaissance of 1935, costing just £1400. In 1934, he and his old Kenya friend, Bill Tilman, had carried out a brilliant exploration of India's famed Nanda Devi Sanctuary, traveling fast and light on a shoestring budget, reminding the committee men in London what Himalayan expeditions could be like.

So Shipton was given a free hand on Everest in 1935. To some minds he blew his chance, arriving late on the mountain when the monsoon ruled out a serious attempt. However, it should be remembered that his official job was not actually to reach the summit. This was an exploratory "reconnaissance" and Shipton made the most of that brief to indulge his insatiable wanderlust. Much mapping was achieved by Michael Spender (brother of the poet Stephen), building on the earlier survey work of Morshead, Hazard, and Hari Singh Tapa. The expedition explored the Nyonni Ri Range, over on the east side of the Arun Valley from Everest—possibly the only Westerners ever to have investigated the area. One member, Dr. Charles Warren, was asked many years later, "How many first ascents over 20,000 feet did your team make in 1935—was it 11?" There was a long pause, then, with the precision and perfect memory that he never lost up to his death in 1999, the nonagenarian replied, "No—it was actually 26."

Among those 26 first ascents in 1935 were several peaks immediately east of Everest, including Khartaphu (23,893 feet/7283 m). After several weeks in the field, Warren was delighted to find at the old Everest Camp III cases of toffee, chocolate, and Carlsbad plums, left by the 1933 expedition whose gastronomic excesses had so offended Shipton. A more

Although the 1935 expedition made no serious impression on Everest, it succeeded in climbing many other peaks in the region, including Kellas Peak and Khartachangri. This photo (opposite) was taken during extensive explorations around the upper Kharta Glacier.

PHOTO: UNKNOWN, 1935

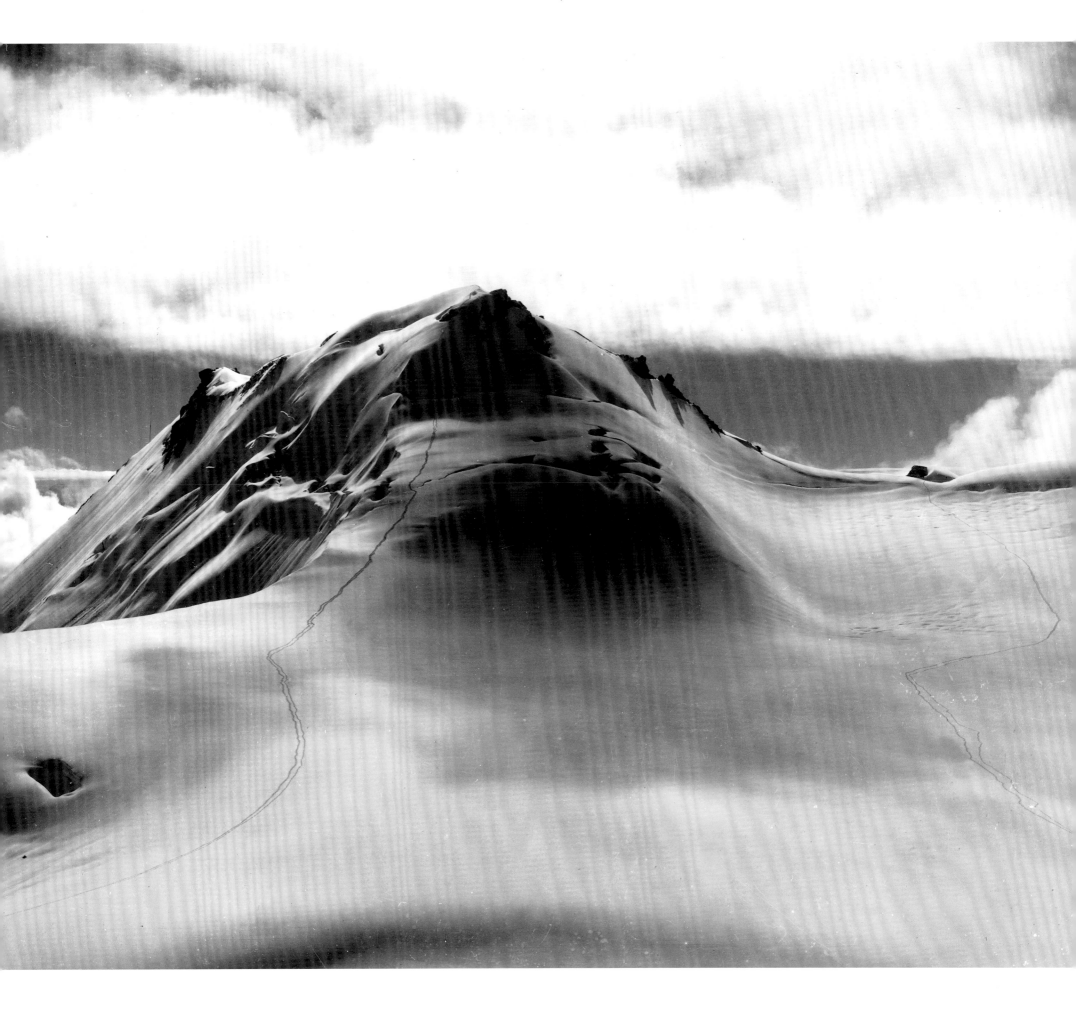

grisly find was the remains of Maurice Wilson, the ex-army officer who had flown single-handed to India the previous year and made his way alone right up to the slopes of the North Col, sustained by prayer and a deluded optimism in his illegal solo attempt on the world's highest mountain.

Given his almost total lack of experience, Wilson's solo attempt on Everest had no chance of succeeding. However, that does not mean that the huge, expensive, quasi-military operations of 1933 and 1936 were necessarily the only sensible way to try the mountain. After all, in the final analysis, the summit had to be gained by just two climbers, operating alone, beyond any realistic hope of rescue, utterly committed above the top camp. As events would prove many years later, it did not necessarily require a huge logistical pyramid to put those two men within striking distance of the summit.

Tilman also, despite his military background (he had previously served as an artilleryman under Norton on the Western Front), was committed to the notion of "small is beautiful." As leader of the 1938 expedition, he proved that even a lean, tightly budgeted team could make a serious attempt on the mountain, and it was bad weather, not any inherent weaknesses in the plan, that turned his expedition back at about 27,300 feet (8320 m).

Reading between the lines of those repeated journeys over the Tibetan plateau (Shipton took part in all four of the official 1930s expeditions), one cannot help but get a sense of growing ennui. The magic of discovery had been lost and there was no summit reward to replace it. For Smythe, the ascent of Everest had "become a duty, perhaps a national duty, comparable with attempts to reach the poles, and … far removed from pleasurable mountaineering."

In 1937 Frank Smythe sought solace in quiet exploration of the "Valley of Flowers" close to the scene of his first Himalayan triumph, Kamet. Shipton and Tilman, too, when they were not engaged on Everest, ranged far and wide over the immense spaces of the Himalayas. In 1936, Tilman triumphed on the summit of Nanda Devi with Noel Odell. The following year, he and Shipton traveled to the far northern reaches of Kashmir to explore and survey huge tracts of the mighty Karakoram Range with Michael Spender and John Auden (another famous poet's brother); and Shipton returned there again in 1939.

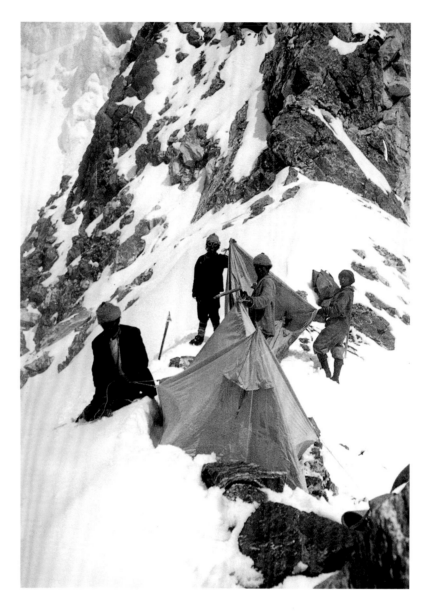

Camp *(left) on a 20,200-foot (6165-m) peak above the Kharta Valley.*

PHOTO: L. V. BRYANT, 1935

Those brilliantly executed journeys were made possible through the loyal support of a few tried-and-tested Sherpas, most notably Ang Tharkay, who was also sirdar (head of the Sherpa team), on Everest in 1938. On Everest the Sherpa teams were, of course, much bigger. Many of the men crossed the traditional trade route over the Nangpa La from their homes in Nepal to join the expeditions at Rongbuk. Others lived in the Indian tea station of Darjeeling and joined the sahibs as they set out from there.

One of the keenest to join in 1935 (as personal servant to Charles Warren) was Tenzing Norgay. Although he claimed to be a true Sherpa from Nepal, he was actually born in the Kharta Valley in Tibet and as a boy had tended his parents' yaks on the meadows east of Chomolungma. But at some stage the family moved to Nepal and later young Tenzing moved to

A *column of more than 30 porters (opposite) carrying supplies up the slope leading to the North Col. It was on this slope, dangerously laden with new snow, that seven porters died in an avalanche in 1922. In 1936, a huge avalanche on the same slope nearly killed Eric Shipton and Percy Wyn-Harris.*

PHOTO: FRANK SMYTHE, 1936

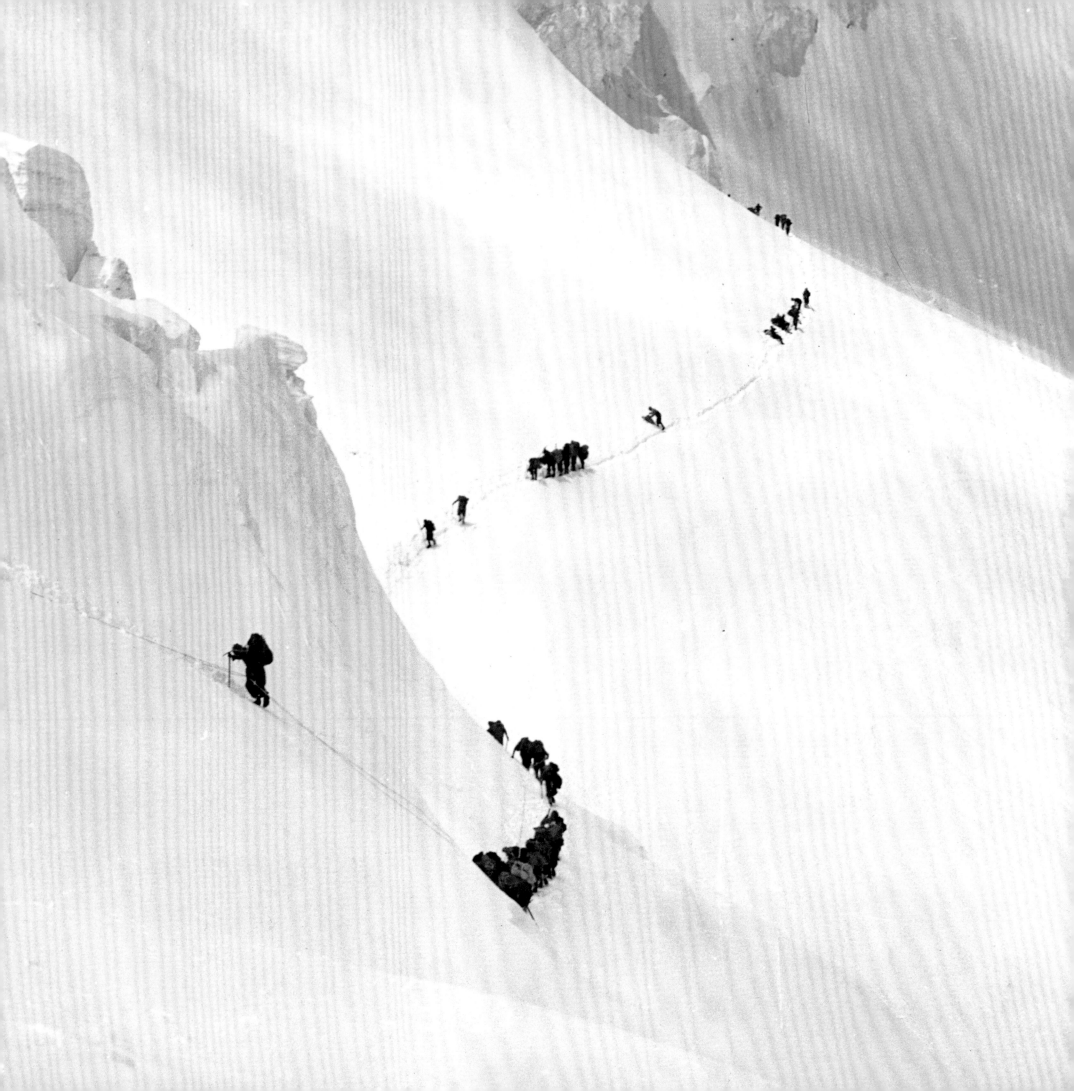

Darjeeling to seek his fortune. Right from the start he proved strong, cheerful, enthusiastic, and energetic, with a natural talent for mountaineering.

Other seeds of eventual success were being sown indirectly during the 1930s. In 1933, two Westland biplanes took off from northern India to make the first flight over the summit of Everest. A stunning photo of Makalu, the world's fifth highest mountain, subsequently appeared in *The Times*, captioned "Over Everest." Not for the last time did the wrong mountain make it into the press, but at least on this occasion the photo was not printed back-to-front, as would sometimes happen. The real Everest appears in another photo, with one of the planes in the foreground, approaching the mighty south wall of Lhotse, with Everest's Southwest Face rising beyond, the black headwall pierced by the single white ribbon of snow that would prove the key to success on that face 42 years later. The pilots also took shots looking straight down on the Northeast Ridge, showing the intractable nature of the infamous rocky steps that were to elude Wager and Wyn-Harris a month later. However, it was in 1945 that the most significant aerial photos were taken, this time by a Spitfire pilot trespassing into Nepalese and Tibetan airspace to fly right over the Kama Valley and take the first detailed shot of the upper Southeast Ridge, complete with what would become the Hillary Step.

As well as recruiting Tenzing Norgay in 1935, Shipton set in motion another unconscious, serendipitous link to the

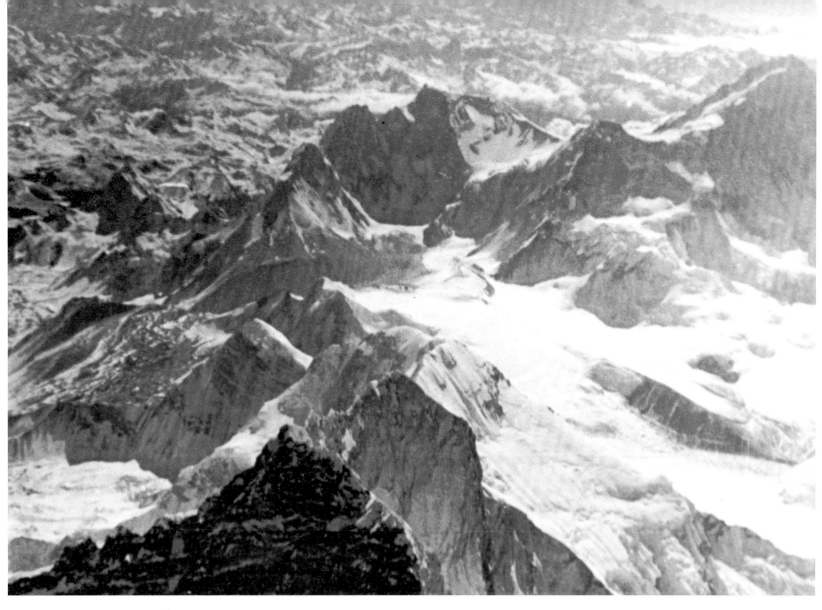

After World War II, the Royal Air Force took photographs during unofficial reconnaissance flights. This photo looks over the fearsome rocky South Face of Lhotse (bottom left) toward Chomolönzo (center), and Makalu (right), with the Kama Valley just appearing on the extreme left.

PHOTO: RECONNAISSANCE FLIGHT OVER EVEREST, 1945 OR 1947

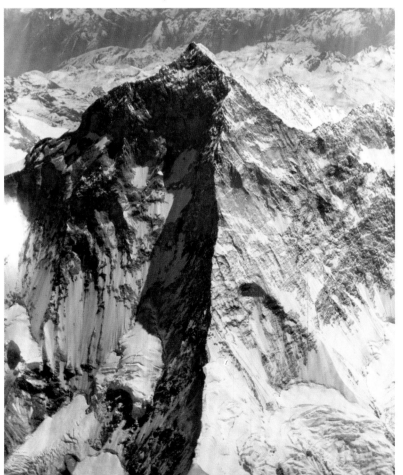

The distinctive West Buttress of Makalu, Everest's neighbor (left). The Times newspaper published this photograph full-page size on its front page, incorrectly titled "Over Everest."

PHOTO: COL. L. V. S. BLACKER, 1933

Everest from the east (right) with the Southeast Ridge rising from the South Col at the bottom left. This photo convinced Dr. Michael Ward that there was a potential route from the south.

PHOTO: PILOTS OF 684 SQUADRON, 1945

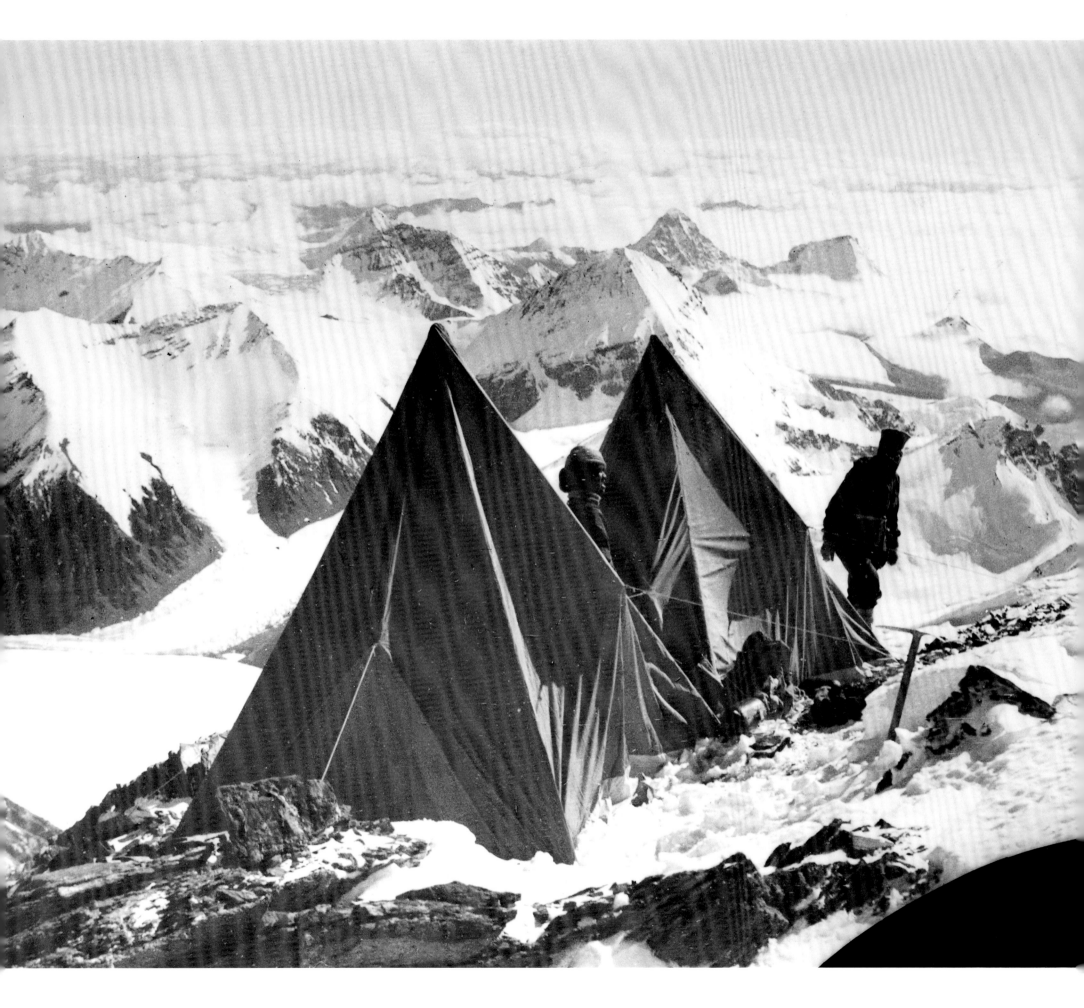

the praises of the masters of that art, Shipton and Tilman, and would have felt complete empathy with the 1938 Everest attempt led by Tilman. But he would also, probably, have warmed to the work done on that expedition by Peter Lloyd, experimenting with—and working to improve—oxygen equipment. Tilman himself had no time for the apparatus.

One of the finest travel writers of the twentieth century, back at his house on the Barmouth estuary in North Wales, Tilman wrote: "My own opinion is that the mountain could and should be climbed without [oxygen], and I think there is a cogent reason for not climbing it at all rather than climb it with the help of oxygen … If man wishes gratuitously to fight nature, not for existence or the means of existence but for fun, or at the worst self-aggrandizement, it should be done with the natural weapons."

A year later, as Europe slid inexorably toward war, Tilman readied himself for a resumption of military duty. His younger fellow mountain-wanderer Shipton was more of a free spirit and set off optimistically on a second huge ambitious journey of exploration through the Karakoram. It was there, camped in the middle of a great glacial basin called Snow Lake in September 1939, that one of the younger expedition members, Scott Russell (future son-in-law of George Finch), brought Shipton news that Prime Minister Chamberlain had just announced that Britain was at war with Germany—the terrible culmination of the tensions that had been intensifying ever since the end of the previous world war. For Shipton, the political turmoil of the 1930s had been the distant background to his own personal decade of enchantment, achieving things far beyond his wildest boyhood dreams. Now all that was coming to an end. As Russell and Shipton sat and smoked their pipes, wondering if bombs were already dropping on London and talking about an uncertain future, they mused about the possibility of surviving the war and one day returning to the Himalayas. Everest was mentioned, inevitably, and Shipton declared that by the time the war was over he would be too old for the job. But then he suddenly announced that actually, if (as rumored) Nepal was considering the possibility of opening her door to foreigners, he would love to lead an expedition to the south side of Everest and visit the homeland of the Sherpas whom he knew so well.

future, when he formed a lastingly favorable impression of New Zealand mountaineers—those tough pioneers of the Southern Alps, represented on the Everest expedition of that year by Dan Bryant. Even less obvious at the time was the significance of one Lt. John Hunt applying to join the 1936 expedition. He had already done some fine exploration in Sikkim, but the doctors turned him down because of apparent heart problems, telling him to be careful climbing the stairs. Like any sensible mountaineer, he ignored the doctors and consoled himself with an expedition to Saltoro Kangri, one of the unclimbed giants of the Karakoram.

John Hunt's approach to Himalayan climbing was one of romantic enchantment with the pure adventure of traveling through remote unexplored country. All his life he was to sing

ALBUM: THE 1930S EXPEDITIONS

Edward Shebbeare (right) with standard expedition umbrella, looking decidedly unhappy and proving that Himalayan climbing is not necessarily good for you. After becoming ill at Camp III, he never ventured higher than Camp II.

PHOTO: FRANK SMYTHE, 1933

A portrait of Lewa (center), the chief sirdar on the 1933 Mount Everest Expedition.

PHOTO: FRANK SMYTHE, 1933

The head lama (far right) of Rongbuk monastery.

PHOTO: FRANK SMYTHE, 1933

Kharta villagers engrossed by Noel Coward's "Mad Dogs and Englishmen" played on the 1936 expedition gramophone. Frank Smythe called the elderly monk "Father William" after the character in the Lewis Carol poem:

"You are old, Father William" the young man said, "And your hair has become very white; And yet you incessantly stand on your head. Do you think, at your age, it is right?"

PHOTO: FRANK SMYTHE, 1933

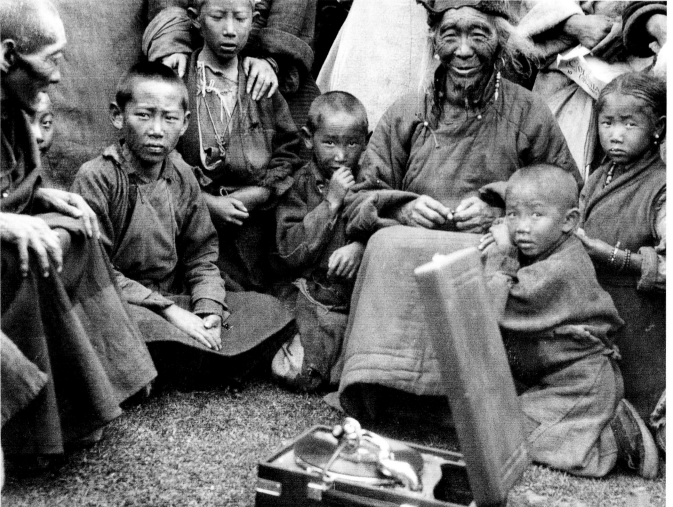

Eric Shipton with Sherpas at a glacier lake on the main Rongbuk Glacier (opposite). Shipton held the record for taking part in the most Mount Everest expeditions, going to the north side in 1933, 1935, 1936, and 1938, then leading the southern reconnaissance of 1951 and the Cho Oyu training expedition of 1952. Taught by bitter experience to expect many hours of tentbound inactivity, Shipton always packed a good book. In 1938, his choice of reading was Gone with the Wind.

PHOTO: L. V. BRYANT, 1935

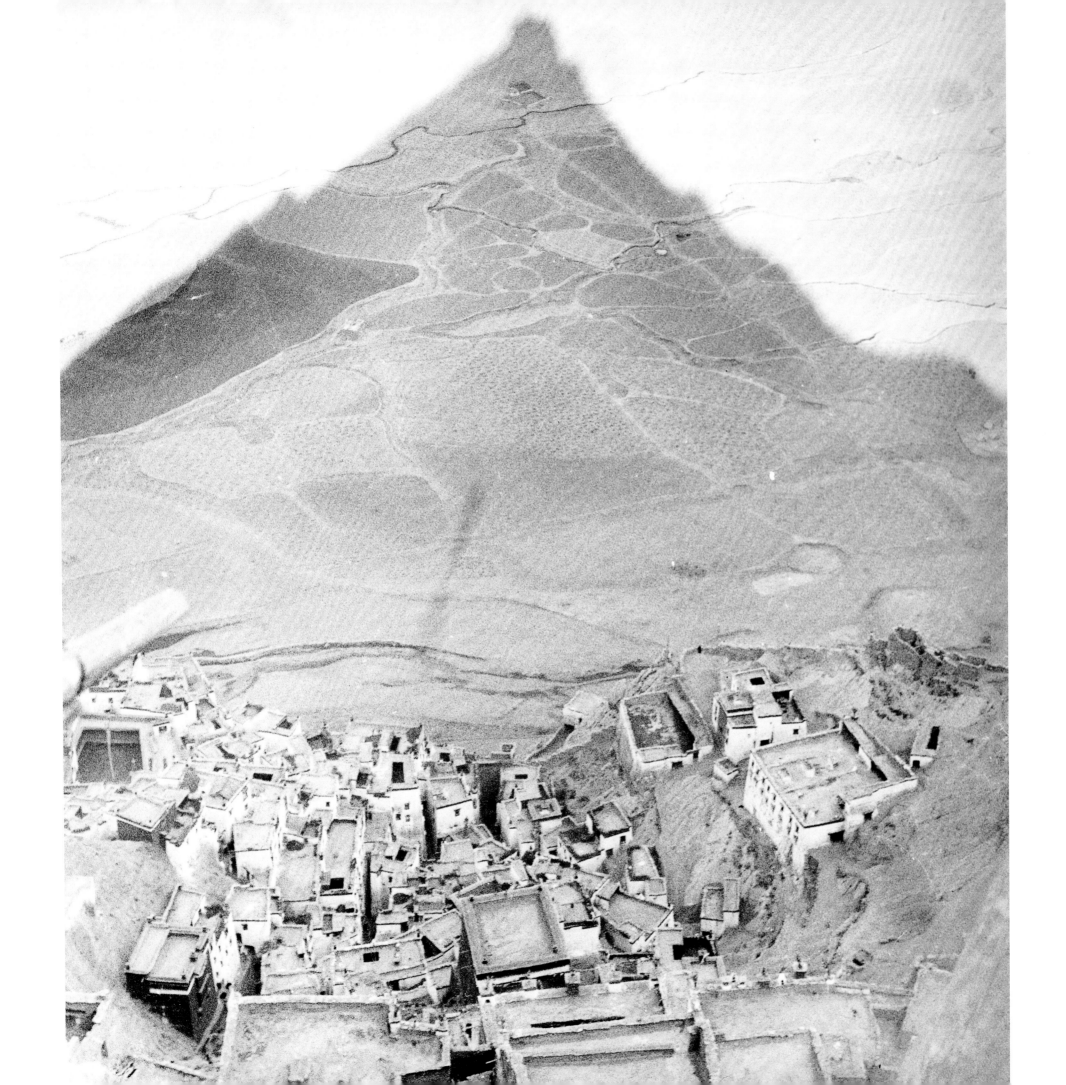

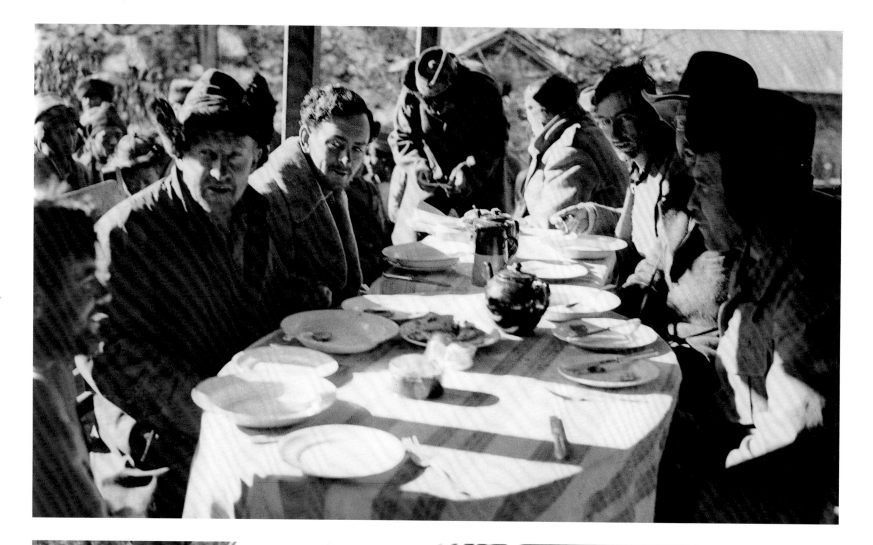

The 1933 Everest team sits down to breakfast in Gautsa. As on every Everest expedition, this team became increasingly obsessed with food. Subsisting on condensed milk, jam, and acid drops at Camp VI, despite his laryngitis, Eric Shipton was reported to have whispered hoarsely, "Oh, for a few dozen eggs."

Photo: Frank Smythe, 1933

The 1936 expedition (opposite) contemplates the magnificent view of Mount Everest from the Rongbuk Glacier.

Photo: E. H. L. Wigram, 1936

John Morris (left) at the 1936 Base Camp's dining table, surrounded by familiar British brands including Huntley & Palmer's ginger nut biscuits, Heinz tomato ketchup, and sardines from J. Sainsbury Ltd. Compared with Shipton's 1935 reconnaissance, both the 1933 and 1936 expeditions were lavishly supplied. In addition to the staples seen here, there were plenty of gourmet treats such as quails in aspic, Carlsbad plums, and champagne.

Photo: P. R. Oliver, 1936

The 1922 Everest Expedition team sits down to breakfast during the approach march, probably enjoying supplies bought at Fortnum & Mason's. Left to right: Arthur Wakefield, John Morris, Brig.-Gen. Charles Bruce, an unknown sherpa, Edward Norton, a Gurkha, and Capt. Geoffrey Bruce.

PHOTO: CAPT. J. B. NOEL, 1922

Eric Shipton sits at the head of a make-shift table drinking tea with the 1936 expedition members (below, left). Maintaining hydration levels was very important at altitudes where the body easily lost moisture in the thin dry air.

PHOTO: FRANK SMYTHE, 1936

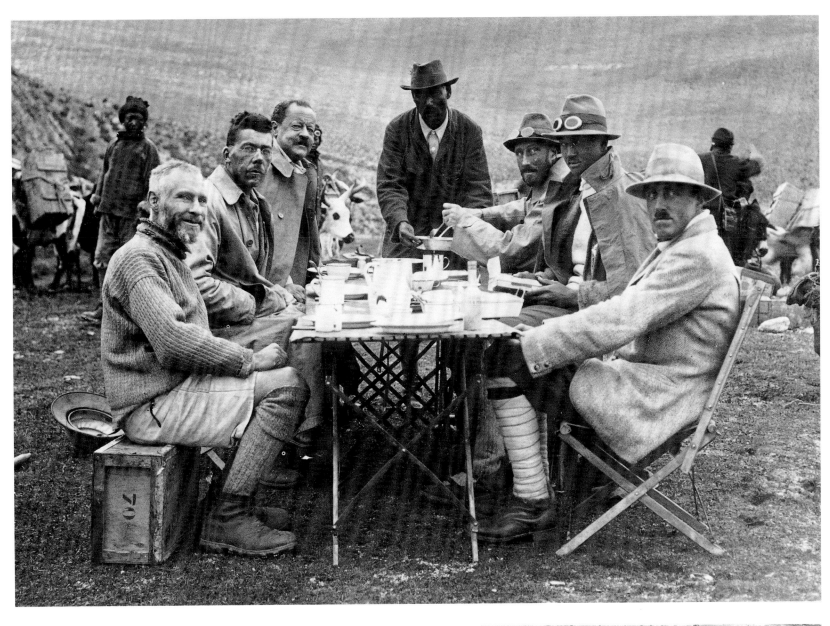

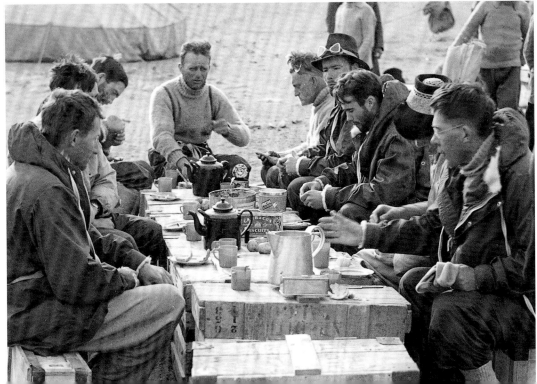

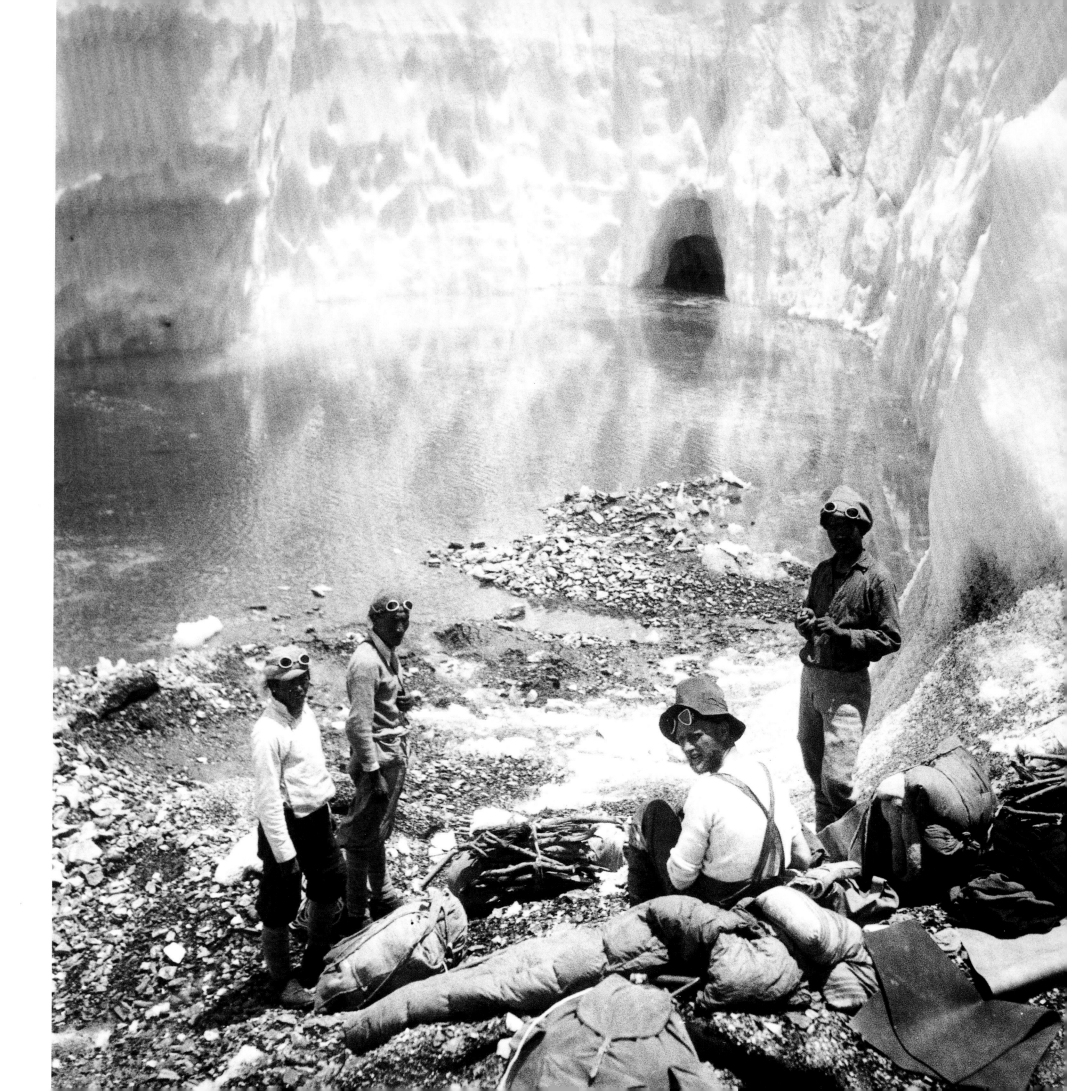

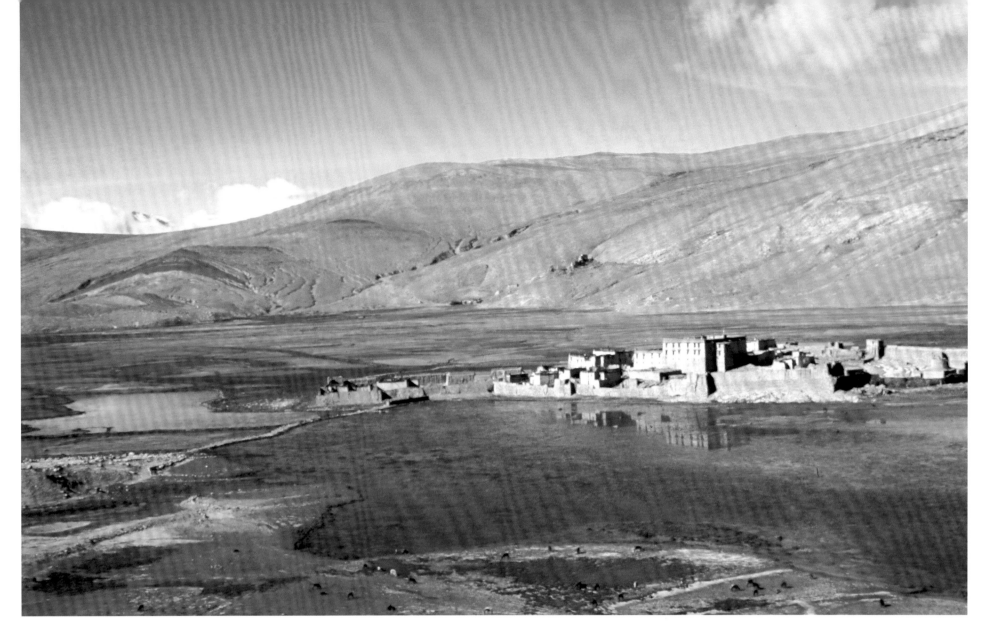

One of only a handful of color photographs (above) taken during the prewar Mount Everest expeditions. Tengkye, or Tingri, Dzong was an important trading post and the closest major habitation to Everest. Although the land appears bleak and brown in the early spring, there is enough water to irrigate fields of barley and other crops, sustaining a substantial population of farmers and semi-nomadic shepherds.

PHOTO: CHARLES WARREN, 1936/38

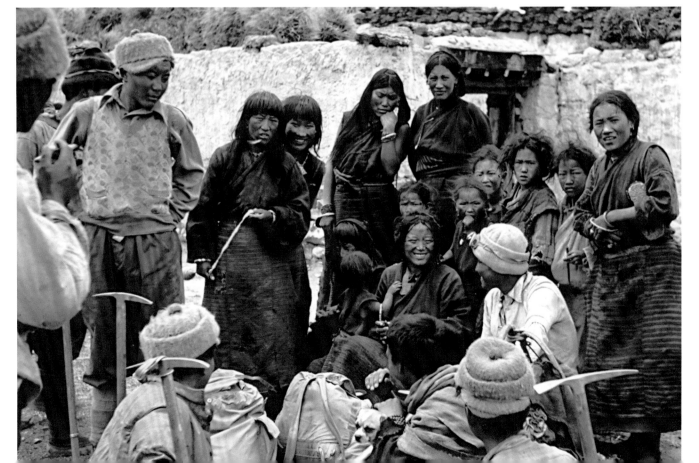

Sherpa porters talk with Tibetan women (right). This rare color photograph was taken by Frank Smythe, who excelled both in climbing mountains and taking pictures of them.

PHOTO: FRANK SMYTHE, 1938

Shegar Dzong (left) casts a pyramid shadow over the patchwork of fields that sustain the town and monastery at the foot of the mountain. The town of Shegar nestles below it.

PHOTO: FRANK SMYTHE, 1933

The wind on the Tibetan plateau was the cause of constant complaint (above). Here, team members struggle against its force while pitching a mess tent at Shegar.

PHOTO: FRANK SMYTHE, 1933

Various ways of crossing rivers had to be found, including a ford over the Chiblung-Chu, which caused much excitement when most of the bedding became soaked. On this occasion (left), Jack Longland tries his hand at a typical rope bridge, suspended in a simple harness—Tibet's answer to the Tirolean traverse.

PHOTO: FRANK SMYTHE, 1933

From the summit battlements of Shegar Dzong, three members of the 1933 expedition sight Mount Everest some 50 miles (80 km) away. Despite bad weather, they did catch fleeting glimpses of famous features such as the North Ridge—the first climbers to see them since Norton led the last team home in 1924.

PHOTO: FRANK SMYTHE, 1933

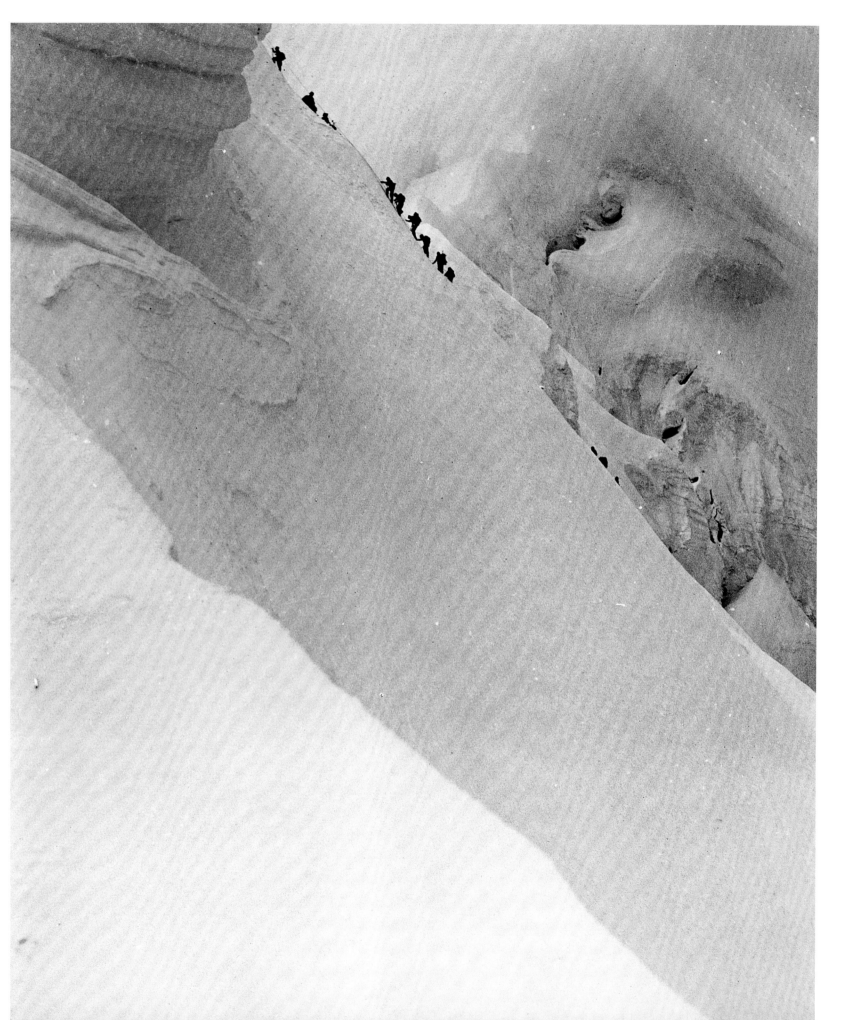

Porters carrying up supplies to Camp IV on top of the North Col (left). Deep snow continuously hindered the 1936 expedition. Ruttledge commented that it was hard to imagine how bad the weather had been from the photographs taken, as most showed Mount Everest bathed in endless sunshine.

PHOTO: FRANK SMYTHE, 1936

Afternoon clouds build up, signaling the start of the monsoon (opposite). The 1936 expedition experienced sunny and bright mornings, a build-up of clouds by noon, and by evening heavy snow that continued to fall through the night.

PHOTO: E. H. L. WIGRAM, 1936

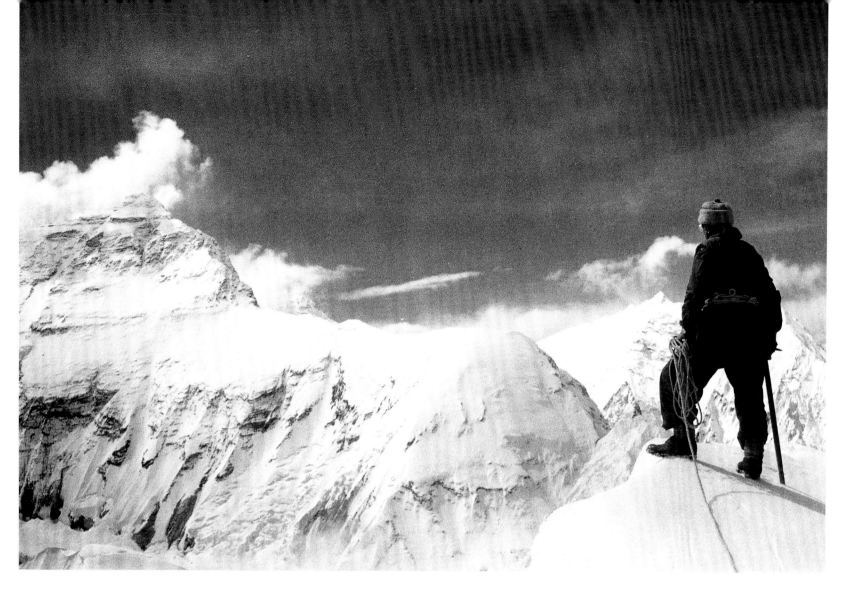

*E*ric Shipton (left) stands at the summit of a peak at 21,120 feet (6439 m) above the Rongbuk Glacier and looks out at Everest's North Face and West Ridge, with Nuptse on the right, in Nepal. Both peaks are draped in heavy monsoon snow.

Photo: L. V. Bryant, 1935

*P*orters enjoy the late afternoon sunshine (opposite) at Camp II on the East Rongbuk Glacier, while Peter Oliver practices his step-cutting on one of the glacier's spectacular ice pinnacles.

Photo: Hugh Ruttledge, 1936

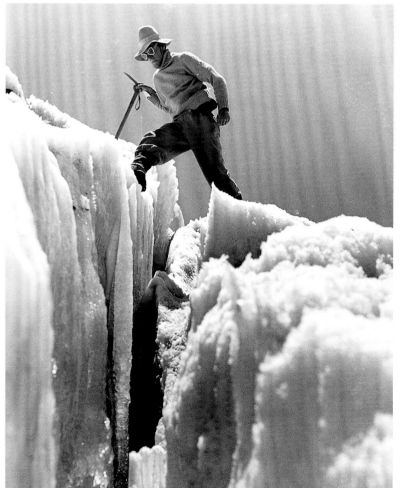

*L*awrence Wager (right) gives scale to a classic glacier table, caused by a rock slab shading its supporting pillar of ice from fierce solar radiation. The surrounding ice, unprotected, has melted by several feet, probably in just a few weeks.

Photo: Hugh Ruttledge, 1933

A sun hat and goggles protect against the fierce sunshine (left); the ice-ax makes a convenient balancing aid for crossing a small crevasse.

Photo: W. R. Smyth-Windham, 1936

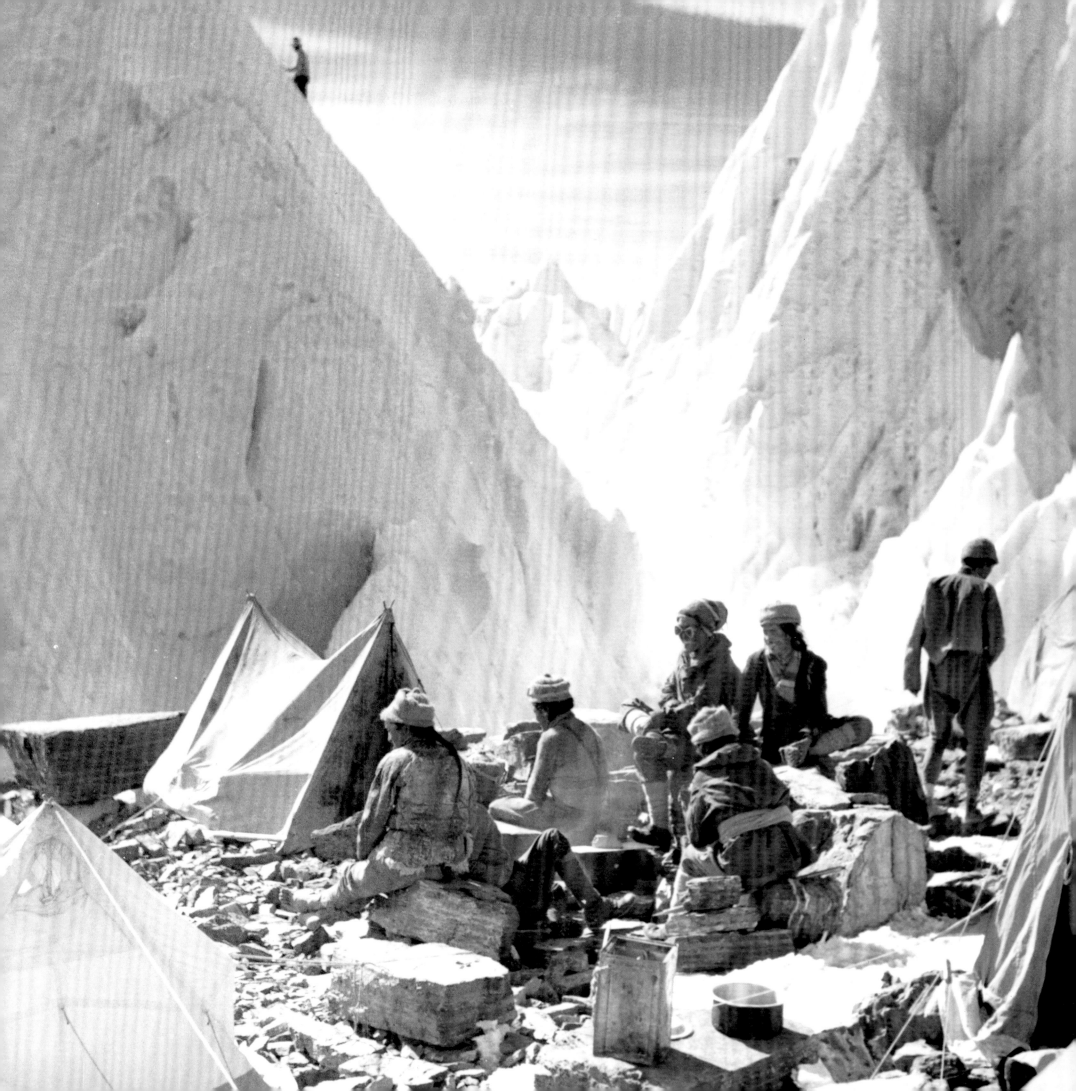

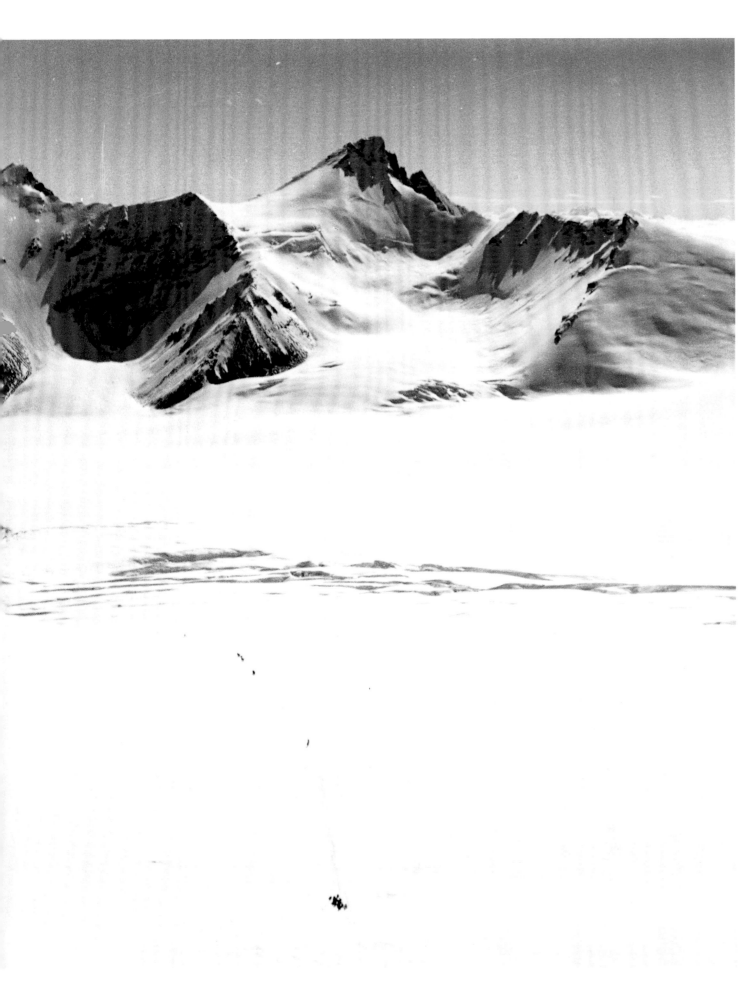

A party (left) heads up the now very familiar trail from Camp III to the start of the slope leading to the North Col. Behind them is the great upper snowfield of the East Rongbuk Glacier, which had proved so elusive in 1921. The Lhakpa La, from which the 1921 reconnaissance first reached this basin, is on the horizon ridge on the left of the picture. The 1938 expedition also crossed this col, seeking greenery, relaxation, and thicker air in the Kharta Valley beyond.

PHOTO: UNKNOWN, 1938

A team (opposite) sets off up the North Ridge from the North Col in 1938. This was the seventh expedition to attempt the mountain, but it too was defeated, this time by persistent bad weather. Despite this, the team managed to reach the North Col from both sides—east and west—and to continue right up to Camp VI at 27,200 feet (8293 m). But from here it took Eric Shipton and Frank Smythe a whole hour to climb just one rope-length, wading forlornly through powder snow. After this stoic effort the attempt was abandoned and no official expedition visited the mountain for 13 years.

PHOTO: UNKNOWN, 1938

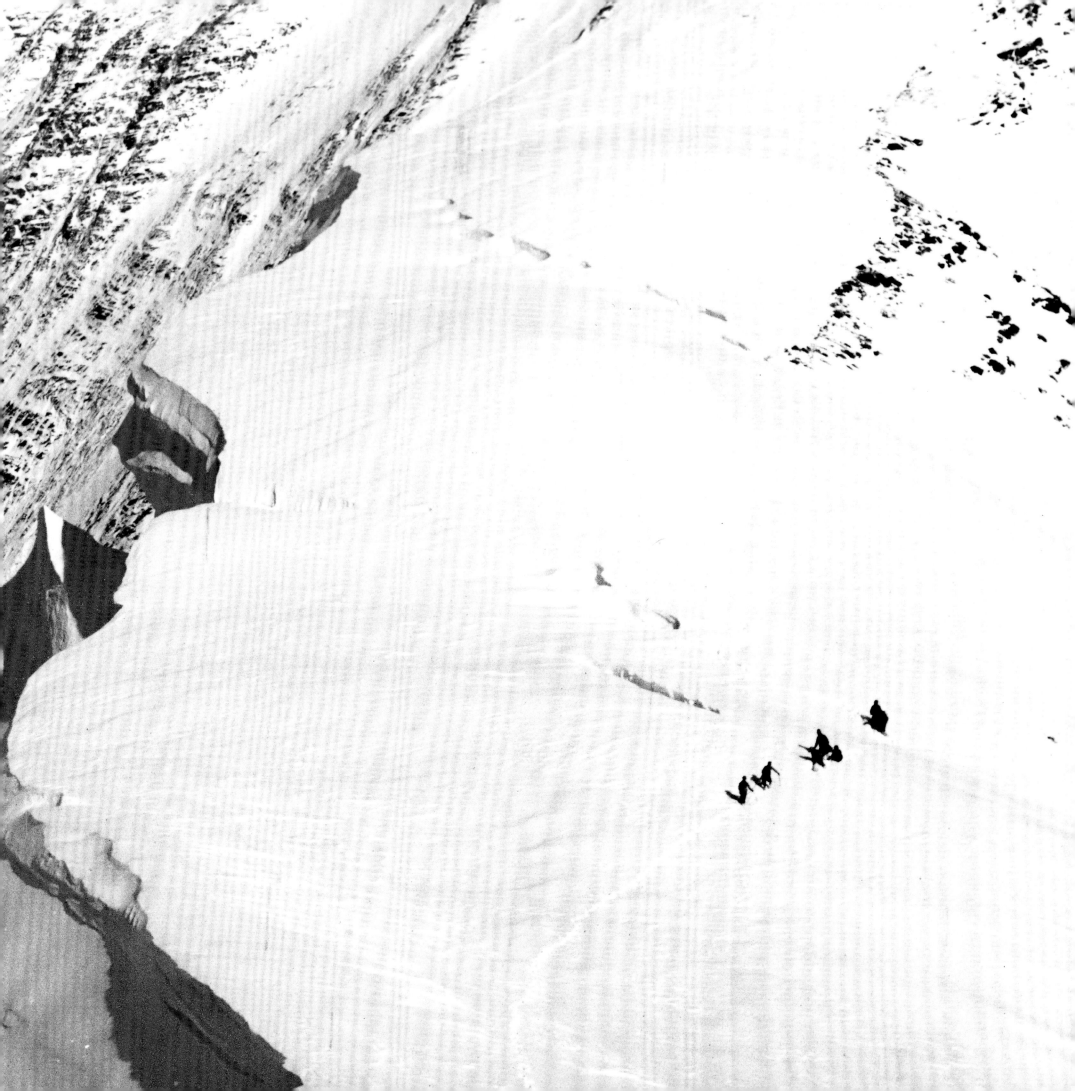

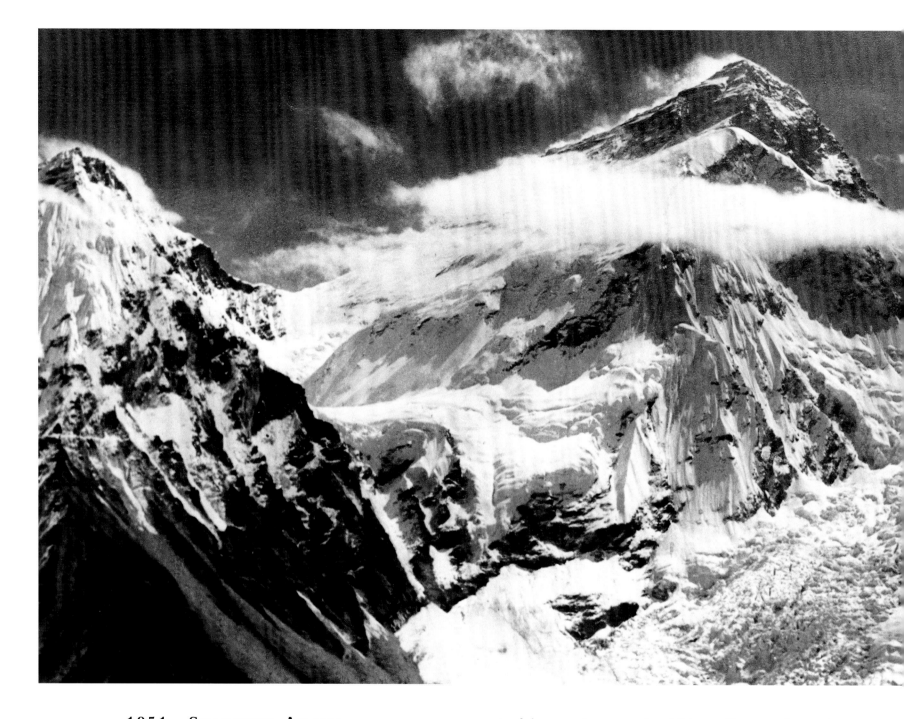

1951—STARTING AGAIN

Early in 1951, a young surgeon doing his military service with the Brigade of Guards in London would sneak off whenever he could to browse through the archives of the Royal Geographical Society. His name was Michael Ward. Examining forgotten maps and photographs, including Mallory's famous shots looking down into Nepal from Tibet, and the recent aerial shots of the unknown Southeast Ridge, he began to wonder if Everest might be climbable from the south.

The British Empire was now being dismantled, India was independent, and any possibility of renewing ties with Tibet was out of the question now that Chinese Communist armies had taken ancient claims of "suzerainty" over Tibet to their logical conclusion. However, after decades of isolation, the Nepal government was now allowing foreigners to visit its unknown mountain interior. In 1947, Bill Tilman had been permitted to explore the Langtang region, to the southwest of Everest. Then, in 1950, Maurice Herzog's French expedition gained a precious permit to try one of the prestigious "eight-thousanders" that were so revered by the heirs to Napoleon's metric system. After many adventures trying to separate topographical fact from the confusion of existing maps,

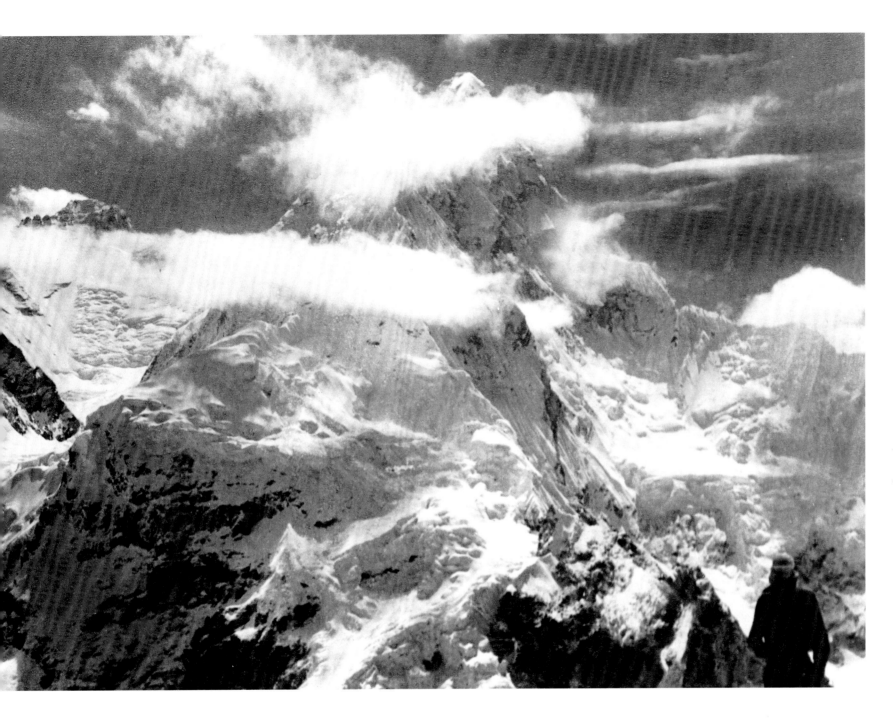

The definitive image of the 1951 Everest Reconnaissance, which was the frontispiece of a special edition of The Times. This view, with Hillary on the far right, was taken from high on Pumori and looks left across the Lho La to the great sweep of Everest's North Face and the North Col, scene of seven previous expeditions and now closed to foreigners. It also looks ahead to the future, straight up the Khumbu Icefall to the secret valley of the Western Cwm. Although several prewar expeditioners had glimpsed the cwm from the frontier ridge, no one had yet seen so far into it. This photo shows, for the first time, the distant snow face at the head of the cwm, leading directly—and apparently quite straightforwardly—to the South Col (just obscured by the band of white cloud). A few days after they saw this view, Shipton's team succeeded in overcoming the most obvious obstacle, the initial icefall. That success, combined with the evidence of this photo and earlier aerial photos of the Summit Ridge, gave the southern route up Everest a realistic chance of success.

PHOTO: UNKNOWN, 1951

they eventually made a lightning dash to the summit of Annapurna—the highest summit so far attained by man, and the first above 8000 m (26,240 feet). While Herzog and his frostbitten companions were making a desperate retreat through the monsoon-drenched jungles of the Nepalese lowlands, a small Anglo-American trekking party was on its way to the most sought-after high valley in Nepal—the Solu Khumbu region immediately south of Everest.

The Everest party was organized by Oscar Houston and included his son Charles. At the last minute they bumped into Charles's old companion from the 1936 Nanda Devi Expedition, Bill Tilman, and invited him along, too. As well as climbing on Nanda Devi, Houston had led an attempt on K2 in 1938 and was to have another near miss on the world's second highest mountain in 1953. However, this 1950 trip to Nepal was a more relaxed affair. As much as anything else it was a chance just to experience the enchantment of walking through the Nepalese countryside. Many of those early visitors had been to other Himalayan regions in India, Kashmir, Sikkim, and Tibet, but Nepal seemed to have a special magic of its own. It was partly the sheer novelty of going where no Westerners had ever been before, but it was also the staggering

The heat of the Nepalese valleys came as a surprise to the 1951 team. One of the ways they sought refuge from the high temperatures was to bathe in the Arun river under umbrellas. Left to right: Eric Shipton, Michael Ward, and Bill Murray.

PHOTO: UNKNOWN, 1951

beauty of the landscape, the magnificence of the architecture, from the Hindu temples of the capital to the Buddhist monasteries and paved villages of the high valleys, and the genial friendliness of the people.

The Houston party walked all the way up to Namche Bazar, on to Rongbuk's famous sister monastery, Thyangboche, and then on up the valley to climb a short way up the mountainside above the Khumbu Glacier and gawk across at the jaws of Mallory's "Western Cwm." Of the enclosed upper valley they could see little. As for the ice cataract tumbling from its maw, the splintered chaos of the "Khumbu Icefall," they reported that it might prove possible, but that it looked decidedly difficult and dangerous.

That was to be Tilman's last visit to the Himalayas. Already in his late 50s he was finding altitude a struggle and had decided that his future lay in the polar regions, using sailing boats to reach remote mountains closer to sea level and write about them in his uniquely witty, erudite style. But a new generation of thrusting climbers was not going to be put off so easily. Examining all the evidence in London, Michael Ward became convinced that it was time to organize a proper

reconnaissance of the southern approaches to Everest; and now that access to the mountain was through Nepal, with no exclusive rights to the British, it was time to move fast, before other nations snatched the prize.

In 1947, while still a Cambridge undergraduate, Ward had been involved in a terrible fall in the Dauphiné Alps, which killed one member of the team of three. The other survivor was an older climber, Bill Murray, who had spent the war in a German prisoner-of-war camp, using stolen lavatory paper to write the manuscript of his seminal book *Mountaineering in Scotland*. By 1951, Murray's experience also included a successful exploratory expedition to the Garhwal Himalayas, close to the India-Nepal border. He and Ward now made the initial plans for the Everest reconnaissance. They invited Tom Bourdillon, a young rocket engineer and recent graduate from Oxford, to join them. But they still seemed to lack the necessary gravitas for a major Everest expedition and felt they needed a suitably eminent leader. So they stuck their necks out and asked the grand old man of Everest himself, Eric Shipton.

Shipton had spent the war in splendid isolation as British consul in Kashi (Kashgar). He was then posted 2000 miles (3200 km) east to Kunming, the capital of Yunnan province, where he did his best to uphold British interests as the Chinese Red Army advanced south, leaving him with a lasting hatred of Communism. When Ward and Murray approached him in 1951 he had only just escaped the chaos of Kunming with his wife and two very young children. His first priority was to get his family settled in Britain and he was, at best, ambivalent about now embarking on his first serious mountaineering expedition in 12 years. In the end, it was not so much Everest itself as the chance to visit Solu Khumbu that persuaded him to say "Yes."

The reconnaissance was now a fully fledged expedition, with a world-famous mountaineer at its head, full backing from the Everest Committee, and the legendary Sherpa, Ang Tharkay, booked to act as sirdar. Then, at the last minute, the New Zealand Alpine Club sent word that some of their finest young climbers were already in the Himalayas, attempting an Indian peak called Mukut Parbat suggested to them by a visiting geology professor, Noel Odell. Would it be possible for them to join Shipton's team? Shipton cabled back

After successfully finding a route up the Khumbu Icefall, the 1951 team treated itself to an orgy of exploration, ranging far and wide over the mountains around Everest. One journey, photographed here, explored the complex icefall leading toward the Nup La, on the Tibetan border. The following year, during the Cho Oyu training expedition, Edmund Hillary and George Lowe trespassed right over the pass, into Tibet, and right up to the old prewar Camp III on the East Rongbuk Glacier.

PHOTO: UNKNOWN, 1951

to say he would be delighted to have two of the New Zealanders along, provided they brought their own provisions. The message was relayed to India, where the four young New Zealanders debated acrimoniously who should be allowed to go. The leader, Earle Riddiford, had seniority and private means on his side and took one of the places. George Lowe wanted desperately to go but had run out of money. Ed Cotter also lost out in the lottery. The fourth expedition member, a beekeeper called Edmund Hillary, still had a little money left and decided that the bees at home could wait. Three weeks later, in the steamy hot valley of the Arun river in eastern

Nepal, he and Riddiford arrived at the village of Dingla and were shown up a staircase to a dimly lit room. As he later recalled, "a strongly built man with a short grizzled beard turned toward me with a welcoming smile and I knew I was meeting Eric Shipton for the first time."

The 1951 reconnaissance was almost as extraordinary as the first Everest expedition 30 years earlier. True, a great deal more was now known about the world's highest peak, and technical knowledge of high-altitude mountaineering had also increased enormously. Nevertheless, in those halcyon days before tourism became Nepal's great sustaining industry, the mountain country

Yeti Footprints?

Shipton's famous close-up (below) of the "Yeti" footprint was a scoop that delighted *The Times*, official sponsor of the 1951 Reconnaissance Expedition. It is significant that the tight frame shows just one footprint—very different from the long line seen in the other two photos. To this day, surviving members of the expedition seem confused or reticent on the subject of exactly who saw what and when. More than one expert has suggested that Shipton fabricated the elaborate toe marks as a deliberate hoax for a gullible Fleet Street and its equally gullible readership. Which leaves the question of who—or what—made the long line of less elaborate prints? The most likely candidate is a Himalayan bear.

While exploring the Menlung Chu, east of Everest, during the 1951 reconnaissance, Shipton took this photograph (above) of Michael Ward beside a line of mysterious tracks in the snow.

PHOTO: ERIC SHIPTON, 1951

"Yeti" footprints (right) leading off into the mountains, next to a rucksack and ice-ax.

PHOTO: ERIC SHIPTON, 1951

south of the Tibetan frontier was still virtually untouched. Of course, the high pastures and some of the passes—particularly the Nangpa La—had been known to local people for many centuries; but the intricate detail of the high peaks and glaciers so dear to Western explorers and mountaineers was still waiting to be discovered.

Shipton was in explorer's heaven. Not only that, he was lionized, welcomed with his old accomplice Ang Tharkay into every Sherpa village with copious draughts of *chang*. The expedition ranged far and wide—west to Menlungtse and Gaurishankar, east to Makalu. There was a job to do and the first priority was to climb up the slopes of Pumori to gain a good view of the much-derided Khumbu Icefall. Climbing higher than Tilman had the previous year, the 1951 team got a proper perspective, right into the Western Cwm, spying what looked like a realistic route all the way to the high saddle of the South Col. As for the icefall itself, it began to look feasible.

The team then worked its way up the icefall, cutting steps, fixing the occasional rope, winding and weaving a labyrinthine route through tottering towers and gaping crevasses, eventually arriving right on the upper edge of the icefall, where only one final, gigantic crevasse separated them from the smooth snow surface of the Western Cwm. They were not equipped to get over the crevasse, but they had seen enough. The icefall was undoubtedly dangerous but not outrageously so. They had seen most of the route beyond to the South Col, and Ward had studied the aerial photos of the final ridge above that. It seemed that Everest could be climbed from the south.

Back in London *The Times* published a special supplement on the 1951 reconnaissance, complete with Shipton's photos of what purported to be yeti footprints on a glacier. On the more serious subject of Everest itself, Ward was "incandescent with rage" when he discovered that the dear old Everest Committee, ever cautious, had failed to secure a permit from the Nepalese government to attempt the mountain in 1952 and the Swiss had got there first. In the forlorn hope that the Swiss would not manage to complete the final pieces of the jigsaw, the elders of the Alpine Club and Royal Geographical Society were able to secure a permit for 1953, with the French booked for 1954 and the Swiss keeping a second option for 1955. The race was surely on.

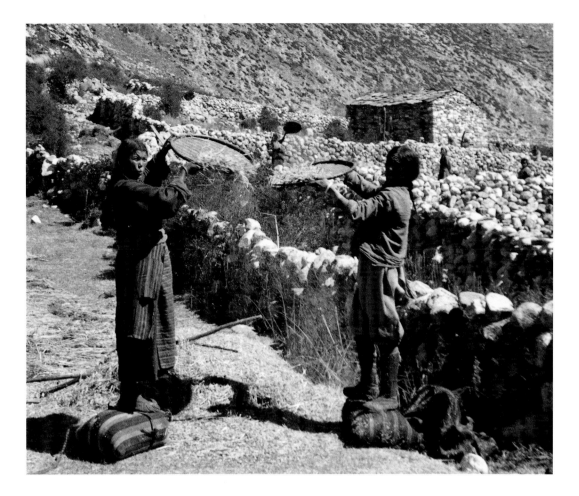

1952—"JUST A LITTLE BIT TOO HIGH"

Between 1950 and 1960 all 14 of the world's peaks higher than 8000 m (26,240 feet)—all in the Himalayas—would be climbed for the first time. How much of this success was due to improved equipment and how much to psychology is a moot point. Many climbers would tend to agree with the old romantic explorer, Francis Younghusband, that it was primarily a triumph of the human spirit, riding a surge of confidence as successive barriers were crossed. Others took a less mystical view. Michael Ward, closely involved in preparations for the 1953 expedition, was adamant—and remains adamant—that, on Everest at least, success was achieved through science. The veteran of 1922, George Finch, by 1953 a professor at Imperial College, London, must have been delighted to see Ward, Bourdillon, Bourdillon's father, and Griffith Pugh, a new recruit to the project, all dedicating themselves to the development of reliable oxygen equipment, assisted by a famous rock climber at the Gas Board called Alf Bridge, and Peter Lloyd, a member of the last prewar expedition. In their determination to solve "the oxygen problem" they were

Winnowing barley, a staple crop, at Dingbochi, Solu Khumbu, Nepal. The highest village in the Khumbu where crops are grown is situated at 14,500 feet (4420 m). The barley is mostly roasted and made into tsampa.

PHOTO: UNKNOWN, 1951

Permission from the Nepalese government for the Swiss to climb Mount Everest in 1952 came as a severe blow to the Joint Himalayan Committee. They had expected to be given access, but had to wait until 1953. The committee decided to send a training expedition, led by Eric Shipton, to Cho Oyu, the world's sixth highest peak, in preparation for Everest. With Shipton were a band of climbers who were to form the nucleus of the 1953 Everest team, including Hillary, Lowe, Gregory, Pugh, and Bourdillon. This picture, taken in April 1952, looks down a valley between Chule and Lunak en route for Cho Oyu.

PHOTO: UNKNOWN, 1952

influenced as much as anything by Charles Houston's 1947 pressure-chamber experiments, which had subjected human volunteers to the atmospheric pressure that would be found above 29,000 feet (8840 m). The volunteers had survived, but the debilitating effects of low atmospheric pressure on body and mind had been demonstrated very clearly.

Pugh was an ex-Olympic skier who had spent much of the war at the mountain warfare training school in the mountains of Lebanon. Aided by new fabrics and technologies developed during the war (not least among them nylon rope), he applied himself to every aspect of climbing Everest, from diet, hygiene, hypothermia, and stoves, to oxygen equipment. Much of this work was done in Nepal during the 1952 training expedition.

As well as preparing for Everest, the 1952 expedition was supposed to make an attempt on the world's sixth highest peak, Cho Oyu. However, realizing that this would involve trespassing into Tibet, Shipton got cold feet. The previous year,

he had nearly been arrested after straying into the Tibetan part of the Rongshar Valley. Now the Chinese had an even firmer grip on Tibet. Mindful of his own unpleasant experiences in Kunming, he decided not to risk an international incident.

Hillary, disappointed by Shipton's apparent timorousness, went trespassing anyway. With fellow New Zealander George Lowe, now happily enrolled on the Everest project, he made a long, hazardous glacier journey over the uncharted Nup La Pass, down on to the West Rongbuk Glacier, round to the old prewar Base Camp and up the East Rongbuk Glacier to the historic Camp III beneath the North Col. It was brilliant and buccaneering and must have fanned the flame of ambition. By now, he seems to have had a firm sense of destiny with Everest. He was 32, at the peak of fitness, amassing huge amounts of priceless experience: He was the right man in the right place at the right time. There was just the niggling worry about the Swiss expedition trying for the summit at that very moment.

While Edmund Hillary was roaming over the Tibetan frontier, a few miles away in the Western Cwm another man was also living out his destiny with Everest. Tenzing Norgay was now one of the most experienced Sherpas alive, with many Himalayan summits under his belt. He, too, had trespassed on the north side of the mountain, accompanying the Canadian Earl Denman on an illegal attempt in 1947 that had almost reached the North Col. Tenzing Norgay had climbed the east summit of Nanda Devi, India's own mother goddess mountain, and in the same Garhwal region had made several ascents with the leading Swiss climbers of the day. A high mutual regard had grown between Tenzing and the Swiss and when they invited him to join their 1952 Everest Expedition team there was the expectation that he would be in any summit bid they made. Almost uniquely among his people at that time, it seems, Tenzing Norgay viewed Everest as more than just a place of employment: He actually nursed a profound ambition to get to the summit himself.

The 1952 Swiss expedition led by Dr. Wyss-Dunant ought to have reached the summit. Among its members were Raymond Lambert and André Roch, both responsible for some of the first great alpine ascents of the 1930s. In terms of pure mountaineering experience they were well ahead of the British-New Zealand team that was preparing for 1953. Ironically, the Swiss—a people renowned for meticulous engineering and sensible democratic organization—put on a brave but ultimately flawed performance, with malfunctioning oxygen equipment and poor teamwork contributing to its ultimate failure. But they had made a fine attempt. They equipped the icefall with ropes and ladders; they crossed the final crevasse with a Tirolean traverse and became the first human beings to enter the majestic Western Cwm—the "Valley of Silence," hidden between the immense encircling walls of Everest, Lhotse, and Nuptse; they equipped the "Geneva Spur" so that Sherpas could carry loads all the way up to the South Col; and there, at 25,941 feet (7909 m), they established the world's most bleak, miserable, wind-blasted campsite.

The final push for the summit was a heroic effort spearheaded by Lambert and Tenzing. Because of a breakdown in communications and muddled logistics, they ended up camping at about 27,230 feet (8302 m) with no sleeping bags

The Swiss team (above) on their second attempt at Everest, fall, 1952.

PHOTO: SWISS FOUNDATION FOR ALPINE RESEARCH, 1952

Raymond Lambert and Tenzing Norgay (left). Tenzing wore a scarf given to him by Lambert on his successful ascent of Everest with Edmund Hillary a year later.

PHOTO: SWISS FOUNDATION FOR ALPINE RESEARCH, 1952

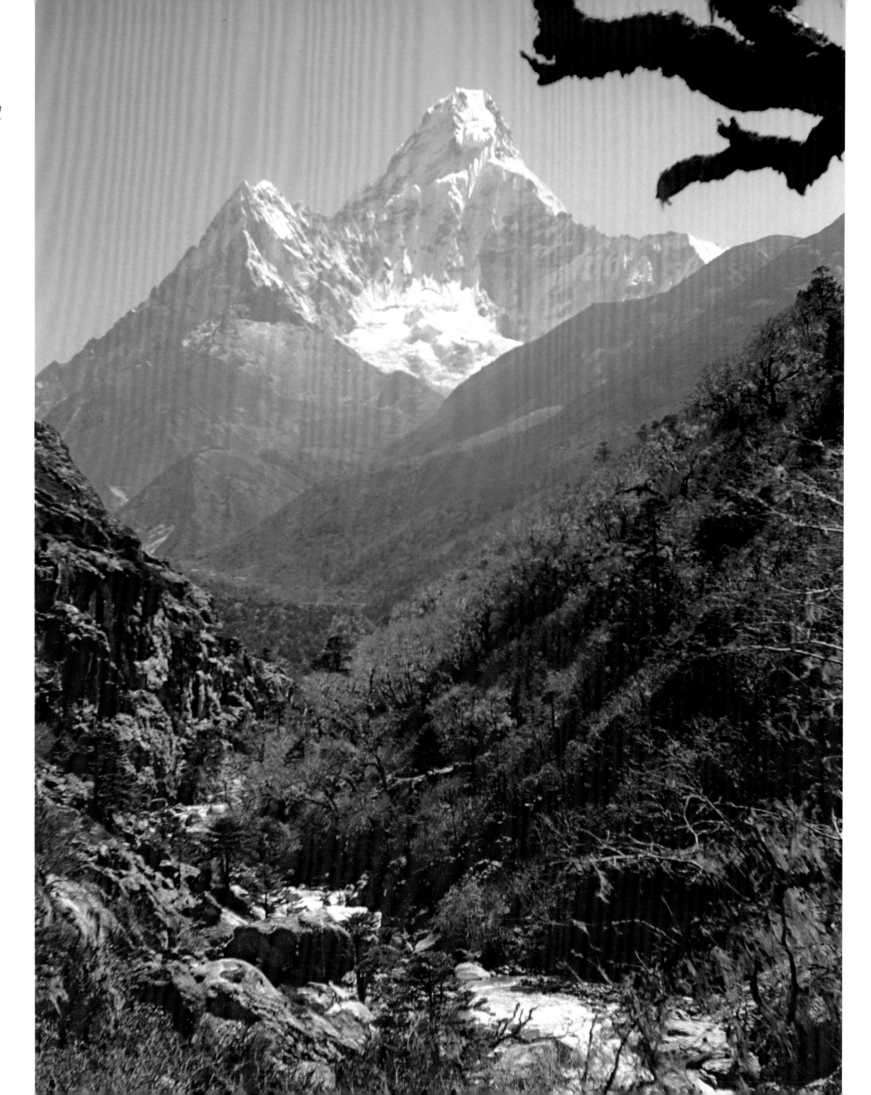

The icy tooth of Ama Dablam (right), one of the most dramatic peaks in the Khumbu region, seen from the Imja river, on the approach to Base Camp. The showpiece of the Khumbu region, it is one of the icons of Sherpa culture and means something like "Mother's Charm Box." "Ama" refers to the encircling arms; "Dablam" to the ice formation, reminiscent of the double pendant containing pictures of deities worn by many Sherpa women.

PHOTO: GEORGE LOWE, 1953

and with barely functioning oxygen sets. Despite this, and hampered by the weight of oxygen apparatus that was giving them hardly any breathing advantage, they pushed on toward the South Summit, higher than anyone, even Teddy Norton in 1924, had been before. At about 28,200 feet (8597 m) they had to admit defeat and descend.

André Roch, a habitually outspoken maverick, remarking later on his team's lack of cohesion, said that "we behaved like children." He also remarked drily that "the trouble with Everest is not that it is a very hard mountain: It is just a little bit too high." He and his companions of the Swiss reconnaissance team in the spring of 1952 had proved that, bar any unseen, insurmountable obstacle on the very final ridge, the new route up Everest was technically climbable. But the physiological problems posed by pushing on above 28,000 feet (8530 m) were still very daunting; and if you assumed that those problems had to be solved by taking oxygen equipment, that posed a whole new set of logistical problems.

Self-measurement form for Edmund Hillary's feet (far left), which shows him wearing two pairs of socks for boots that would be needed for the 1953 Mount Everest Expedition.

A diagram showing Edmund Hillary's measurements for shirt and trousers for the 1953 Mount Everest Expedition (left). Braemar Knitwear Ltd. supplied cashmere pullovers and woolen underwear, while Flint Howard Ltd. supplied windproof clothing and gloves to the team.

Route map of the 1951, 1952, and 1953 expeditions. The 1953 expedition set off from Nepal's capital, Kathmandu, and traveled east to the Solu Khumbu district. The team then headed north to the village of Namche Bazar and from there to the Khumbu Glacier, where Mount Everest lies on the Tibetan-Nepal border.

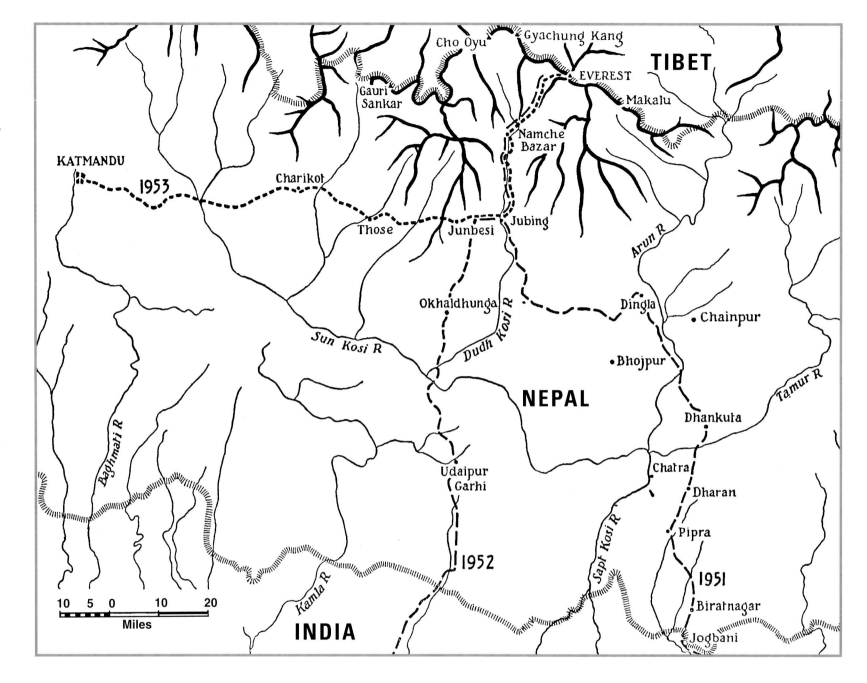

1953—"I AM GRATEFUL"

While the Swiss licked their wounds and prepared for a second, post-monsoon attempt in 1952, the British watched anxiously and continued with their own preparations for 1953. Inside the smoke-filled committee rooms of the Royal Geographical Society, behind closed doors, men in gray suits plotted and counterplotted in the customary manner of the Everest Committee. Alarmed by Eric Shipton's apparently nonchalant approach to expeditioning, disappointed by his dithering over Cho Oyu, and concerned that he was not applying himself seriously to the all-out oxygen-assisted assault on Everest, they decided to look for a new leader. The name of

John Hunt, the man who had been turned down from the 1936 expedition, came up. He was a professional soldier with a fine war record, and a good all-round mountaineer with several Himalayan expeditions to his credit. Hunt also was a determined, efficient, hard worker. The committee invited him over from Germany, where he was serving with the British army of occupation, and asked whether he would like to lead the 1953 Everest Expedition, with Shipton as climbing leader. For both men it was an embarrassing, impossible situation. Shipton made it clear that he could not countenance any kind of coleadership and, realizing that the committee was really asking him to fall on his sword, he resigned the leadership.

As one of the climbers and organizing secretary, Charles Wylie, put it many years later, "Shipton was simply Mr. Everest—he was The Man." It must have been a bitter disappointment to the doyen of Himalayan exploration, who had devoted several of the best years of his life to the mountain. It was one of the saddest moments in the Everest saga, but also one of the most uplifting. Shipton, with great dignity and graciousness, persuaded his team to give their loyalty to the new leader. Hunt, in turn, faced with an initially hostile team threatening to resign en masse, won them over with his charm, his deeply held beliefs about the value of companionship, and his obvious powers of organization.

The team bequeathed by Shipton had all been on the 1952 expedition. Michael Ward and Griffith Pugh were the expedition scientists and physicians; Tom Bourdillon was also working on the oxygen equipment; Charles Wylie, an officer in a Gurkha regiment, was transport and organizing secretary; Charles Evans, a brain surgeon, became Hunt's deputy leader; Alfred Gregory was the official photographer. At Shipton's insistence, Hunt also kept on the two New Zealanders, George Lowe and Edmund Hillary, both of whom were formidable performers at altitude. Determined to have a large enough team to allow for the attrition of altitude and weather, Hunt set about recruiting additional climbers. Wilfred Noyce, like Mallory before him a teacher at Charterhouse school, was a gifted climber, writer, and poet who had run an RAF mountain training school in the Himalayas during the war. Michael Westmacott, a statistician recently graduated from Oxford, was walking down from his last alpine climb of a very successful 1952 season when he and a friend started to talk about the forthcoming expedition. Westmacott applied, was interviewed by Hunt, and gained a place on the team. The youngest new member, George Band, was still an undergraduate at Cambridge. Mindful that this was probably Britain's last chance to be first in achieving the coveted "Third Pole," the expedition was to be immortalized in both print and film, with Tom Stobart as film director and James Morris as special correspondent for *The Times*.

Hunt knew that for the kind of logistical build-up he envisaged, a strong, loyal team of Sherpas was essential. He invited Tenzing Norgay to act both as sirdar of the Sherpas

and a lead member of the climbing team. But first he had to wait and see whether or not Tenzing would invalidate all his carefully laid plans by reaching the summit with the Swiss in the autumn of 1952.

The second Swiss attempt was again a fine effort—the first ever to get high on the mountain in the bitterly cold, windy conditions of the post-monsoon season. Morale received a setback when an ice avalanche killed Mingma Dorje, Everest's first victim since Maurice Wilson had died his lonely death in 1934. The accident happened on the steep approach to the Geneva Spur and prompted the leader, Gabriel Chevalley, to switch to the less direct but easier-angled line Roch had

Climbing members of the 1953 Mount Everest Expedition. Back row (left to right): Stobart, Pugh, Noyce, and Evans. Middle row (left to right): Band, Ward, Hillary, Bourdillon, and Westmacott. Front row (left to right): Gregory, Lowe, Hunt, Tenzing, and Wylie.

PHOTO: ALFRED GREGORY, 1953

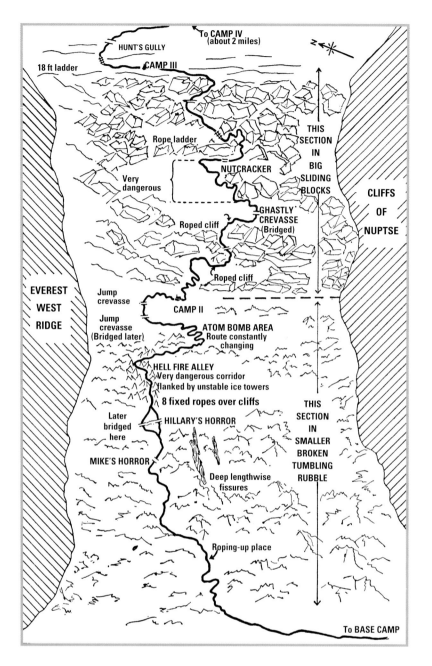

suggested in the spring, up the undulating hanging-glacier slope of the Lhotse Face to the right, which would become the standard route for all future expeditions. Once again, Lambert and Tenzing reached the South Col. They even tried to push on up the Southeast Ridge, but it was now November 19. The winter jetstream winds were already blasting the mountain and the summit was out of the question. The prize was still there for the British to take if they could.

The 1953 Everest Expedition was John Hunt's defining moment, catapulting him from a successful but comparatively obscure military career into a new life as a world-famous public figure. For him, the most important message of Everest was the triumph of teamwork. Later, of course, the revisionists

would rummage beneath the glossy surface of official accounts to pick over unedifying scraps of discord. Even Sir Edmund Hillary himself, in his most recent autobiography, felt free to recall the niggling irritations of expedition life, whether it was Pugh fussing over scientific experiments or Ward losing his temper. Niggles apart, however, it seems to have been an unusually happy and harmonious expedition. In any case, it is reassuring to know that Hunt was leading a team of normal human beings, not dull saints. How reassuring, also, to know that, for all the brilliant organization and scientific preparation, in the end, during those final days in the last week of May 1953, the team played out a tense, nail-biting drama where success was never a foregone conclusion.

As with all the prewar Everest expeditions, Oxbridge and the Home Counties provided most members and, apart from Alf Gregory, the north of England was not really represented. In terms of pure mountaineering experience, the team was not necessarily the cream of British talent. On the other hand, common background probably helped cement the team together and the sheer strength and energy of the New Zealanders compensated for any lack of experience among the British. Right from the start, John Hunt impressed everyone with his warmth and determination—and his sound organization, building on the lessons of the past, in particular, the recommendations from the 1952 training expedition.

For the first time, a British Everest expedition arrived at the mountain fit and healthy with plenty of time to spare. By now it was possible to fly to Kathmandu, but the walking still started a short way outside the capital. It was a long, beautiful trek over a series of ridges, quite different from the windy, dusty rigors of the Tibetan plateau, heading east and then north up into the Khumbu Valley to the Sherpas' market town of Namche Bazar, then on to Thyangboche, which they reached on March 27. At this gorgeous spot beside the monastery they based themselves for three weeks, allowing plenty of time to acclimatize, trekking, exploring, and climbing several peaks, including the now famous Imjatse or Island Peak (20,252 feet/6173 m). For Mike Westmacott, for instance, this was the perfect way to acclimatize before tackling the serious business of the Khumbu Icefall, where he was in the first prospecting party on April 11, with Hillary and Band.

The icefall became very much Westmacott's patch later in the expedition as he was asked to keep the route open for the Sherpa teams carrying supplies up to the Western Cwm and beyond. It was all very different from today's expeditions, which rig a series of aluminum ladders over all the trickiest sections of the icefall. In 1953 they had just two aluminum ladders, supplemented by the occasional rope ladder and a few tree trunks. And whereas today the Sherpas run a kind of high-altitude guiding service for visiting climbers, in 1953 the sahibs were very much in charge, responsible for leading and safeguarding the Sherpa ferrying parties.

Not that the natural stamina and potential skill of the Sherpas went unrecognized. Young Nawang Gombu, for instance, just 17, was thrilled to carry all the way to the South Col and already had ambitions to go further one day (10 years later he would become the first person to summit Everest twice). His elder cousin Tenzing Norgay was clearly destined for the summit right from the start of the 1953 expedition, but was also entrusted with the difficult balancing act of being both sirdar of the Sherpas and a member of the climbing team. Hillary was later quite honest about the fact that, with an eye to the main chance, knowing that Hunt would be unlikely to select both New Zealanders for the summit, he distanced himself slightly from his old friend Lowe. Encouraged by Tenzing's skill at holding him on the rope one day, when he plunged into a crevasse in the "Atom Bomb" area of the icefall, he struck up a partnership with the man. And what a partnership it was! The Tibetan yak herder turned Sherpa role model and the New Zealand beekeeper turned Himalayan explorer. Both were brimming with ambition, energy, and confidence in their own abilities, and just hoping that, this time, they would get the vital bonus of luck.

Team members about five to six days in from Kathmandu (above, left). On the walk to Everest, the day began at 6:00 a.m. with a cup of tea, followed by a two-to-three hour march, breakfast, then several more hours of walking until early evening.

PHOTO: ALFRED GREGORY, 1953

George Lowe (above) wearing a hat of magnolia flowers.

PHOTO: UNKNOWN, 1953

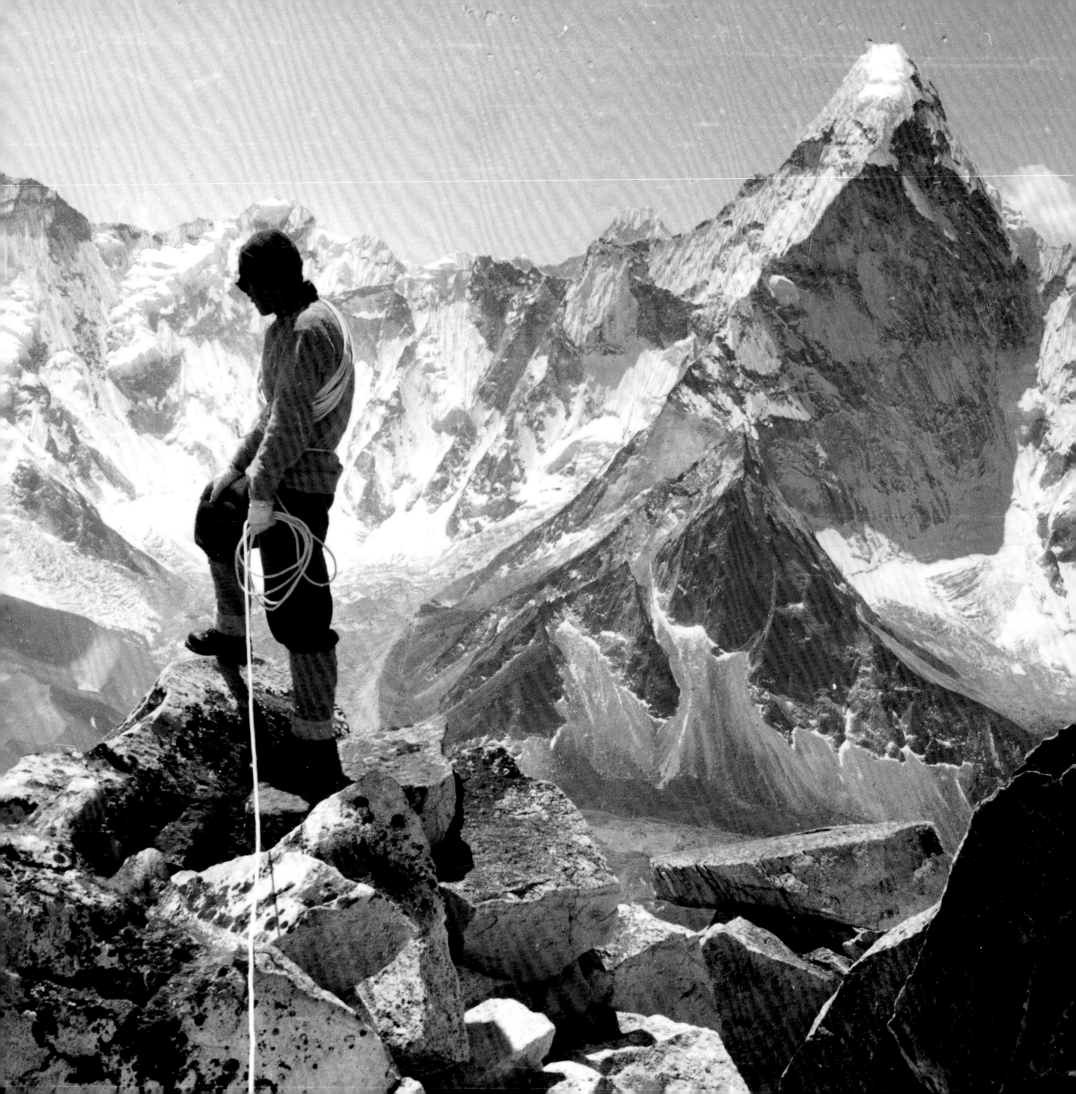

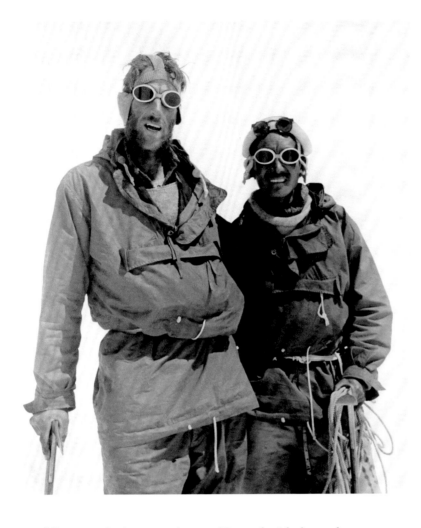

Building on Swiss experience, Hunt decided to place a camp halfway up the Lhotse Face. This section of the route, rising for over 3200 feet (1000 m) in a single sweep from the secluded calm of the Western Cwm to the wind-scoured desert of the South Col, had proved too exhausting for a single load carry in 1952. As it turned out, even with a halfway staging post, the Lhotse Face almost brought the 1953 expedition to a halt. At Advance Base in the Western Cwm, John Hunt announced his plans on May 7, by then already making it clear that Bourdillon and Evans would make the first reconnoiter, pushing the route to the South Summit, followed by Hillary and Tenzing aiming for the summit itself. First, though, it was the job of Band, Lowe, and Westmacott to prepare the route up the Lhotse Face.

As often happens, the Himalayan novices succumbed to altitude. Two years later, George Band would surge to the top to make the first ascent of Kangchenjunga, but on Everest he was frustrated by illness. Westmacott also seemed to have hit a personal altitude ceiling at about 22,000 feet (6700 m).

Even George Lowe went through a bad patch, failing to maintain the desired progress. Different sahibs and Sherpas shunted up and down the slope, trying to keep the momentum going as the days of May raced by. In the end, it was Wilfred Noyce and Sherpa Annullu who made the final breakthrough to the South Col on May 21.

Throughout this tantalizing period Hillary pushed and fretted, impatient to have the whole laborious caravan moved up to the South Col. In an interesting confession in his recent autobiography, he describes reaching his then personal altitude record of 24,000 feet (7315 m) and taking a turn in the lead: "This was the highest I had been before and I was very pleased at how strong I felt at this altitude without oxygen. On the way up with Wilf I noticed he was following faster than I was leading and the rope was trailing on the ground between us. Almost instinctively I increased my pace and made sure from then on that the rope remained tight between us. In retrospect I realise this was an unnecessarily competitive act, probably motivated by my conviction that Wilf Noyce was very fit and a potential summiter himself."

Hillary continued to fret, eventually persuading the leader that he and Tenzing should be allowed to lead the vital load carry to the South Col, even though they were supposed to be resting and waiting for their summit bid. Hunt agreed and on May 22 the two men climbed up to Camp VII, halfway up the Lhotse Face, Tenzing's presence boosting the morale of the 14 porters waiting to do the vital load carry to Camp VIII. The next day, Hillary and Tenzing, together with Charles Wylie, used oxygen and noticed the difference as they powered up the top half of the Lhotse Face. The porters were all managing without, and most of them were carrying vital bottles for use above the South Col. What was impressive (and so different from most of today's expeditions) was the way Hillary, Tenzing, and Wylie helped those Sherpa porters who were struggling—relieving three of them of their 20-lb (9-kg) full oxygen cylinders and adding them to their own loads. Fourteen porter loads were delivered safely to the South Col that day and as Hillary and Tenzing made their way back down the Lhotse Face, they met Bourdillon and Evans on their way up—both men plugged into closed-circuit oxygen sets and bound for the South Summit of Everest.

Closed or Open?

In 1953, it was the accepted wisdom that auxiliary oxygen was required to summit Everest. From George Finch's early tests in 1922, the technology had improved greatly, due in no small measure to the advances fostered by wartime research. However, the various systems available were all still experimental to some degree, and there had not been time to design and test any wholly new apparatus. Hunt wisely elected to bring both the older "open-circuit" system and the newer, arguably more efficient, "closed-circuit" variety. Both could use either lighter aluminium alloy cylinders, or the standard RAF steel cylinders. The lighter alloy tanks weighed 11.5 lb (5.25 kg), but only held 800 liters; the heavier steel tanks weighed 21 lb (9.5 kg), but held 1400 liters—almost an even trade between an increase of volume of 75% against an increase of weight of about 80%.

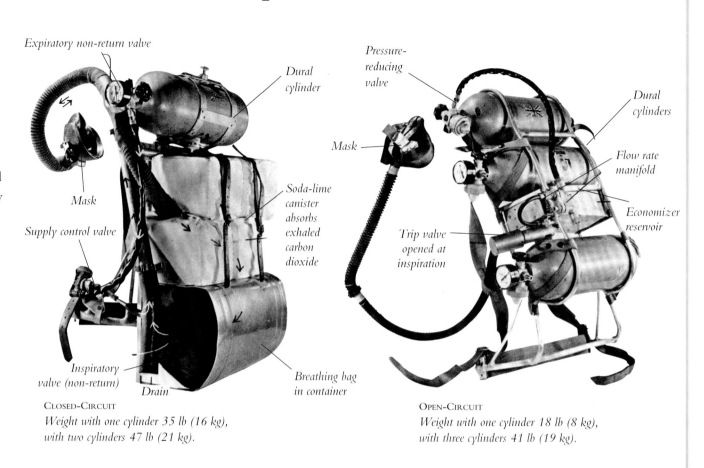

CLOSED-CIRCUIT
Weight with one cylinder 35 lb (16 kg), with two cylinders 47 lb (21 kg).

Expiratory non-return valve

Dural cylinder

Mask

Supply control valve

Soda-lime canister absorbs exhaled carbon dioxide

Inspiratory valve (non-return)

Drain

Breathing bag in container

Pressure-reducing valve

Mask

Trip valve opened at inspiration

Dural cylinders

Flow rate manifold

Economizer reservoir

OPEN-CIRCUIT
Weight with one cylinder 18 lb (8 kg), with three cylinders 41 lb (19 kg).

Before, during, and after the 1953 expedition it was repeated endlessly, like some kind of mantra to the great god Science, that oxygen equipment was the key to success on Everest—and it probably was. Yet because the oxygen was organized by a committee of strong-minded scientists, there were inevitable disagreements about what system to use. John Hunt, hedging his bets pragmatically and keeping everyone on side, decided they should take both systems with them—the "open-circuit" sets that were to become standard and the "closed-circuit" system so dear to Tom Bourdillon.

The closed-circuit system was an excellent idea, using a soda-lime canister to process exhaled carbon dioxide, converting some of it back to oxygen to be recycled back to the climber's lungs. This greatly reduced the wastage rate, allowing a given supply of oxygen to last longer and to be delivered to the climber in a much richer form. As Peter Lloyd had demonstrated on the North Face in 1938, it could enable a climber to move much faster than the open-circuit system—when it worked at all. In reality, though, it was a delicate mechanism prone to all manner of problems, with a complex system of tubes and valves that increased the chance of a malfunction. And when it did go wrong the climber was in big trouble, suddenly having to adapt from breathing almost pure oxygen to using the meager supply naturally obtainable from the atmosphere at one-third of normal air pressure.

Nevertheless, Bourdillon was sold on his system and it was agreed that he and Evans would use it on the reconnoiter to the South Summit. Hunt, Ang Tenzing, and Da Namgyal would follow part of the way in support, hoping to establish a Camp IX well above the South Col, as a kicking-off platform for the Hillary-Tenzing summit bid. Writing later in *The Ascent of Everest*, Hunt admitted that on the way up from Camp VII, he, the eldest member of the team at nearly 43, was already finding it very hard work, not helped by the frequent malfunctioning

Above Camp III at the entrance to the Western Cwm, expedition members cross a big crevasse using a light metal sectional ladder (opposite). This ladder was moved from crevasse to crevasse— exhausting work that today has been made less complicated by having many ladders and copious amounts of fixed rope.

PHOTO: ALFRED GREGORY, 1953

Edmund Hillary's picture captures all the mind-numbing bleakness of Camp VIII on the South Col, with high winds blasting the summit ridge of Lhotse 1970 feet (600 m) above. Immediately behind the camp is the snow hump which climbers have to climb back up on their return from the summit, before they can begin their descent into the Western Cwm on the right.

PHOTO: EDMUND HILLARY, 1953

of his open-circuit oxygen set (closed or open, they were all prone to hiccups). Late that afternoon, descending from the hump at the top of the Geneva Spur on to the South Col, he describes staring up at the South Summit—"no longer a 'minor eminence' as I had described it in London, but an elegant snow spire, breathtakingly close yet nearly 3000 feet above our heads"[10]—then takes the reader through the desperate reality of pitching a tent at 26,000 feet (7925 m), fingers freezing and mind numbed, as the wind blows like some malignant force determined to snatch the fabric from your hands and fling it down the Kangshung Face into Tibet. He mentions the pathetic, tattered remains of the Swiss tents— the beginnings of the world's most celebrated high-altitude rubbish tip. And he describes the laborious business of collecting ice to melt for vital drinking water.

As so often happens, the best intentions to start early in the morning were defeated by the reality of events. Exhausted from their previous day's efforts, the party was not ready to set off from the Col on May 25 and Hunt decided to wait there a day. They rested and sorted themselves out. Hunt went for a walk to the eastern edge to look out toward the peaks he had climbed near Kangchenjunga 16 years earlier and to stare 8500 feet (2600 m) down the Kangshung Face to the Kama Valley. He did a little scavenging among the Swiss remains, finding a tin of tuna fish and eating it "not without a certain feeling of shame that I was unsocial enough to conceal this tit-bit from my companions."

At 7:00 the next morning they finally got away, Hunt and Da Namgyal starting ahead while Bourdillon and Evans attended to last-minute oxygen problems. Ang Tenzing, known as Balu, was not feeling well, so Hunt and Da Namgyal were carrying heavier loads than planned. They hoped to leave the supplies for Camp IX right up at the snow shoulder known now as the Balcony, approaching 28,000 feet (8530 m). Nowadays most parties approach this by a broad snow tongue leading straight up the center of the face above the Col. The 1953 team took the steeper, shorter "Lambert Couloir" further right, which breaks out on to the Southeast Ridge well below the Balcony. Right from the start, Hunt was struggling and only later discovered that his oxygen supply tube had been partially blocked with ice. Da Namgyal was also struggling, and Bourdillon and Evans soon raced past with their closed-circuit sets. Later that morning, struggling on a short way beyond the remains of the tent left by Tenzing and Lambert a year earlier, Hunt and Da Namgyal had to admit defeat, dumping their loads at about 27,350 feet (8340 m) before returning to the Col to find the second assault arriving.

Bourdillon's faith in his apparatus, working properly at last, was vindicated that day. He and Evans moved quickly up the Southeast Ridge, passing the highpoint of 1952 somewhere near the Balcony and going on higher than human beings on earth had ever been before. From the Balcony the ridge rises gently for a while before steepening in a final surge to the South Summit. Here, anxious about the dangerous avalanche-prone windslab on the Kangshung side of the ridge, Evans and Bourdillon moved left, off the snow and on to a crest of pale,

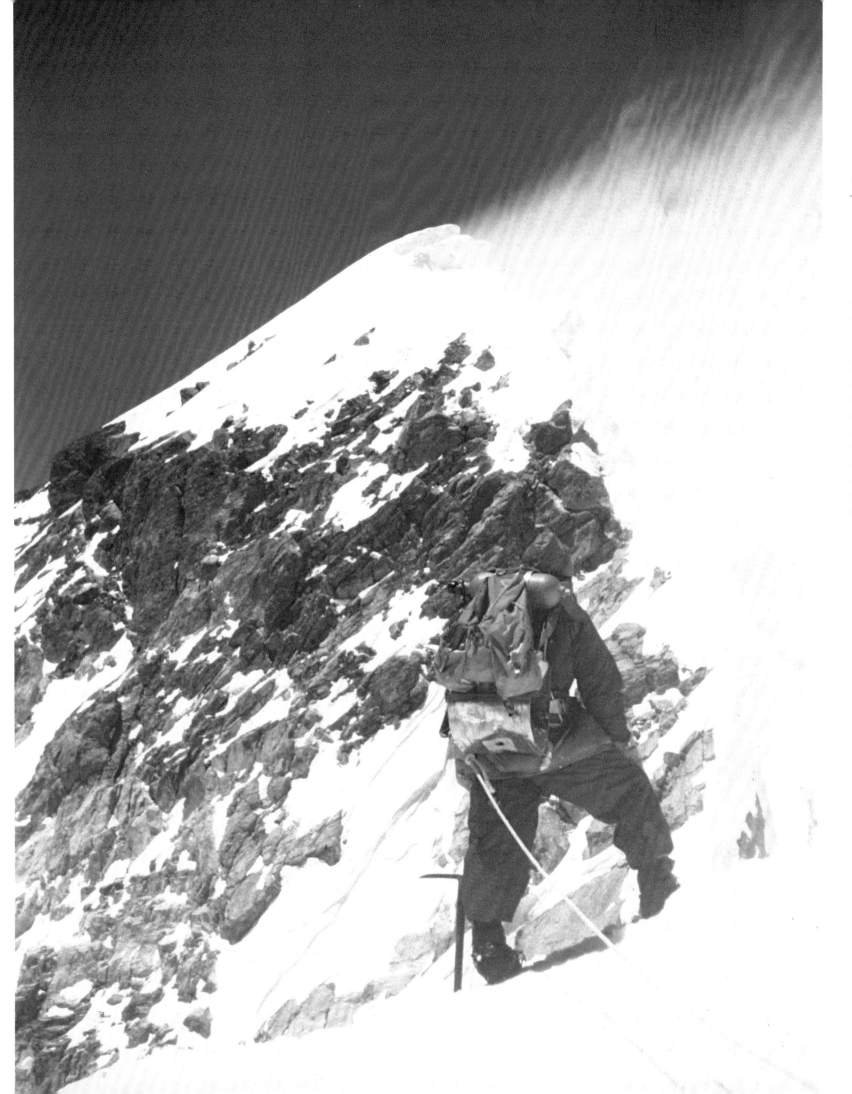

From the South Summit, Tom Bourdillon and Charles Evans were the first people ever to see the final dramatic arête of the Southeast Ridge. Here, Bourdillon gazes across at this final, tantalizing sting-in-the-tail, torn between ambition to go further and fear of getting overstretched late in the day by the obvious difficulties leading to a still invisible summit. After some debate, caution prevailed, and the two men headed back to the South Col, leaving the final honors for Hillary and Tenzing.

PHOTO: CHARLES EVANS, 1953

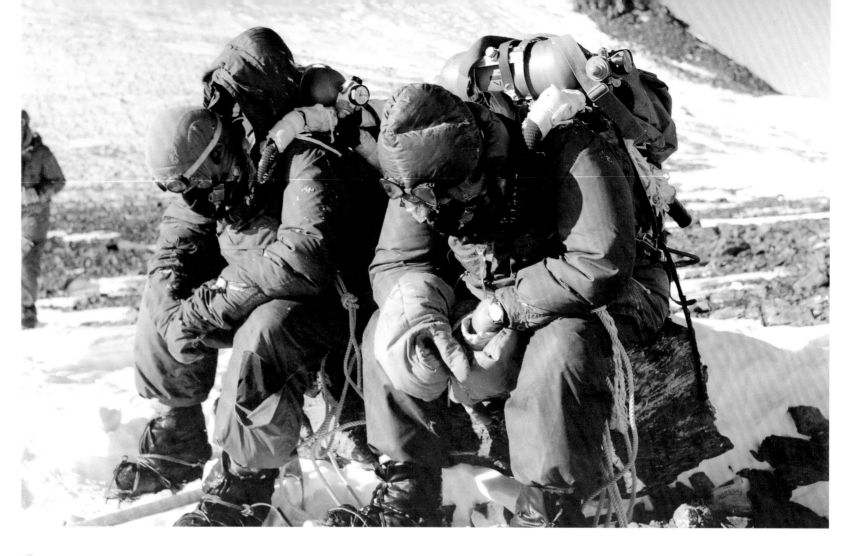

Charles Evans
and Tom Bourdillon,
exhausted and weighed
down by their
cumbersome closed-
circuit oxygen sets,
return to the South
Col after their record-
breaking climb to
the South Summit.
At 28,703 feet
(8751 m) it was
higher than anyone
had ever been before.

PHOTO: ALFRED
GREGORY, MAY 26,
1953

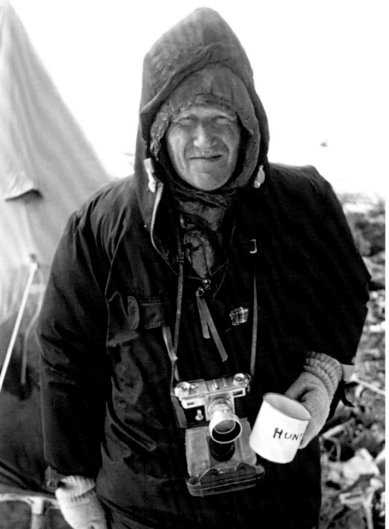

Portrait of a tired-
looking John Hunt at
the South Col after
descending from the
Southeast Ridge, with
his camera around his
neck and a mug of tea.

PHOTO: EDMUND
HILLARY, 1953

shattered rock. At least here the strata, which dip down on the North Face, were tilted upward, offering reassuringly positive holds. But it was still quite delicate terrain for a climber bulked out in down clothing with huge unwieldy boots on his feet and oxygen paraphernalia cluttering the view immediately in front of his chest.

There was a final steepening snow face merging into a sharp crest and at 1:00 p.m. they arrived at the South Summit of Everest. In just five-and-a-half hours they had ascended nearly 3000 feet (915 m) and they now stood at 28,703 feet (8751 m). Opinions still differ over exactly what their role was to be. Were they purely a reconnaissance party or were they intended to try for the summit itself? Whatever the precise intentions, there is no doubt that the younger man, Bourdillon, looking across the gap from the South Summit, was tempted desperately to continue. The summit was only just over 300 feet (90 m) higher, still hidden by a prominent step in the ridge, but he knew it was not far beyond the point he could see. There were still six hours of daylight and it ought just to be possible to make it to the top and most of the way back down to the South Col before darkness fell.

Evans was more circumspect. He calculated that it could take three hours to reach the top and another two just to get back to the South Summit, by which time their oxygen would long since have run out. We know now that his calculation erred on the conservative side. Nevertheless, the ridge ahead looked hard—much more exposed than anything so far, with a drop of 8000 feet (2440 m) to the left and huge cornices overhanging a drop of 10,500 feet (3200 m) to the right. And the step—the final sting in Everest's tail—looked decidedly difficult. If he had agreed to continue, they might well have reached the summit, but there is a good chance that they would not have returned alive.

Desperate to go just a little further, Bourdillon climbed down into the gap beyond the South Summit and went a short way along the knife-edge beyond, before agreeing with Evans that the only reasonable decision was to descend. As many climbers would discover in the future, it is a very long journey to make from the South Col to the summit and back in one day. Even turning back from the South Summit, Bourdillon and Evans found the descent exhausting and Bourdillon had to stop several times to tinker with his companion's problematic oxygen set. Descending the Lambert Couloir, Evans slipped and dragged Bourdillon some way before he could check the fall; and when they finally reached the tents at 4:30 p.m. both men were utterly spent.

Like all the best leaders, John Hunt had led from the front and, determined to be in the thick of the action, he planned to stay at the South Col while Hillary and Tenzing made their summit bid. Yet the photos taken by Lowe and Gregory show a man looking temporarily much older than his 43 years—graphic evidence of the ravaging effects of altitude. On the morning of May 27, as Bourdillon began to stumble and stagger on his way back to the Lhotse Face, it was obvious that someone had to help Evans escort him down. Hunt asked George Lowe to take that role and Lowe remonstrated: Hunt was burnt out—he should go down. But Hunt persisted and eventually Lowe packed up reluctantly to leave. Then, at the last moment, Hunt relented and agreed that he would descend, leaving Lowe to help with the final summit push.

That was surely Hunt's finest hour—the moment of self-realization when he admitted that he had done all he could at the South Col and that it was time to descend and wait below. As Hillary wrote later: "I have never admired John more than I did at that moment. When we were alone, grey and drawn, but with his blue eyes frostier than ever, John gripped my arm and told me of his deep belief that we had a duty to climb the mountain. Many thousands of people had pinned their hope and faith on us and we couldn't let them down. 'The most important thing is for you chaps to come back safely. Remember that,' he implored. 'But get up if you can.'"[11]

Hillary now showed the full extent of his thoroughness, spending much of the day with a spanner, checking cylinders,

A *page from John Hunt's diary written during the 1953 Mount Everest Expedition.*

MAY 27, 1953

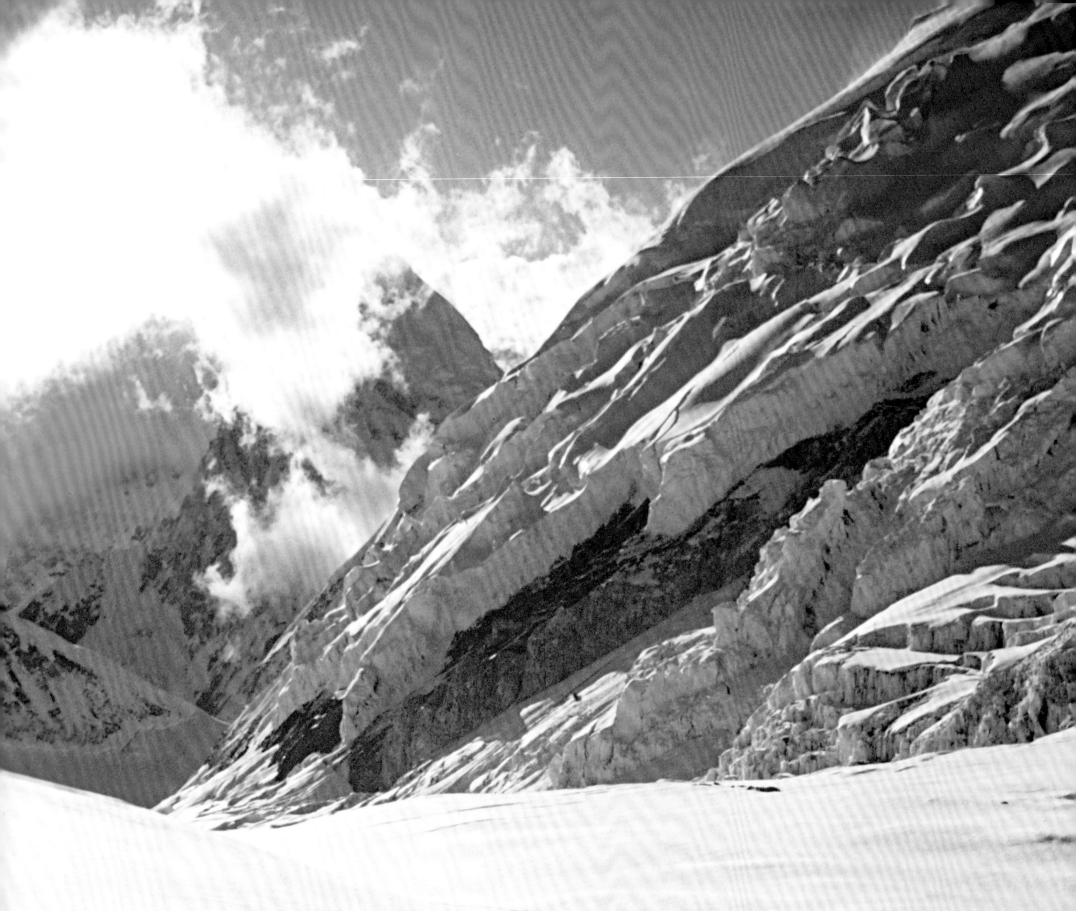

The second summit party (far left). Edmund Hillary checks Tenzing Norgay's equipment at Camp IV before the pair depart for their ascent to the summit of Everest.

PHOTO: GEORGE LOWE, 1953

The second summit party ready to move (left). Note the summit flags wrapped around Tenzing's ice-ax.

PHOTO: GEORGE BAND, 1953

calculating oxygen flow rates, leaving nothing to chance. On the morning of May 28 he set off with Tenzing, Lowe, Gregory, and Ang Nyima. Once again, they were short-staffed, with just one Sherpa porter instead of the planned three. Added to that, Hunt had not been able to place the Camp IX cache as high as planned, two days earlier. By the time they had collected the equipment left by Hunt and Da Namgyal, including the 14.5-lb (6.5-kg) Meade tent, and shared out the whole payload on top of their personal oxygen sets, each man was carrying over 50 lb (22.5 kg) and Hillary was carrying 60 lb (27 kg)—above 27,000 feet (8230 m)!

At about 27,900 feet (8504 m) the five men stopped. Both Gregory and Lowe had been recording the day's events on Kodachrome still film. Lowe was also shooting movie footage on a miniature 8-mm cine camera. After the brief hiatus on the Lhotse Face earlier in the expedition, he had come into his own that afternoon, working selflessly to place

the highest camp in history and thus give his old friend the best possible chance he possibly could of reaching the top of the world. He had to get back to the South Col with the other two members of the support team and they quickly said goodbye, leaving Hillary and Tenzing to make themselves as comfortable as they could.

High-altitude climbing is as much about domestic organization as it is about climbing ability. And this is where Hillary and Tenzing excelled. They still had energy to spare to cut out a ledge for their tent, surprised to discover that they could do this at 27,900 feet (8504 m) without their oxygen switched on. The platform they produced was a precarious two-tier job, with Tenzing curled up on the lower ledge and Hillary half-sitting, half-lying back against the slope of the mountain, on the upper ledge. What was so impressive was his ability, still, to be doing his mental arithmetic, working out precise oxygen rations for the night to help them rest and sleep

Two figures (opposite), dwarfed by the grandeur of the Western Cwm, make their way up in the late afternoon from the steep, narrow funnel of the Khumbu Icefall.

PHOTO: UNKNOWN, 1953

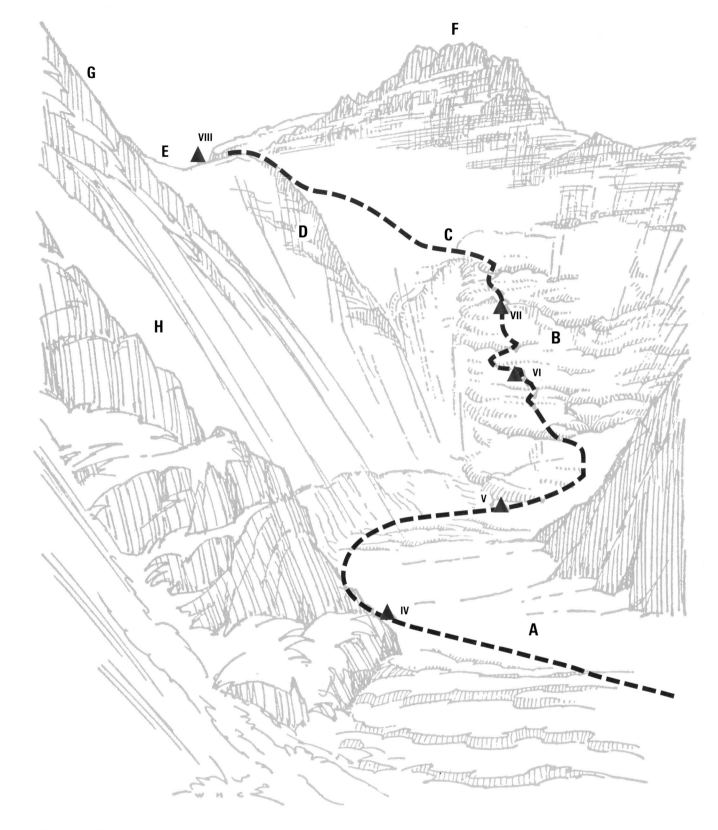

The Lhotse Face

a little, while leaving enough for the morning. He even built into his calculations the half-used bottles that Evans had left near the South Summit.

Prewar expedition accounts had been full of the horrors of high-altitude cooking. Norton, for instance, wrote that "I know nothing which is so utterly exhausting or which calls for more determination than this hateful duty of high-altitude cooking. Perhaps the most hateful part of the whole process is that some of the resultant mess must be eaten."[12]

Thirty years on, Hillary managed to get his paraffin primus stove functioning perfectly, even at this extreme altitude, melting enough snow to give both of them copious drinks of soup and lemonade, accompanied by biscuits, sardines, jam, honey, dates, and tinned apricots. The temperature dropped to −16° F (−27° C) but both men were ensconced warmly in down suits, inside their down sleeping bags, with a limited amount of oxygen to help boost body temperature. Several times they had to brace themselves to hold the tent against

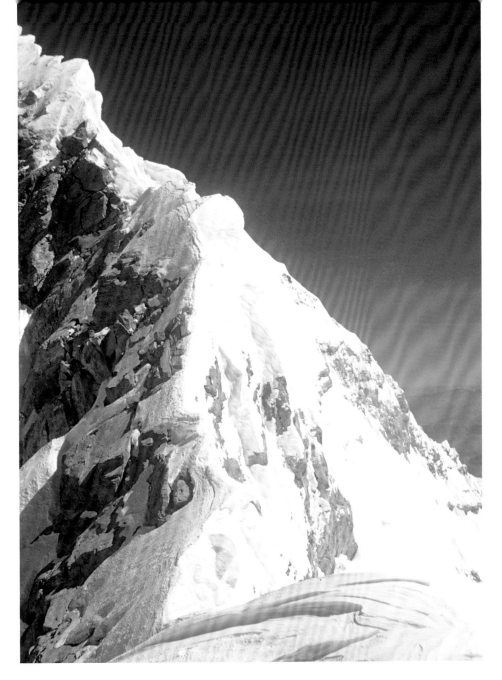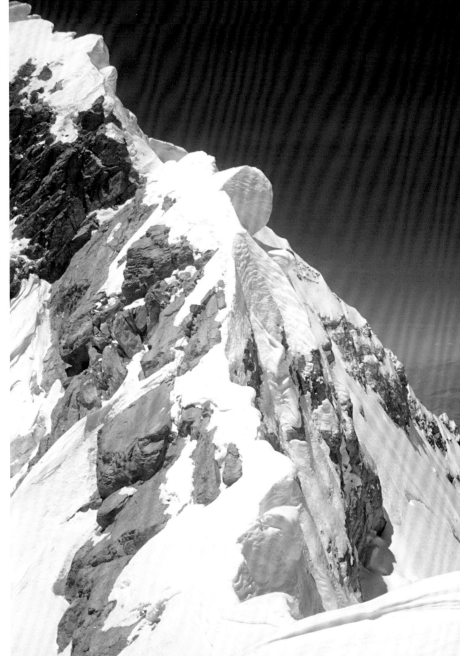

gusts of wind, but at 4:00 a.m. when they relit the primus for breakfast they looked out on a perfect still dawn. As Tenzing related later to his biographer James Ramsey Ullman, "God is good to us, I thought. Chomolungma is good to us."[13] He pointed out to Hillary Thyangboche monastery, a tiny rectangle in the blue valley mist, 16,000 feet (4880 m) below.

Tenzing was acutely aware at this defining moment of all the people who were with him in spirit. Beneath his official cobalt blue British expedition anorak he wore a sweater knitted by Mrs. Henderson of the Himalayan Club in Darjeeling, socks knitted by his mother, a woolen helmet given to him by Earl Denman, and "most important of all, the red scarf around my neck was Raymond Lambert's." His boots also—reindeer skin encased in neatly laced fabric overboots—were Swiss and he had kept them on all night. Hillary had the

warm but unwieldy standard-issue British boots, which looked like giant rubberized galoshes. He had taken them off overnight and they were frozen, so an hour was wasted kneading them over the primus stove before he could get them on.

At 6:30 a.m. they clambered out of their tent. "Okay?" Hillary asked Tenzing.

"Acha—yes, ready."

They were soon following the ridge crest. Out to the east, Nyonni Ri, Ama Drime, and the distant great mass of Kangchenjunga were blue silhouettes against the blazing sunshine. Beneath their feet the snow was glittering, whipped into frozen windshapes. As the face steepened near the South Summit they took off their oxygen masks to discuss the unnerving, slabby conditions, but decided to carry on anyway, taking turns to cut steps with their heavy, long-shafted axes.

The view from the South Summit (above, left), showing the summit ridge with the Hillary Step near the top. Only four men had seen the ridge and none had set foot on it.

PHOTO: EDMUND HILLARY, MAY 29, 1953

Taken at 12:45 p.m., this photo (above, right) shows the tracks left by Tenzing and Hillary as they returned from the summit.

PHOTO: EDMUND HILLARY, MAY 29, 1953

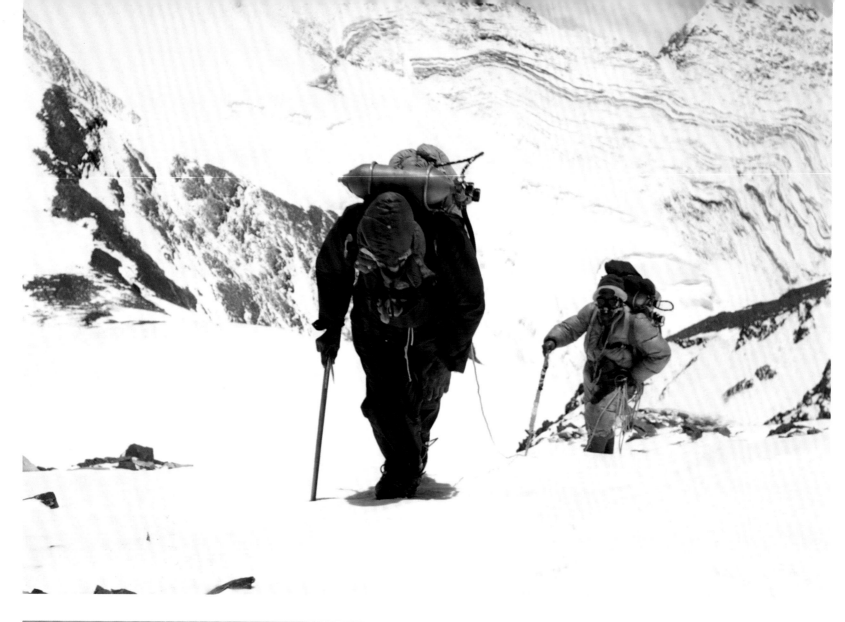

Edmund Hillary and Tenzing Norgay (right) in the couloir leading from the South Col onto the Southeast Ridge, on the great day when they climbed to a higher camp than had ever before been established. In addition to their heavy and cumbersome oxygen sets, they carried equipment for Camp IX. Behind them can be seen the characteristic swirling strata on the Lhotse-Nuptse wall— part of the same ancient geological formation as Everest's Yellow Band.

PHOTO: ALFRED GREGORY, MAY 28, 1953

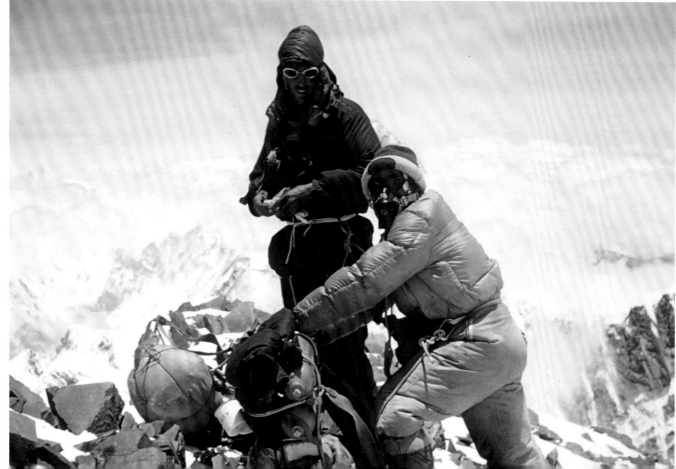

Hillary and Tenzing (right) pause at the dump left two days earlier by Hunt and Da Namgyal, at about 27,300 feet (8323 m). From here they and their companions, Gregory, Lowe, and Ang Nyima, each had to carry additional equipment, with Hillary's load totaling 60 lbs (27 kg).

PHOTO: ALFRED GREGORY, MAY 28, 1953

Tenzing's and Hillary's view south from the summit (opposite). In the foreground is the highest visible bedrock in the world, close to dangerous cornices overhanging the gigantic Kangshung Face. Behind is the still untrodden summit of Lhotse and behind that the flat top of Chamlang, with the Hongu Valley far down on the right.

PHOTO: EDMUND HILLARY, MAY 29, 1953

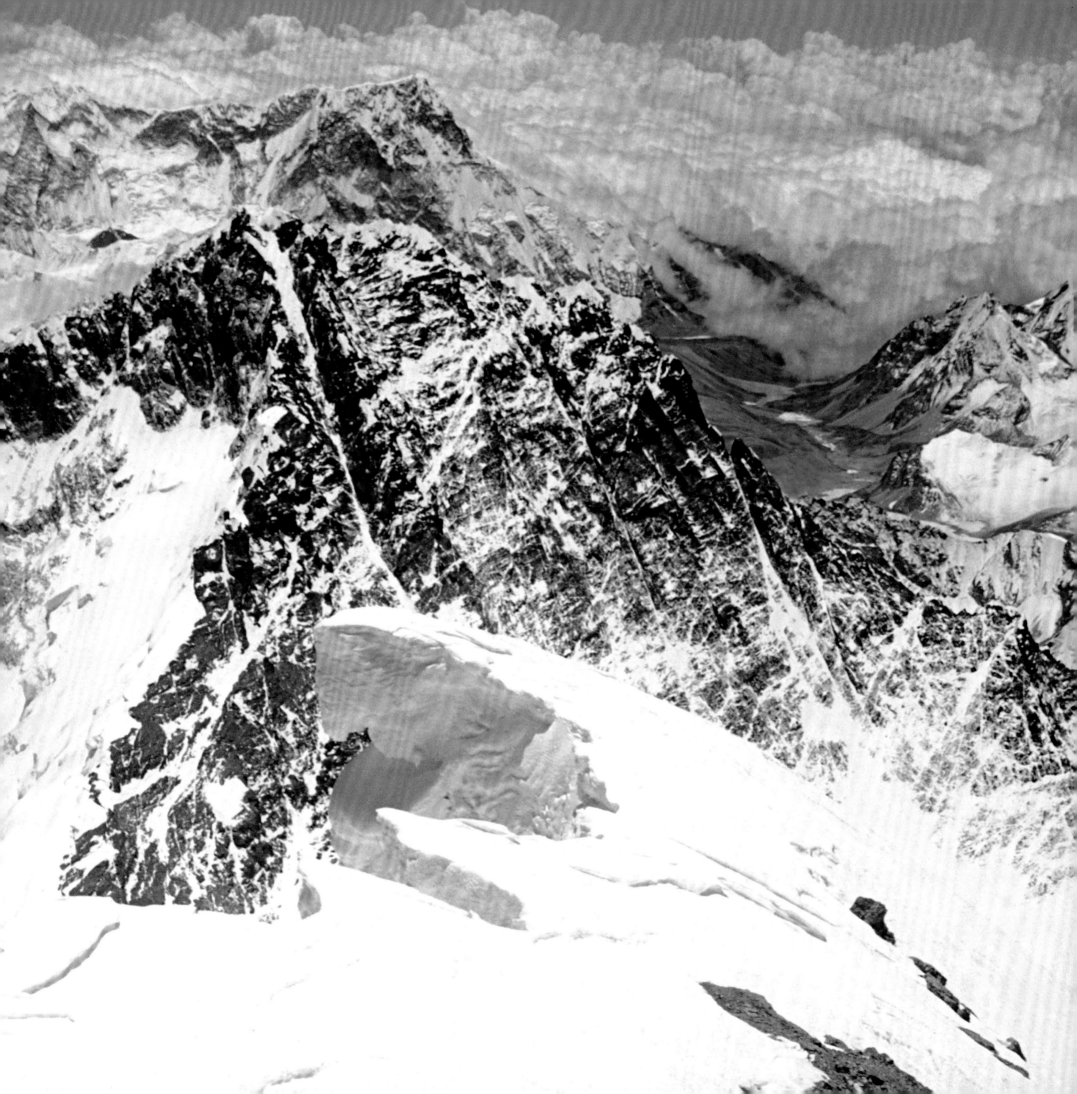

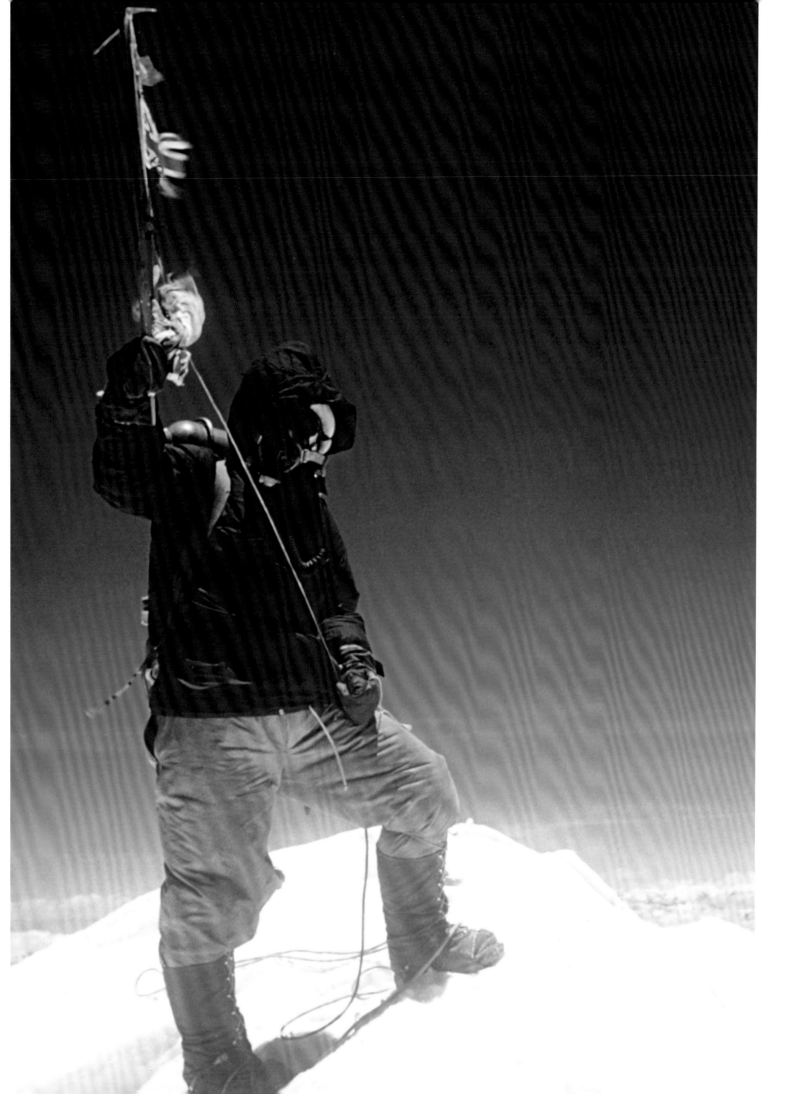

Team members return to Camp IV after the ascent. Charles Evans (far left) walks next to Edmund Hillary still roped to Tenzing Norgay. To the right are Tom Bourdillon and George Band.

PHOTO: ALFRED GREGORY, MAY 30, 1953

At 9:00 a.m. they reached Bourdillon's and Evan's high point on the South Summit. Recording the moment in the official expedition account with an expression of supreme understatement, Hillary wrote, "we looked with some interest at the virgin ridge ahead."[14]

Some interest indeed. The classic color photo shows it all—the bridge they had to cross to achieve their destiny. Slabby rocks topped with a crest of wind-whorled snow, poised above immense depths, leading for about 320 feet (100 m), almost horizontal, to the great step. Beyond the step a jagged line of huge white cornices, flung eastward against the sky, suspended treacherously over a precipice of nearly 12,000 feet (3660 m).

They descended from the South Summit onto the bridge, continuing beyond Bourdillon's agonized probe of three days

earlier. Hillary led, sticking mainly to the snow crest, cutting steps. "To my surprise I was enjoying the climb as much as I had ever enjoyed a fine ridge in my own New Zealand Alps."

After an hour they reached the cliff, which Hillary estimated to be 40 feet (12 m) high. Many years later, in 2001, an American climber would bring a measuring tape to the famous "Hillary Step" and record its height as precisely 57 feet (17.4 m). Away to the left of the crest they could see a slanting, boot-sized crack in the rock and other suggestions of climbing possibility. But at nearly 29,000 feet (8840 m), that kind of rock climbing would be virtually impossible. Right on the crest itself, defying gravity, a great plaque of wind-packed snow is plastered vertically against the east face of the bedrock. With modern, front-pointing crampon points, it is possible to kick

steps into this column of snow with the right foot and search out rugosities on the rock for the left foot.

Hillary had no front-pointing claws but there was a narrow gap between rock and snow. Wedging his right foot in the crack, facing left, with his left foot on the rocks, pushing backward to the east, he "literally cramponed backwards up the crack, with a fervent prayer that the cornice would remain attached to the rock." The cornice did remain attached, Hillary reached the top, Tenzing followed him and the two men continued up the final undulating ridge, staying well to the left of the giant cornices.

From the top of the Hillary Step it is 720 feet (220 m) horizontally to the summit of Everest. Employing the exhausted, shuffling plod of climbers nearly 9000 m above sea level, that constitutes about 400 steps. Like most summits, Everest's remains hidden until the last minute. But by this time, Hillary and Tenzing were almost convinced that nothing could stop them now.

Breathing oxygen at 3 liters a minute, they plodded on, over two or three false summits, still finding the energy and patience to cut steps for their great clodhopping boots. They passed a bare patch of shattered limestone—formed 350 million years earlier at the bottom of the Tethys Sea, now the highest visible bedrock in the world—then chopped their way up a final slight steepening in the snow, to realize, with immense relief, that they were looking over the crest of the West Ridge, to the north. And there, far below them, were the Rongbuk Glacier, Changtse, the North Col, and all those other historic landmarks of the north side that had played their earlier part in the long quest to reach the summit. They veered slightly right and "with a few more whacks of the ice-axe in the firm snow, we stood on top."

Hillary, with fitting Anglo-Saxon reserve, held out his hand; but Tenzing flung his arms around the huge man's shoulder, thumping him on the back. Then he unfurled the flags of Britain, Nepal, India, and the United Nations, which had been wrapped round his ice-ax ever since he had set off from the Western Cwm five days earlier, and held them up against the flawless blue sky. Ever professional, Hillary took no chances and clicked three frames of the photo that would become an icon of the twentieth century. And, as incontrovertible proof of

Edmund Hillary and Tenzing Norgay arrive at Camp IV after their successful ascent of Everest, desperate for a cup of tea and a rest.

PHOTO: GEORGE BAND, MAY 30, 1953

their achievement, he took a 360° panorama of shots looking down all three sides of the mountain.

They turned off their oxygen and removed their masks, to savor the crystalline silence of this wonderful moment. They did not black out and breathing was not impossible, but both men felt that actually to climb to the summit without oxygen would have been very risky, if not impossible. Hillary buried in the snow the small crucifix John Hunt had given him, while Tenzing laid down his offerings of some sweets and a blue-and-red pencil given to him by his daughter Nima, then added the flags from his ice-ax.

Inevitably, both men thought about Mallory and Irvine and looked around to see if there was any sign of their having visited this spot 29 years earlier. And of course, even if they had been there, there would have been no sign, for Everest's summit is a giant snow cornice, many meters thick, blown continually up and out to the east, to curl back on itself in a great wave, so that anything left on top is soon embedded on the eastern underside of the wave.

The rest, as they say, is history. With supreme discipline, Hillary continued to calculate oxygen rates, rationing the flow to ensure a safe descent all the way to the South Col where he shouted out to his old friend and fellow Kiwi George Lowe the bluff *après sommet* quote that was never intended for a wider audience: "We knocked the bastard off." Tenzing later related to Ramsey Ullman a more sensitive and politically correct "Tuji Chey, Chomolongma: I am grateful."

The radio would not function at the South Col, and it was only the next day that John Hunt, waiting anxiously in the Western Cwm, knew the happy outcome. The film taken of the reunion says it all: tired, but deliriously happy figures in baggy, billowing overtrousers, their bearded, suncream-caked faces cracking into huge smiles, running across the snow to fling their arms around each other. Then Mike Westmacott's heroic race down through the jumble of the Khumbu Icefall, at dusk, with the mountaineering novice James Morris, determined to get his exclusive news relayed by runners back to *The Times* in time for the Coronation of Elizabeth II three days later. The message, coded to confuse competitors, read:

"Snow conditions bad stop advanced base abandoned yesterday stop awaiting improvement" which translated as "Summit of Everest reached on May 29 by Hillary and Tenzing."

On any classic large-team expedition most of the climbers have to face the disappointment of not going to the summit themselves. No member of the 1953 team can have set out from Kathmandu without nursing a secret hope that he might be one of the lucky ones. Even John Hunt was hoping at one stage that, should the first two attempts fail, he might even have a crack at the summit himself. But what makes his enterprise so inspiring is the way in which everyone managed to suppress those personal ambitions, particularly in the aftermath of success. In the film scene in the Western Cwm, in the photos of the triumphant return at Heathrow Airport, in the men's response to the whirlwind of international acclaim that took them completely by surprise, and in the continuing reunions as they gather in now-dwindling numbers, every five years, at a small hotel in the heart of Snowdonia, you get the sense of a contented group of people proud to have been a part of that great shared endeavor.

George Band, Edmund Hillary, Charles Evans, and Michael Ward lying in a tent listening to the Coronation news "happy on rum" after their Everest success.

PHOTO: ALFRED GREGORY, JUNE 2, 1953

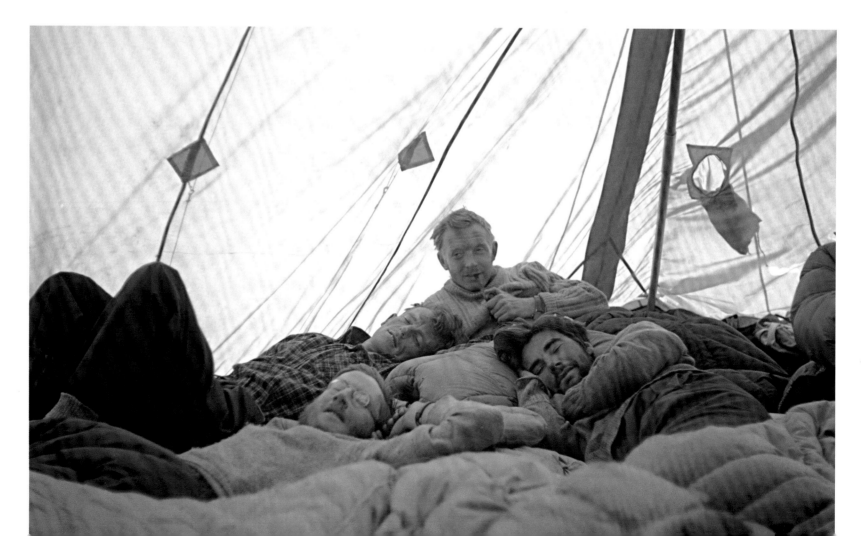

How I Broke the News

The news of the first ascent of Everest reached London on the evening of June 1, 1953. It had been sent by James Morris (now Jan Morris), correspondent for *The Times*, who accompanied the expedition into the Western Cwm, and who hastened down through the Khumbu Icefall to Base Camp as soon as he heard the news.

In the absence of long-range radio, he had sent all his previous dispatches by runner to be cabled onward from Kathmandu, but for this final, crucial dispatch he made use of an Indian Army radio transmitter that happened to be operating from the Everest region. Since international competition for the story was intense, he couched the news in a simple prearranged code, just enough to let his newspaper (and the world) know the essential facts—that Mount Everest had been climbed at last, and that Hillary and Tenzing were the first two men on the summit.

The message read as follows: SNOW CONDITIONS BAD (Everest climbed) ADVANCED BASE ABANDONED (Hillary) YESTERDAY (May 29) AWAITING IMPROVEMENT (Tenzing) ALL WELL (nobody killed or injured). It was published in *The Times* on the morning of June 2—which was, by happy conjunction, the day of the Coronation of Queen Elizabeth II.

Letter from James Morris (The Times correspondent) to The Times (top, and bottom, far left) explaining the code words for the telegram to be sent in the event of a successful ascent of Mount Everest (bottom, left).

MANUSCRIPTS: JAMES MORRIS, 1953

ALBUM: THE 1950S EXPEDITIONS

Two of the 34 altitude Sherpas (right), employed and equipped to carry essential supplies, prepare for their daily work by attaching crampons to their boots.

PHOTO: ALFRED GREGORY, 1953

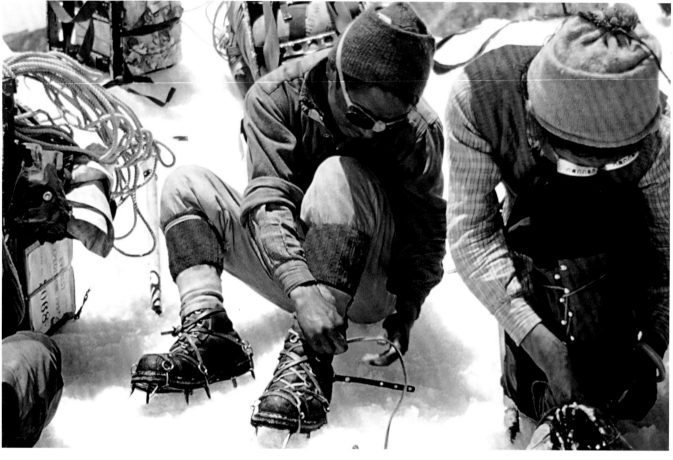

George Lowe assists Sherpas (opposite) carrying supplies through the Khumbu Icefall, with Pumori, 23,442 feet (7147 m), in the distance. From Pumori in 1951, Shipton's reconnaissance team had studied the icefall and realized that, although obviously risky, it did seem just climbable.

PHOTO: EDMUND HILLARY, 1953

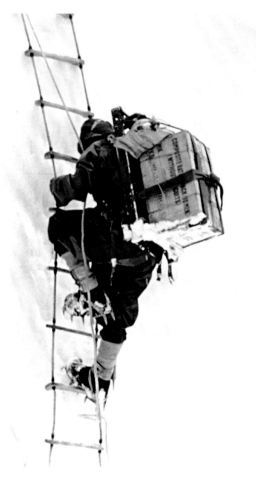

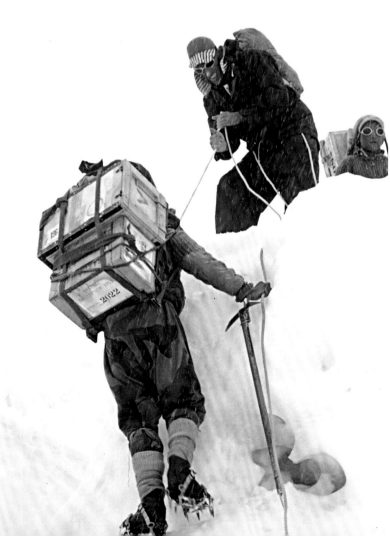

Edmund Hillary (left) assisting Sherpas with supply loads in the Khumbu Icefall. Over three tons of stores were ferried through the icefall by the porters, all of whom were properly equipped and clothed for climbing at high altitudes.

PHOTO: GEORGE LOWE, 1953

A Sherpa (far left) carrying equipment on a rope ladder in the icefall. The 30-foot (9-m) rope ladder was a potholing ladder donated by the Yorkshire Ramblers Club to the 1953 expedition to help them overcome vertical ice pitches.

PHOTO: ALFRED GREGORY, 1953

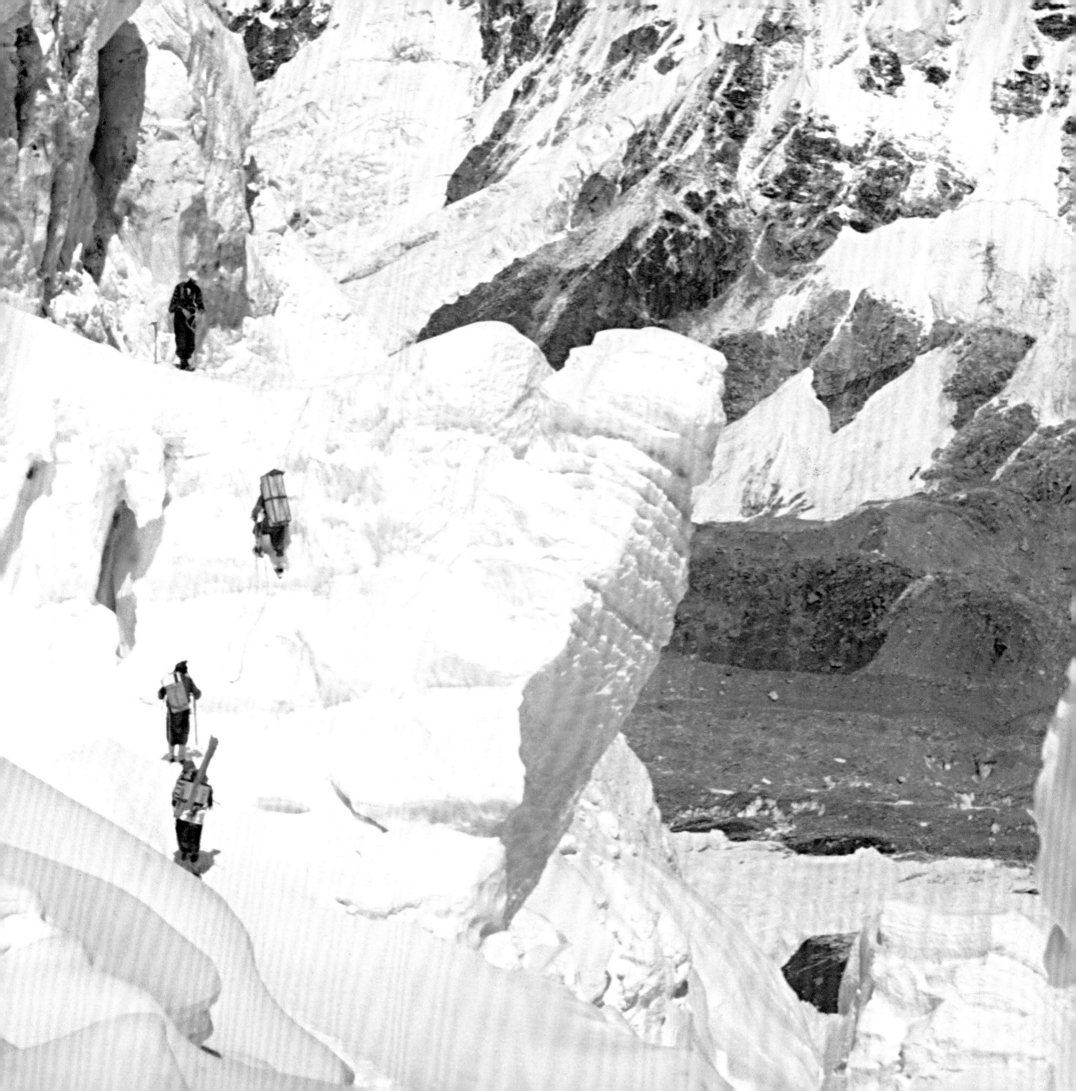

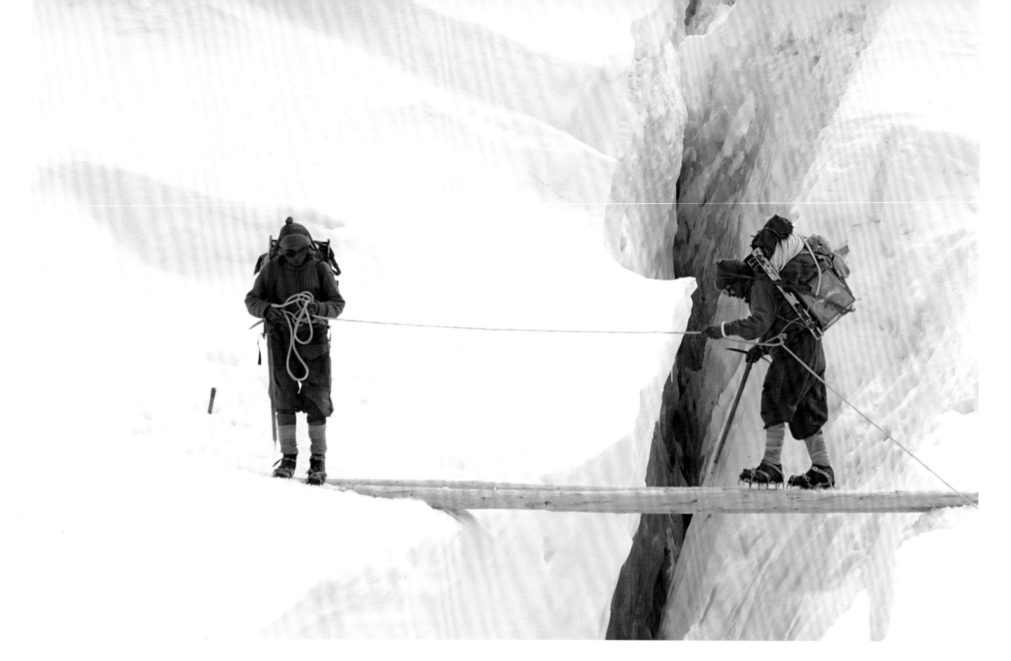

Compared to modern expeditions, with their fixed ropes and many alloy ladders, the 1953 team was modestly equipped with only one or two metal ladders to span giant crevasses in the Khumbu Icefall, the chaotic labyrinth of tottering ice towers that must be climbed to reach the Western Cwm. Here (above), a heavily laden Sherpa, safeguarded by his companion, edges gingerly across a log bridge.

PHOTO: ALFRED GREGORY, 1953

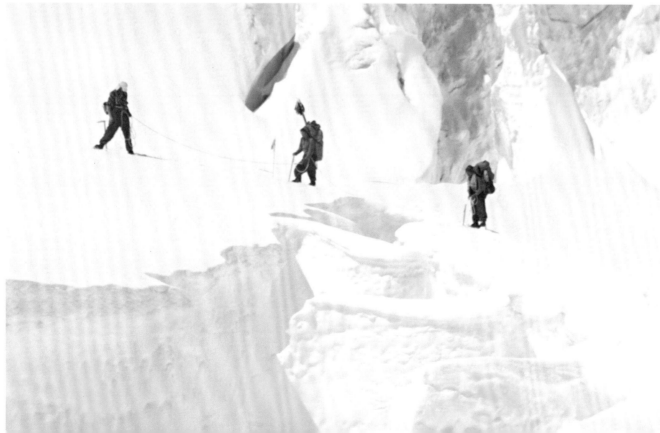

A ferry party (left) in the Western Cwm passing a crevasse on the way to Camp IV. The afternoon snowfalls tended to obliterate footprints, so marker flags were used.

PHOTO: EDMUND HILLARY, 1953

A yawning crevasse in the Western Cwm (opposite), one of many crevasses that posed constant dangers to Sherpa parties ferrying supplies to Camp IV.

PHOTO: ALFRED GREGORY, 1953

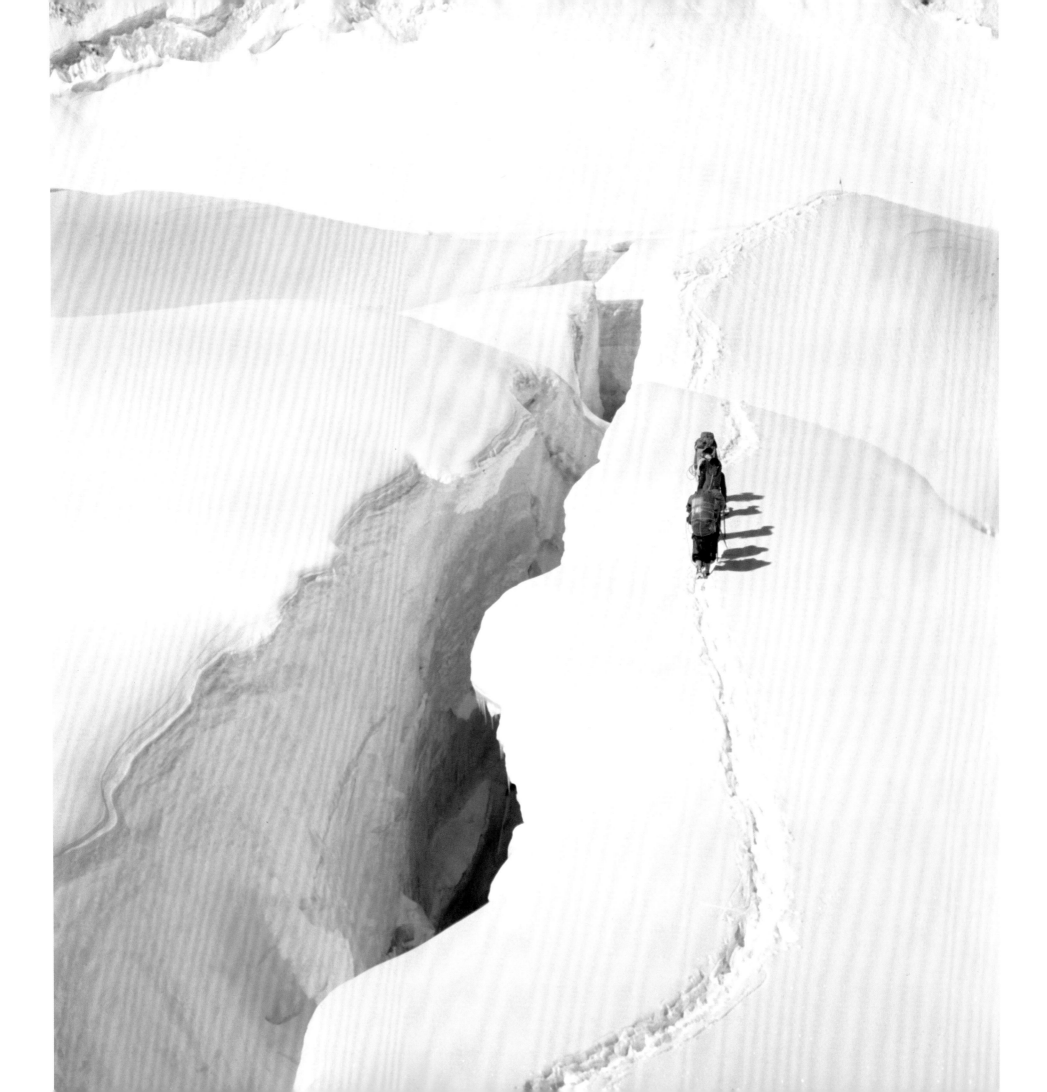

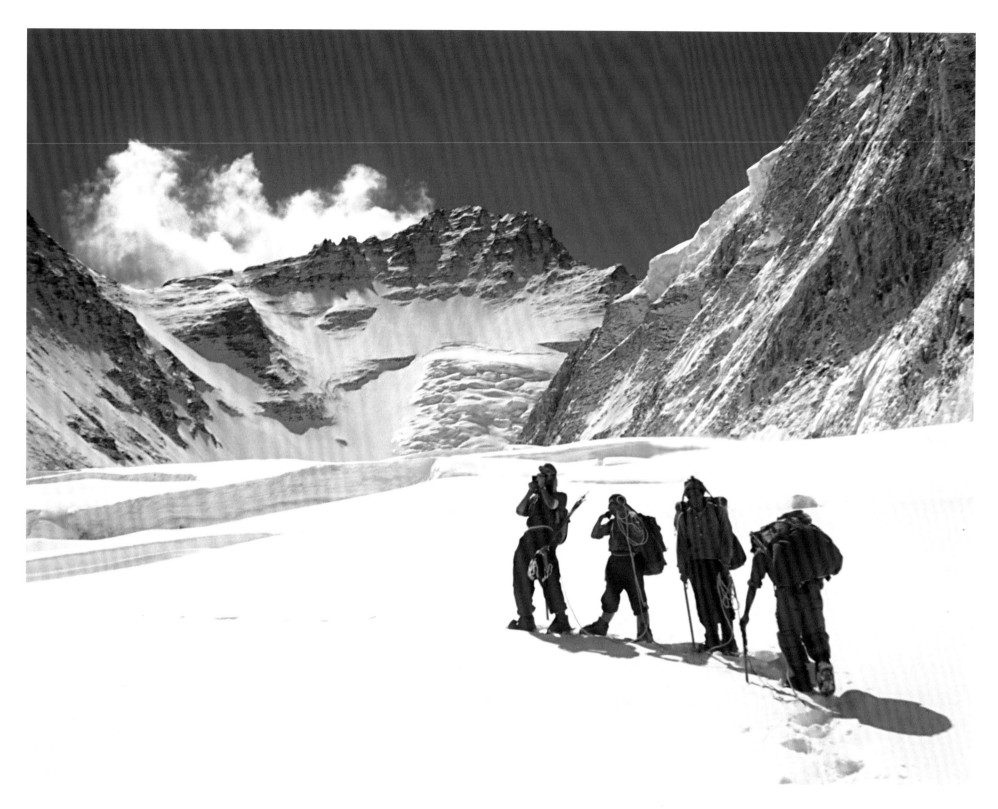

Edmund Hillary
leads three Sherpas into
the Western Cwm
(above). Behind them
stands Lhotse with
clouds forming in the
electric blue sky.

PHOTO: GEORGE LOWE,
1953

Edmund Hillary
leads a group
(opposite) into the
Western Cwm with
Lingtren behind them.

PHOTO: GEORGE LOWE,
1953

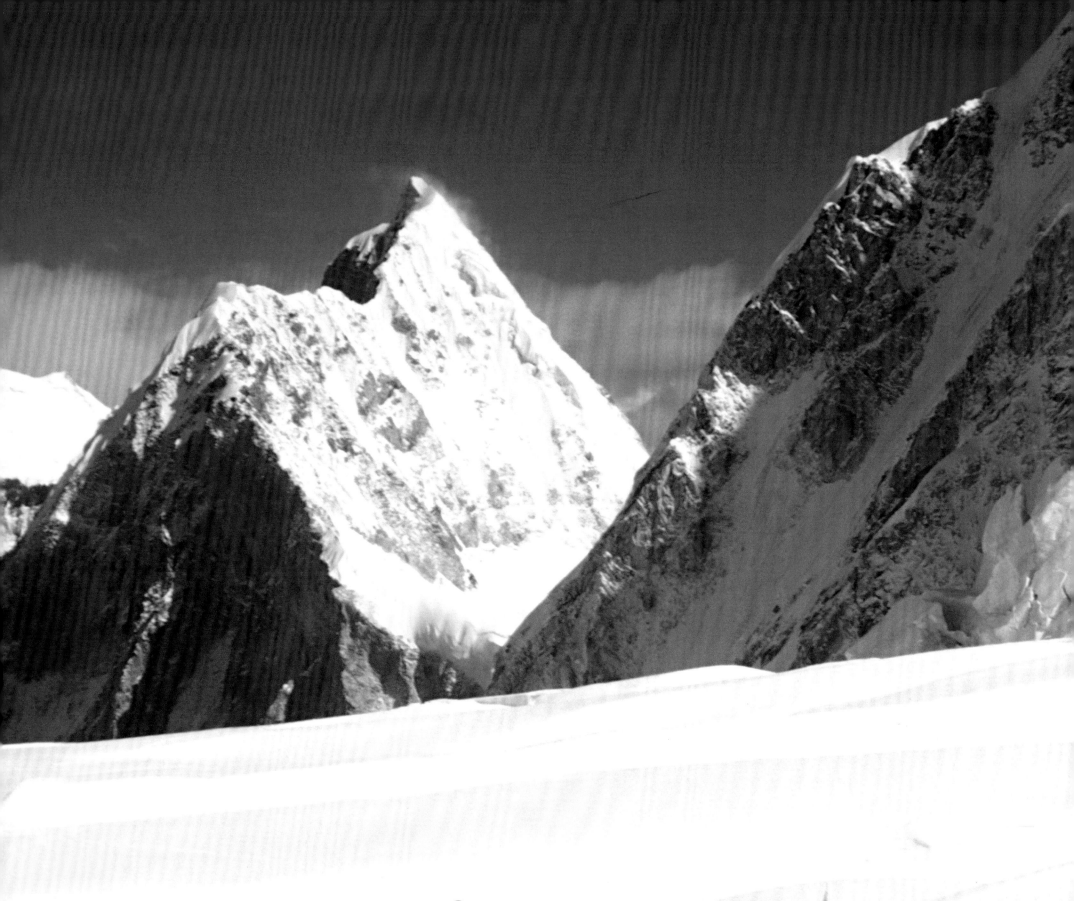

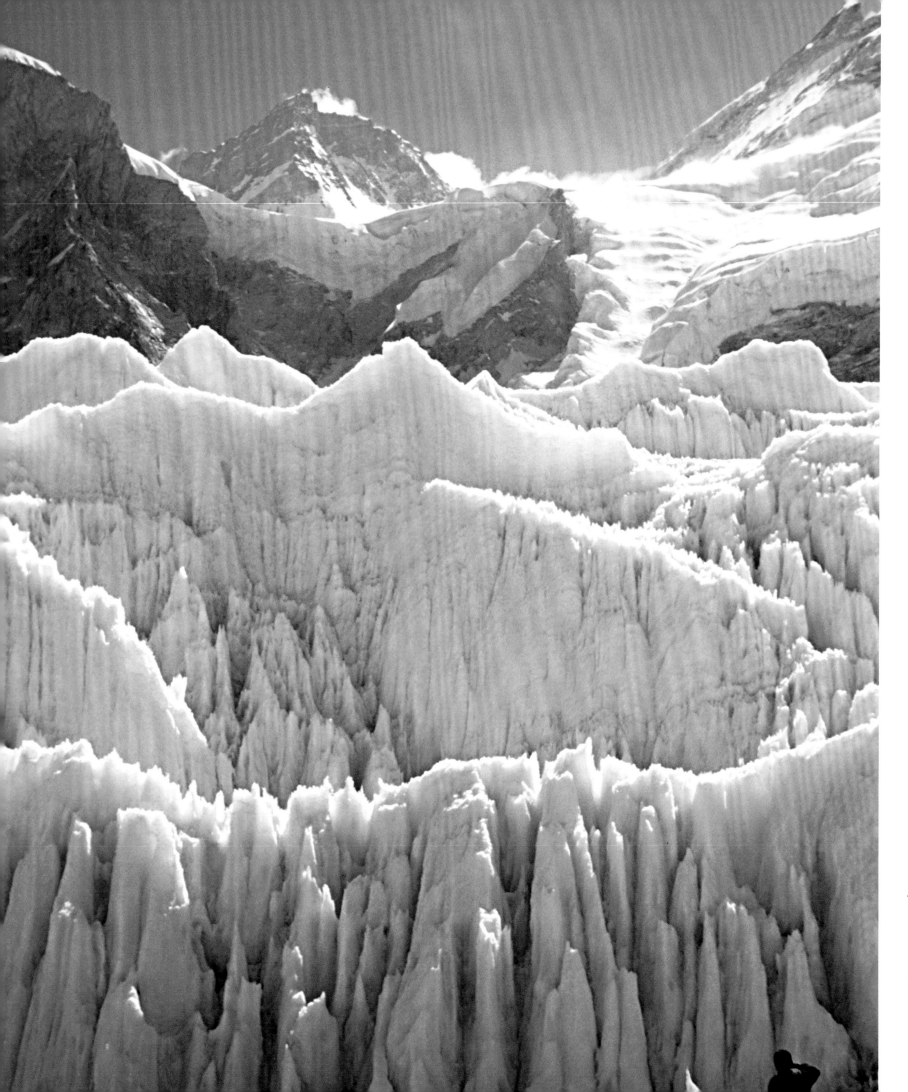

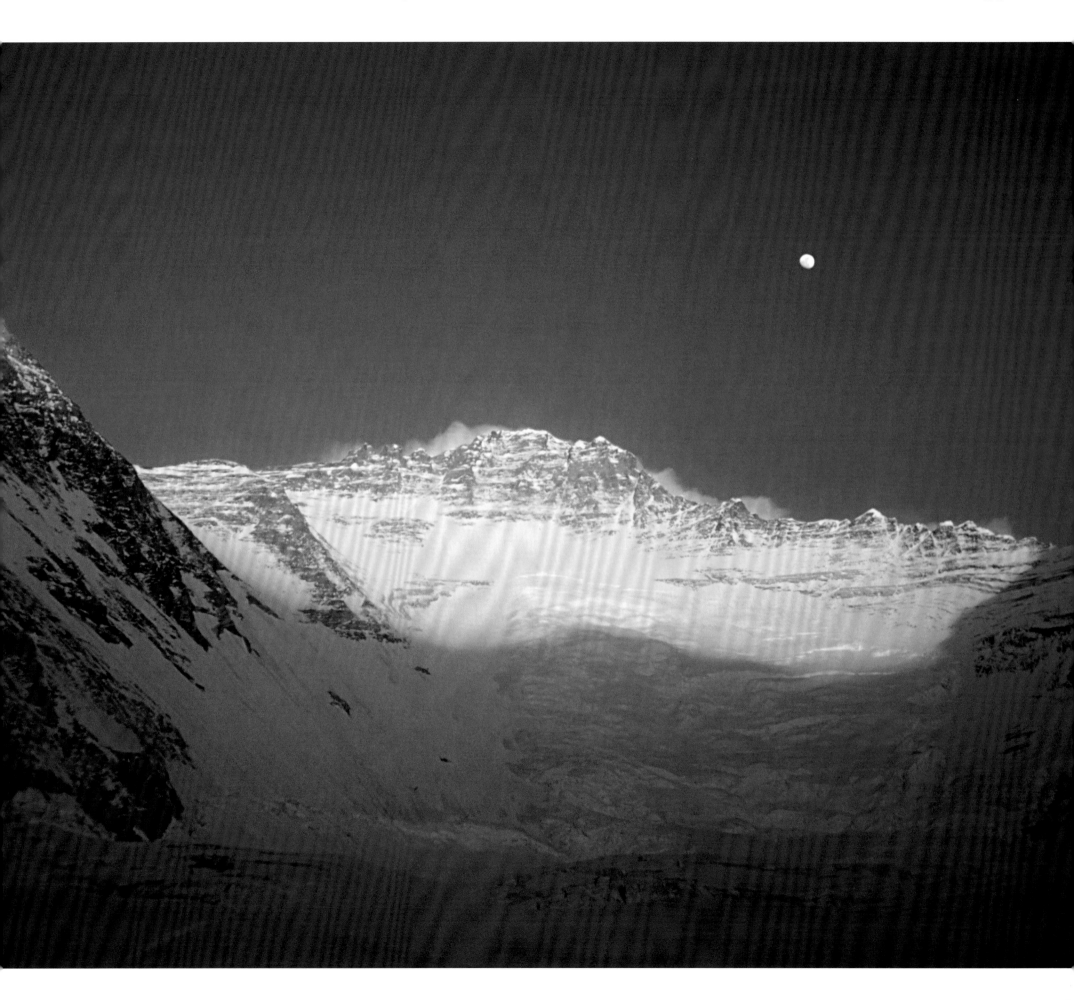

Sherpani (top, left) with improvised goggles or sunglasses that protected the eyes from the constant glare of the sun at Lake Camp.

PHOTO: ALFRED GREGORY, 1953

Sherpa child (left) at Lake Camp with improvised goggles made of hair.

PHOTO: ALFRED GREGORY, 1953

During a rest stop, a Sherpani combs and greases her Sherpa boyfriend's hair (above).

PHOTO: GEORGE LOWE, 1953

A Buddhist monk (left) wearing a yak headdress and holding a ritual hand drum and bone drumstick.

PHOTO: ALFRED GREGORY, 1953

A Sherpa porter (below) tending a cooking fire. Hot food and drink are vital to sustaining any expedition. In 1953, cooks, such as Dawa Thondup, were loved by team members for the food they prepared and served at even the loftiest elevations.

PHOTO: ALFRED GREGORY, 1953

A Buddhist monk (below) fingering his rosary beads at Thyangboche, with Ama Dablam just visible in the distance.

PHOTO: CHARLES WYLIE, 1953

John Hunt brought to the 1953 expedition all the methodical organization of a highly experienced professional soldier determined to leave nothing to chance. Selecting, packing, and cataloging the 13 tons of expedition baggage that arrived at Tankot, 5 miles (8 km) from Kathmandu, was a massive undertaking, coordinated by the Gurkha officer Charles Wylie.

PHOTO: CHARLES WYLIE, 1953

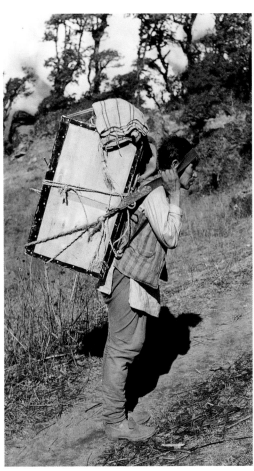

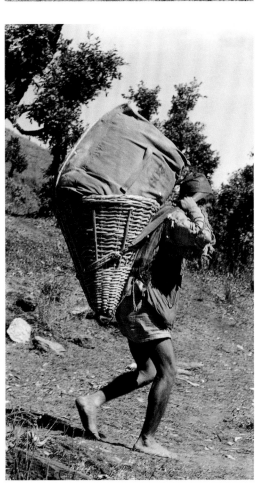

The equipment needed for the 1953 Mount Everest Expedition was packed in the U.K. into 473 packages, weighing seven-and-a-half tons. This was sent by ship from the U.K. to India, where it was transferred to trains, then to lorries, then to conveyor trays on an overhead rope-way to Kathmandu. From there 350 porters accompanied the main party on the 17-day march to Thyangboche, with another group following a month later as the expedition moved up to Base Camp. In total, approximately 13 tons of equipment and supplies were transported to Base Camp.

PHOTO: CHARLES WYLIE, 1953

1921–1953 EXPEDITION TEAM MEMBERS

Members of the 1921–1953 Mount Everest expeditions. Clockwise from top: 1921 Mount Everest Expedition. 1924 Mount Everest Expedition. 1936 Mount Everest Expedition. 1933 Mount Everest Expedition. 1922 Mount Everest Expedition.

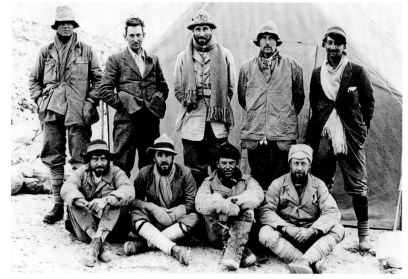

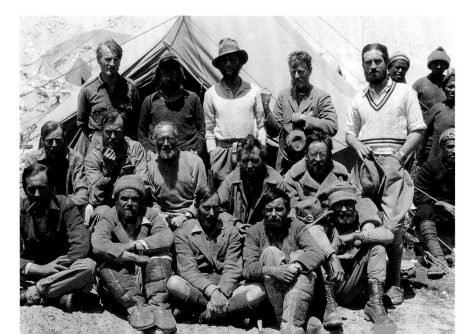

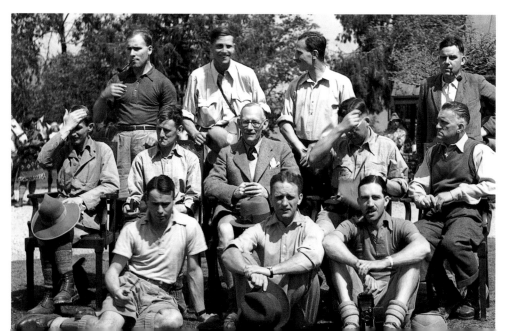

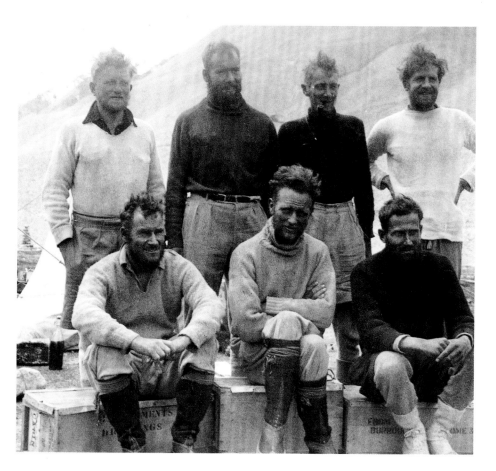

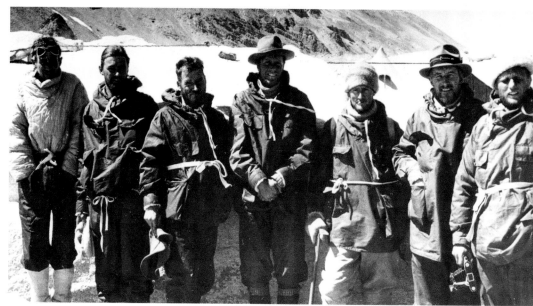

Members of the 1921–1953 Mount Everest expeditions.
Clockwise from top left:
1935 Mount Everest Expedition.
1938 Mount Everest Expedition.
1953 Mount Everest Expedition.
1951 Mount Everest Expedition.

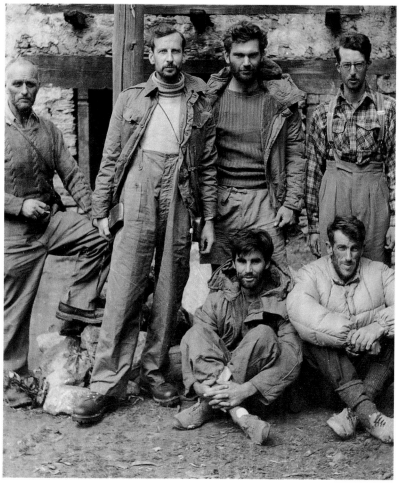

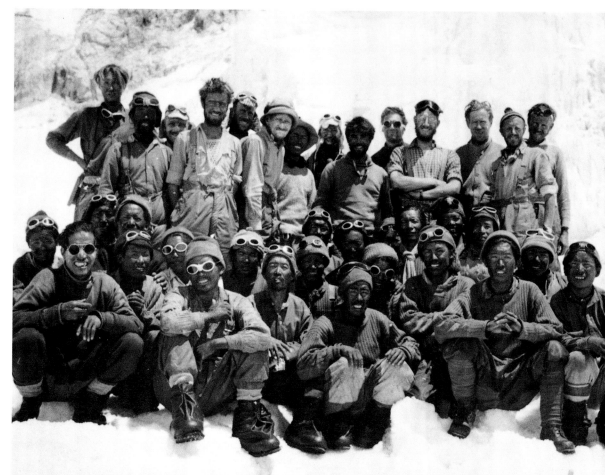

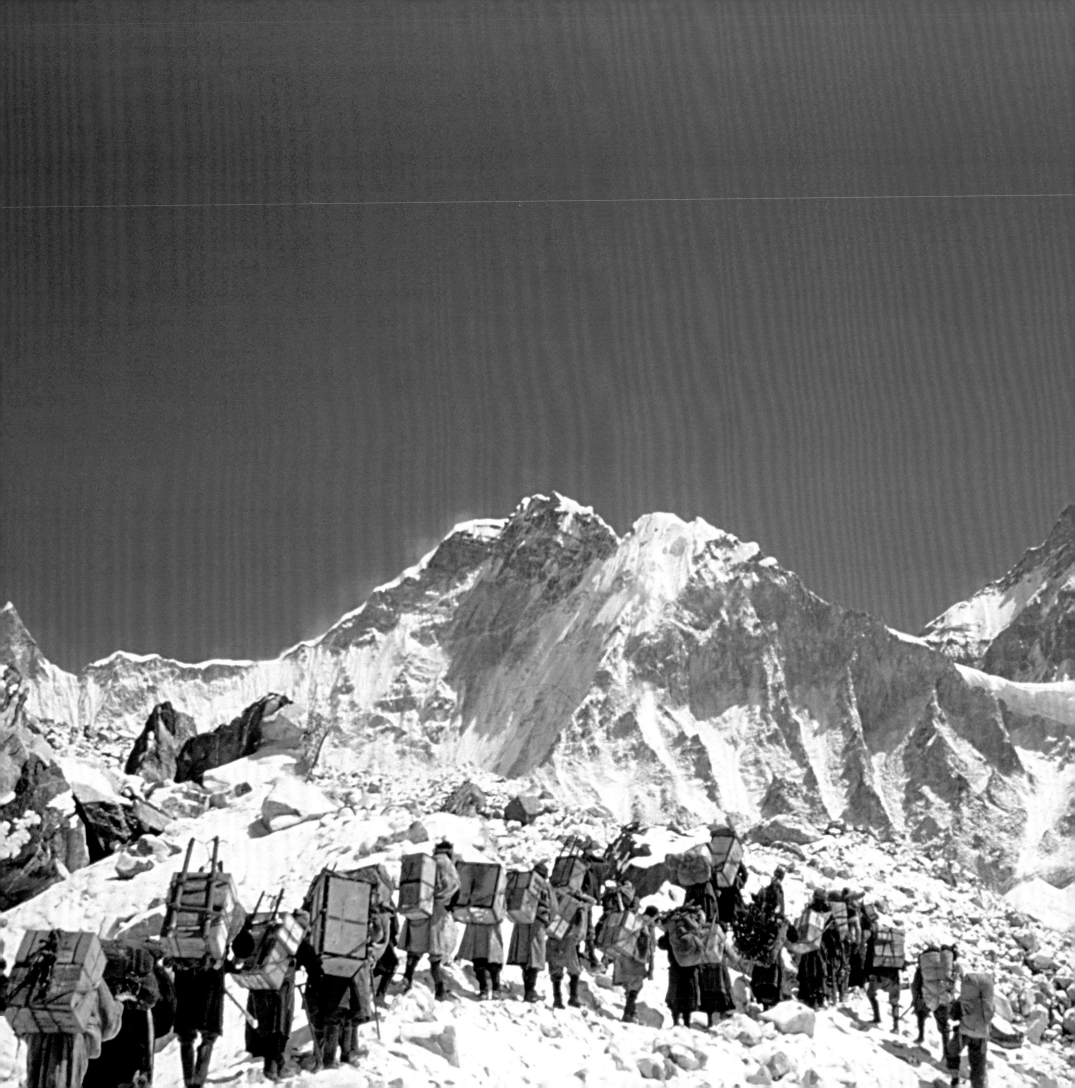

SHERPAS: TIGERS OF THE SNOW

"He had a shrewd judgement both of men and of situations, and was absolutely steady in any crisis. He was a most loveable person: modest, unselfish and completely sincere, with an infectious gaiety of spirit. He has been with me on all my subsequent journeys to the Himalaya, and to him I owe a large measure of their success and much of my own enjoyment."[1]

TASHI AND JUDY TENZING

THUS WROTE LEGENDARY British climber and Himalayan explorer Eric Shipton of the great Ang Tharkay Sherpa. Yet the same could have been said of so many Sherpas who were involved in exploration and climbing in the Himalayas from the early years of the twentieth century onward. Their contribution can never be overstated, nor can the effect their success and world renown have had on them individually (as in the case of Tenzing Norgay) and as a race. Everest—Chomolungma to the Sherpas and the Tibetans—and the Sherpa clan are inextricably bound together, spiritually and geographically. While it was the Sherpas and their invaluable support of the Western quest for Everest that opened the door to its summit, it is the mountain and the aftermath of its conquest that opened the Sherpas' eyes to the world beyond.

THE PEOPLE OF THE EAST

Sherpas are essentially Tibetans in every sense except politically. They are people from the far eastern region of Tibet, near Everest (*sher* means "east" and *pa* means "people" in the Tibetan language). Prior to the arrival of outsiders in the early 1900s, they lived a nomadic or semi-nomadic life under the control of a powerful Buddhist theocracy—a union of state and monastery that dictated every aspect of their lives. Sherpas speak a dialect of the Tibetan language (although there is no written form of this dialect) and embrace all its traditions, rituals, and cultural mores. Even when they migrated across the Himalayas more than five centuries ago, to the marginally less forbidding valleys of the Khumbu region on the southern flanks of Everest, their lifestyle changed little save for those who were escaping the harshness of sometimes cruel Tibetan landlords. Many still plied the old trade routes over the great Himalayan passes, bringing yakloads of salt from Tibet to trade with communities in what is now Nepal and India. Many chose to settle in the Khumbu valleys beneath Everest and grow potatoes and barley and tend yak herds, oblivious to the world beyond those towering ridges. The greatest peaks on earth surrounded them, yet not one Sherpa seems to have considered scaling them. Certainly there were a great number who feared the wrath of the spirits whom they believed dwelled on these mountaintops. For mortals to venture to these sacred places was considered taboo; indeed even today there are many sacred summits that have never seen the imprint of a

Sherpa men and women carrying supplies on the final day of the approach to Everest Base Camp in 1953. PHOTO: ALFRED GREGORY, 1953

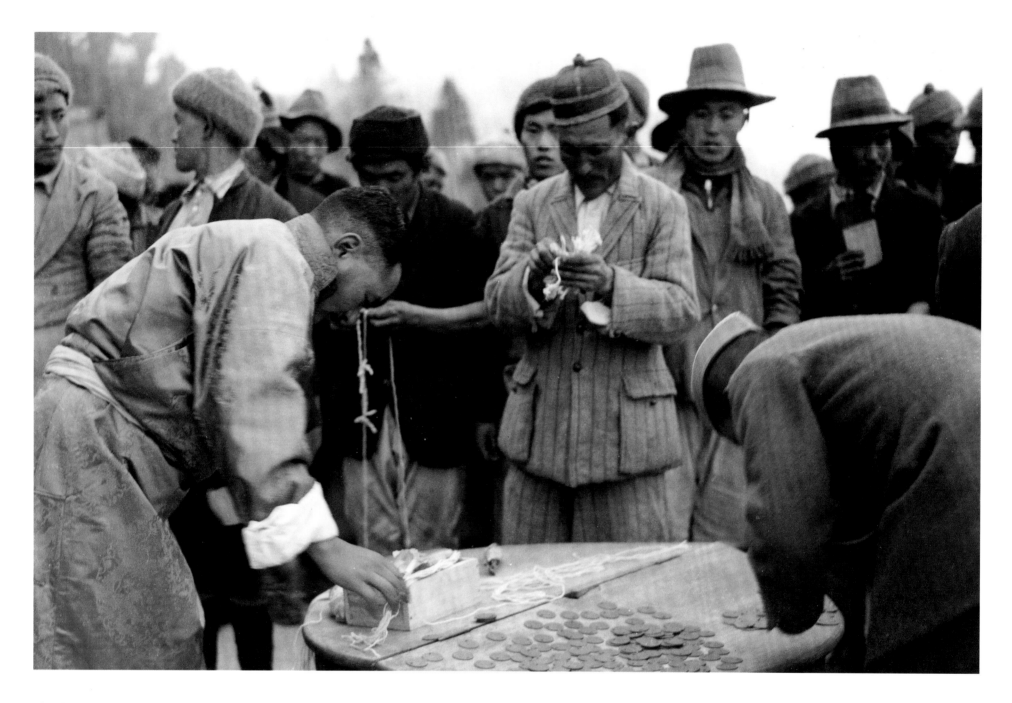

climbing boot or an ice-ax (such as Mount Kailas, which many have tried to climb, or Machhapuchare, where those who have climbed it deliberately stopped short of the summit). For most Sherpas, the lack of interest in climbing was due simply to the fact that life was challenging enough in this harsh, high-altitude environment and survival was uppermost in their minds. Had the idea even occurred to them it would not even have been seen as a necessary step on the path to final enlightenment or nirvana—the spiritual quest of all Buddhists. Yet in a few short decades the world of the Sherpas would change irrevocably. Centuries-old myths and traditions would be put aside to accommodate the foreign quest for a mountain, and to take

advantage of the opportunity for a poor, uneducated community to earn much-needed income.

The role to be played by Himalayan folk in Himalayan mountaineering emerged as early as the 1890s. In 1892, William Martin Conway led an exploratory expedition to the Karakorams, accompanied by Lt. Charles Granville Bruce of the Fifth Gurkha Regiment of the Indian Army. Though not Sherpa by race, these tough Nepali hill men, who had been trained in mountain warfare, proved a great asset to the expedition and led Conway to comment in his account of it in the *Geographical Journal* of the Royal Geographical Society in October 1893: "If you can teach these soldiers to act as good

Payday on Everest. Good work references and pay were the main reasons that Sherpas sought work on climbing expeditions.

PHOTO: HUGH RUTTLEDGE, 1936

Sherpas photographed by Dr. Alexander Kellas, one of the first to recognize their value in high-altitude work.

PHOTO: DR. A. M. KELLAS, 1907–11

Records in the Mount Everest Archive show the thumbprints of Sherpas who were employed on the 1922 Mount Everest Expedition—proof of payment for their services and work.

mountain guides, then you have solved the problem of the exploration of the snowy Himalayas."

Yet even these well-trained Nepali mercenaries with their natural mountain sense and physical stamina were to prove unequal to the high-altitude endurance and strength of the Bhotias, as the Tibetans who migrated south to Nepal, Sikkim, and Bhutan were collectively known. Life at altitudes above 13,000 feet (4000 m) was commonplace for them and crossing high Himalayan passes over 16,500 feet (5000 m) a regular occurrence in the course of their trade, yak grazing, and religious pilgrimages. Coupled with this was the geographical location in which these Bhotia groups lived—the eastern Himalayas, a short distance from the British hill town of Darjeeling. With Nepal's doors firmly closed to all outsiders, thus barring any southern route to Everest, Darjeeling was the only route into forbidden Tibet and to Everest itself.

In 1907, a Scottish chemistry lecturer and high-altitude physiologist named Alexander Mitchell Kellas led yet another of his many adventurous forays into the Himalayas, this time into Sikkim. He took with him a small band of Bhotias to carry loads and assist with his physiological tests on the effects of high altitude. He soon recognized the value of these men to Himalayan exploration and in later years began to train them in mountaineering and survival techniques with an eye to using them on the first Everest Reconnaissance Expedition in 1921 under Lt.-Col. Charles Howard Bury. And so the tradition was born that would culminate in one such Bhotia's attaining the crowning glory—the first ascent of Everest.

Why did these Sherpas climb with the Western sahibs? They had no desire to explore hidden valleys or chart vast, untrodden ranges, nor did they harbor any dreams of mountain summits or international acclaim. The answer is simple—they

A page from the 1936 Everest Expedition album showing portraits of many of the Sherpas who took part, including Tenzing Norgay, who is shown in the first picture in the fourth row.

PHOTO: MAJ.-GEN. J. M. L. GAVIN, 1936

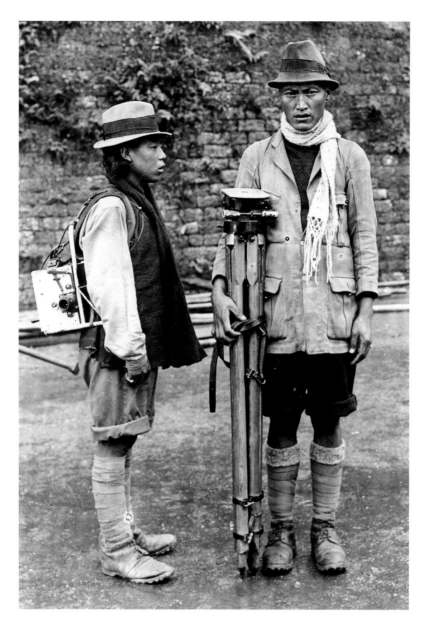

Two Sherpa photographic porters who carrried a cine camera to Everest's North Col. The porters were able, according to Capt. J. B. Noel, to carry loads beyond the power of any Westerner.

PHOTO: CAPT. J. B. NOEL, 1922

communities in Khumbu and the hill station of Darjeeling, which became the base for all British Himalayan exploration and Everest expeditions before World War II. Their interest in the mountains and in mountaineering developed, too, and the desire for summit success began to burn slowly within many of them. It was this small band of more ambitious Sherpas who instigated the legendary tradition of the "Tigers of the Snow," a title given by the sahibs to Sherpas who carried loads to the highest altitudes. Indeed, in Hugh Ruttledge's 1933 expedition to Everest, there were eight "Tigers" who carried loads to Camp IV at 27,400 feet (8350 m)—Ang Tharkay, Da Tshering, Nima Dorje, Ang Tshering, Kipa Lama, Pasang, Rinzing, and Tshering Tharkay. (Whether Sherpas are known by one or two names, they are all personal names; a clan or village name is sometimes added by Sherpas themselves to distinguish similarly named individuals, but that practice has rarely filtered through to Westerners.)

All Sherpas in general were deeply honored by the recognition, as were all who would receive it. On the seventh British expedition to Everest in 1938, the leader and Himalayan legend Bill Tilman formalized the title with the presentation of a Tiger Medal to all the "Tigers" on that climb who reached 27,000 feet (8230 m)—including Tenzing Norgay and the sirdar (the leader of the Sherpa team) Ang Tharkay. It is a tradition held in high esteem even today, and Tenzing Norgay held this honor above all others throughout his life.

By the 1920s, the British reconnaissance of the Himalayas, and specifically the quest for Everest, was in full swing and the Sherpa climbers and porters were an integral part of the path forward. With Nepal closed to all foreigners and Darjeeling the only gateway to Everest, this gracious old hill station, which had been the summer retreat from the stifling plains of India for the British in the days when Calcutta was the center of commerce and administration for the British Raj, became the mountaineering capital of the world.

Many of the Khumbu Sherpas who had come to Darjeeling seeking work on expeditions had decided to stay in the town and make it their home. Indeed, Sherpas such as Tenzing Norgay, Ang Tshering, and Pasang Phuttar were never to return to their adopted homeland of Khumbu, while others such as Da Tenzing and Ang Tharkay would eventually retire

were well paid and the work was generally not difficult for them. These were men who survived at a meager subsistence level in a harsh and unforgiving environment. Luxuries were few and travel other than for work or religion unknown. Here was an opportunity to carry relatively easier loads than those to which they were accustomed into regions beyond their life's experience with these strange yet fascinating *feringhi* men who gave them their first experience of cash wages and a new lifestyle. In short, these expeditions were a paid adventure—an irresistible opportunity for any young, curious person.

THE TIGERS OF THE SNOW

As the years passed, these Sherpas gained in experience and in prosperity, and this flowed back to their families and

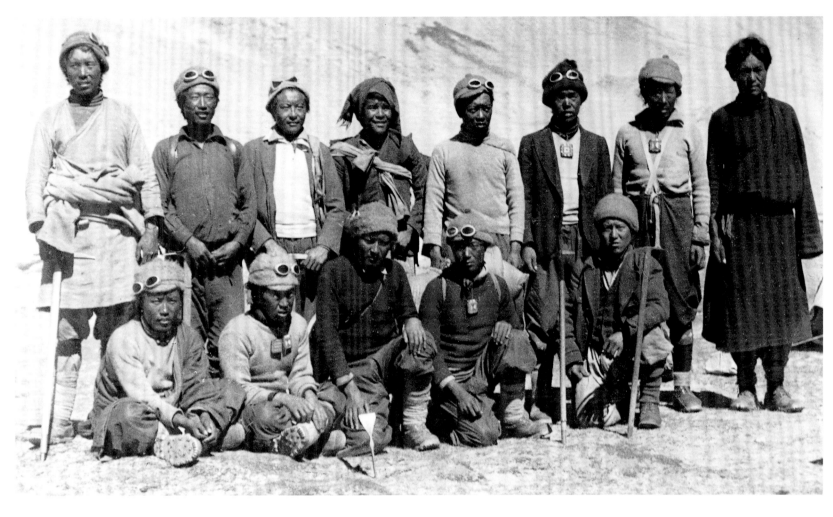

The "Tigers" of 1938. Tilman comments: "It is of course a matter for wonder, no less than thankfulness, how much these men will do and how far they will go with, one imagines, few of the incentives which act as a spur to us."

Photo: Unknown, 1938

to the familiar valleys and villages of their youth in Nepal when their climbing days were finally over.

The old Tea Planters' Club in Darjeeling became the recruitment center for expedition Sherpas. Sahibs would stand on the rotunda and review prospective applicants waiting in the narrow street below clutching any letters of reference they might have from previous expeditions or employers. In 1935, one such hopeful, sporting a new khaki jacket that he hoped would make him look "more professional," stood nervously below while Eric Shipton made his selection. With no references or experience his chances were slim, yet Shipton saw something in his now famous smile and quick expression that augured well for the future. Tenzing Norgay, the last man chosen that year, became the "first man" of Everest in years to come.

This rather haphazard method of Sherpa staff selection began to change after the establishment of the Himalayan Club in 1928, with branches in Bombay (now Mumbai), Calcutta, and Darjeeling. The aim of the club was to promote science, literature, and general knowledge relating to the Himalayan, Karakoram, and Hindu Kush ranges. But more importantly it aimed to assist Himalayan exploration and travel by publishing detailed descriptions of Himalayan routes and formulating the system by which expeditions recruited, paid, and selected Sherpas as porters and guides. To this end, the Club established a book system whereby each Sherpa had his own book in which he recorded his name, home village, contact details (often a rather vague affair), and a list of his expedition experience. The book was duly filled in and stamped after each expedition by both the expedition leader and the Himalayan Club Secretary. This system proved invaluable in subsequent years and now provides an excellent historical record of all those Sherpas who contributed so much to Himalayan mountaineering, but who might otherwise have been forgotten or misidentified, given the similarity of so many Sherpa names. And while for many in the world there is but one Sherpa name known and remembered—that of "Sherpa Tenzing" or Tenzing Norgay—there were many who were equally worthy of global acclaim and personal admiration. First on such a list would be

A *young Ang Tharkay, a legend among British climbers and among his own Sherpa people, photographed in 1935.*

PHOTO: L. V. BRYANT, 1935

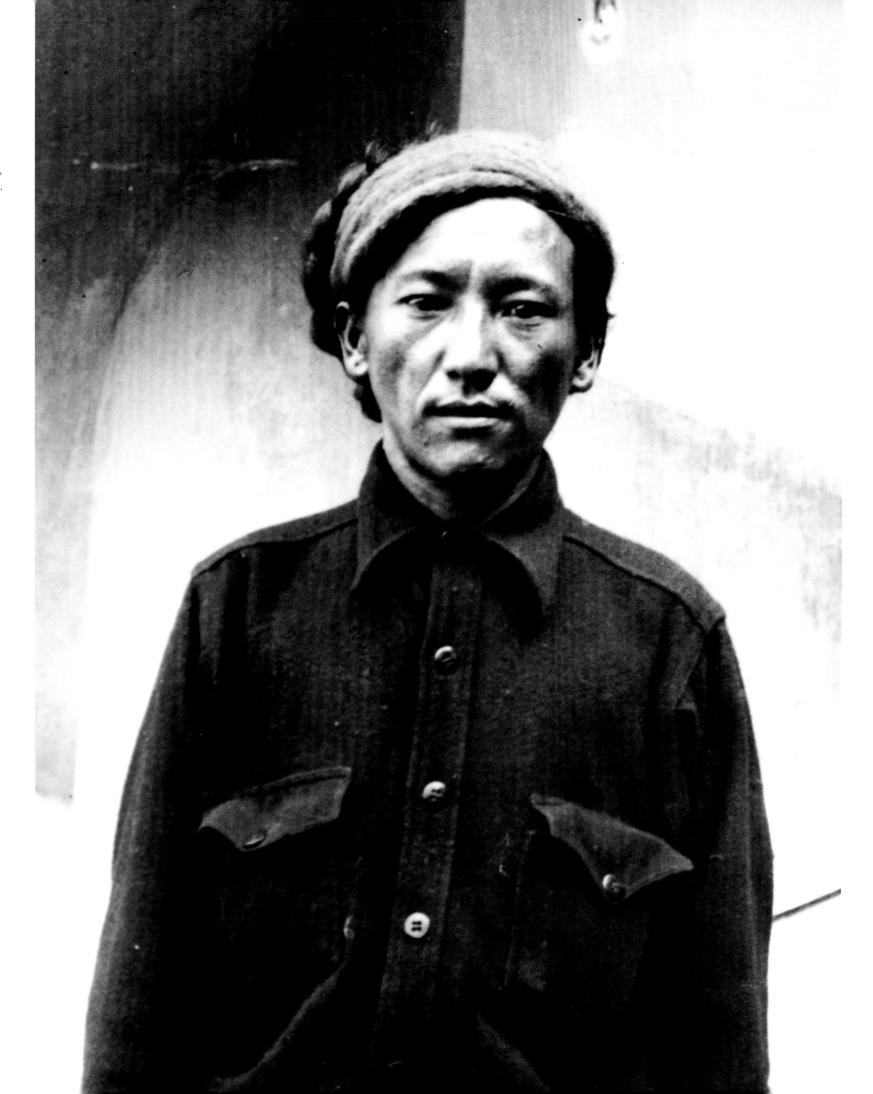

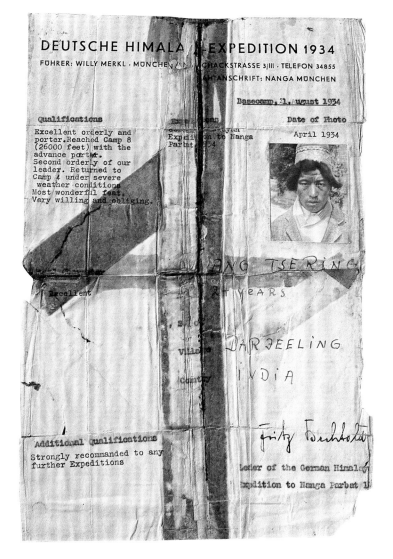

DEUTSCHE HIMALAYA EXPEDITION 1934
FÜHRER: WILLY MERKL · MÜNCHEN / HACKSTRASSE 3/III · TELEFON 34855
DRAHTANSCHRIFT: NANGA MÜNCHEN

Basecamp, 21. August 1934

Qualifications Date of Photo

April 1934

Excellent orderly and porter. Reached Camp 8 (26000 feet) with the advance party. Second orderly of our leader. Returned to Camp 4 under severe weather conditions. Most wonderful feat. Very willing and obliging.

Additional qualifications
Strongly recommended to any further Expeditions

Ang Tharkay Sherpa, a veteran of numerous Himalayan "firsts" and admired and remembered by scores of veterans of British Himalayan expeditions and climbing ventures.

Born in 1909, in the Khumbu village of Khunde, Ang Tharkay was to become a legend among British climbers as well as among his own Sherpa people. Number 19 on the Himalayan Club register of Sherpa guides, he was a man of the old school—dignified, loyal, incomparably capable, and eternally good-humored. His childhood had been spent tending yaks and helping with the family plots of barley and potatoes until 1931 when tales of adventure and excitement—and financial reward—came to Khumbu from Darjeeling. Like so many others, Ang Tharkay set off to find work on an expedition as a porter; his first climb was with a Bavarian team on Kangchenjunga in Sikkim (an unsuccessful attempt in which two climbers died in a fall). This was followed by work on Ruttledge's 1933 Everest team where, despite his tiny frame and knock-knees, Ang Tharkay proved a powerhouse on the mountain, once taking on the load of a sick porter and carrying a total of almost 160 pounds (72 kg) at high altitude. His mountaineering abilities were matched only by his organizational flair and his unique skill in managing people. Dr. Michael Ward, Himalayan explorer, climber, and physiologist, recalls an incident during the 1951 Everest Reconnaissance Expedition when the team inadvertently crossed the frontier into Tibet (forbidden territory after the war) on their return route to Kathmandu from Everest. They were detected by the Tibetan authorities, who were described by Dr. Ward as "a group of Tibetan levies armed with muzzle-loading guns with antelope-horn rests and brandishing swords."[2] As the Tibetans approached, the shouting and verbal threats began in earnest. The Sherpas, primarily Ang Tharkay, who was clearly enjoying himself, responded with great vigor and the sahibs were advised to stand back and let their sirdar handle the matter. Twenty minutes and a good deal of shouting later, Ang Tharkay returned, grinning broadly, to report that all was settled and that the princely sum of seven rupees would be necessary to persuade the Tibetans to turn a blind eye to their diplomatic blunder. The furor, Ward assumed, had been about getting them to agree to this. But it seems that diplomacy had not been the issue—they had initially requested 10 rupees, which Ang Tharkay considered an outrageous demand. The shouting had arisen from the haggling over three rupees!

In 1934, Ang Tharkay accompanied Eric Shipton and Bill Tilman to the wild Rishi Gorge in the Garhwal Himalayas and helped force a seemingly impossible route into the famed Nanda Devi Sanctuary. He was again on Everest in 1936 with Hugh Ruttledge, then with an expedition to the Karakoram the following year with Tilman and Shipton. In 1938, on the last expedition to Everest before World War II, his contribution was immeasurable and, at the age of just 29, he received one of the first Tiger Medals ever awarded. After some very tough years during the war he was again rewarded in 1950 when he was sirdar on Maurice Herzog's history-making ascent of Annapurna 1 (26,504 feet/8078 m), the highest peak ever achieved at that time. Ang Tharkay was awarded the French *Légion d'Honneur* and he became the first Sherpa to travel to Europe when he visited France soon after his success. He also published his autobiography (in French), another Sherpa "first,"

A porter fords a river (right) carrying both his friend and a dog! The route to Everest took the 1920s and 1930s expeditions over many rivers and streams, and great ingenuity was used to prevent the teams from getting wet.

PHOTO: FRANK SMYTHE, 1933

Sherpas take a rest between Camps I and II (far right). They were provided with the boots and clothing they needed for the climb, including snow goggles. On the 1933 expedition goggles were needed above Camp II to prevent snow blindness.

PHOTO: TOM BROCKLEBANK, 1933

Members of the 1933 expedition brought sporting paraphernalia with them, including six sets of boxing gloves. At Tingri Dzong, Hugh Boustead gave lessons to the porters in the art of boxing, and matches were a great Tibetan crowd pleaser.

PHOTO: FRANK SMYTHE, 1933

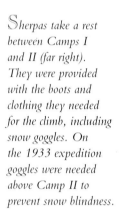

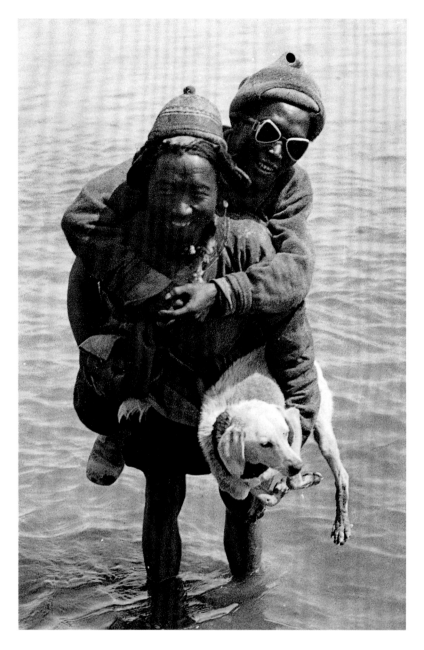

in 1954. But he was never comfortable abroad and longed to be home with his own people and among his own mountains.

Ang Tharkay was again with Shipton on the 1951 British Reconnaissance Expedition to Everest through newly opened Nepal. He was once more at the forefront of the push up the great Khumbu Icefall, the greatest hindrance to a route to the upper part of Everest. The following year, while his old friend Tenzing Norgay was on Everest with the Swiss, he was again with the British on Cho Oyu as they prepared for their 1953 Everest bid. After subsequent climbs on Nun and Dhaulagiri (1953), and Makalu (1954), Ang Tharkay's expedition career came to a close. With the establishment of the Himalayan Mountaineering Institute in Darjeeling by the

Sherpas carry an ailing Capt. E. St. J. Birnie from Camp II to Base Camp. Sahibs were not the only ones to suffer on the mountain. Sherpas too suffered owing to the vagaries of climate and altitude, and as a result would help each other by sharing loads.

PHOTO: HUGH RUTTLEDGE, 1933

Indian Prime Minister Jawaharlal Nehru in 1954 under the guidance of Tenzing Norgay, the old Tiger Ang Tharkay became one of its first professional mountaineering instructors. He retired to Nepal, buying a large tract of land south of Kathmandu in 1966 and spent his twilight years growing vegetables and keeping cattle. He died of cancer in 1981, and was survived by his wife Ang Yangzen, a daughter, and four sons.

Ang Tharkay and his contribution to Himalayan mountaineering and exploration must rank at the forefront of the story of Everest. His professionalism, reliability, and integrity played a central role in establishing the respected and honorable reputation enjoyed by the Sherpas throughout the world. In this he was aided by many others, among whom are Ang Tshering and Dawa Tenzing Sherpa, a much-loved climbing companion on many British expeditions. In his youth, Ang Tshering was determined not to climb Himalayan peaks because he feared the wrath of the spirits that dwelled on them, a fear that was confirmed for him as he waited at Base Camp when Mallory and Irvine failed to return from their summit bid in 1924. Tragedy struck again for him on the 1934 German Nanga Parbat Expedition when he was caught in a hurricane-force storm that lasted nine days and took the lives of five Sherpas and all three German climbers—Ang Tshering being the sole survivor of the nine-man summit team. It took many years for him to recover his strength and nerve before finally, in 1960 at the age of 52, he reached his

first Himalayan summit—Nanda Ghunti in the Garhwal Himalayas. After so many disastrous climbs, Ang Tshering could finally believe that a summit was possible without tragedy and loss of life. It was enough for him and, with one more small peak under his belt, he hung up his boots and crampons and focused his life on his young family and on life in Darjeeling, where he lived until his death in 2002.

Old Dawa Tenzing (or Da Tenzing as he was known) was a man who could never have been enticed by the bright lights of success or foreign lands. Throughout his life he upheld the traditions and values of his people and his religion, even keeping his long hair intertwined with red braid in the Tibetan style, a turquoise earring adorning one ear. He was a tall, strong, reliable climbing companion much loved by his British friends, who maintained close ties with him and his Khumbu family until his death in 1983. His mountaineering record is remarkable: Everest, 1924; Everest, 1953 (deputy sirdar to Tenzing Norgay); Makalu, 1954 (with Edmund Hillary); Kangchenjunga, 1955 (with Charles Evans on the first ascent); Everest, 1956 (sirdar on the first Swiss ascent); and Everest, 1963 (the first American ascent); as well as expeditions to Ama Dablam, Annapurna 2 (with Col. Jimmy Roberts on the first ascent of that peak), and Kanjiroba Himal in Western Nepal. An impressive career, yet what endeared him most to his friends and colleagues was his dry sense of humor and a dogged determination to remain himself—a Khumbu Sherpa. His visits abroad brought many stories of his riotous comments and observations on Western life. Always dressed in his traditional *chuba* (the knee-length, kimono-like garment worn by all Tibetans and Sherpas on special occasions), he was not overly impressed with foreign ways. European cows, however, he found most desirable and when he was asked what he would like to take with him from England to Nepal his response was "a good breeding cow." London did not hold any appeal for him as he found that "no-one in that village has the time to stop and talk to anyone else." In his retirement years, when his income proved barely enough to sustain his family, he refused to accept the charity of his devoted British friends. However, Tony Streather, who had been on the 1955 Kangchenjunga Expedition, managed to convince him that because of his distinguished contribution to British mountaineering he was

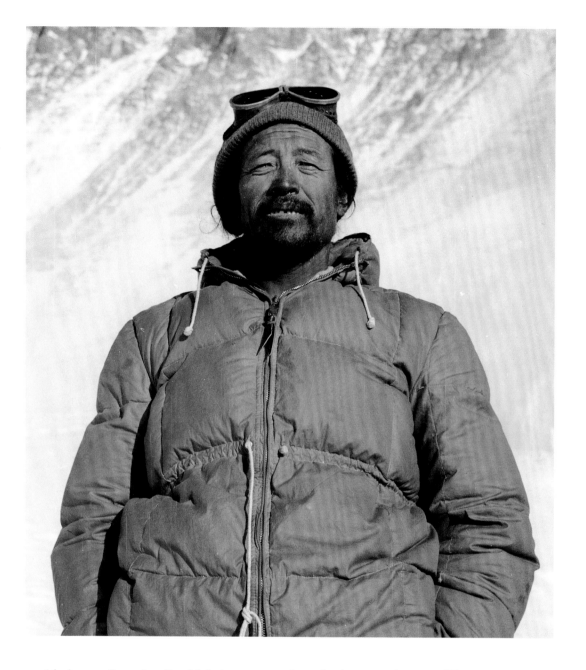

entitled to a "pension," which he accepted with dignity—his friends maintaining these payments until his death.

These remarkable characters—accomplished mountaineers and devoted friends of so many abroad—have remained largely anonymous to the world in general. Their personalities and achievements were known only in Himalayan circles and, even so, there were many who ranked their contribution far below that of the sahibs. Today, when you speak to the great Western climbers about the Sherpas with whom they have climbed and shared so much of their lives, they marvel that so few people ever ask them about their Sherpa counterparts. So the likes of old Ang Tshering and Da Tenzing remain gems to be treasured by those few who take the time to seek out their stories.

The legendary Da Tenzing (above), who served on Everest expeditions from 1924 to 1963.

PHOTO: ALFRED GREGORY, 1953

Sherpas bore the brunt of this dangerous work in the Khumbu Icefall (opposite), both in 1953 and on all subsequent expeditions.

PHOTO: GEORGE LOWE, 1953

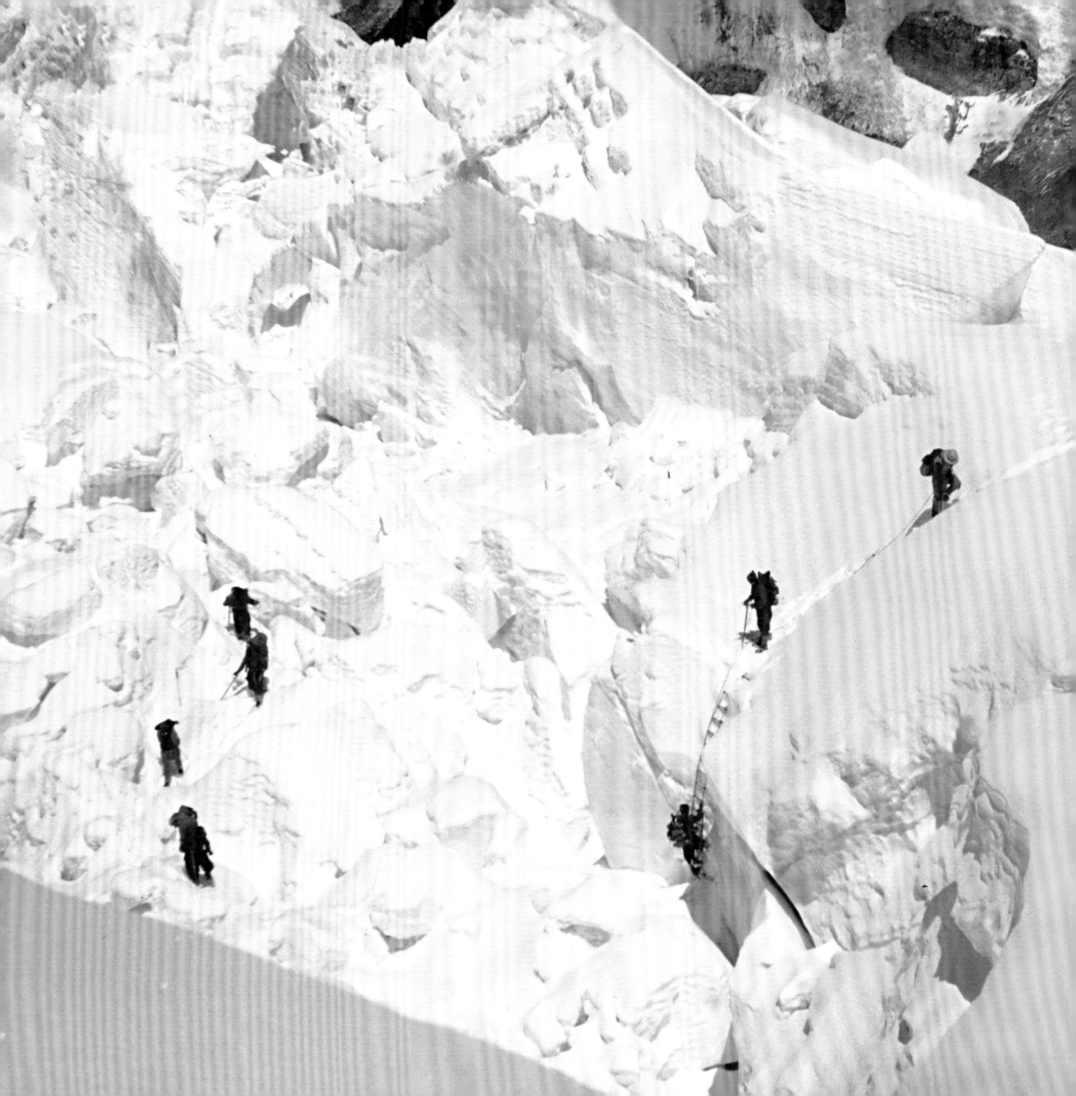

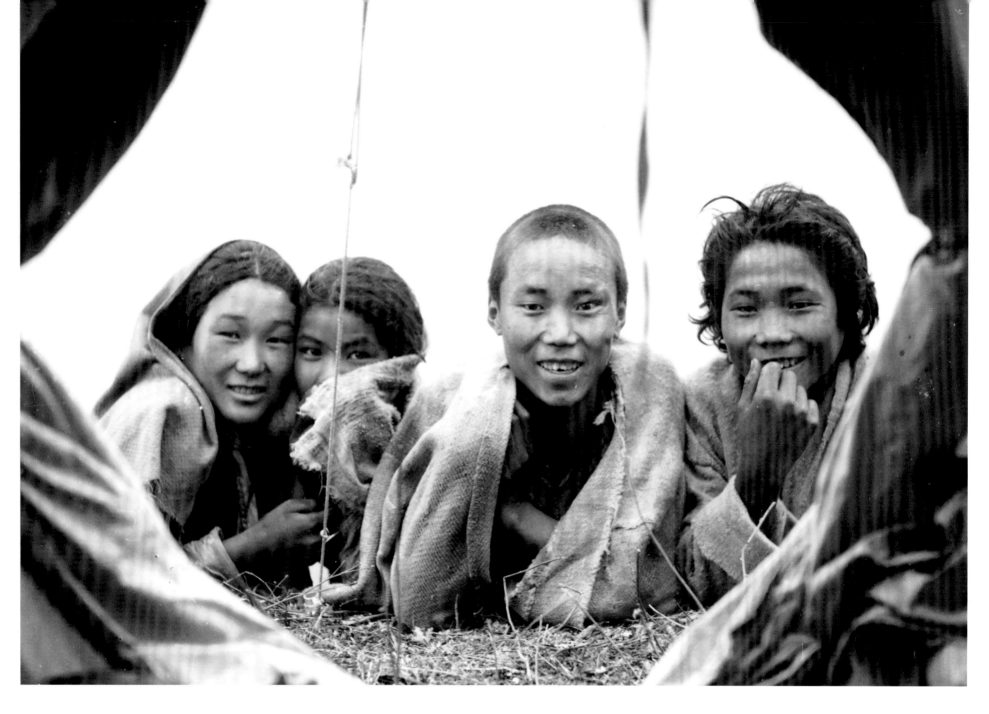

TENZING NORGAY: SEVENTH TIME LUCKY

One Sherpa, however, was to make the name of his people and their hard-earned reputation in the mountains household words: Tenzing Norgay. Born in the tiny village of Moyey in the Kharta district of eastern Tibet, Tenzing spent his early years in abject poverty and was often cruelly oppressed by a Tibetan landlord. One of 13 children, he and his parents and siblings gradually escaped this harsh life by crossing the great Nangpa La into the Khumbu of Nepal, where they settled in the small village of Thamey. Here they worked as farmers and servants. As a yak herder, young Tenzing spent much of his youth atop the high ridges that provided rich summer pastures. Here, a dream began to grow as he looked in awe at the great peaks that encircled his valleys—Everest, Lhotse, Nuptse, Cho

Oyu, Makalu. For him, they did not exemplify malice or the threat of spiritual wrath. Rather, they enticed and comforted him. This was an unusual response for a very traditional Sherpa, and one that would set him apart from his fellow Sherpas in the years to come. Seven expeditions to Everest would ultimately reward him with the ultimate prize—the summit— but the road was not without its tragedies and sacrifices.

Tenzing lost his eldest son in infancy, and soon thereafter his first wife Dawa Phuti, while he was stationed in Chitral in present-day Pakistan during World War II. Good fortune finally smiled on him when he met Ang Lhamu, whom he married and who became the beloved mother of his two daughters, Pem Pem and Nima. She was also the staunchest support he could have hoped for in the Everest years ahead. In 1947,

Tenzing joined a team of Swiss climbers attempting several 6000-m (19,700-foot) peaks in the Garhwal. In itself, this was nothing new for Tenzing, save that it would provide his first Himalayan summit (Kedarnath) and establish an enduring bond with the Swiss that would bring his greatest achievement and his greatest sorrow in mountaineering. For on this expedition Tenzing came to experience a level of friendship and camaraderie he had not yet known with foreign climbers. The Swiss were mountain people like the Sherpas, and the social hierarchy of colonial India was never an issue with them. They treated Tenzing and the other Sherpas as equals and the Sherpas responded accordingly. Being given the opportunity to reach a summit further cemented Tenzing's affection for and faith in them and when the Swiss were granted the first bite of the Everest apple by the Nepali government in 1952, Tenzing was overwhelmed with happiness—Everest, and with the Swiss! It went without saying that he would be asked to join them as sirdar, but when they announced that he would be a full member of the climbing team Tenzing could see that his Everest dream was within his grasp.

The final blessing came when he met the Swiss team in Kathmandu, a team that included Raymond Lambert. The two could not communicate verbally as Lambert spoke little English and Tenzing, at that time, no French, yet there was an immediate and powerful bond between them, which lasted until death. In two campaigns, in the spring and the fall of 1952, Tenzing and Lambert battled against Everest's fiercest storms and most paralyzing cold, only surrendering some 800 feet (245 m) from the summit. Without a word, they turned down the mountain, knowing that the summit could not be theirs together.

WITH HILLARY TO THE TOP

When 1953 came, Tenzing was reluctant to accept the British offer of a role as sirdar and climbing member of the team. He had climbed and trekked for many years with the British and had been treated fairly and kindly by them all, especially by the Sherpas' favorite, Eric Shipton. But his loyalty to Lambert clouded his dream of the summit and he was also deeply disturbed and saddened that Shipton, to whom most old Himalayan hands believed Everest "belonged," would not lead this first British attempt from the south. Tenzing had resigned

himself to remaining at home, but then he received word from Raymond Lambert, who reminded him of his dream and of the passion they shared for Everest. Tenzing would climb for the British, but he would climb for Lambert as well.

When Tenzing met the British team in Kathmandu he was heartened by the efficiency and warmth of John Hunt and his team. Hunt, who had been selected to replace Shipton, spoke excellent Hindustani and Maj. Charles Wylie perfect Nepali, so communication was instantly far beyond his prior experiences with the British. The team was large and well equipped, and he was given full responsibility as sirdar and climber. He was finally comfortable with his decision to join and, once the climb was under way, began to appreciate the caliber of his climbing fellows. His Sherpa team, too, was an excellent group of climbers: Da Tenzing was deputy sirdar, with numerous

Kinzom, Tenzing Norgay's mother, greeted her son on his arrival with the 1953 expedition at Thyangboche monastery. Kinzom wanted to see that her son was fit and well, and on ascertaining this she gave Tenzing her blessing for his Everest climb.

PHOTO: CHARLES WYLIE, 1953

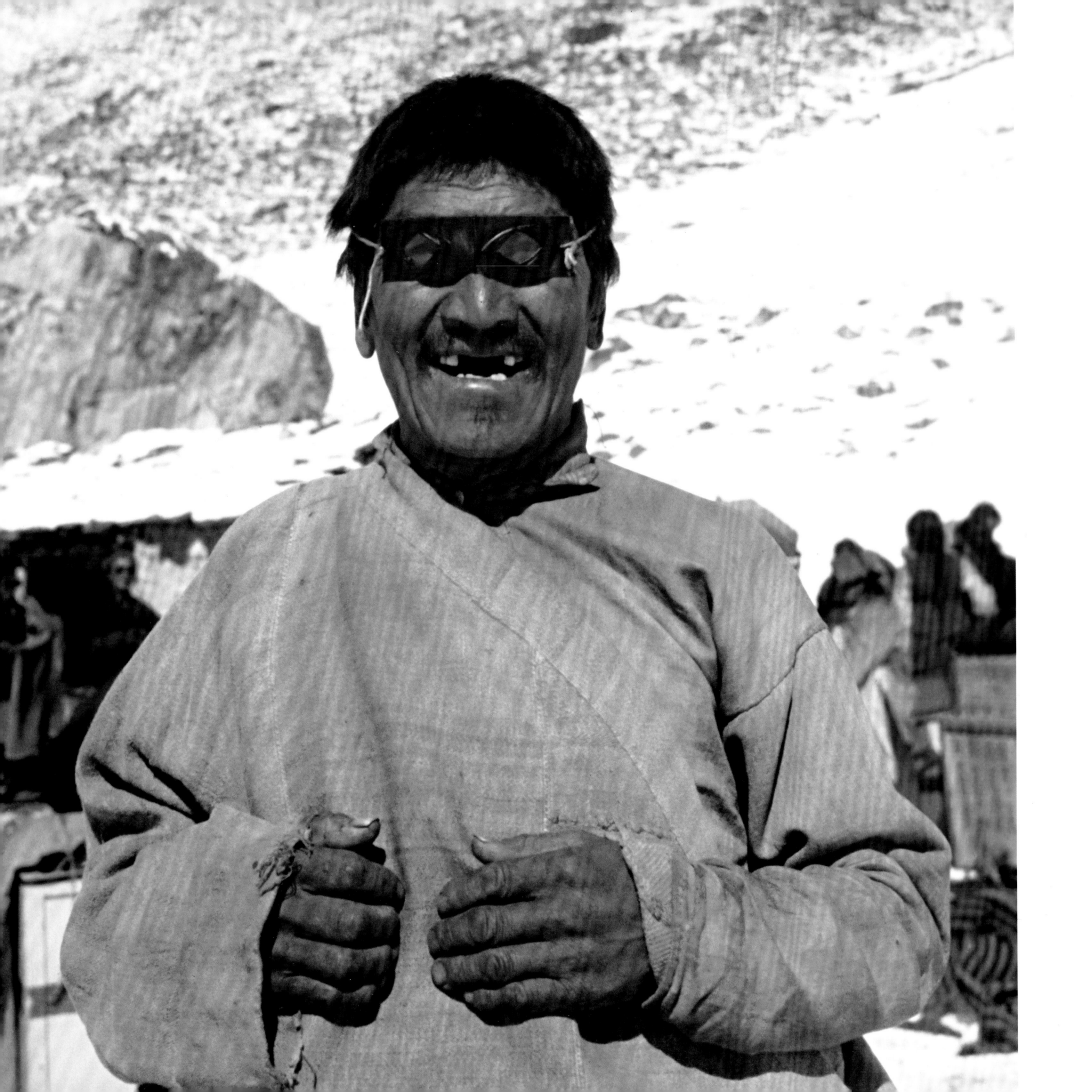

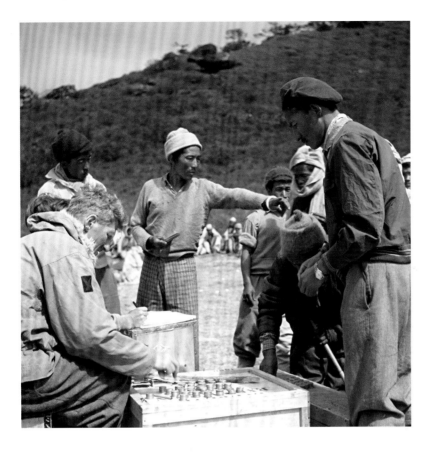

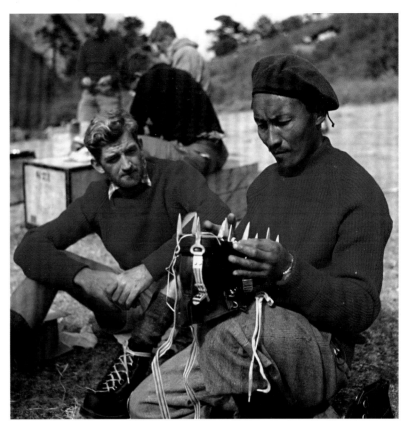

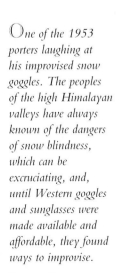

other Everest veterans, and one new boy—Tenzing Norgay's nephew Nawang Gombu, who would later become the first person to climb Everest twice.

As the summit day neared, Tenzing could see the climbing teams forming and he carefully watched one lanky New Zealander, Edmund Hillary, who seemed quietly determined to secure a place on one of the summit teams. Hillary had also been watching Tenzing and was impressed by his strength and speed on the mountain. Hillary was quite fascinated to find a Sherpa whose heart was as doggedly fixed on the summit as his own. Socially they were chalk and cheese—Tenzing gregarious, polite, and humble; Hillary a loner, somewhat brash, and very ambitious. Yet the two worked supremely well as a climbing team and it soon became obvious to John Hunt that they would be one of the two teams given a chance for the top when the time came.

Charles Evans and Tom Bourdillon were to make the first bid for the summit, but the weather forced them back and when Hunt instructed Tenzing and Hillary to prepare for their turn they both knew their day had come. Wearing a red scarf given to him by Raymond Lambert, Tenzing set out with Hillary, climbing strongly in near-perfect conditions.

The rest is history, and both Hillary and Tenzing came down the mountain to a world that would never be the same for them again. Political tensions, rivalries, and media manipulation all took their toll on Tenzing, and the days after Everest were some of the most difficult and disillusioning of his life. In the depths of his unhappiness he began to wish that he had not climbed Everest. Yet time and the support of his Sherpa and foreign friends enabled him to come to terms with all that this historic event meant, and in time he was able to savor the sweetness of his realized dream and the benefits that had sprung from it. A new life began for him and his family with a lifetime position at the newly created Himalayan Mountaineering Institute—such security and prestige were hitherto unknown for any Sherpa. Doors opened for him, and remained open for his children, their children, and the entire Sherpa community.

The Sherpas had been instrumental in opening Everest to the world; now the world would offer them the chance to partake of all it offered. The facilitator for this process was Edmund Hillary who, with the establishment of the Himalayan Trust, repaid the Sherpa people a thousandfold for all they had done for Himalayan mountaineering and the eventually successful pursuit of so many sahibs' dreams.

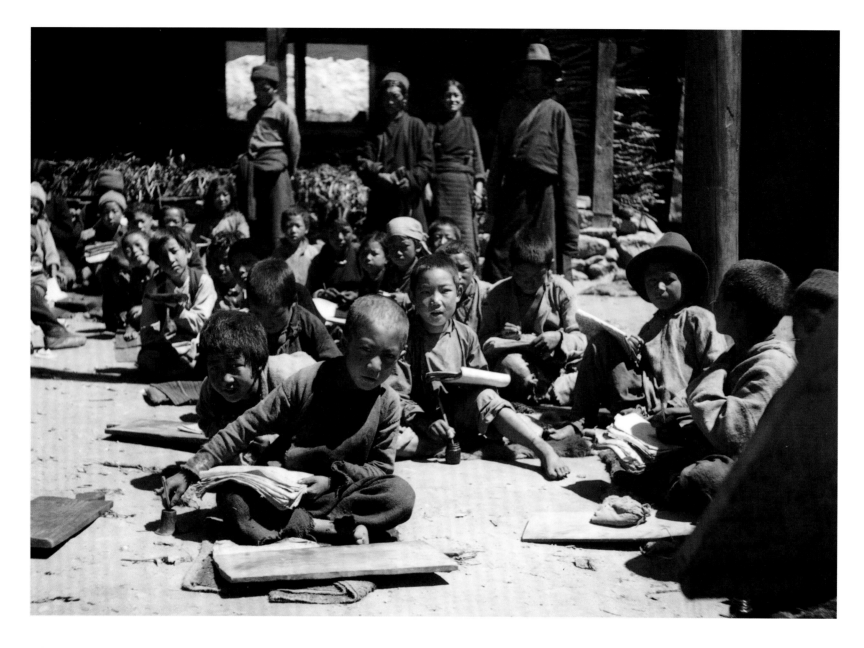

A school in Namche Bazar (left). Edmund Hillary saw the Solu Khumbu for the first time in 1951. Since his ascent of Everest in 1953, he has worked tirelessly, through the Himalayan Trust, to support education and health for the Sherpa people who live in this remote area.

PHOTO: UNKNOWN, 1951

This gruff, burly New Zealander, who clawed his way up Everest with Tenzing, has built schools, hospitals, and health clinics, restored monasteries, established teacher training colleges, and set up scholarship grants for gifted Sherpa students. He continues to raise funds for projects throughout the Sherpa region of Solu Khumbu and is held in the highest esteem by every Sherpa in the Everest area. Climbing Everest is history, but the Sherpa people revere Sir Edmund Hillary for what he has achieved for them in the half century since. They could not have hoped for a more perfect pair to attain the Holy Grail of climbing—a Sherpa together with a man of such character as Edmund Hillary.

Tenzing and Hillary have made this new world prosperous and rewarding for the Sherpa people. Tenzing gave them hope

and confidence that they could achieve whatever is in their hearts. And Hillary offered them a practical pathway to achieving those dreams. There are still many Sherpas who wish to climb Everest—indeed, another lad from the village of Thamey, Apa Sherpa, has climbed the mountain 12 times. Yet the true gift lies in the choice Sherpas now have—to climb or not to climb. For Apa and the new breed of Sherpa climbers the choice is theirs, but for many Sherpas the doors have been opened in a variety of other fields—medicine, law, environmental studies, travel, and tourism, to name a few—and Sherpas have excelled in all of them. The energy, intelligence, and determination with which they have always climbed the great peaks of the Himalayas will continue to sustain them on the path they now follow into the twenty-first century.

Sherpas resting on the North Ridge of Everest (opposite). Although the men are supplied with British equipment, one has chosen to carry his load with a traditional headstrap.

PHOTO: UNKNOWN, 1938

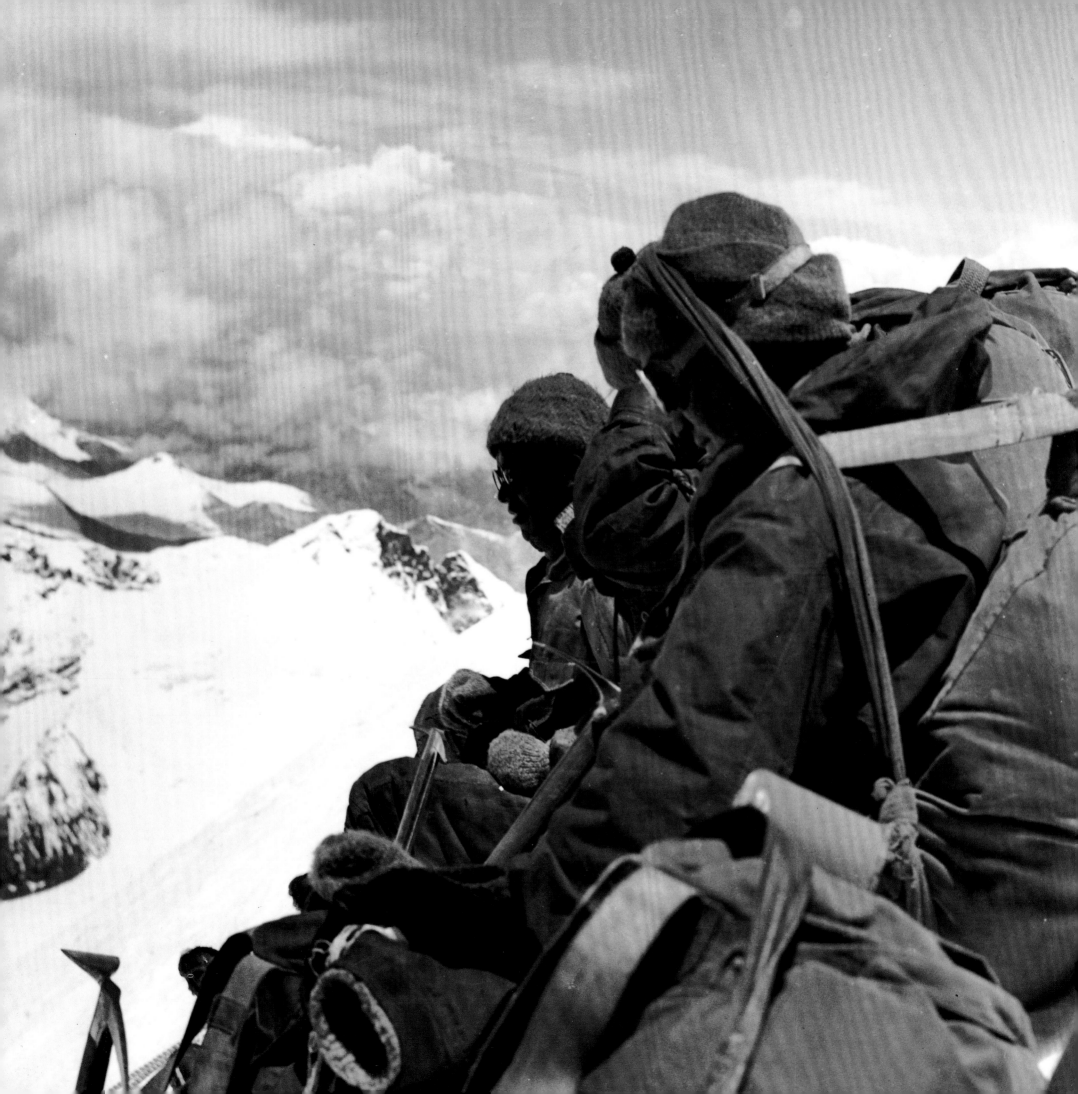

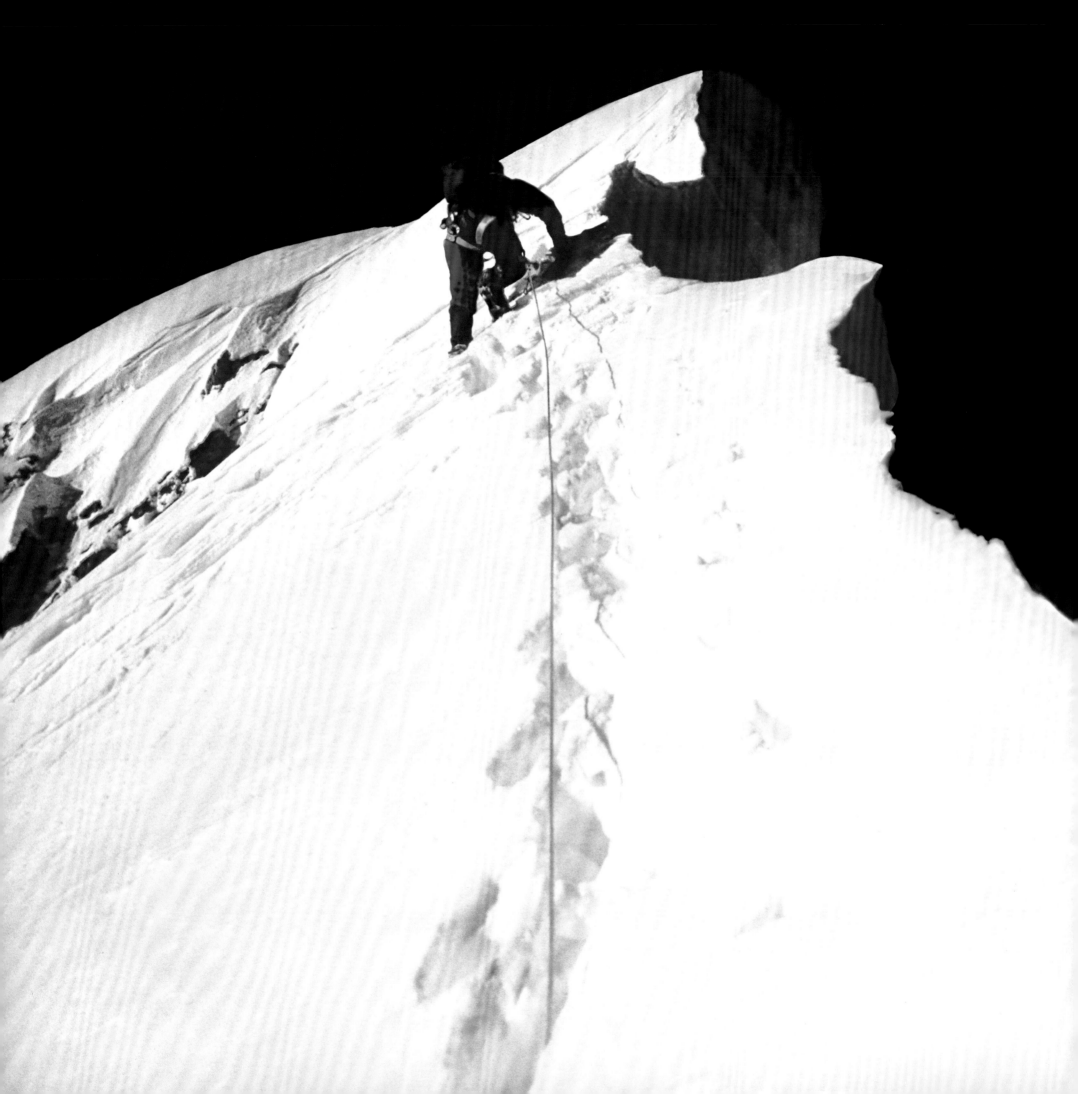

THE CONTINUING CHALLENGE

"We too can respect the mountains if we see them as almost *beyond* our abilities. If we use all
the technology available to approach the mountains in an aggressive way, we destroy that respect.
But if we limit the means at our disposal, there will always be something *beyond our ability*,
and that is vital."

STEPHEN VENABLES WITH REINHOLD MESSNER

IN AUGUST 1953, SECLUDED IN the Shropshire village of Llanfair Waterdine, John Hunt raced to complete the final paragraphs of what would become his best-selling account *The Ascent of Everest* (published in the U.S. as *The Conquest of Everest*). He concluded with some stirring words about the universal values of teamwork and comradeship, then looked to the future, suggesting quite rightly that the real challenge lay on all the other thousands of unclimbed Himalayan peaks. He looked, too, into Everest's own crystal ball and predicted that "Some day Everest will be climbed again. It may well be attempted without oxygen, although I do not rate the chances of success very high at present. Let us hope for the opening of the frontier dividing Nepal and Tibet to climbers from both sides of that political barrier, for the route to the top of the mountain by the North Face remains to be completed. The time may come when the prospect of traversing across the summit, climbing up by one ridge and descending by another, may no longer be a fantasy. These possibilities, and others, give scope for adventure in this one small area of the globe alone."[1]

Prescient words indeed, but little did he realize how quickly his predictions would be not only confirmed, but exceeded.

In terms of pure climbing adventure, the 50 years since 1953 have seen a previously unimaginable explosion of activity, with notions of what is humanly possible continually redefined, far beyond Hunt's tentative prophecies. To many minds, the mountain also has been subjected to the worst that humanity can throw at it, with examples of egotism, selfishness, and a steady decline in true adventure tarnishing the icon beyond recognition. On the political front, the border has reopened, but only in a very limited way, offering little benefit to local Nepalese and Tibetan people.

Hunt's proselytizing zeal for adventure has certainly borne fruit in the steady growth of exploratory expeditions—many supported by the Mount Everest Foundation he encouraged— to every corner of the Central Asian ranges. He can never have imagined, though, the extent to which inexpensive mass air travel would transform tourism into the world's largest industry, with mountaineers jumping enthusiastically on the bandwagon. Nor had his oxygen transport officer, Jimmy Roberts, yet dreamed up the system of guided Himalayan trekking that would blossom into a multimillion-dollar international business with Nepal at its epicenter.

Dougal Haston kicks steps up the final arête, after completing the first ascent of the Southwest Face. PHOTO: DOUG SCOTT/MOUNTAIN CAMERA, 1975

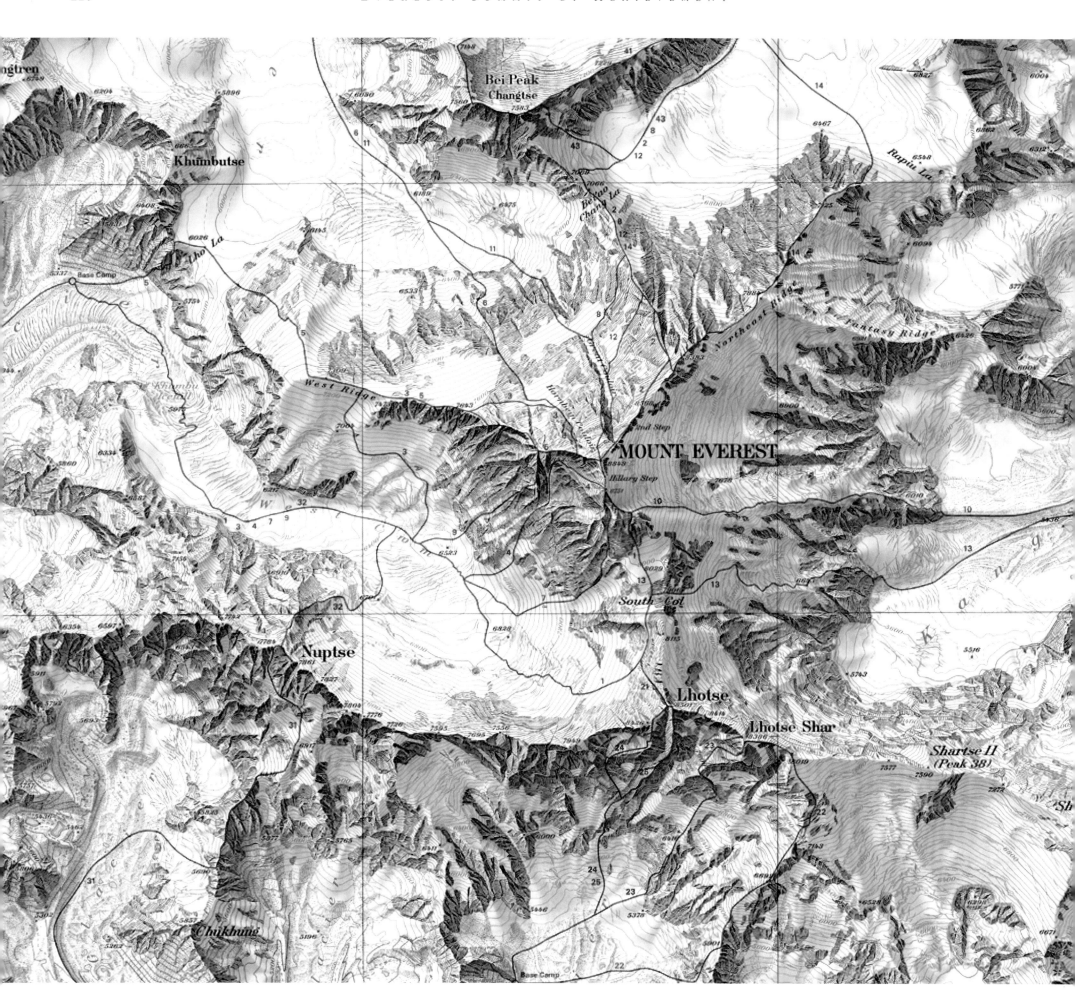

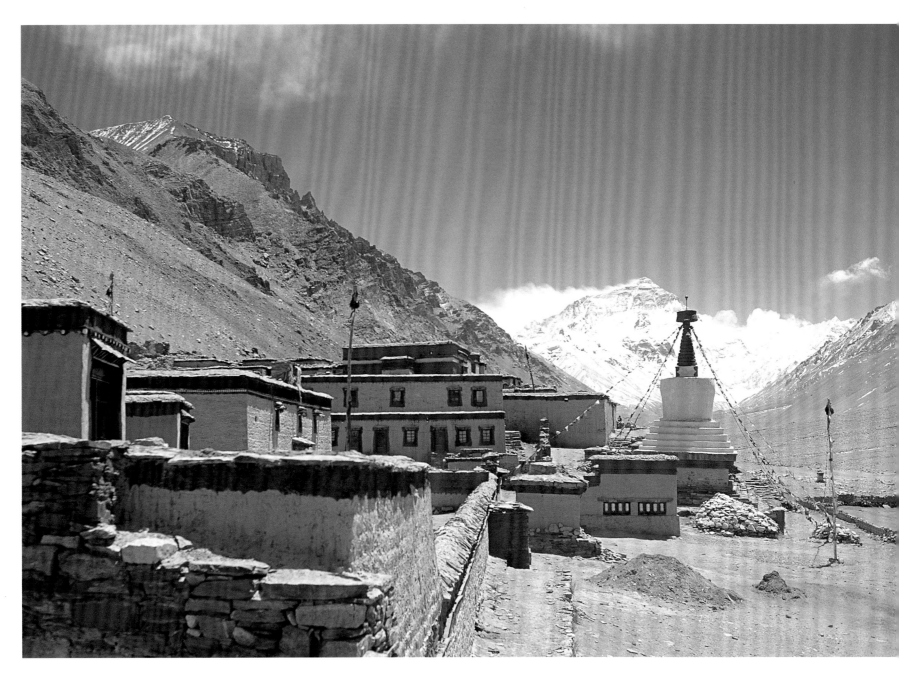

*B*radford Washburn has for many years mapped, surveyed, and photographed the Everest region. In association with the Boston Museum of Science, the National Geographic Society, and the Swiss Foundation for Alpine Research, Washburn compiled this "Everest Area; First Ascents Route Map at 1:50,000" (opposite), which shows 24 of the 43 routes pioneered to the summit of Everest.

PICTURE: SWISS FOUNDATION FOR ALPINE RESEARCH/ BOSTON MUSEUM OF SCIENCE, 1991

Nor, probably, did anyone realize how quickly Nepal's population would double, putting huge pressures on the fragile mountain ecology, not to mention the capital Kathmandu, over which a pall of pollution now hangs.

One thing the pioneers of 1953 might have foreseen, given the record of totalitarian regimes in the first half of the twentieth century, was the institutionalized madness of the Chinese Cultural Revolution and its disastrous impact on Tibet. Now, of course, some of that damage—at least the physical damage—has been patched up so that we, the foreign mountain tourists, can gawk at the lamaistic theme park represented by the monasteries at Lhasa, Shigatse, Gyangtse,

Shegar Dzong, and Rongbuk, the latter so redolent with memories of prewar expeditions to Mount Everest.

Seeking an external and personal perspective of the past 50 years on Everest, I arranged to talk to the well-known Tirolean mountaineer who has become synonymous with all that is bold, adventurous, experimental, and questioning in modern Himalayan climbing—Reinhold Messner. With his castle in the South Tirol, his farms, his highly paid speaking engagements, and his recent new role as a member of the European Parliament, he epitomizes success. Now in his late 50s, he remains phenomenally fit; at his peak he was one of the best mountaineers of all time, with strength and boldness

This Tibetan boy's warm clothing (right), essential against the searing dry wind of the high plateau, is probably all that he possesses. The contrast with the wealth of the climbers and tourists who have been coming to Tibet in increasing numbers since the border was reopened in 1980 is acute.

PHOTO: DEMETRIO CARRASCO, 2002

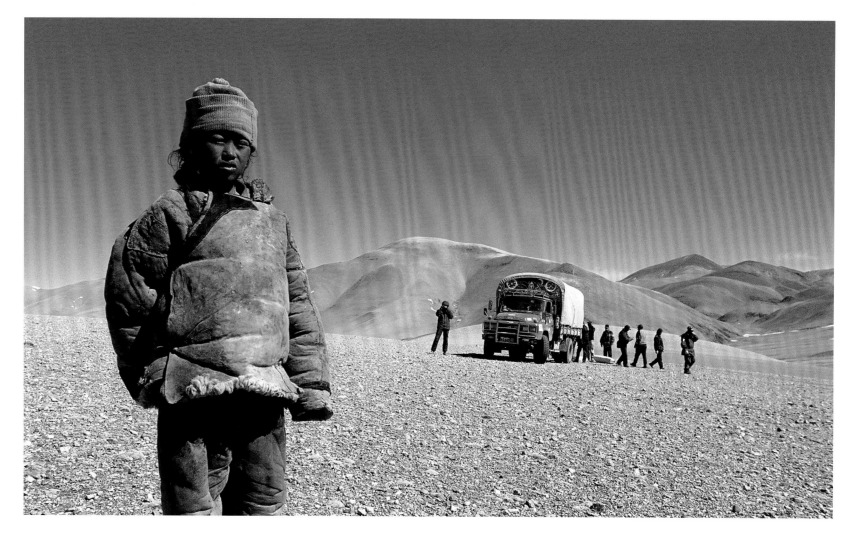

A crocodile of porters (opposite) labors toward Base Camp with yet another expedition's baggage. Porters such as these, usually from peoples other than the Sherpas, often earn little more than a dollar a day.

PHOTO: JOHN CLEARE/ MOUNTAIN CAMERA, 1971

underpinned by a long apprenticeship of hard, technical alpine climbs. However, mountaineering is not just about physical performance: It also is about the ideas and attitudes that make the performance possible. And here Messner has always been his own man—thoughtful, creative, outspoken, and at times downright opinionated. Strongly built, with long dark hair and beard, and a resonant bass voice, he has an imposing presence. His spoken English is not perfect, but it has a kind of idiosyncratic conviction that is best left unedited.

As far as Everest is concerned, Messner's greatest impact was when, with Peter Habeler, he took up John Hunt's gauntlet and reached Everest's summit without supplementary oxygen for the first time. Before that historic moment in 1978 he had been to Nepal several times, attempting Tilicho, Dhaulagiri, and Lhotse; in 1972 he reached the summit of Manaslu. I started by asking him about his first impressions of Nepal.

"I was very impressed by the Nepalis and by this landscape, which I thought was the most beautiful place in the world.

Later, of course, I discovered Tibet and found that country even more special. But I was delighted by Nepal and especially by the Sherpas. I had read Oppitz's book[2] describing how they came from Tibet in the seventeenth century, with the leader riding on a black horse; but I could see for myself that they looked different from other tribes in Nepal. They were so helpful on expeditions, like the Hunza people who had helped us on Nanga Parbat in Pakistan—only the Sherpas were better climbers."

Twenty years after the first ascent of Everest the expedition landscape had changed dramatically. All 14 of the 8000-m (26,240-foot) peaks had been climbed and a new generation, Messner included, was starting to attempt the harder unclimbed faces of the highest peaks in the world. Meanwhile, Jimmy Roberts's Mountain Travel trekking business was just beginning to spawn the first copycats. Although large areas of Nepal's hinterland remained virtually unknown, a few mountain honeypots—Annapurna and Everest in particular—were seeing a regular stream of tourists. And the Sherpas, those inveterate

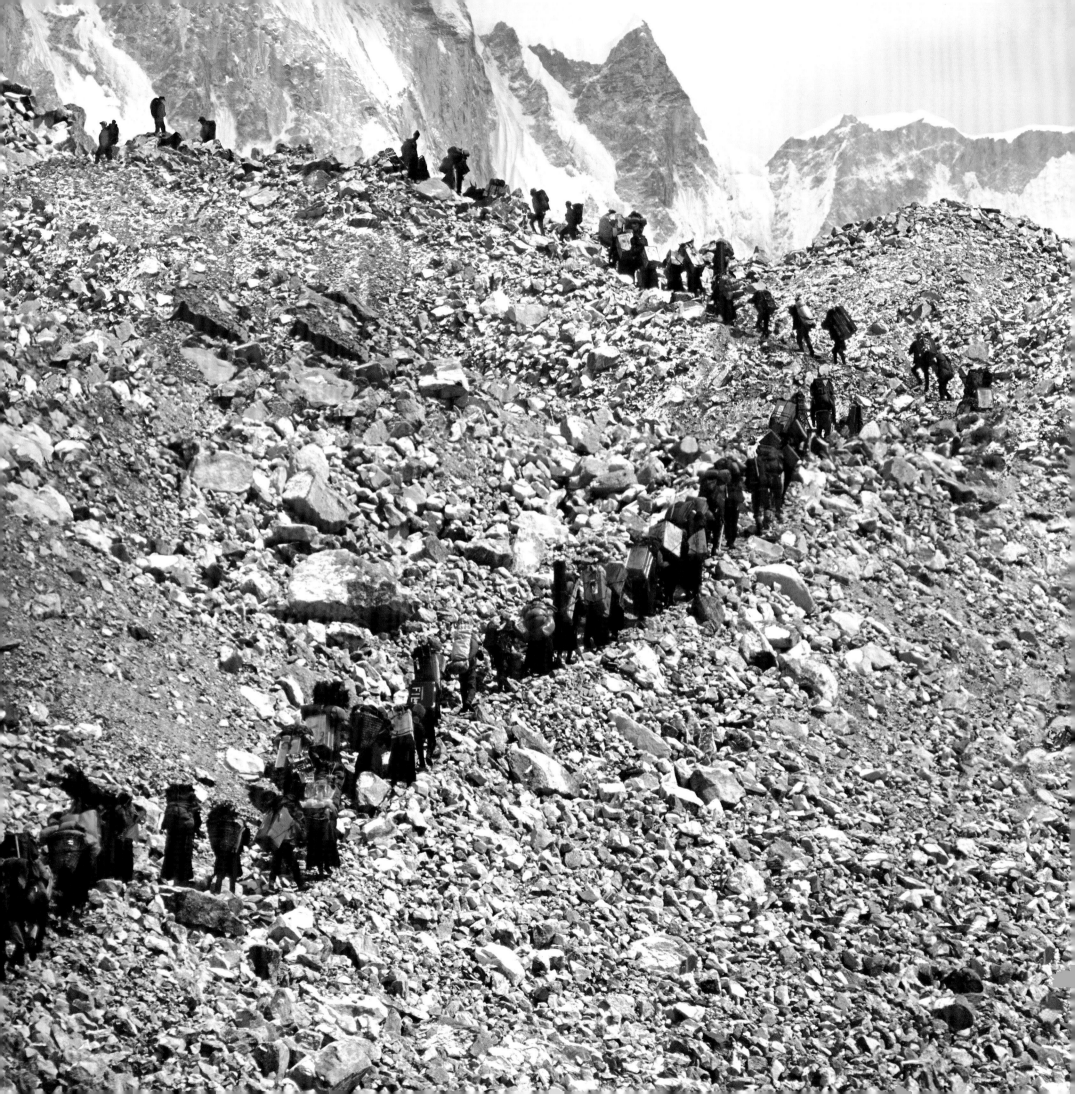

entrepreneurs now denied regular trade with Tibet, were cashing in on the new commercial opportunities.

Despite all that, Nepal remained, and still remains, one of the poorest countries in the world. Even the most insensitive Western mountaineer cannot help but feel uneasy at the contrast between the expense of his self-indulgent hobby and the spartan lives of the local subsistence farmers who eke a living from the mountain landscape. Some climbers have decided to address that imbalance, most notably Sir Edmund Hillary. Where John Hunt used the kudos of Everest to embark on a new career of public service at home in Britain, Hillary decided to cultivate his philanthropic tendencies right at the foot of Everest, in Solu Khumbu. It really got started in 1961, at the end of the Silver Hut Expedition.

The Silver Hut was a prefabricated base for a highly successful medical research expedition organized by Griffith Pugh, physician on the 1953 expedition. The medical team included Michael Ward, and the mountaineer test subjects included Barry Bishop, soon to join the first American Everest Expedition, and Edmund Hillary. The mountaineering successes

Class 10 students studying algebra at Khumjung School, founded in 1961 by Sir Edmund Hillary's Himalayan Trust. Many of the high-altitude porters who worked for the 1953 Everest Expedition came from this village, so it was a natural choice for the first of several schools now established in Solu Khumbu.

PHOTO: BRUCE HERROD, 1993

of the Silver Hut Expedition included the first ascent of the Sherpas' stupendous holy mountain, Ama Dablam, but the true climax came at the end of the expedition, when some members of the expedition stayed on there to help build a schoolhouse in the village of Khumjung—the first of many schools, clinics, and hospitals to be built in Solu Khumbu with money raised by Hillary's Himalayan Trust.

As Messner said, "Without Hillary being a figurehead, it could never have happened. I have great respect for what he has done in Nepal; I think his social work is just as important as his ascent of Everest." As the following generation's comparable celebrity, Messner has also seen through the romance of mountain peasant life, to the reality of infant mortality and all the other health problems posed by subsistence living in a harsh, remote mountain landscape. A combination of strategic airstrips and local hospitals has now brought medical assistance closer. But for Messner the schools are the most important contribution to Sherpa life. "In a globalized world you have to have English and Mathematics to survive. Particularly when things get hard and some people have to travel to cities to find work."

But what, I asked him, about the criticism sometimes leveled at Hillary that his work has focused all the attention on a tiny minority, the Sherpas, at the expense of all the other people, such as the Rais, Gurungs, Tamangs, and so on, who inhabit the Nepal Himalayas, not to mention all the millions living in the lowlands? Ever quick to point out the venality of Kathmandu government officials, Messner fires back: "Those Nepalis who criticize Hillary are not very intelligent. He cannot provide schools and hospitals for the whole of Nepal! These things have to be done on a small, local scale, with one person responsible for each area. Hillary's system *works*, and, in fact, I am trying to set up something similar myself in the Diamir Valley, below Nanga Parbat, in Pakistan."

It was on Nanga Parbat (26,660 feet/8126 m), where Messner achieved the first ever traverse of an 8000-m peak, that he launched his own Himalayan career in 1970. Despite the trauma of his brother's death on the descent—and almost losing his own life—he was soon back in the Himalayas and, from 1975, forging a new path. Turning away from the traditional heavy-handed assaults on the highest peaks, his

Children working and playing among the temples and market stalls of Durbar Square, Kathmandu. Despite earnings from tourism, Nepal remains one of the poorest countries in the world.

PHOTO: STEPHEN VENABLES, 1988

climbs were planned to show what could be done by the smallest teams, taking to its logical conclusion the philosophy espoused by earlier pioneers such as Longstaff, Tilman, and Shipton. As the most forceful prophet in the high-altitude wilderness, Messner is amply qualified to comment on what has happened on the highest mountain of all since 1953.

As we talked through the highs and lows of 50 years of climbing history, he made sure that I did not forget the Swiss. They pioneered the South Col route in 1952, and in 1956 they returned, not only to make the second ascent of Everest, but, in the same beautifully organized expedition, to climb Lhotse as well. However, the first real leap forward came in 1963 during the American ascent. Jim Whittaker took the first honors, climbing from the South Col with Tenzing's young cousin

Nawang Gombu, who had worked so hard for the British in 1953. But it was Tom Hornbein and Willi Unsoeld who made the most significant history three weeks later with their West Ridge route. In fact, the ridge crest itself was too hard, but their trespass on to the North Face into Hornbein's eponymous couloir was, to Messner's mind, "a genius solution. And going up there, not knowing the way down … and that beautiful sunset photo of the American flag on the summit."

Messner was singing to the tune of adventure, applauding the commitment of those two Americans in 1963, reaching the summit late in the day by a completely new route, knowing they had to get down the Hillary Step before nightfall, then meeting Lute Jerstad and Barry Bishop, who had climbed the now "normal" route (Hillary and Tenzing's) the same day,

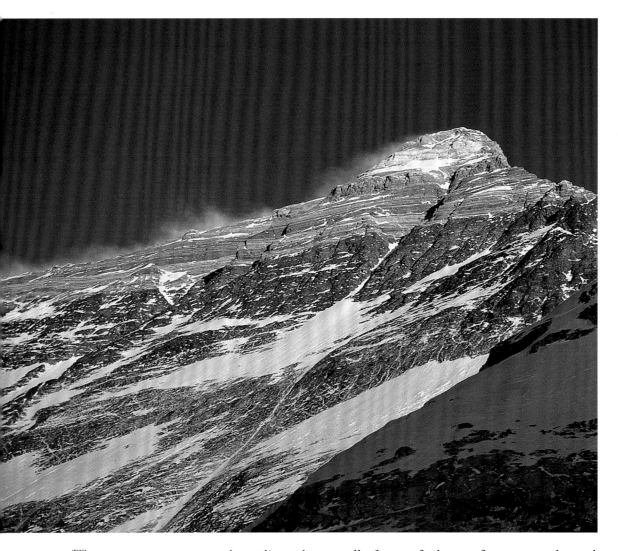

The sedimentary rocks of the Yellow Band glow bright orange at sunset. The great sweep of Everest's North Face is bound on the right by the complex turrets and steps of the West Ridge, possibly the hardest route on Everest, first climbed by the 1979 Yugoslav expedition. In 1963 Tom Hornbein and Willi Unsoeld cleverly outflanked it and traversed diagonally left into the great cleft of the Hornbein Couloir.

PHOTO: ED WEBSTER, 1985

and settling down—all four of them—for an unplanned bivouac at about 27,900 feet (8506 m). Messner also pointed out that the Hornbein Couloir was only the second new route made up an 8000-m peak (the first was the Diamir Face of Nanga Parbat in 1962).

Nawang Gombu returned to climb the South Col route again, this time with the Indians in 1965, becoming in the course of the expedition the first person to reach the summit of Everest twice. But it was the Hornbein Couloir that had pointed the real way forward—finding new, harder ways to the summit. In the early 1970s, while Reinhold Messner was cutting his own Himalayan teeth on Nanga Parbat and other peaks, a succession of huge, heavily funded teams was laying siege to what was increasingly hyped as the ultimate Himalayan challenge—the Southwest Face of Everest. Rising 8000 feet (2440 m) from the Western Cwm, the face was huge and brutish, with an uncompromising great band of vertical black rock starting at about 26,250 feet (8000 m).

Forging his path as an international mountaineering celebrity, Messner had his own designs on the wall. "At one point I tried to go with a very rich Italian expedition leader, Guido Monzino. I made a proposal to use his South Col route permit in 1974 and accompany the Italians into the Western Cwm, then make my own way up the Southwest Face. But he said 'No.' So the next year, in 1975, I was looking at exactly what Chris Bonington was doing on the Southwest Face, hoping they would fail once more!" Bonington had already tried the face unsuccessfully in 1972. This time he was better prepared, with a formidably talented British team, a small army of well-equipped high-altitude Sherpa porters, a slick timetable getting the climb underway as soon as the monsoon dissipated at the end of August, and a healthy dose of luck in the form of beautiful, clear, autumn weather. Late on September 24, 1975, Dougal Haston and Doug Scott reached the summit just as the sun was setting, committed, like Hornbein and Unsoeld, to a bivouac in the open. Assuming that Mallory and Irvine did not make it to the top in 1924, they were the first Britons to reach the summit. In Messner's estimation it was an outstanding feat: "What they did—that long traverse across the top of the Southwest Face, on difficult snow … then the South Summit gully, and the bivouac … was very impressive. I was in Salzburg, on a lecture tour, when I saw an English newspaper announcing their success; and I decided then that I would have to try it without oxygen. So I owe it to Chris Bonington's team that I found the energy to go and climb Everest without oxygen."

Few mountaineers admit to such naked ambition, but Messner always seems to have been determined to make history. His chance came in 1978 when he and his Tirolean colleague, Peter Habeler, hitched themselves to a large German-Austrian team climbing the South Col route. The team provided the vital permit and infrastructure within which the oxygenless pair acted as a semi-autonomous unit.

Why, I wondered, had no one else attempted this during the 25 years since the first ascent? "I think that the oxygen factor had become a prejudice. It started in 1922 when Finch got higher than Mallory, and they got the feeling that oxygen was necessary. And with the success of Hillary and Tenzing in 1953 using oxygen, the whole world thought that this must be the only way. Nobody had the interest to say 'Let's try.' In the

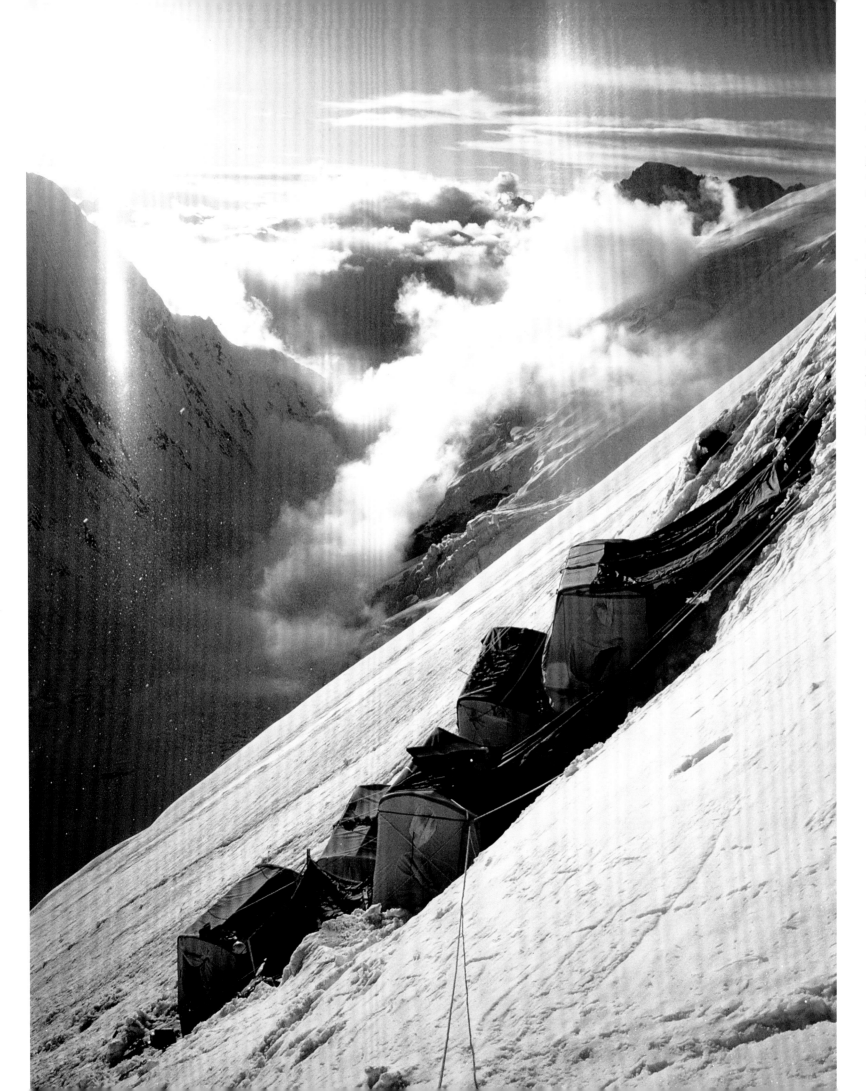

Early attempts on the Southwest Face of Everest were plagued by avalanche and rockfall. For the successful ascent in 1975, Hamish MacInnes designed bombproof box tents, here stacked on prefabricated alloy platforms at Camp IV. They made a secure base from which alternating teams could set to work on the infamous rockband above them.

PHOTO: DOUG SCOTT, CHRIS BONINGTON PICTURE LIBRARY, 1975

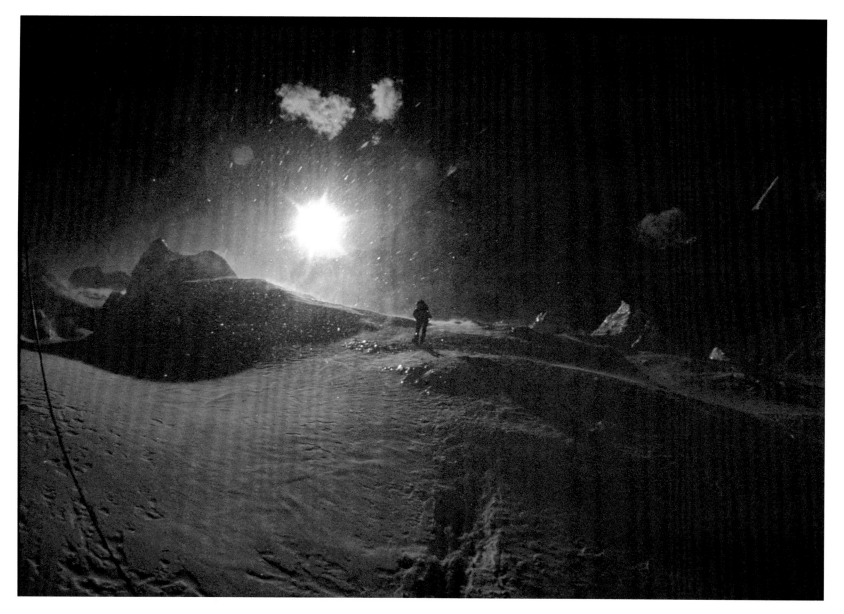

Reinhold Messner
(left) fights through
blasting spindrift
during the first
oxygenless ascent of
Everest in 1978.

PHOTO: REINHOLD
MESSNER, 1978

1970s, Everest was still a big deal and, because only the Nepal side was open, the only big challenge available was the Southwest Face. But once that had been climbed, then the next thing was to try the mountain without oxygen."

And try he did. On the first attempt, Habeler felt unwell, so Messner climbed with Ang Dorje and Mingma Nuru to the South Col. "The weather was perfect and I was thinking maybe I can climb to the summit with these two Sherpas. We had no oxygen with us." But then a terrible storm struck the exposed wind funnel of the col, and they found themselves fighting for their lives. "As one tent collapsed, I put up my tiny bivouac tent inside the second big tent, which was also about to collapse. We spent two nights without cooking or drinking. All the time Dorje was very helpful, but Mingma was only lying there complaining and saying he was going to die."

After two days, battered and dangerously dehydrated, they were able to escape back down to Base Camp, after which the main oxygen-assisted team reached the summit successfully. Then Messner, who had recuperated remarkably well, returned to the South Col, this time with Peter Habeler. On May 8, 1978, in slightly more than 10 hours, they climbed all the way from the South Col to the summit, with no supplementary oxygen, thereby vindicating those prewar Everesters who had believed that this was the right way to climb the mountain.

As Messner put it: "I had always thought that if Norton could climb to 28,126 feet (8575 m) in 1924, without oxygen, why not go 902 feet (273 m) more? After my descent of Nanga Parbat, I always knew that going down would be possible; the only question was whether I could climb *up* that last bit without oxygen."

Reinhold Messner
and Peter Habeler
(opposite) make their
way up the now
famous route into the
Western Cwm, passing
beneath the cliffs of
Nuptse. In those days
only one expedition per
season was allowed to
attempt Everest and it
was only by attaching
themselves to Oswald
Ölz's large, traditional
expedition that the two
men could make their
semi-independent
oxygenless attempt
on the summit.

PHOTO: REINHOLD
MESSNER, 1978

Now they had proved that it was indeed possible, although Habeler was so terrified of brain damage resulting from lack of oxygen that he turned round immediately and made an astonishing one hour descent to the South Col. Messner lingered to do more filming, removing his goggles for some time. Back at the Col that night he became snow blind. Habeler had developed a severe headache and the two men seemed utterly spent when the Welsh member of the film team, Eric Jones, escorted them down the next day.

For those of us hearing the news back at home, the first oxygenless ascent was an inspiration. But in Nepal, there was a briefly unpleasant aftertaste. Goaded by journalists asking why Europeans, not the legendary Sherpas, had been the first to achieve this feat, absurd rumors began to circulate about hidden caches of oxygen—even little mini-cylinders carried in the climbers' pockets! Messner thinks that the rumors started with Mingma Nuru. Be that as it may, Mingma himself reached the summit without oxygen the following fall, with Ang Dorje, for whom Messner has only praise: "He was a *very* nice man and very strong. He became one of my best friends and later became a climbing member—not just sirdar—of my Kangchenjunga expedition, coming to the summit with us."

Despite his remarks about the Southwest Face being the only real unclimbed challenge accessible from the Nepal side at that time, a Russian team did climb a magnificent and harder companion route up the left-hand buttress on the face in 1984. Before them, in 1979, a Yugoslav team made the first ascent of the massive West Ridge direct. "Yes," agreed Messner, "this may be the most difficult route on the mountain." The summit team included Andrej Stremfelj who, 24 years later, remains one of the world's most active and successful Himalayan climbers.

The Yugoslavs reached the Lho La—the saddle at the start of the gigantic West Ridge—from the Nepalese side. But by now, in 1979, overtures were being made for the first legal visit by foreigners to the northern side since 1938. For four decades, while the Tibetan people had been subjected to invasion, indoctrination, reeducation—and, at times, wholesale massacre—to force them into the mold of Maoist Communism, their holy Chomolungma had become a testing ground for the collective spirit. When Doug Scott and Dougal Haston reached the summit in 1975, they found a surveying tripod left by

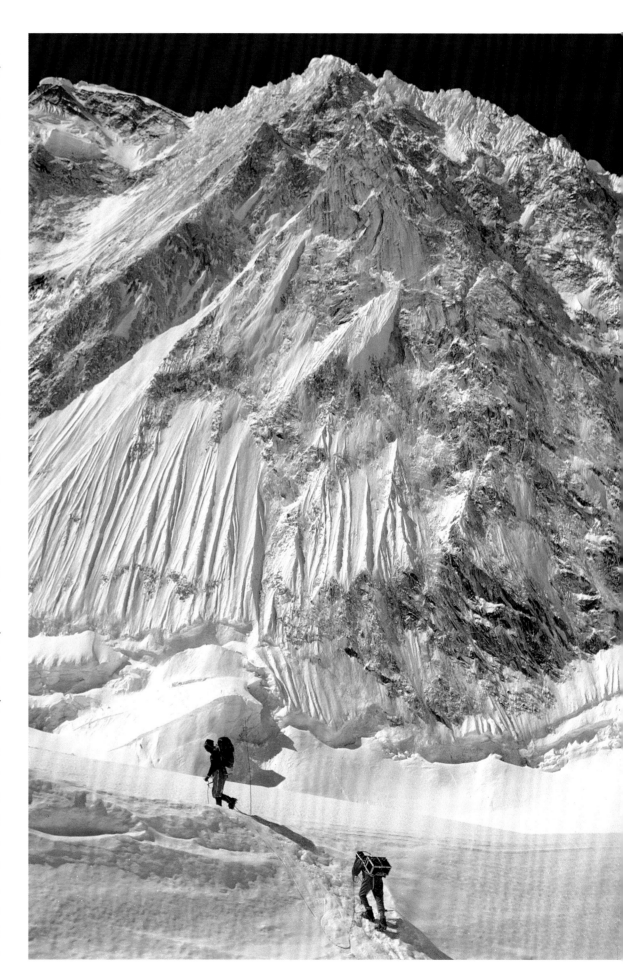



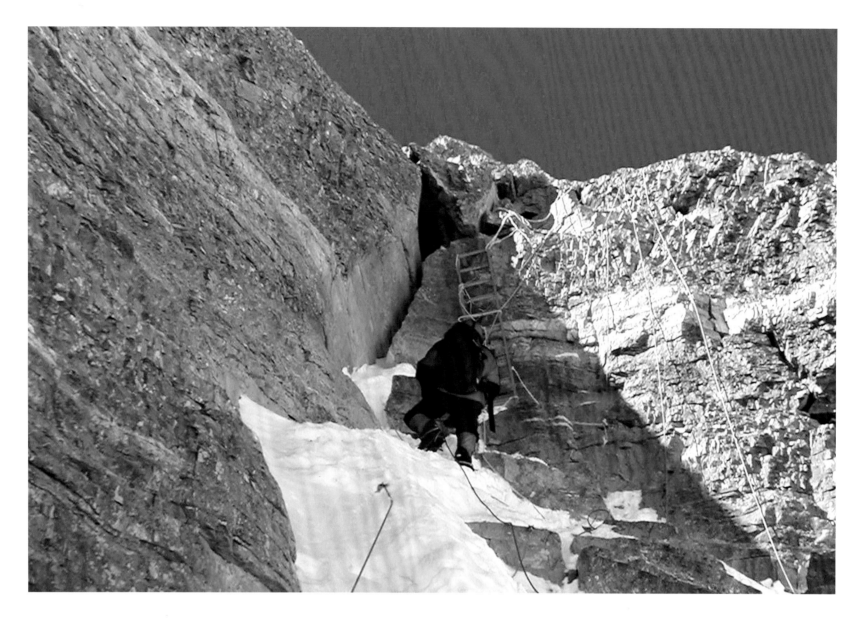

A climber on a recent expedition approaches the infamous Chinese ladder (right), bolted to the final vertical section of the Second Step in 1975. In 1999 the American climber Conrad Anker attempted to free climb the wide crack to the left of the ladder. Apart from stepping briefly on one of the rungs, he succeeded. He protected the hard moves with a modern camming device placed in the crack and wore rubber-soled boots. Anker thinks it very unlikely that Mallory and Irvine succeeded in climbing this obstacle in 1924.

PHOTO: JAVIER SALAZAR, 2002

Dawson Stelfox (opposite), on his way to becoming the first Irishman on top of Everest, approaches the famous Second Step on the Northeast Ridge. Everest's summit appears tantalizingly close, but the immediate terrain is steep and exposed over an 8000-foot (2440-m) drop. The photo also shows just how formidable is the Second Step. The route taken by the Chinese pioneers climbs up the right-hand side of the Step, with the ladder bolted to the steepest section at the top.

PHOTO: FRANK NUGENT, 1993

the Chinese earlier that year—irrefutable proof that they had completed the British prewar route all the way to the summit, successfully scaling the infamous Second Step with the aid of a metal ladder, which remains bolted to the rocks to this day, although it was not mentioned in the official account of 1975.

What remained controversial—and is still doubted by many experts to this day—is the Chinese claim of an earlier ascent in 1960. Improbability seemed to ooze from every sentence of the official account, from the apparently crazy claim that Chu Yin-Hua had scaled the final vertical cliff of the Second Step barefoot, to the constant references to Party solidarity and the inspiration of Chairman Mao. Not for the first or last time, Chomolungma was being hijacked as a vehicle for propaganda. When I asked Reinhold Messner about the 1960 claim he told me that the American mountain filmmaker David Breashears

had just viewed a new version of the Chinese 1960 film. "Breashears says there is no doubt from the film that the Chinese reached the top of the Second Step in 1960. But maybe this version has had parts of the 1975 film edited into it? I do not think they succeeded on the Second Step. I think they got to the foot of the Step and realized it was not climbable. We know that they tried again in 1974 and then knew exactly what they needed, so that in 1975 they came with a special ladder, prepared in sections."

My own feeling is that one cannot dismiss the Chinese claim so lightly. Reading between the lines and through all the hype, there are crucial points of accuracy, such as the description of traversing round onto the North Face just below the summit—precisely the route taken by all modern parties completing the final part of the Northeast Ridge above the

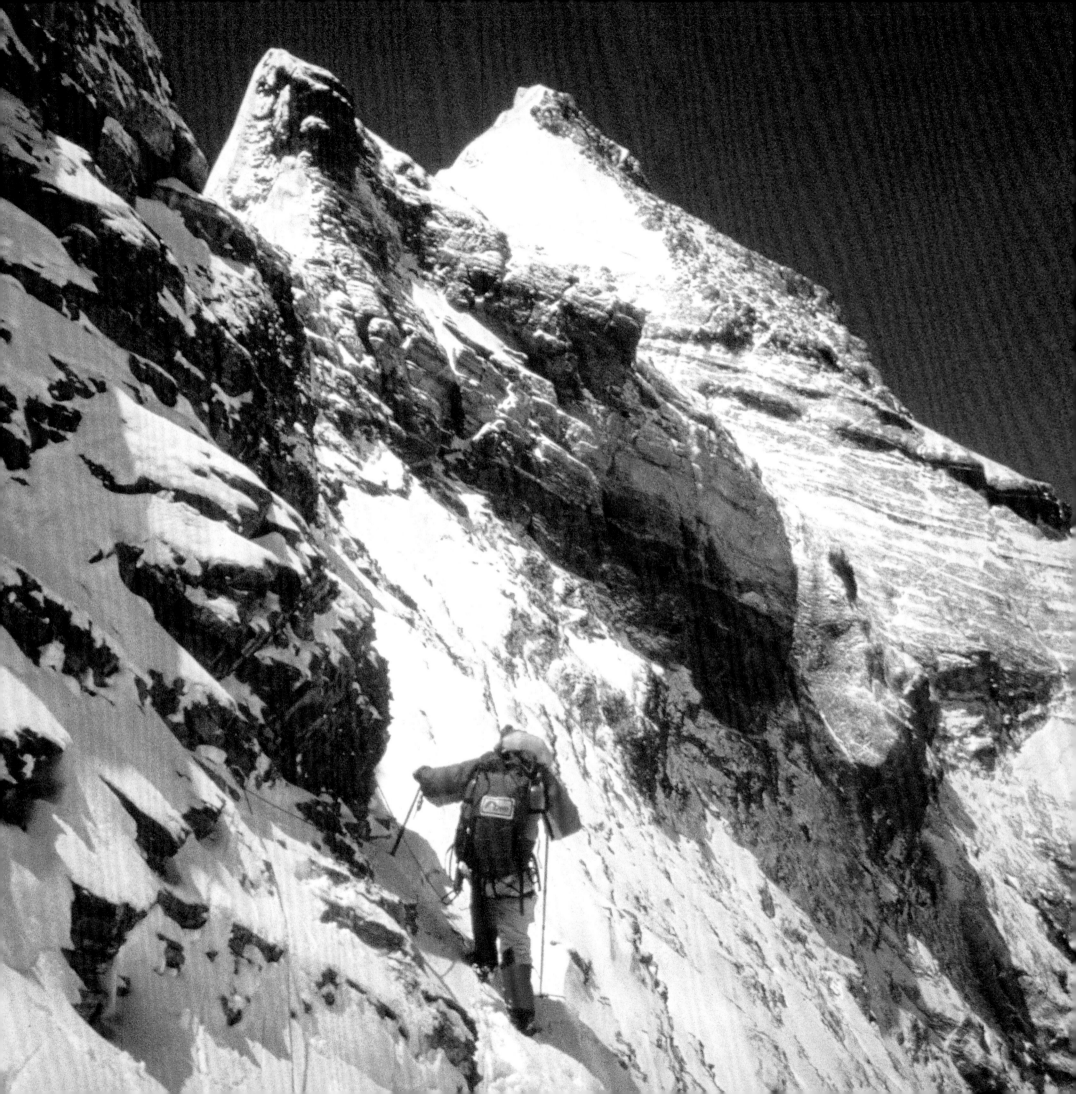

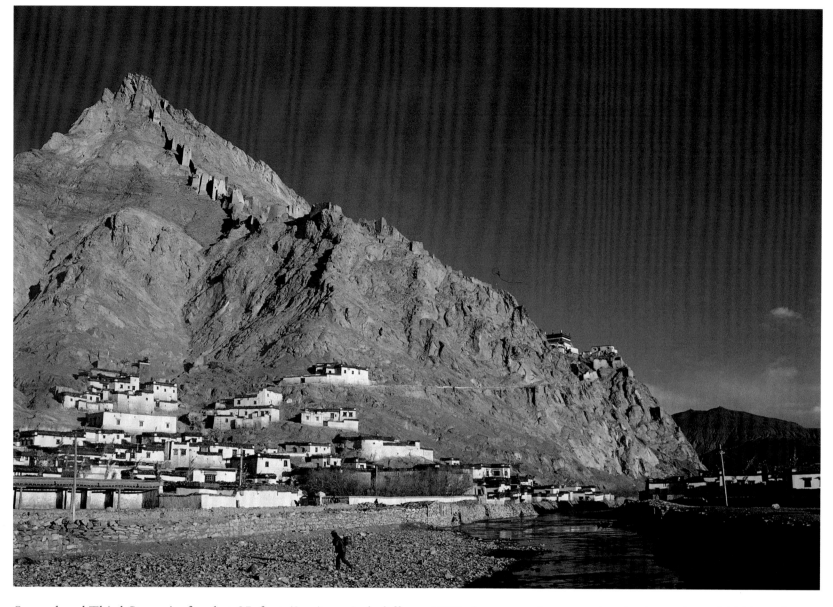

Second and Third Steps. As for that 25-foot (8-m) vertical cliff at the top of the Second Step, on a fine, windless day, even at 28,200 feet (8595 m) on dry rock, climbing with bare feet is just conceivable for a suitably determined zealot prepared to sacrifice his feet to the inevitable frostbite. Of course, unanswered questions remain—such as how they got back down the Step, having spent the night out above it—but there seems to be a significant germ of truth in the summit claim.

With President Nixon's visit to Beijing, then Mao's death in 1976 and the subsequent move toward the liberalization of China, the first tourists began to arrive—and the first mountaineering tourists in the now Chinese-occupied province of Tibet. Ever-assiduous in the search for prestigious new mountain terrain, the Japanese were the first outsiders to visit the old prewar Rongbuk Base Camp, with a reconnaissance in

1979, then a massive operation in the spring of 1980, with one team repeating the Chinese North Ridge/Northeast Ridge route and another team creating a new route, the huge couloir cutting through the lower cliffs of the North Face to attain the Hornbein Couloir, first approached from the West Ridge in 1963. Despite the large numbers of people involved, both summit attempts ended up as bold, lonely affairs. On the Northeast Ridge, Yasuo Kato reached the summit alone; having previously climbed the South Col route, he was now the first person to have climbed Everest from both sides. (Two years later, after making the first winter ascent of Everest, he disappeared on the descent.) On the face route, Shigehiro Tsuneo and Ozaki Takashi ran out of oxygen about four hours below the summit, but continued without, reaching the top late in the day and bivouacking on the way down. Once again,

modern attitudes and modern insulation equipment had allowed climbers to risk pushing on in a manner that had been unthinkable to the prewar pioneers.

Meanwhile, Reinhold Messner had put in his own bid to be permitted to visit the north side of Everest in 1980. "I wasn't allowed to be there at the same time as the Japanese, so I had to come later, during the monsoon." For company he had with him just his girlfriend, Nena, and the Chinese interpreter and liaison officer. "I had a very nice liaison officer, who let me do what I liked—walking a long way towards the Nangpa La [the pass that formed part of the old Sherpa trading route between Tibet and Nepal], going to look at Shishapangma [26,336 feet/8027 m high, some 60 miles/100 km distant from Everest], meeting many nomads and pilgrims. I was specially fascinated by the villages. I found that these people were living a bit like the farmers in my own valley in the South Tirol, where I grew up in the 50s. When I was 13 and 14, I spent two summers working on a farm. At one stage I even wanted to be a farmer. The Himalayan farmers operate a similar system to what we used to have in the Alps—keeping the cattle (or yaks in Tibet) down in the valley in the winter, then bringing them gradually up to higher pastures in the summer … what's the word? Yes—transhumance."

It was the beginning of a long love affair with Tibet, but it was not all rosy. "Around Rongbuk we found many, many caves where hermits had been living, but the monastery itself was *totally* destroyed. You could see that it had been done with big artillery." The irony is that that artillery was presumably hauled up the road built to facilitate the climbing expedition of 1960. Now, post Cultural Revolution, the recent damage was less serious, but still depressing: "On the glaciers there was a lot of material from the Chinese and Japanese expeditions. There were even telephone wires all the way up the East Rongbuk Glacier to Advance Base."

For his own climb, Messner did not even take a radio. This was to be the ultimate, pared down, minimalist project—the first (and so far only) true solo ascent of Everest. It nearly came to a sticky end in the early hours of August 18 when Messner paid the soloist's most obvious penalty and fell into a concealed crevasse below the North Col. Totally alone on the mountain, Messner was lucky to escape alive and, as he crawled out along

Reinhold Messner's evocative self-portrait shows him standing alone in monsoon cloud on the summit of Everest in 1980. The 1975 Chinese survey tripod, now almost buried in Everest's ever-changing summit cornice, provides incontrovertible proof of Messner's incredible solo ascent.

PHOTO: REINHOLD MESSNER, 1980

precarious snow bridges, he thought that he should pack it in this time. But as he emerged into the starlight he changed his mind. "Only because I had had this fantasy—because for two years I had been *pregnant* with this fantasy of soloing Everest—was I able to continue."

Carrying his tiny lightweight tent, sleeping bag, stove, and basic rations on his back, he continued on and camped part of the way up the North Ridge, then slanted diagonally right, as Finch and Bruce had done in 1922, traversing a full 1.2 miles (2 km) before stopping to pitch his tent a second time, at 26,900 feet (8200 m).

On the third day he entered the Great Couloir, continued up it, and achieved what had eluded Norton, Wager, Wyn-Harris, and Smythe—continuing up, out of the Great Couloir on to the final terraces leading to the summit.

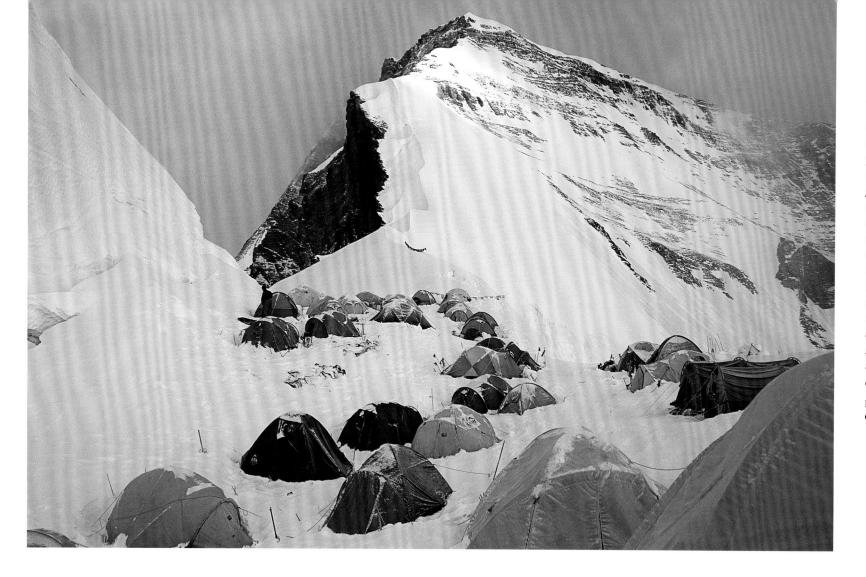

This scene (left) would be familiar to any veteran of the prewar Everest expeditions—the glacial shelf in the lee of the North Col, site of what used to be called Camp Four, with the summit of Changtse rising behind. However, the massed nylon-domed tents of several modern expeditions jostling for space could hardly have been imagined by the early pioneers.

PHOTO: DEMETRIO CARRASCO, 2002

Utterly alone, far above any other human beings on earth, isolated in the clouds, he struggled on wearily, stopping at the last moment to rig up his self-timer camera and record his final steps up to the Chinese tripod on the summit. Later, he wrote in *Mountain* magazine: "I was in continual agony; I have never in my whole life been so tired as on the summit of Everest that day. I just sat and sat there, oblivious to everything … I knew I was physically at the end of my tether." Back at the tent that night he was too weak even to eat or drink, and the next morning he ditched all his survival equipment, adding his contribution to Everest's litter and committing himself to descending all the way to Advance Base in a single day.

Since 1980 no climber has quite repeated what Messner achieved—not that total solitude. Even during the monsoon period, it has become quite normal for teams to attempt the north side of the mountain, hoping to snatch the same window of opportunity that Messner seized so cannily at the end of the summer. As for the spring and fall seasons, they have seen ever-increasing numbers on the mountain, making any true solo climb an impossibility.

Looking at what has happened since 1980, four main trends seem to have emerged. First, there has been the continuing quest for difficult new routes up the mountain, often achieved by large, heavily equipped teams. Second, the small teams operating without oxygen, trying to develop the spirit of self-contained adventure. Third, the search for ever more improbable "firsts" such as the first winter ascent, first flight from the summit, first ski descent, first night out on the summit, and so on. And fourth, the ever-increasing numbers of commercially organized teams "guiding" massed ascents of the two "normal" routes up the mountain—that is, the South Col/Southeast Ridge and the North Col/Northeast Ridge.

Talking over these trends with Messner, I have no doubt that his sympathies lie with the small teams. Nevertheless, he acknowledges that the first winter ascent of the mountain, achieved by a huge team of Polish climbers led by the charismatic Andrej Zawada in February 1980, was a great ascent, resonant with all the dogged, patriotic determination so typical of Polish climbers at that time. He acknowledges the true pioneering spirit of the American team that first climbed

Robert Anderson, leader of the 1988 Kangshung Face Expedition, follows a fixed rope up a steep rockband (opposite). Although the team was small—just four climbers with no high-altitude porters in support—they decided to fix ropes, spending nearly a month working at the hardest section of the route.

PHOTO: STEPHEN VENABLES, 1988

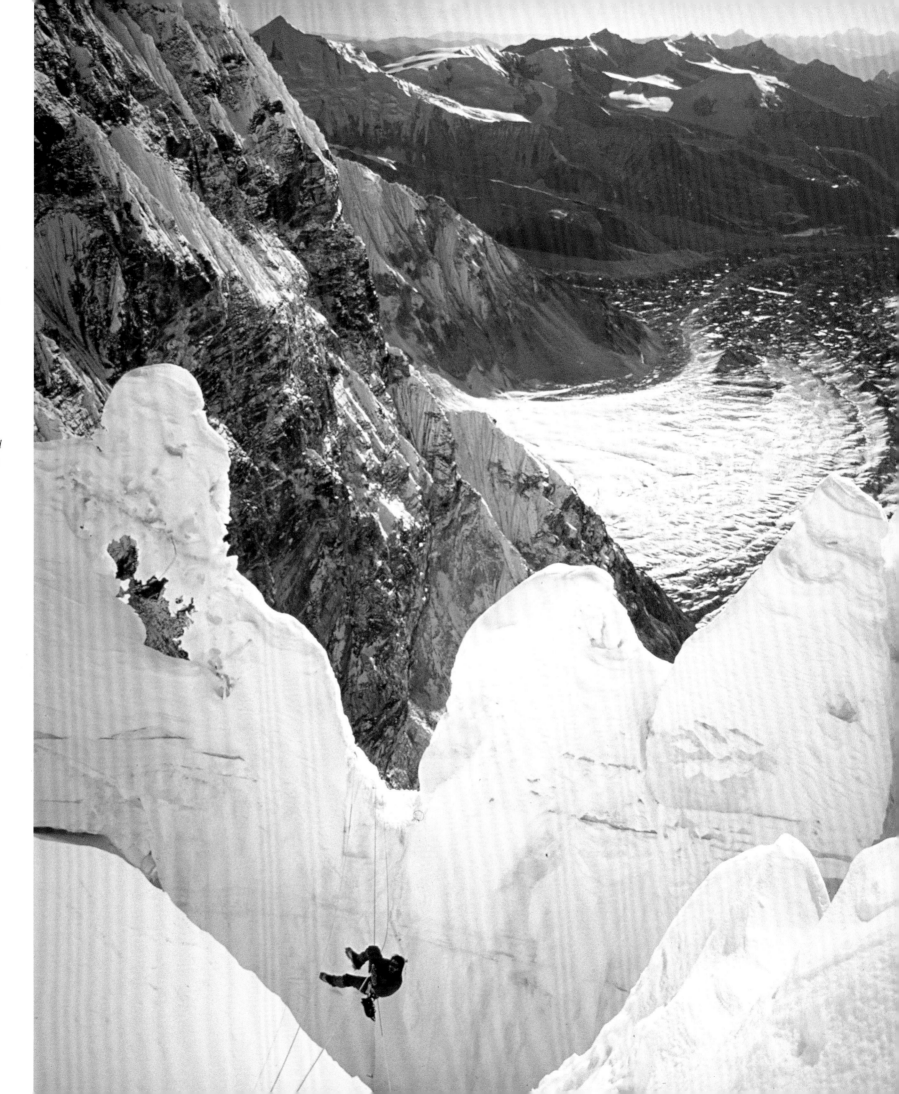

Ed Webster, one of the four-man American-Canadian-British Expedition up the Kangshung Face, crossing a crevasse 3000 feet (910 m) above the Kangshung Glacier in 1988. In the absence of metal ladders, he rigged this Tirolean traverse over the chasm. Behind him is the majestic profile of the giant buttress climbed by the 1983 American expedition, probably the hardest technical climb on Everest. Immediately behind that, on the horizon, is the pyramid summit of Khartse, the mountain climbed by Nyima and George Mallory in 1921.

PHOTO: STEPHEN VENABLES, 1988

the great East Face—the Kangshung Face rejected so unequivocally by Mallory—in 1983, putting five climbers on the summit. But what about the complete Northeast Ridge, where Peter Boardman and Joe Tasker disappeared in 1982— was their attempt doomed? "It was a great idea to try it like that in alpine style and they both had a lot of experience. But seeing how the Japanese later climbed it—a huge expedition in 1995 with many, many fixed ropes and oxygen—I can see that Boardman and Tasker did not have much of a chance. Maybe they were forced to carry on because they could not retreat."

Photos from the 1995 Japanese expedition show just how precarious is the terrain through the Pinnacles of the Northeast Ridge. However, in 1988, the New Zealander Russell Brice, with the Briton Harry Taylor, did succeed in climbing in a single push through the Pinnacles, helped just by some oxygen for sleeping. As for Boardman and Tasker, the exact nature of their fate, like Mallory and Irvine's, remains a mystery. In 1992, a Kazakh expedition found Boardman's body, sitting in the snow on the Second Pinnacle. It looked as though he had just died of exhaustion or hypothermia. Of Tasker there was no sign.

More feasible for a small team without oxygen was the new line up the North Face achieved by the first Australians ever to climb Everest, in 1984. They called their route "White Limbo" after the huge central snowfield on the North Face that led them into the Great Couloir. In essence, they made the first complete ascent of the Great Couloir, with Tim Macartney-Snape and Greg Mortimer reaching the summit at sunset. Even more impressive than this was the climb, two years later, that really took Messner's vision a stage further. In just 40½ hours the Swiss climbers Erhard Loretan and Jean Troillet romped up and down the Japanese Couloir/Hornbein Couloir route, eschewing tents or sleeping bags and relying on the comparative warmth of the daytime to rest and recuperate halfway up the 8000-foot (2440-m) climb.

Messner was full of admiration for what the Swiss men achieved, particularly Loretan: "I think he and the Polish climber Jerzy Kukuczka were the best high-altitude climbers at that time. And this direct route up the North Face is a very logical way to the summit. I think this would have been the best route for Mallory and Irvine, because it is probably easier than the Northeast Ridge." I reminded him that the Swiss did

it in September, when the route was banked up with monsoon snow. "Ah, yes, in the spring, with bare rocks and hard ice, they never could have managed in 1924. But in the autumn, maybe," Messner conceded.

Others continued to try and emulate the lightweight approach. The British climber Alison Hargreaves made a brilliantly efficient, competent, oxygenless ascent of the North/Northeast Ridge route in 1995, carrying all of her own equipment and making her own camps, despite the other teams on the route. Enjoying a less crowded experience, I took part in an American-Canadian-British ascent of a new route up the Kangshung Face in 1988, joining the 1953 route at the South Col. We felt proud to add one of the last new routes to the mountain with a team of just four climbers, unaided by oxygen or high-altitude porters; and, like so many other parties, I found myself forced to bivouac in the open, returning from the summit—in this case alone—too late in the day. All of us clucked appreciatively when the guru, Messner, later said it was one of the great Everest climbs of recent years.

While our small group was plowing our lonely furrow up the Kangshung Face in 1988, a huge international "Asian Friendship" Expedition was ushering in a new era, with a simultaneous, televised traverse of the northern and southern "normal" routes. Suddenly Everest was becoming crowded. Over the next few years, more and more teams would gather each year, particularly for the spring season, to lay siege to the two main routes up the mountain. Fixed ropes proliferated on all the hard sections and it became quite normal for 30 or more people to arrive on the summit on a single day.

Some people continued to achieve remarkable feats. Particularly impressive was the ski descent of the complete 1953 route by the Slovenian Davo Karnicar in 2000. Even more astounding was Marco Siffredi's 2001 descent of the North Face on a snowboard, assisted by Lobsang Temba. And in terms of sheer physiology, the Sherpa Babu Chiri upped the ante in 2000 with his sprint up the 1953 route, taking just 16 hours to get from Base Camp to summit, to complete his 10th ascent of the mountain and equal Ang Rita's previously unchallenged tally. Messner acknowledges such astonishing athleticism with reservations: "I could never have done it that fast, even when I was in my prime—Babu Chiri was amazing."

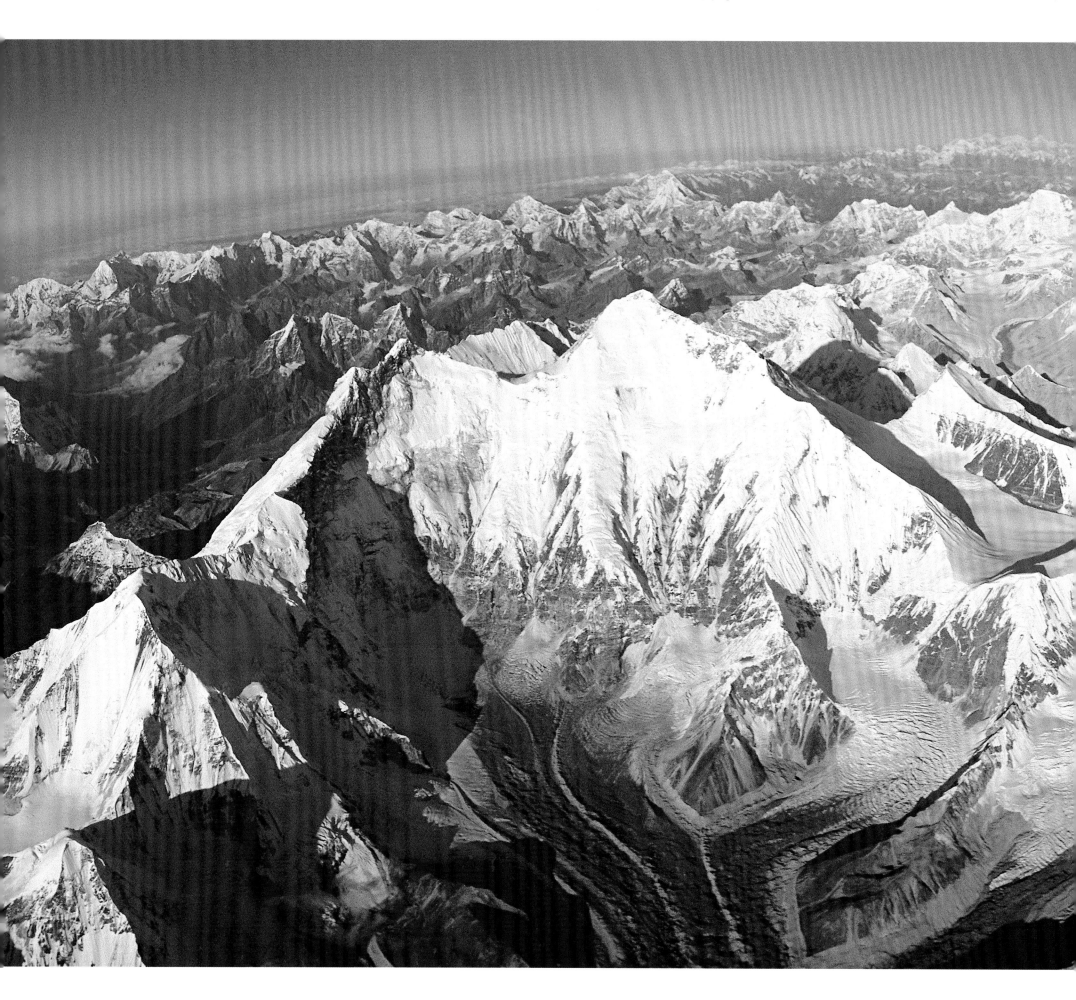

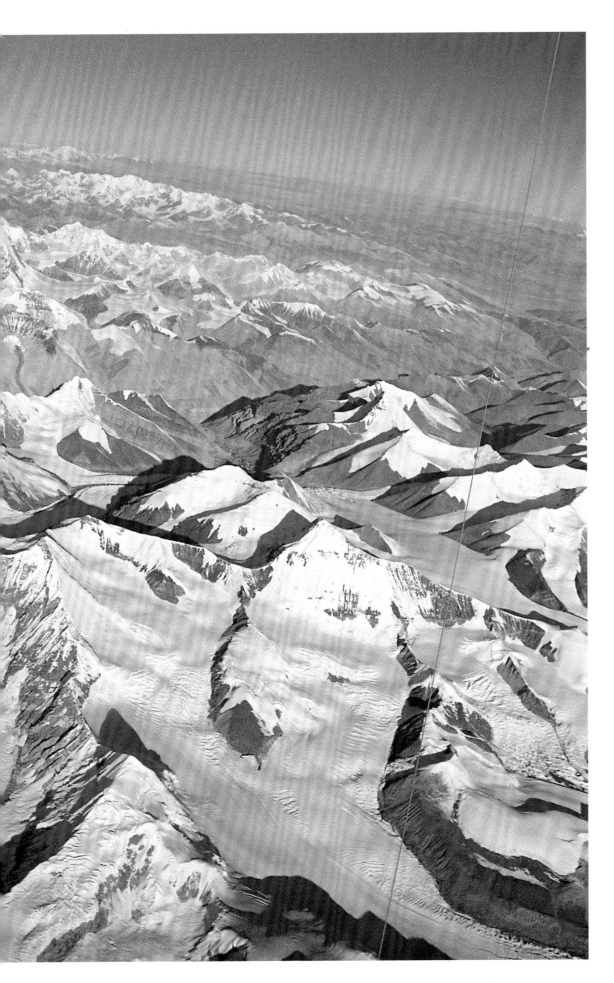

Leo Dickinson took this stunning panorama during his dangerous balloon flight in 1991 (opposite). The huge East Face of Everest is just left of center, with the Kangshung Glacier flowing down to the bottom of the photo. To the right is the complex glacial puzzle explored on foot by the Everest reconnaissance, 60 years earlier.

PHOTO: LEO DICKINSON, 1991

Marco Siffredi (above) near the start of his astonishing snowboard descent of the North Face. He is traversing below the prominent vertical gray step at the top of the North Face.

PHOTO: JEAN MARC PORTE, 2001

Thamel, the tourist quarter of Kathmandu and commercial hub of Nepal's trekking, climbing, and river-rafting industry.

PHOTO: RAUL LEDESMA, 2002

But what is interesting is to go on *new* lines, with no infrastructure. The whole deal is to be responsible for yourself, not relying on other people—going and going and going and not knowing if you are able to get back."

To some, that might seem unduly elitist, but he remains convinced that there are simply far too many people on the mountain—hence the public's obsessive fascination with rubbish tips and dead bodies on the mountain. For Messner, discarded oxygen bottles—even cadavers—at the South Col are not destroying Everest. "The real problem is the huge Base Camp on the south side (and to a lesser extent the Rongbuk). Having 500 people living on the glacier, which is the water source for all of the Solu Khumbu—*this* is the problem. People are attempting solutions with special toilet huts, rubbish disposal, and so on. But I think the real solution would be for the Nepalese government to go back to having just *one* permit on *one* route per season—like it was in my time. That way you do your own approach and are not interfering with anyone else. But the Nepalese are getting a lot of money from all the permits, so they prefer to have all these expeditions."

He is certainly correct that Everest is a big earner, not only for individuals in Kathmandu, but also for the local people of Solu Khumbu. And, yes, there is evidence of bacteriological contamination of the Dudh Kosi (the main river of the Khumbu) traceable to Everest Base Camp, although the Khumbu Glacier is only one of many sources draining into the main valley. Perhaps we should return to those halcyon days of the 1970s, when one lucky, heavily sponsored team per season could enjoy some serenity on Sagarmatha. But the chances of that seem very remote. As George Lowe put it to me once, mountaineers "opened the oyster;" although the majority of the 15,000 or so annual visitors to Solu Khumbu are not Everest climbers, it is the pioneering mountaineers who open the doors to commercial trekking in remote mountain regions. The onus is therefore on mountaineers to act responsibly.

Litter can be carried down from high camps, and not necessarily just by egotistical, self-serving, Western "clean-up" expeditions that generate their own superfluous waste, but in the normal course of events, paying Sherpas to bring down all the junk that most sahibs are too weak or lazy to carry themselves. The question of Base Camp pollution is more complex, but the problems should be soluble. England's Peak District National Park, like Solu Khumbu, an area populated by indigenous farmers and traders, manages to cope with 22 million visitors a year, as opposed to Solu Khumbu's 25,000. Of course, England has roads, railways, abundant electricity, and all the infrastructure of a rich industrialized nation; nevertheless, with appropriate technology and intelligent regulations, properly enforced, Solu Khumbu and other Himalayan regions ought to be manageable.

Talk of rules and regulations will be anathema to many mountaineers who pride themselves on their free-spiritedness. When George Lowe and his friends were "opening the oyster" 50 years ago there was no need for regulations. While vast tracts of the Himalayas still see no Western visitors for years on end, in popular areas such as Solu Khumbu things must be "managed." To some extent, these changes are already happening. The Sagarmatha Pollution Control Committee, for instance, has had some success in redressing the more deleterious effects of tourism. But there needs to be wider, more comprehensive compliance, with everyone—both foreign visitors and successful

local Sherpa businessmen—cooperating. Likewise, there must also be consolidation of the slow move toward kerosene and micro-hydroelectric schemes to lessen reliance on firewood and relieve some of the pressure on the forest. George Lowe, Hillary's loyal supporter and trustee of the Himalayan Trust for so many years, has helped organize the planting of hundreds of thousands of slow-growing *Pinus wallichiana* seedlings. For all the talk of deforestation and environmental degradation, the Sagarmatha National Park looks in pretty good shape. The real problems lie further down the valley, below the park boundaries, where the forests are not protected. Some of the wood still finds its way up into the park to fuel hot showers for foreign trekkers and climbers. But much of the wood also goes into local kitchen fires, and the age-old practice of lopping foliage for animal fodder continues.

The local population explosion—not Everest sightseers—is the most potent threat to the environment. In just eight years,

from 1994 to 2002, the national population rose from 20 million to 24 million. As for the Tibetan side of the mountain, timber extraction from the idyllic Kama Valley has increased in recent years. At the moment, the timber is carried, log by log, on the backs of phenomenally tough Tibetan men and women. But if the Chinese government ever completes its project to build a road into the valley….

Returning to Messner and steering him away from the sordid business of Everest overcrowding in the twenty-first century, back to the beautiful high valleys that surround the mountain, I asked what he thought about the benefits of tourism versus traditional subsistence farming. "In Tibet I think they will continue with this kind of semi-nomadic farming for the next few decades. They have nothing else: All the money from tourism goes to Party officials. In Nepal the local people are benefiting a little more from tourism." But what about their traditional agricultural skills, I wondered—was there a

Mountaineers and trekkers bring with them the modern disease of excessive packaging. Here, mounds of rubbish litter the natural rocky debris of the Tibetan landscape beside the East Rongbuk Glacier. Some organizers of commercial Everest expeditions are now building comprehensive rubbish removal into their budgets, but there remains the question of what to do with the rubbish once it has been brought down. The Sagarmatha Pollution Control Committee, on the Nepalese side of Everest, is trying with limited funds to address the problem.

PHOTO: ROGER MEAR, 1990s

danger that they will be lost? "The best is to combine local self-sufficient agriculture with selling the surplus to tourists. That is much more intelligent than porters carrying in Coca Cola for the visitors. They should produce special local food. For instance, from yak meat they could make something similar to our carpaccio. And sausages. And good cheese from the milk—they are already doing this lower down in Nepal. All this produce could be sold to trekkers and to expeditions, for use at their Base Camps. This is what I am doing at my own farm in the South Tirol: *local* culture in combination with tourism. Our produce is sold direct to the tourists in the mountains, because lower down you cannot compete with the supermarkets."

What of the future? When the first foreign mountaineers visited the Swiss village of Zermatt, below the Matterhorn, 150 years ago, the local shepherds, farmers, and craftsmen eked out an impoverished existence. Now the valley is filled to bursting with hotels, bars, and glitzy shops and the people of Zermatt live very comfortably off their mountain goldmine. In the 82 years since the first British explorers set foot on Everest, little has changed at Rongbuk and Kharta. On the Nepalese side there has been much more development during the 50 years since John Hunt set up his base at Thyangboche. The people of Solu Khumbu have to some extent capitalized on the foreigners' obsession with their mountain, just as the hoteliers and mountain guides of Zermatt did in the nineteenth century. Many, like my friend Pasang Norbu, owner of Pasang's Lodge and Restaurant in Namche Bazar, maintain quite a satisfactory equilibrium, balancing Buddhist ritual, traditional yak herding, and subsistence vegetable growing with the modest cash rewards offered by tourism.

In Pasang's case, he started his career as a cookboy at Everest Base Camp, working under the legendary sirdar and old colleague of Eric Shipton, Ang Tharkay. Later, Pasang progressed to the more lucrative but dangerous role of high-altitude porter, carrying loads to the South Col. Now retired from high-altitude work, he organizes treks, owns several lodges, and runs a bottled mineral-water company.

It is doubtful whether Namche Bazar will ever begin to approach the glittery wealth of Zermatt. The Himalayan landscape is just so massive, wild, and unstable compared to the Alps—and the countries involved so desperately poor in comparison to Europe. Even with a massive redistribution of the global economy, there just wouldn't be enough money to go round. For the moment, the changes remain incremental and, if they are handled intelligently, places like Solu Khumbu will retain the kind of pastoral charm that so delights the foreign visitors. As for the mountain that put Namche, Thyangboche, Rongbuk, and Kharta on the international map, it will continue to be the magnet that draws the crowds.

Until recently, most of them just came to look from a distance. Now, increasingly, they actually want to tread on its summit and are prepared to pay good money to get there, even if they have not necessarily built up the skills and intuitive attitudes necessary for the job. Things came to a head in 1996 when 12 people died, most of them in a single storm. Among the dead were three experienced guides, driven, apparently, by an overwhelming desire to bolster their companies' reputations by getting as many clients as possible to the summit. Reinhold Messner was not surprised. "In the 1980s I had a rich man approaching me and asking me to take him up Everest, but I said 'no—it's too dangerous.'"

Some might think that the pejorative use of the word "rich" is perhaps a little disingenuous coming from the first mountaineering millionaire, who has managed, shrewdly, to make a lot of money from his vocation. But that misses the point of his criticism, which is that Everest's real value—its potential as a symbol for all of our hopes and dreams and aspirations—depends on the spirit in which it is approached. Messner put it to me this way: "Today the world thinks that Everest has great prestige, but they don't understand that this prestige is meaningless if you are relying on infrastructure—following a line of ropes prepared by Sherpas. The real challenge is not there. Nobody is doing difficult lines, nobody is doing new routes. It has become boring. But the public still thinks you've climbed Everest so you are the greatest. We have to remember the approach of the local people. They have always seen the mountains as holy. We too can respect the mountains if we see them as almost *beyond* our abilities. If we use all the technology available to approach the mountains in an aggressive way, we destroy that respect. But if we limit the means at our disposal, there will always be something *beyond our ability*, and that is vital."

Everest's North Face towering behind Changtse—the view that has formed a backdrop to the lives of generations of Rongbuk monks. Monsoon snow blankets the mountain and, from this distance, there is no sign of the detritus left by the visiting foreign mountaineers. What can be seen are the legendary landmarks such as the North Ridge, the Yellow Band, the Great Couloir, the Second Step, the Hornbein Couloir, and the West Ridge, which still, after all these years, evoke a deep thrill in anyone who dreams of climbing to the top of the world.

PHOTO: STEPHEN VENABLES, 1988

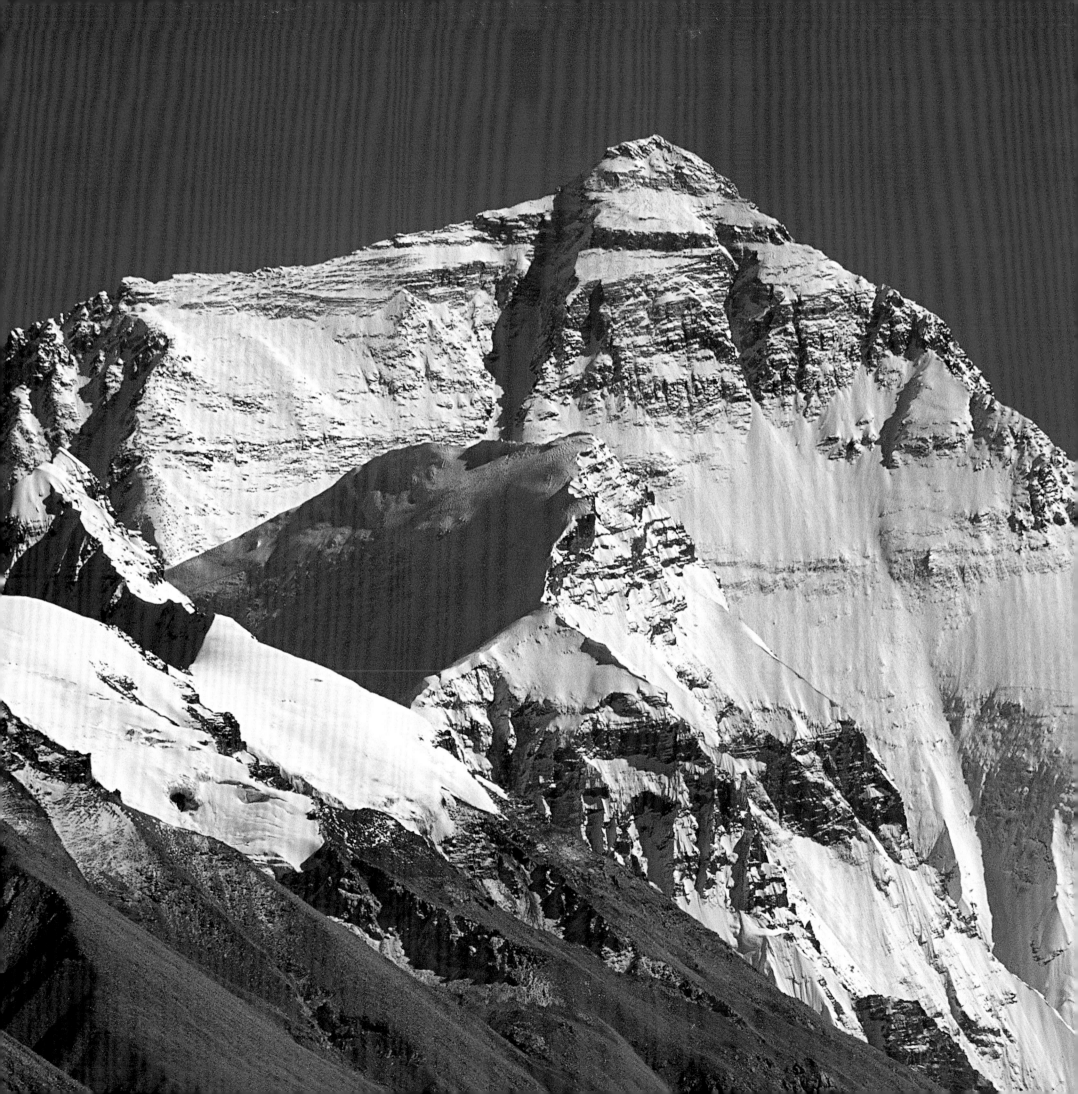

MOUNT EVEREST EXPEDITION MEMBERS, 1921–1953

Ang Nyima *(1931–1986)*

Ang Nyima, who lived in Darjeeling, was on both the spring and fall Swiss expeditions to Everest in 1952. In 1953, he worked on the Lhotse Face, and was the only Sherpa apart from Tenzing Norgay to carry a load to the top camp.

Later that year he went to the Annapurna Group with the Japanese. In 1957 he went to Machhapuchare and in 1960 to Annapurna II, reaching the summit. Later, he enlisted in the 10th Gurkha Rifles and saw service in Malaya and Borneo.

Ang Tharkay *(1907–1981)*

Born and raised in Khumbu, later migrating to Darjeeling, Ang Tharkay's first expedition was to Kangchenjunga in 1931. He was on Everest in 1933, 1935, and 1938, when he was cook and sirdar, having been formally made sirdar for the first time on Nanda Devi in 1934. He was exceptional as both climber and sirdar, and his character won high praise from all who knew him.

He went to Annapurna with the French in 1950, to Everest in 1951, to Cho Oyu in 1952, to both Dhaulagiri and Nun in 1953, to Makalu in 1954, and finally to Everest with the Indians in 1962. In his last years, he farmed a large parcel of land to the south of Kathmandu.

Ang Tshering *(c. 1904–2002)*

A member of the 1924 and 1933 expeditions, Ang Tshering was born in Khumbu but went to Darjeeling at the age of 16.

He was with Smythe on Kamet in 1931, and went with German teams to Kangchenjunga and Nanga Parbat, where in 1934 he was the only survivor among three sahibs and six Sherpas when a storm destroyed Camp VIII (24,000 feet/7315 m). He took part in six postwar expeditions before finally reaching a summit himself (Nanda Ghunti, 20,700 feet/6309 m) when he was 52 years of age.

George Christopher Band *(1929–)*

George Band, who already had several fine alpine climbing seasons behind him, was the youngest member of the 1953 expedition.

In 1955, on Charles Evans's expedition to Kangchenjunga, he and Joe Brown were the first to reach the top of the world's third highest peak. In the 1950s he also climbed in the Karakoram, Peru, and the Caucasus, as well as in the Alps and in Britain. After retiring from 36 years in the international oil industry, most of which was spent overseas, he continues to enjoy modest climbing and trekking in the greater ranges, having latterly visited Nepal, Bhutan, and Sikkim. He is a former President of the Alpine Club and of the British Mountaineering Council.

Bentley Beetham *(1886–1963)*

Bentley Beetham was a climbing member of the 1924 expedition. Plagued by dysentery and sciatica, he never made his mark on the advanced stages of the expedition but still managed to take some fine photographs.

Beetham was a pupil and then a teacher at Barnard Castle School, County Durham, for over 40 years. He was an enthusiastic and experienced mountaineer, and also a close friend of Somervell, with whom he made 32 alpine ascents in six weeks in 1923. As an expert ornithologist, he wrote several bird books. Following Everest, Beetham continued to climb in the Tirol and the High Atlas of Morocco, but never regained his health after a serious fall while climbing in Britain.

Colonel Eugene St. John Birnie *(1900–1976)*

"Bill" Birnie was transport officer of the 1933 expedition, having helped Smythe to his 1931 ascent of Kamet. In the annals of Everest he is largely remembered for a vehement disagreement with Wyn-Harris, which cost two days in establishing Camp V at 25,500 feet (7770 m) and, possibly, the success of the expedition.

Birnie was a career soldier who fought in the Third Afghan War (1919) and served in India, the Middle East, and Italy. He was a fluent speaker of Hindi and a good polo player. After World War II he served as military secretary to the Governor-General of Pakistan (1947–48) and as secretary to the Church of England Children's Society (1949–65).

Thomas Duncan Bourdillon *(1924–1956)*

Tom Bourdillon was largely responsible for developing the closed-circuit oxygen apparatus used by Charles Evans and himself on their pioneering climb to the South Summit in 1953. Before that, he had been with Shipton on the 1951 reconnaissance and on Cho Oyu in 1952. He was in charge of all oxygen equipment in both 1952 and 1953.

Educated at Oxford, he made his career as a physicist employed on rocket research. A quiet and modest man, he was an inspiring figure in the postwar renaissance of British climbing in the Alps, leading climbs of a standard not hitherto attempted by British climbers. He died while attempting a route on the Jägihorn, in the Bernese Oberland.

Colonel Sir John Edmund Hugh Boustead *(1895–1980)*

Hugh Boustead was a climbing member of the 1933 expedition, for which he was recommended by Norton following his 1926 exploration of the Zemu Gap on the northeast shoulder of Kangchenjunga. On Everest, he incurred Ruttledge's wrath when his premature descent with Birnie cost two days in establishing Camp V.

Boustead had a long military and political career spanning 25 years in Africa (where he commanded the Sudan Camel Corps in 1931) and 16 years in Arabia. In 1920 he captained the British Olympic Modern Pentathlon team.

Thomas Anthony Brocklebank *(1908–1984)*

Tom Brocklebank was a climbing member of the 1933 expedition, for which he was recommended by Longstaff, and provided creditable support up to Camp V.

Like Irvine, Brocklebank was a rower at Oxford; he was, however, a more seasoned mountaineer, with three alpine seasons under his belt by the time he joined the Everest expedition. From 1934 to 1961, he was a teacher at Eton College.

Brigadier-General Charles Granville Bruce *(1866–1939)*

Charlie Bruce (known as "Bruiser"), hard-drinking Himalayan veteran and larger-than-life leader of the 1922 expedition, was a fluent Nepali speaker who, both in 1922 and 1924, bridged perfectly the cultural divide between sahib and Sherpa. However, malaria forced him to relinquish his leadership of the 1924 expedition to Norton while he was still en route to the mountain.

Bruce served a swashbuckling career with the Gurkhas (1889–1920) and was severely wounded at Gallipoli in World War I. Bruce's extensive mountaineering experience included climbing with Conway in the Karakoram (1892), with Mummery on Nanga Parbat (1895), and with Longstaff on Trisul (1907). From 1931 to 1936 he was Honorary Colonel of the 5th Royal Gurkha Rifles of the Indian Army. When Bruce was felled by a stroke in 1939, Raymond Greene was his doctor.

Major-General John Geoffrey Bruce *(1896–1972)*

As a young Gurkha officer, Geoffrey Bruce was invited by his cousin General Bruce to serve as transport officer and interpreter on the 1922 expedition. On effectively his first ever climb, the younger Bruce achieved the remarkable feat of accompanying Finch to a then-record altitude of 27,300 feet (8320 m), using oxygen. In 1924 Geoffrey Bruce again proved an invaluable climber, carrying loads to Camp V at 25,500 feet (7770 m).

From a young soldier in the Third Afghan War of 1919, Bruce rose to become Deputy Chief of General Staff of the Indian Army. He retired in 1948.

Leslie Vickery Bryant *(1905–1957)*

"Dan" Bryant was invited by Shipton on the 1935 reconnaissance for his superb ice-climbing skills and irrepressible Kiwi humor, which sustained him on ten climbs of over 20,000 feet (6100 m).

Between 1930 and 1946 he was a schoolteacher, mainly in the South Island of New Zealand, where he climbed extensively in the Southern Alps. During sabbaticals in London in 1934 and 1938 he climbed also in the European Alps. As a New Zealander, this popular and energetic man indirectly influenced Shipton's decision to invite Hillary and Lowe on the 1951 reconnaissance. Bryant died in a car crash.

Guy Henry Bullock *(1887–1956)*

Guy Bullock reached the North Col at 23,000 feet (7010 m) on the 1921 reconnaissance with Wheeler and Mallory, his old schoolfriend and climbing companion from the Ice Club run by Graham Irving, a senior master at Winchester College.

Born in Beijing, Bullock was a level-headed mathematician, who followed his father into the Consular Service and spent 34 years in Africa, South America, and Europe. He was given special dispensation to join the 1921 reconnaissance by Lord Curzon, then British Foreign Secretary.

Chheten Wangdi *(?–?)*

Chheten Wangdi was interpreter and general agent for the 1921 reconnaissance expedition.

Wangdi was Tibetan, and had been a captain in the Tibetan army. He was also attached to the Indian army in Egypt during World War I.

Colin Grant Crawford *(1890–1959)*

"Ferdie" Crawford (so called for his resemblance to Czar Ferdinand I of Bulgaria) joined the 1922 expedition as transport officer, a role at which he was "useless" according to General Bruce. A good rock climber, but not a strong performer at altitude, Crawford escaped the disaster on the North Col in 1922 that killed seven porters. He later returned to Everest in 1933.

On graduating from Cambridge, Crawford entered the Indian Civil Service. In the 1940s he taught at Eton with Brocklebank and in his latter years sometimes fished with Longstaff in Scotland, where he died on his local cricket pitch, aged 69.

Dawa Tenzing *(1907–1985)*

Born and living all his life in Khumbu, Dawa Tenzing had memories of the disappearance of Mallory and Irvine on Everest in 1924. His expedition record before 1952 is lacking, but in his middle years, 1952–63, he took part in a series of expeditions—reaching the South Col twice in both 1952 and 1953, being sirdar of the 1955 Kangchenjunga expedition, and going again twice to the South Col with the Americans in 1963.

Retaining the Sherpas' traditional pigtail, he made no concessions to modernity, and those who knew him held that he had a certain "presence." He was a devout Buddhist and earned respect for his character and his performance as climber and sirdar, and affection for his wicked sense of humor.

Sir Charles Evans *(1918–1995)*

Robert Charles Evans was deputy leader in 1953, making the first ascent of the South Summit of Everest with Tom Bourdillon. He led the successful Kangchenjunga expedition in 1955, which put four climbers on the summit, and himself took a load to the top camp.

Evans was educated at Shrewsbury and Oxford. He climbed in the Alps in 1939, and again after the war, as well as extensively in Britain. As a young doctor, he served in the Burma campaign in World War II, and was mentioned in dispatches for bravery. Later, he became a neurosurgeon in Liverpool. In 1950, he embarked on a decade of climbing and mountain exploration in the Himalayas. In 1958 he was appointed Principal of Bangor University in Wales, holding that post until retirement in 1984. Shortly after this appointment, he began to suffer from multiple sclerosis, which cut short his climbing career, although for some years he engaged in adventurous small-boat sailing.

Professor George Ingle Finch, FRS *(1888–1970)*

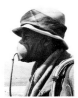

George Finch reached 27,300 feet (8320 m) on Everest in 1922 accompanied by Geoffrey Bruce, both men using oxygen.

Finch was a firebrand—Australian by birth, but raised as a German-speaker in Switzerland, where he both climbed and studied physical sciences at Geneva University. Finch fell out with the Everest Committee after 1922, but his pioneering work on oxygen, which he pursued with messianic zeal, remained crucial to future expeditions. From 1936 to 1952 Finch was Professor of Applied Physical Chemistry at Imperial College, London. He never climbed in the Himalayas again, but remained a strong devotee of the Alpine Club, of which he became President.

Major-General James Merricks Lewis Gavin *(1911–2000)*

"Jim" Gavin was the only member of the 1936 expedition without previous Himalayan experience. Nevertheless, he made a creditable climb with Smythe to the North Col.

Gavin read mechanical sciences at Trinity College, Cambridge, where he was an active member of the University Mountaineering Club. His other interests included skiing and sailing. During a long army career with the Royal Engineers, Gavin specialized in sabotage during World War II. His last posting was as Assistant Chief of Staff, Intelligence. After leaving the army, Gavin joined the British Standards Institution, where he helped plan the introduction of the metric system to the UK.

Dr. Charles Raymond Greene *(1901–1982)*

Raymond Greene, brother of the novelist Graham Greene, joined the 1933 expedition as senior doctor, chief intellect, and a competent mountaineer of gigantic physique.

Greene qualified as a doctor in 1927; during his distinguished medical career he became an expert on the thyroid, migraine, and frostbite. As a boy, he climbed in the Lake District of northwest England; as an Oxford undergraduate he discovered the Alps. But his introduction to the Himalayas came from his old school acquaintance Smythe on Kamet (25,446 feet/7756 m) in 1931. During World War II Greene was medical officer to intelligence agents being sent to Occupied France. From 1960 to 1980 he was Chairman of Heinemann Medical Books. On Coronation Day in 1953, it was Greene who announced on the BBC that Hillary and Tenzing had climbed Everest.

Alfred Gregory *(1913–)*

In 1952 Alfred Gregory was with Shipton's Cho Oyu expedition, and in 1953 he went to 27,900 feet (8500 m) in support of Hillary and Tenzing. On that expedition he was also in charge of stills photography.

"Greg" was educated at Blackpool Grammar School. During World War II he served in North Africa and Italy as an officer in the Black Watch regiment. Before the war he had climbed extensively in the English Lake District, Scotland, and the Alps. Later in the 1950s he led several expeditions—to the Rolwaling range, west of Solu Khumbu, where 19 peaks were climbed and a plane-table survey made, to Ama Dablam, to Disteghil Sar in the Karakoram, and to the Cordillera Blanca in Peru. He has traveled to most countries as a professional photographer and now lives near Melbourne, Australia.

Gyalzen Kazi *(?–?)*

Gyalzen was interpreter for the 1921 reconnaissance and interpreter/sirdar in 1922.

Gyalzen hailed from Gangtok, in Sikkim, and was well read in the Tibetan scriptures. As a *Kazi* and a landowner, he was a man of some standing.

John de Vere Hazard *(c. 1885–1968)*

John Hazard joined the 1924 expedition on the recommendation of Morshead, his commander on the Somme in World War I. Although a strong alpine climber, Hazard was severely criticized for "leaving" four porters on the North Col, who had to be rescued by Norton, Mallory, and Somervell. After the expedition he also upset the Tibetans by conducting unauthorized survey work along the Zangbo river. This contributed to a ban on Everest expeditions for the next nine years.

Prior to Everest, Hazard was a sapper in the Indian Army and thus also brought general engineering skills to the expedition.

Alexander Macmillan Heron *(1884–1971)*

Alexander Heron, geologist on the 1921 Everest Reconnaissance, was refused permission to join the 1922 expedition for having upset the Tibetans in 1921 by "disturbing demons in the ground." Nevertheless, his work laid the foundations for later work by Odell (1924) and Wager (1933).

Heron was a graduate of Edinburgh University who joined the Geological Survey of India in 1906 and became its director from 1936 to 1939. During his long career, Heron spent 23 years conducting a geological survey of Rajasthan. He died aged 86 in the Nilgiri Hills of South India.

Sir Edmund Percival Hillary, KG, KBE, ONZ *(1919–)*

Edmund Hillary joined Shipton's 1951 Everest Reconnaissance and the expedition to Cho Oyu in 1952, before making the first successful ascent to the summit of Everest, with Tenzing Norgay, as part of the 1953 expedition.

He was educated at Auckland Grammar School and spent two years at Auckland University before joining his father as a professional beekeeper. During World War II he served as a navigator for the RNZAF in the Pacific theater.

Introduced to the Southern Alps of New Zealand at age 16, he later spent every spare day exploring and climbing them, and made a number of difficult first ascents. In 1951 he ventured with three others to make six first ascents of peaks of over 20,000 feet (6100 m) in the Garhwal Himalayas. A series of adventures followed his ascent of Everest in 1953, including driving three "caterpillar vehicles," which were adapted from farm tractors to the South Pole and taking three fast jet boats up the Ganges river from the ocean to its source in the Himalayas.

For four years Hillary served as New Zealand High Commissioner to India. However, his main objective became, and remains to this day, the welfare of the Sherpa people. Through his charitable foundation, the Sir Edmund Hillary Himalayan Trust, he has constructed 27 schools, 2 hospitals, many bridges, fresh-water pipelines, and supported and rebuilt many Buddhist monasteries. He has also constructed several airfields in the Solu Khumbu area.

Major Richard William George Hingston *(1887–1966)*

Richard Hingston, doctor and naturalist on the 1924 expedition, presided over the collection of an astonishing 10,000 animal (mostly insect) and 500 plant specimens. Although not himself a mountaineer, he managed to climb to Norton's aid at Camp IV when Norton was struck down by snow blindness.

Irish by birth, the quiet and unassuming Hingston entered the Indian Medical Service in 1910. During World War I he served in France, East Africa, and Mesopotamia, winning the Military Cross. Hingston retired in 1927, but subsequently made expeditions to Greenland, Guyana, and Africa and continued to write extensively.

Lieutenant-Colonel Charles Kenneth Howard Bury *(1883–1963)*

In 1920, at Sir Francis Younghusband's request, Howard Bury visited India and successfully paved the way for the first expedition to Everest the following year. As leader of the 1921 reconnaissance, but no great mountaineer, he reached 22,000 feet (6700 m).

He was educated at Eton and Sandhurst before joining the army in 1904. As a boy he climbed in the Austrian Tirol and, while on military leave, explored the Greater Ranges of the Indian subcontinent: Early forays included Tibet (1905), and Kashmir and the Karakoram (1909), where he indulged his passion for botany and game hunting. Howard Bury was also a wealthy landowner and member of parliament; he retired in 1931 to Ireland where he bred racehorses.

Gordon Noel Humphreys *(1883–1966)*

Noel Humphreys joined the 1936 expedition as a 53-year-old doctor with a remarkable series of careers already behind him: as a surveyor, pilot, botanist, and explorer.

Humphreys's surveying work took him to Mexico (1910–12) and to Uganda after World War I, where he made seven expeditions to the Ruwenzori mountains. As an officer with the Royal Flying Corps he was shot down in 1915, but used his time in prison to become an expert botanist. Like Wollaston, Humphreys viewed medicine as a means to exploration: He qualified as a doctor in 1931 while living on a pittance in a London attic. This kind-hearted, energetic man eventually retired to a family life in Devon.

Henry Cecil John Hunt, Lord Hunt of Llanfair Waterdine, KG, CBE, DSO *(1910–1998)*

Leader of the 1953 expedition, John Hunt had climbed in the Himalayas since the 1930s, applying to join the 1936 expedition, for which he was turned down on medical grounds. He was chosen at short notice to replace Eric Shipton on the 1953 expedition, and quickly won round his skeptical team mates with his warmth, dedication, and impressive organizational skills.

Educated at Marlborough College, John Hunt passed first in his year to the Royal Military College, was awarded the Anson Sword on passing out, and had a distinguished army career. He was twice decorated in World War II, reaching the rank of brigadier. He climbed his first alpine summit at the age of 14 and afterward climbed throughout the world whenever he could, in particular taking advantage of service in India to make several adventurous forays into the Himalayas. A very gifted linguist, he volunteered in India for anti-terrorist work with the police and was also much engaged with young people, diverting the energies and enthusiasm of young Bengalis to sporting and other activities.

Three years after the Everest success, he retired early from the army, and spent the rest of his life in public service, mainly concerned with young people and with mountaineering, but also with the rehabilitation of prisoners and their early release on proof of good conduct. He undertook difficult government assignments in Nigeria and in Northern Ireland. His lifetime of service was recognized by his appointment as a life peer and by the Order of the Garter.

Andrew Comyn Irvine *(1902–1924)*

"Sandy" Irvine, the surprise member of the 1924 expedition, was selected at the age of only 21 for his all-round agility and mechanical dexterity, which effectively made him Odell's right-hand man as oxygen officer and also influenced Mallory's choice of him for their summit bid. On June 8, 1924, Odell glimpsed Mallory and Irvine going for the summit of Everest. Irvine was never seen again.

A shy, handsome young man, Irvine rowed for Oxford University. In December 1923 he went to the Swiss Alps to improve his snow and ice skills, at that stage limited to some rock climbing undertaken in Wales, and the Merton College expedition to Spitsbergen with Odell.

Karma Paul *(1894–1984)*

Fluent in English, Nepali, and Tibetan, Karma Paul was interpreter, recruiter, and general go-between for all expeditions from 1922 to 1938.

Born Karma Palden, in Tibet, and orphaned when in Darjeeling, he was cared for by Christian evangelists, but remained a Buddhist. He was an entrepreneur, became a skilled car mechanic, owned taxis, and in the 1950s made a small fortune from horse racing.

Dr. Alexander Mitchell Kellas *(1868–1921)*

Alexander Kellas came to the 1921 Everest Reconnaissance with impeccable credentials as an explorer, photographer, and veteran Himalayan mountaineer: He first visited Sikkim in 1907, and in 1911 achieved first ascents of Pauhunri (23,375 feet/7126 m) and Chomiomo (22,404 feet/ 6830 m). Kellas was also an expert on altitude as a result of his laboratory work undertaken at Middlesex Hospital Medical School, where he lectured in chemistry, as well as forays over the mountains of Sikkim. Following a period of illness in 1919 and an expedition to Kamet with Morshead in 1920, this dogged Scotsman was already in poor health by the time of the 1921 reconnaissance. He died on the approach to Kampa Dzong, where he was buried within sight of Everest and the mountains he had first climbed.

Edwin Garnett Hone Kempson *(1902–1987)*

Edwin Kempson came to the 1935 and 1936 expeditions as a highly experienced alpine climber. He performed useful roles on both occasions, including, in 1935, helping Spender with surveying work.

Kempson was educated at Marlborough College, where he returned as a teacher after graduating in mathematics from Cambridge. Kempson had 12 seasons of alpine climbing experience by 1935 and actively fostered climbing at Marlborough College, whose pupils included Wigram, Ward, Hunt, and Wylie. A kindly and respected man, Kempson acted as College Archivist until 1986. He was also a keen lecturer on local history.

Peter Lloyd, CBE *(1907–)*

One of the climbing party on Everest in 1938, Lloyd was involved in the development and use of the oxygen equipment, and later applied his experience for the benefit of the 1953 party.

Educated at Greshams School and Cambridge, Peter Lloyd was a chemist, first working on industrial heating processes. In 1944 he was appointed Director General of engine research and development for the Ministry of Aircraft Production, and finally became head of British Defence Research and Supply Staff in Australia. He first went to the Himalayas on the successful Anglo-American Nanda Devi expedition in 1936. He returned with Tilman in 1950 and later visited the Kulu Himal. After retirement, he returned to the UK from Canberra, but subsequently emigrated to Australia.

Sir John Laurence Longland *(1905–1993)*

Jack Longland came to the 1933 expedition as a 28-year-old rock climber of unparaleled reputation. On Everest he helped establish Camp VI at 27,400 feet (8350 m) before leading a party of porters down to Camp V in severe conditions.

Longland established his rock-climbing credentials at Cambridge University and climbed extensively in the Alps, particularly with Wager, with whom he also visited Greenland in 1935. Longland lectured in English at Durham University from 1930 to 1936 and became an influential figure in education, local government, and mountaineering circles. He was also Question Master of the BBC radio quiz *My Word* (1956–76).

Tom George Longstaff *(1875–1964)*

Tom Longstaff was chief medical officer and naturalist on the 1922 Everest Expedition. He was also the team's amiable non-climbing father figure, whose ascent of Trisul (23,385 feet/7128 m) in 1907 was a record altitude at the time.

Longstaff's vast expedition and mountaineering experience, contained in 50 volumes of diaries, included 20 visits to the Alps, 6 to the Himalayas, and 5 to the Arctic. As an early proponent of lightweight alpine-style expeditions, his other notable Himalayan achievements included a bold attempt on Gurla Mandhata (25,350 feet/7726 m) in Tibet (1905) and the discovery of the Siachen Glacier (1909). Longstaff eventually retired to Scotland, where he indulged his love of fishing and birdwatching.

Wallace George Lowe, OBE, CNZM *(1924–)*

George Lowe joined up with Shipton's Cho Oyu expedition in 1952, and the following year he worked notably on the Lhotse Face of Everest and helped to establish the top camp.

Lowe was educated at Hastings High School and Wellington Teachers College, after which he taught in New Zealand for some years. He climbed widely in the Southern Alps and first went to the Himalayas in 1951. After the 1953 expedition he climbed again in the Himalayas, as well as in the Pamirs, Greenland, and elsewhere. In 1957–58, he made the first crossing of Antarctica with Sir Vivian Fuchs's party, meeting Hillary at the South Pole. From 1959, he taught at Repton School, leaving in 1963 to teach, and then became headmaster, at Grange School in Santiago, Chile. On return to Britain in 1973, he became an Inspector of Schools until his retirement. He is chairman of the UK branch of the Sir Edmund Hillary Himalayan Trust, which exists to provide financial and other help to the Sherpa people.

Dr. William MacLean *(c. 1899– ?)*

"Willy" MacLean had a fairly long list of alpine climbs to his credit before going to Everest in 1933 as doctor's assistant to Greene. Although he spent much of the time laid low by pneumonia, he managed to reach Camp IV.

As a young man, MacLean served in the Royal Artillery in World War I, qualifying as a general practitioner after the war.

George Herbert Leigh Mallory *(1886–1924)*

George Mallory, the only veteran of all three 1920s expeditions, on which he was universally considered to be the finest climber, vanished with Irvine en route to the summit of Everest on June 8, 1924.

Mallory began his climbing career on the roof of his father's church in Cheshire and progressed to the Alps while at Winchester College. Handsome, athletic, and idealistic, he went on to read history at Magdalene College, Cambridge (1905–09), where he mixed with the emerging set of writers and artists who would later become the famous Bloomsbury Group. In 1910 Mallory became a teacher at Charterhouse School, while continuing to climb in the Alps and in Wales. In 1914 he married Ruth Turner, initiating a 10-year period of domesticity punctuated by long absences during World War I and the Everest expeditions. On May 1, 1999, Mallory's frozen corpse was found at 26,800 feet (8170 m), 75 years after his disappearance.

James Morris/Jan Morris, CBE *(1926–)*

James Morris accompanied the 1953 Everest Expedition as correspondent of *The Times*, making a dash from the mountain to wire the coded news of the success to London in time for the Coronation of Queen Elizabeth II.

Twenty years later she completed a change of sexual role and, as Jan Morris, went on to write some 40 books of history, travel writing, fiction, and autobiography, including the *Pax Britannica* trilogy about the rise and fall of the Victorian Empire, six volumes of collected travel essays, major studies of Wales, Spain, Venice, Oxford, Manhattan, Sydney, Hong Kong, and Trieste, and a novel, *Last Letters from Hav*, which was shortlisted for the Booker Prize.

John Morris *(1895–1980)*

John Morris came to the 1922 expedition as transport officer and interpreter, a role he was again assigned on the 1936 expedition.

Morris went on to serve in the trenches during World War I and subsequently with the Gurkha Rifles in Palestine and the Third Afghan War in 1919. In his autobiography, *Hired to Kill*, Morris writes candidly about confronting his homosexuality during his army career, which was eventually terminated by a bout of tuberculosis. A music lover and intellectual, Morris read social anthropology at Cambridge before teaching English in Japan during the anxious years of 1938–41, leading up to the Pacific war. After being repatriated, he worked for BBC Radio as Director of the Far Eastern Service (1943–52) and as Controller of the Third Programme (1952–58, later Radio 3).

Lieutenant-Colonel Henry Treise Morshead *(1882–1931)*

Henry Morshead, Chief Surveyor on the 1921 Everest Reconnaissance, proved such a popular and tough team member that General Bruce invited him back as a climber in 1922, when he reached 25,000 feet (7620 m) but sustained severe frostbite.

Morshead was commissioned into the Royal Engineers in 1901, and joined the Survey of India in 1906. In 1913 he and Capt. F. M. Bailey (later to become Political Officer in Sikkim) explored the Yarlung Zangbo Gorges, demonstrating beyond doubt the continuity of the Zangbo and Brahmaputra rivers. In 1920 he accompanied Kellas to Kamet. In 1929 Morshead was posted to Burma as local Director of the Survey of India. While out riding near Maymyo on May 17, 1931, he was murdered by a mystery attacker.

William Hutchinson Murray, OBE *(1913–1996)*

After a wide-ranging expedition to Garhwal in 1950, Murray initiated (with Mike Ward) and organized the 1951 reconnaissance of Everest.

Bill Murray was one of a group of active Scottish climbers before World War II. His book *Mountaineering in Scotland*, written in a German Prisoner-of-War camp, has inspired generations of British climbers to tackle Scottish winter climbing. In 1953 he explored the Api group in Nepal with John Tyson. There followed a lifetime of service to mountaineering and to the care of the environment in Scotland, as well as a successful career in writing (novels, biographies, and travel books).

Nawang Gombu *(1936–)*

Tenzing Norgay's nephew, and one of the youngest Sherpas in 1953, Nawang Gombu carried a load twice to the South Col. He took part in several later expeditions, reaching the summit of Everest with the Americans in 1963 and with the Indians in 1965, becoming the first man to reach the summit of Everest twice.

Born and raised in Tibet, Nawang studied as a boy at the Rongbuk monastery, before running away to Darjeeling. There, he became an instructor at the Himalayan Mountaineering Institute (set up in 1954 under Tenzing Norgay's directorship), and eventually Field Director on his uncle's retirement.

Captain John Baptist Lucius Noel *(1890–1989)*

John Noel joined the 1922 expedition as climber, photographer, and film maker. In 1924 he concentrated on cinematography, buying all photographic rights to the expedition from the Everest Committee for the then-huge sum of £8000.

Enterprising, enthusiastic, and eccentric, Noel had a long army career: In World War I he escaped from German captivity; subsequently he made his first film, about the caviar industry, while on horseback reconnaissance south of the Caspian Sea. In 1913 he made an illegal foray into Tibet within sight of Everest, bringing back intelligence that proved a vital trigger to the instigation of the 1921 Everest Reconnaissance. Noel's remarkable 1922 and 1924 film footage, with accompanying music by Somervell, survives him.

Lieutenant-General Edward Felix Norton *(1884–1954)*

Edward Norton proved, arguably, the strongest member of the 1922 and 1924 expeditions, climbing without oxygen to nearly 27,000 feet (8230 m) in 1922 and then to 28,126 feet (8573 m) in 1924. This was an altitude record not

exceeded until 1952 and a record for climbing without supplementary oxygen that stood till as late as 1978. In 1924 he had been made acting leader of the expedition following General Bruce's forced withdrawal due to ill health.

Educated at Charterhouse School, Norton spent a good deal of his 40-year military career in India, where he gained a reputation as a fearless horseman. Tall and imposing, Norton was also a renowned linguist and bird lover. As grandson of Sir Alfred Wills, who climbed the Wetterhorn in 1854, Norton learned his climbing skills at the "Eagle's Nest," the family chalet in the Haute Savoie. Norton served as Acting Governor of Hong Kong from 1940 until his retirement in 1942.

Cuthbert Wilfrid Frank Noyce *(1917–1962)*

In 1953 Wilfrid Noyce was the first to reach the South Col, and made a second trip there later carrying a load.

He was educated at Charterhouse and Cambridge, where he was awarded a First in modern languages. During World War II he learnt enough Japanese as an intelligence officer to break an important Japanese code. Later, as chief instructor at a service mountain training center, he climbed Pauhunri. He was a brilliant climber, with exceptionally good balance, as well as speed and stamina. After Everest, he went on to climb Trivor in 1960. By profession he was a teacher, but after 10 years at his old school he retired in order to concentrate on writing, both prose and poetry. He lost his life on Mount Garmo, in the Pamirs.

Professor Noel Ewart Odell *(1890–1987)*

Noel Odell was a geologist and oxygen officer on the 1924 expedition. For two weeks he lived above 23,000 feet (7010 m) without supplementary oxygen. He also was the last man to glimpse Mallory and Irvine alive.

Odell served with the Royal Engineers in both World Wars. As a geologist he held academic posts over three decades at Harvard and Cambridge universities and also in Canada, New Zealand, and Pakistan. Odell started climbing at the age of 13 and triumphed in 1936, when he and Tilman reached the summit of Nanda Devi, at 25,645 feet (7817 m). In 1938 Odell returned to Everest with Tilman. He remained an endearing and indefatigable character until his death at the age of 96.

Lieutenant-Colonel Peter R. Oliver *(1909–1945)*

Peter Oliver joined both the 1936 and 1938 expeditions, neither of which proved his most fruitful climbing experience, although he was also a talented artist who illustrated the 1936 book *Everest: The Unfinished Adventure.*

Tough and lean, Oliver was a career soldier who used his leave while serving with the South Waziristan Scouts on the North West Frontier (India) to climb in the Himalayas. In 1933 he made only the second successful ascent of Trisul (23,385 feet/7128 m) since Longstaff in 1907. Oliver was killed in action in Burma in 1945 while trying to help his battalion evade the Japanese.

Dr. Lewis Griffith Cresswell Evans Pugh *(1909–1994)*

Pugh's research for the Medical Research Council in 1951–52 was largely responsible for the solution to the "problem of the last thousand feet" on Everest, and he then joined the 1953 party. He led a physiological expedition to the Everest region in 1960–61, the first to winter at a height of 19,000 feet (5790 m).

Himself an Olympic-class skier, Pugh was a physiologist who specialized in the reaction of the body to extreme conditions. He had worked in the Middle East during World War II, and in Antarctica on physiological problems. His work on hypothermia in more normal conditions undoubtedly saved the lives of many people. He also studied the performance of long-distance swimmers, as well as Olympic athletes, with particular reference to the 1968 Games at Mexico City (held at an altitude of 7300 feet/2225 m).

Harold Raeburn *(1865–1926)*

Harold Raeburn, climbing leader of the 1921 reconnaissance, was chosen as an outstanding mountaineer who had made a reconnaissance of Kangchenjunga with Crawford in 1920. Elderly and generally unpopular, this dour Scotsman was forced by illness to relinquish his position during the 1921 expedition, but still managed to reach 22,000 feet (6700 m).

Raeburn's impressive climbing career was built on numerous new routes up Ben Nevis, as well as extensive experience in the Alps and the Caucasus, where he achieved nine first ascents (1913–14). Raeburn never recovered his health after Everest, laboring at one stage under the delusion that he had murdered Kellas.

Harold Earle Riddiford *(1921–1989)*

In 1951 Riddiford joined Shipton's party on the Everest reconnaissance expedition to the south approach, and in 1952 went to Cho Oyu, helping to organize that expedition.

After service with New Zealand Army Intelligence, Riddiford obtained a law degree from Canterbury University. A passionate and determined mountaineer, he took part in several important climbs of new routes in New Zealand in 1947–49. He initiated, organized, and led the first all-New Zealand expedition to the Himalayas, making the first ascent of Mukut Parbat in 1951. In his last 20 years he was engaged in running and improving an extensive sheep and cattle property originally owned by his grandfather.

Hugh Ruttledge *(1884–1961)*

Hugh Ruttledge, a kindly, retired Indian civil servant, was the surprise choice to lead the 1933 expedition. Ruttledge was also appointed leader in 1936, but only after much bickering triggered by his perceived lack of firm leadership in 1933.

Ruttledge graduated from Pembroke College, Cambridge, and joined the Indian Civil Service in 1909. In the 1920s he served as Deputy Commissioner both at Lucknow and Almora in India. Although not an experienced mountaineer, Ruttledge traveled extensively, particularly in the Kumaon and Garhwal Himalayas. In 1926 he explored the northern approaches to the Nanda Devi basin with Somervell.

Edward Oswald Shebbeare *(1884–1964)*

Edward Shebbeare ("Shebby") acted as transport officer on the 1924 and 1933 expeditions, and was also appointed Deputy Leader by Ruttledge in 1933. Although not himself a climber, he reached the North Col that year at the age of nearly 50.

Shebbeare was educated at Charterhouse School and embarked on a long career with the Indian Forestry Department in 1906. In 1938 he went to Malaya to serve as Chief Game Warden and was held as a Prisoner-of-War by the Japanese in Singapore from 1942 to 1945. Shebbeare was a respected author on forestry, natural history, and elephants.

Eric Earle Shipton *(1907–1977)*

Eric Shipton, the only veteran of all four 1930s Everest expeditions, remained Everest's senior statesman throughout his life. In 1933 he accompanied Smythe in a summit bid, but had to turn back at the First Step (27,890 feet/8500 m). It was Shipton who led the 1951 reconnaissance to the south side of Everest.

Born in Ceylon (now Sri Lanka) but educated in England, the endearing, impulsive, yet steadfast Shipton established his climbing credentials in the Alps. In 1928 he went to farm coffee in Kenya, where he met Tilman, his future expedition and mountaineering partner. There followed two postings as Consul-General to Kashi (China) in the 1940s, as well as spells in Hungary, Persia, and Kunming. Later he began a new phase of writing, lecturing, and exploration, mostly in South America where, in his mid-50s, he traversed the Southern Patagonia Icecap.

Brigadier William Russell Smyth-Windham *(?–1994)*

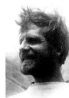

William Smyth-Windham ("Smidge") was chief radio operator on Everest in 1933 and 1936. Although he was not a mountaineer, he achieved a telecommunications first in 1933 by installing a telephone line up to the North Col, thereby allowing Ruttledge to communicate with London and to receive monsoon reports in return.

Smyth-Windham was commissioned into the Royal Corps of Signals in 1927 and retired from the army in 1960. From 1957–60 he served as Aide-de-Camp to Queen Elizabeth II.

Francis Sydney Smythe *(1900–1949)*

Frank Smythe joined the 1933, 1936, and 1938 expeditions on the strength of his having been the successful leader of the first ascent of Kamet (25,446 feet/7756 m) in 1931, accompanied by Shipton, Birnie, and Greene. In 1933 Smythe equaled Norton's 1924 Everest record of 28,126 feet (8573 m).

Like Greene and Tilman, Smythe was educated at Berkhamsted School, where a heart murmur kept him off the football pitch. When sent to Switzerland for his health, however, he discovered the Alps and went on to become a very distinguished climber, as well as an author, photographer, and botanist, constantly striving to compensate for an apparent inferiority complex. Smythe was invalided out of the RAF in 1927, but went on to join Professor Dyhrenfurth's international expedition to Kangchenjunga in 1930. He died at the age of 48 after being taken ill while on a trip to India.

Theodore Howard Somervell *(1890–1975)*

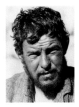

Howard Somervell was a crucial member of the 1922 and 1924 expeditions: In 1922 he reached 26,985 feet (8227 m) and in 1924 accompanied Norton as far as 28,000 feet (8530 m).

Following a Double First in natural sciences at Cambridge, Somervell qualified as a surgeon, and was immediately plunged into the horrors of World War I. Compassionate, brilliant, and versatile, he was not only an experienced alpine climber, but also a talented landscape painter and musician, who found a close friend in Mallory. After the 1922 expedition, Somervell turned his back on a prestigious surgeon's job that could have been his in London and instead worked for nearly 40 years as a missionary doctor in South India before retiring to the English Lake District.

Michael Spender *(1907–1945)*

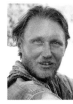

Michael Spender joined the 1935 reconnaissance as a surveyor, mapping the 26 peaks over 20,000 feet (6100 m) of which that expedition was to make the first ascent.

After graduating from Oxford with a Double First in engineering he also worked as a surveyor on expeditions to the Great Barrier Reef (1928–29) and East Greenland (1932 and 1933). In addition, he was a talented musician and the brother of the noted literary critic and poet Sir Stephen Spender. Spender was often arrogant and tactless, but found a friend in Shipton, who appreciated his zest for life. In 1945 Spender became a Squadron Leader with the RAF. He died in a plane crash in the last week of World War II.

Thomas Ralph Stobart, OBE *(1914–1980)*

Tom Stobart was the cameraman who filmed the 1953 expedition, producing the official film of the event, *The Conquest of Everest* (1953).

With a degree in zoology from Cambridge, Stobart decided to pursue a career of travel and adventure and used his expertise in film making to achieve it. In 1941, he set up and headed the first army film unit in India. Already a climber, he led a party to attempt Nun while on leave. In 1949–50 he formed part of an international expedition to Antarctica and in 1951–52 filmed game in Africa (resulting in the film *Below the Sahara,* 1953). He also led the Abominable Snowman Expedition in 1954. His special skill lay in his technique of filming climbers or scientists without asking them to pose or act, yet capturing their activity. In 1956 he was shot while filming in Ethiopia, and in spite of being crippled, he continued with his filming career. He also wrote five books, two of them on cookery.

Lieutenant-Colonel Edward Lisle Strutt
(1874–c. 1948)

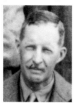

"Bill" Strutt was chosen as Bruce's deputy leader in 1922 for his extensive climbing experience. He was, however, a largely unpopular team member, often seen as pompous and pontificating.

Strutt was a multilingual Catholic aristocrat, educated at Oxford and Innsbruck universities, and also a much-decorated soldier, famed for escorting the family of Charles I, the last Austro-Hungarian Emperor, to safety in Switzerland in 1919. After Everest, Strutt became a formidable presence in the Alpine Club: From 1927 to 1937 he edited the *Alpine Journal*, and from 1935 to 1938 served as the club's President. To the end, he had little time for "new-fangled" devices such as crampons.

Tenzing Norgay, GM *(1914–1986)*

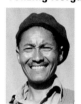

Tenzing Norgay went to Everest as a high-altitude porter on the expeditions of 1935, 1936, and 1938. In 1952, he was a climbing member of the Swiss team during their attempts on Everest, reaching 28,200 feet (8595 m) with Raymond Lambert in the spring campaign. The following year, with Edmund Hillary, he completed the same route in making the first successful ascent to the summit.

Born in the village of Moyey in Tibet, raised in Nepal, and living in India for most of his life, Tenzing never learnt to read or write, but had an active mind and was fluent in several languages. He spent most of the war years in Chitral. In 1947 he became a sirdar of a Swiss expedition for the first time, following a magnificent performance in the rescue of sirdar Wangdi Norbu who had fallen and was seriously injured. He then went to the top of Kedarnath—a first ascent. At that time, few if any other Sherpas seemed interested in climbing per se, but Tenzing was exceptional in this and in other ways. He was a man of great character and warmth to other people. After Everest, he became Director of Field Training at the Himalayan Mountaineering Institute in Darjeeling, traveled widely, and set up a trekking business with the help of his wife.

Harold William Tilman, DSO, MC
(1898–1978)

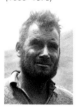

Bill Tilman failed to acclimatize well on the 1935 Everest Reconnaissance, but went on to lead the "lightweight" 1938 expedition. In 1950, he made a visit to Nepal to assess the prospects for climbing the south side of Everest.

After serving with the Royal Artillery in World War I, he emigrated in 1919 to Kenya, where he lived until 1933. Although still a mountaineering novice when he met Shipton, Tilman proved his mettle on their joint first traverse of Mount Kenya's twin peaks in 1930. Many other expeditions together followed, including the Nanda Devi Sanctuary (1934). Taciturn and spartan by nature, Tilman traveled, wrote, and lectured for the rest of his life. In 1954 he bought *Mischief*, his first boat, and embarked on a series of voyages to remote corners of the world. He was lost at sea somewhere between Rio de Janeiro and the Falklands Islands.

Professor Lawrence Rickard Wager, FRS
(1904–1965)

Lawrence Wager ("Waggers") was a last-minute replacement for Odell on the 1933 expedition. He became a key member, both equaling Norton's 1924 record of 28,126 feet (8573 m) and carrying out valuable geological work.

Educated in Yorkshire, Wager graduated with a First in geology from Cambridge. He went on to a distinguished career, crowned by professorships in geology at Durham (1944) and Oxford (1950). While President of Cambridge University Mountaineering Club in the 1920s, Wager met Longland, with whom he made numerous guideless ascents in the Alps. Wager was also an avid geological explorer, who spent over 30 years specializing in Greenland, where he first went with Gino Watkins in 1930–31.

Dr. Arthur William Wakefield *(1876–c. 1949)*

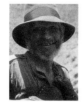

Arthur Wakefield was one of the 1922 expedition's doctors. A graduate of Trinity College, Cambridge, Wakefield qualified at the London Hospital and spent much of his life as a general practitioner in the English Lake District after working in Canada immediately before and after World War I. Although unsuited to high-altitude mountaineering, Wakefield had a formidable record as a fell runner and rock climber, although arthritis marred his later years.

Michael Phelps Ward, CBE, MD, FRCS
(1925–)

In early 1951, Michael Ward, examining forgotten photos and maps in the RGS archives, identified a possible route up the Nepalese side of Everest. Together with Bill Murray, he initiated and took part in Shipton's 1951 reconnaissance. In 1951–52, he worked with Pugh on the high-altitude medical problem, and was a climbing member, as well as medical officer of the 1953 party.

After the 1953 expedition he became a consultant surgeon. He has continued over the past 50 years with mountain exploration in Asia, and with high-altitude medical research. He has co-authored a standard work on this subject, and has also been Master of the Society of Apothecaries of London.

Dr. Charles Warren *(1906–1999)*

Charles Warren joined the 1935, 1936, and 1938 expeditions as both a doctor and climber. In this role, he contributed significantly to Pugh and Ward's knowledge about altitude and the use of oxygen in 1953. Warren's personal Sherpa on all three expeditions was the young Tenzing Norgay.

Warren read medicine at Cambridge, and during his time there climbed with Longland, Wager, and Lloyd. In 1933, by then a qualified doctor and experienced alpine climber, he joined his first expedition to the Garhwal Himalayas, where he climbed Bhagirathi III (21,175 feet/6454 m). After World War II, Warren specialized in pediatrics and continued his 60-year climbing career. Warren was also an expert on early English watercolors and Romantic literature.

Michael Horatio Westmacott *(1925–)*

Michael Westmacott's main job on the 1953 expedition was in the Khumbu Icefall—pioneering the route, later keeping it open, and finally descending it with James Morris to get the news of the successful ascent home.

Westmacott was educated at Radley School and Oxford, and during World War II served in Burma with the Indian Army Engineers. He climbed extensively in the UK and the Alps before going to the Himalayas for the first time in 1953, and continued to do so afterward, making first ascents in Peru, the Hindu Kush, and northern Alaska. He was President of the Alpine Club and of the Climbers Club. Trained as a statistician, he worked in agricultural research and then in Shell International until retirement.

Brigadier Sir Edward Oliver Wheeler
(1890–1962)

Oliver Wheeler, a Canadian, was chosen to work with Morshead on the 1921 expedition for his expertise in the field of photo surveying. With Bullock and Mallory, Wheeler made the first ascent to the North Col and identified the East Rongbuk Glacier as the key approach to the col.

Born in Ottawa, Wheeler was a competent mountaineer, having accompanied his father (also a surveyor) on climbs in the Rockies. After serving in France, Mesopotamia, and India in World War I, he joined the Survey of India in 1919. From 1941 to 1943 he was Surveyor General of India.

Edmund Hugh Lewis Wigram *(1911–1945)*

Edmund Wigram was an irrepressible member of the 1935 reconnaissance, during which he climbed 20 peaks above 20,000 feet (6100 m). On the 1936 expedition he got no further than the North Col owing to bad weather and illness.

Wigram was educated at Marlborough College and Trinity College, Cambridge, and qualified as a doctor. He was already an experienced alpine climber when elected President of the Cambridge University Mountaineering Club (1931–32), and continued to climb during World War II. At the age of 34 he was killed in a fall on the Idwal Slabs, in North Wales.

Alexander Frederick Richmond Wollaston *(1875 –1930)*

"Sandy" Wollaston joined the 1921 reconnaissance as doctor, ornithologist, and botanist. It was he who, during the expedition, discovered the *Primula wollastonii* flower.

Wollaston graduated from King's College, Cambridge, in 1896 and qualified as a surgeon in 1903, but loathed the medical profession, living instead for the natural world and exploration. Early travels took him to Lapland, the Dolomites, Sudan, and Japan, as well as on grueling expeditions to the Ruwenzori mountains in Uganda (1905) and Dutch New Guinea. There, in 1912, he climbed to within 500 feet (150 m) of the summit of the Carstensz Pyramid (16,023 feet/4884 m). In 1920 Wollaston was elected a Fellow of King's, where he inspired affection and respect. To the shock of all who knew him, he was shot dead on June 3, 1930, by a delinquent undergraduate.

George Wood-Johnson *(1905–1956)*

George Wood-Johnson joined the 1933 expedition as a relatively experienced Himalayan climber. However, a gastric ulcer robbed him of his chance to join the final assault on Everest.

Wood-Johnson grew up in the Lake District, but left England at the age of 25 to become a tea planter near Darjeeling, where he was a familiar figure on his motorbike. In 1930 he joined Professor Dyhrenfurth's international expedition to Kangchenjunga as transport officer. Then, with Smythe, he attempted the summit of Jongsong Peak (24,344 feet/7419 m), despite never having worn crampons. After Everest, Wood-Johnson returned to live in the Lake District.

Lieutenant-Colonel Charles Geoffrey Wylie, OBE *(1921–)*

Charles Wylie was organizing secretary of the 1953 expedition. Fluent in Nepali, he was in charge of the Sherpas, leading 15 of them to the South Col.

Wylie was educated at Marlborough School and the Royal Military College, Sandhurst, before being commissioned into the 1st Gurkha Rifles. From the age of seven, he climbed most years in the Alps, Dolomites, or Pyrenees, as well as every year in Britain. He was British Pentathlon Champion. In the east, he climbed in the Dhaula Dhar and in Garhwal, leading an attempt on Nilkantha. A Prisoner-of-War of the Japanese for three years, he worked on the infamous Burma-Siam "death" railway. After Everest he attempted Machhapuchare (also known as the Fish Tail) in Nepal. After retirement, he worked for many years for the Britain-Nepal Medical Trust, and was Chairman of the Britain-Nepal Society.

Sir Percy Wyn-Harris *(1903–1979)*

Wyn-Harris equaled Norton's 1924 record of 28,126 feet (8573 m) on the same day as Wager in 1933 when, at around 27,500 feet (8380 m), he discovered an ice-ax left over from Mallory and Irvine's ill-fated attempt in 1924 (it turned out to be Irvine's). In 1936 he returned to Everest with Ruttledge.

As an undergraduate, Wyn-Harris was a member of the Cambridge University Mountaineering Club and, in 1925, made the first guideless ascent of the Brouillard Ridge on Mont Blanc. He met Shipton in 1929, while serving in Kenya with the Colonial Service. Together they climbed Mount Kenya's twin peaks. Wyn-Harris served for over 30 years in Africa and was Governor of Gambia from 1949–58. Between 1962 and 1969 he circumnavigated the world in his sloop the *Gunning Grundel*.

ASCENTS SINCE 1953

Adventure statistics in this book have been supplied by AdventureStats.com and ExplorersWeb.
Find more statistics on mountaineering, polar, and adventure expeditions at www.adventurestats.com
Compiled by www.adventurestats.com

1953
HILLARY, Edmund Percival (NZ)
TENZING NORGAY (Ind)

1956
MARMET, Jürg (CH)
SCHMIED, Ernst (CH)
REIST, Adolf (CH)
VON GUNTEN, Hansrudolf (CH)

1960
WANG, Fu-zhou (Chn)
CHU, Yin-hua (Chn)
KONBU (Chn)

1963
WHITTAKER, James (Jim) (USA)
NAWANG GOMBU (Ind)
BISHOP, Barry C. (USA)
JERSTAD, Lute G. (USA)
UNSOELD, William F. (USA)
HORNBEIN, Thomas F. (USA)

1965
CHEEMA, A. S. (Ind)
NAWANG GOMBU (Ind)
SONAM GYATSO (Ind)
SONAM WANGYAL (Ind)
VOHRA, C. P. (Ind)
ANG KAMI I (Ind)
AHLUWALIA, Hari Pal Singh (Ind)
RAWAT, Harish Chandra S. (Ind)
PHU DORJE I (Np)

1970
UEMURA, Naomi (Jp)
MATSUURA, Teruo (Jp)
HIRABAYASHI, Katsutoshi (Jp)
CHOTARE (Np)

1973
CARREL, Rinaldo (It)
MINUZZO, Mirko (It)
SHAMBU TAMANG (Np)
LHAKPA TENZING (Np)
INNAMORATI, Fabrizio (It)
EPIS, Virginio (It)
BENEDETTI, Claudio (It)
SONAM GYALZEN (Np)

ISHIGURO, Hisashi (Jp)
KATO, Yasuo (Jp)

1975
TABEI, Junko (Jp)
ANG TSHERING I (Np)

PHANTOG (Chn)
SODNAM NORBU (Chn)
LOTSE (Chn)
SAMDRUB (Chn)
DARPHUNTSO (Chn)
KUNGA PASANG (Chn)
TSERING TOBGYAL (Chn)
NGAPO KHYEN (Chn)
HOU, Sheng-fu (Chn)

HASTON, Dougal (UK)
SCOTT, Douglas Keith (Doug) (UK)
BOARDMAN, Peter (UK)
PERTEMBA (Np)

1976
STOKES, John H. (Brummy) (UK)
LANE, Michael P. (Bronco) (UK)

CORMACK, Robert (USA)
CHANDLER, Chris (USA)

1977
KO, Sang-Don (SK)
PEMBA NORBU (NURU) I (Np)

1978
NAIRZ, Wolfgang (A)
SCHAUER, Robert (A)
BERGMANN, Horst (A)
ANG PHU (Np)
MESSNER, Reinhold (It)
HABELER, Peter (A)
KARL, Reinhard (Ger)
OELZ, Oswald (A)
OPPURG, Franz (A)

MACK, Josef (Ger)
HILLMAIER, Hubert (Ger)
ENGL, Hans (Ger)
RUTKIEWICZ, Wanda (Pl)
ALLENBACH, Robert (CH)
HUPFAUER, Siegfried (Sigi) (Ger)
KLIMEK, Wilhelm (Ger)
MINGMA NURU I (Np)
ANG DORJE I (Np)
ANG KAMI II (Np)
RITTER, Georg (Ger)
KULLMANN, Bernd (Ger)

AFANASSIEFF, Jean (F)
JAEGER, Nicolas (F)
MAZEAUD, Pierre (F)
DIEMBERGER, Kurt (A)

1979
ZAPLOTNIK, Jernej (Slo)
ŠTREMFELJ, Andrej (Slo)
BELAK, Stane (Slo)
BOŽIĆ, Stipe (Cro)
†ANG PHU (Np)

SCHMATZ, Gerhard (Ger)
WARTH, Hermann (Ger)
VON KÄNEL, Hans (CH)
PERTEMBA (Np)
LHAKPA GYALZEN I (Np)
†GENET, Ray (USA)
†SCHMATZ, Hannelore (Ger)
SUNGDARE (Np)
FISCHBACH, Tilman (Ger)
KÄMPFE, Günter (Ger)
BANKS, Nick (NZ)
ANG PHURBA I (Np)
ANG JANGBU I (Np)

1980
CICHY, Leszek (Pl)
WIELICKI, Krzysztof (Pl)
CZOK, Andrzej (Pl)
KUKUCZKA, Jerzy (Pl)

KATO, Yasuo (Jp)
SHIGEHIRO, Tsuneo (Jp)
OZAKI, Takashi (Jp)

ZABALETA, Martín (E)
PASANG TEMBA (Np)

MESSNER, Reinhold (It)

1981
KOPCZYNSKI, Chris (USA)
SUNGDARE (Np)
PIZZO, Christopher (Chris) (USA)
YONG TENZING (Np)
HACKETT, Peter (USA)

1982
BALYBERDIN, Vladimir (Rus)
MYSLOVSKI, Eduard (Rus)
BERSHOV, Sergei (Ukr)
TURKEVICH, Mikhail (Ukr)
IVANOV, Valentin (Rus)
EFIMOV, Sergei (Rus)

CADIACH, Oscar (E)
SORS, Antoni (Toni) (E)
VALLÉS, Carles (E)
ANG KARMA (Np)
SHAMBU TAMANG (Np)
NARAYAN SHRESTHA (Np)

AKUTSU, Etsuo (Jp)
KIMOTO, Satoshi (Jp)
NAZUKA, Hideji (Jp)
SAEGUSA, Teruo (Jp)
SATO, Masanori (Jp)
YAGIHARA, Kuniaki (Jp)
YAMADA, Noboru (Jp)

1986
WOOD, Sharon (Can)
CONGDON, Dawayne (Can)

LORETAN, Erhard (CH)
TROILLET, Jean (CH)

1987
HEO, Young-Ho (SK)
ANG RITA (Np)

1988
YAMADA, Noboru (Jp)
ANG LHAKPA NURU (Np)
CERING DOJE (Chn)
NAKAMURA, Susumu (Jp)
NAKAMURA, Shoji (Jp)
SAEGUSA, Teruo (Jp)
YAMAMOTO, Munehiko (Jp)
LI, Zhixin (Chn)
LHAKPA SONA (Np)

ANG PHURBA II (Np)
RINQING PUNCOG (Chn)
DA CERING (Chn)
SUNGDARE (Np)
PADMA BAHADUR TAMANG (Np)

VENABLES, Stephen (UK)

BAYNE, Paul (Aus)
CULLINAN, Patrick A. (Aus)
MUIR, Jonathan (Jon) (Aus)

BOIVIN, Jean-Marc (F)
METZGER, Michel (F)
FRACHON, Jean-Pierre (F)
VIONNET-FUASSET, Gérard (F)
GEORGES, André (CH)
PASANG TSHERING I (Np)
SONAM TSHERING (Np)
AJIWA (Np)

KIM, Chang-Seon (SK)
PEMA DORJE (Np)
UM, Hong-Gil (SK)
JANG, Bong-Wan (SK)
CHANG, Byong-Ho (SK)
JEONG, Seung-Kwon (SK)
LUCE, Peggy (USA)

BATARD, Marc (F)

ALLISON, Stacy (USA)
PASANG GYALZEN (Np)
TABIN, Geoffrey (USA)
NAM, Sun-Woo (SK)
DAWA TSHERING I (Np)
NIMA TASHI (Np)
PHU DORJE III (Np)

KOENIG, Serge (F)
†LHAKPA SONAM (Np)

LÓPEZ, Jerónimo (E)
BOHIGAS, Nil (E)
GINER, Lluis (E)
ANG RITA (Np)
NIMA RITA (Np)

BRADEY, Lydia (NZ)

†JUST, Jozef (Slk)

1989
BOŽIĆ, Stipe (Cro)
†ILJEVSKI, Dimitar (Mac)
AJIWA (Np)
SONAM TSHERING (Np)
GROŠELJ, Viktor (Viki) (Slo)

TORRES, Ricardo (Mex)
†PHU DORJE III (Np)
ANG DANNU (Np)

BURGESS, Adrian (UK)
ANG LHAKPA NURU (Np)
SONAM DENDU (Np)
MacKENZIE, Roddy (Aus)

†CHROBAK, Eugeniusz (Pl)
MARCINIAK, Andrzej (Pl)

MITANI, Toichiro (Jp)
OHNISHI, Hiroshi (Jp)
YAMAMOTO, Atsushi (Jp)
CHIRING THEBE LAMA (Np)
CHULDIN DORJE (Np)

CHO, Kwang-Je (SK)

CARSOLIO, Carlos (Mex)

CHUNG, Sang-Yong (SK)
NIMA RITA (Np)
NURU JANGBU (Np)

1990
ANG RITA (Np)
ANG KAMI II (Np)
PASANG NORBU (Np)
TOP BAHADUR KHATRI (Np)

LINK, Robert (USA)
GALL, Steve (USA)
ARSENTIEV, Sergei (Rus)
LUNYAKOV, Grigori (Kaz)
DAQIMI (Chn)
JIABU (Chn)
VIESTURS, Edmund (Ed) (USA)
GORBENKO, Mstislav (Ukr)
TSELISHCHEV, Andrei (Kaz)
WADE, Ian (USA)
DAQIONG (Chn)
LUOZE (Chn)
RENA (Chn)
KUI SANG (Chn)
IVANOVA, Yekaterina (Rus)
MOSHNIKOV, Anatoli (Rus)
ILYINSKY, Yervand (Kaz)
TOKAREV, Aleksandr (Rus)
TUCKER, Mark (USA)
WANGJIA (Chn)

ATHANS, Peter (USA)
PORZAK, Glenn (USA)
ANG JANGBU II (Np)
NIMA TASHI (Np)
COFFIELD, Dana (USA)
MANNING, Brent (USA)
BROWNING, Michael (USA)
DAWA NURU I (Np)
LAPKASS, Andrew (USA)

HILLARY, Peter (NZ)
HALL, Robert (Rob) (NZ)
BALL, Gary (NZ)
VAN SNIK, Rudy (Bel)
APA (Np)
REUTERSWÄRD, Mikael (S)
KHILBORG, Oskar (S)

MACARTNEY-SNAPE, Timothy (Tim) (Aus)

LOWE, Alex (USA)
CULVER, Daniel (Dan) (Can)
APRIN, Hooman (USA)
ANG TEMBA I (Np)
GIBSON, Catherine (Cathy) (USA)
KRASNOKUTSKY, Aleksei (Rus)
PHINZO I (Np)

SALINO, Yves (F)
ROCHE, Jean-Noël (F)
ROCHE, Bertrand (Zébulon) (F)

PIVOT, Denis (F)
DESEZ, Alain (F)
DE BOS, René (NL)
ANG PHURBA III (Np)
NIMA DORJE I (Np)

DECAMP, Erik (F)
NAWANG THILE (Np)
SONAM DENDU (Np)
BATARD, Marc (F)
JANIN, Christine (F)
TOURNAIRE, Pascal (F)
BABU CHIRI (Np)

BOK, Jin-Young (SK)
KIM, Jae-Soo (SK)
PARK, Chang-Woo (SK)
DAWA SANGE (Np)
PEMBA DORJE I (Np)

ŠTREMFELJ, Andrej (Slo)
ŠTREMFELJ, Marija (Slo)
JEGLIČ, Janez (Slo)

1991
ANG TEMBA II (Np)
SONAM DENDU (Np)
APA (Np)

ATHANS, Peter (USA)
RICHEY, Mark (USA)
LA FOREST, Yves (Can)
WILCOX, Richard (Rick) (USA)
RUGO, Barry (USA)

SIMONSON, Eric (USA)
SLOEZEN, Robert (Bob) (USA)
DUNN, George (USA)
POLITZ, Andrew (Andy) (USA)
ANG DAWA (Np)
PERRY, Michael (Mike) (NZ)
WHETU, Mark (NZ)
OKITA, Brent (USA)
WILSON, Gregory (Greg) (USA)

VIESTURS, Edmund (Ed) (USA)

MINGMA NORBU (NURU) (Np)
GYALBU (Np)
CRONLUND, Lars (S)

BONALI, Battistino (It)
SULOVSKY, Leopold (Cz)

BABU CHIRI (Np)
CHULDIN TEMBA (Np)

NUKITA, Muneo (Jp)
†FUTAGAMI, Junichi (Jp)
NIMA DORJE I (Np)
PHINZO NORBU (Np)

PÉREZ, Francisco José (Coque) (E)
VIDAURRE, Rafael (E)
GARCÉS, José-Antonio (Pepe) (E)
UBIETO, Antonio (E)

BALYBERDIN, Vladimir (Rus)
BOUKREEV, Anatoli (Kaz)
GIUTASHVILI, Roman (Geo)
MAZUR, Daniel (Dan) (USA)

1992
SINGH, Prem (Ind)
SHARMA, Sunil Dutt (Ind)
LAL (POKHRIYAL), Kanhaiya (Ind)
LOBSANG (Ind)
YADAV, Santosh (Ind)
SANGE MUDOK (Ind)
WANGCHUK (Ind)
SINGH (GUNJYAL), Mohan (Ind)

GILLETTE, Ned (USA)
EREL, Doron (Isr)
CHAM, Yick-Kai (Chn)
BALL, Gary (NZ)
MANTLE, Douglas (Doug) (USA)
HALL, Robert (Rob) (NZ)
DANTA, Randall (USA)
COTTER, Guy (NZ)
SONAM TSHERING (Np)
ANG DORJE II (Np)
TASHI TSHERING (Np)
APA (Np)
ANG DAWA (Np)
BAEYENS, Ingrid (Bel)

NAAR, Ronald (NL)
ÖFNER, Edmond (NL)
DAWA TASHI (Np)
NIMA TEMBA I (Np)

GERASIMOV, Aleksandr (Rus)
VOLKOV, Andrei (Rus)
SABELNIKOV, Ilia (Rus)
DUSHARIN, Ivan (Rus)
PENZOV, Sergei (Rus)
ZAKHAROV, Vladimir (Rus)
VINOGRADSKY, Yevgeni (Rus)
KONYUKHOV, Fedor (Rus)

HORNER, Skip (USA)
BOWEN, Louis (USA)
TEJAS, Vernon (USA)
DAWA TEMBA I (Np)
ANG GYALZEN I (Np)
ATHANS, Peter (USA)
LHAKPA RITA I (Np)
KERR, Keith (UK)
BURLESON, Todd (USA)
MORTON, Hugh (USA)
MAN BAHADUR TAMANG (Np)
DORJE I (Np)

GARCÍA-HUIDOBRO, Cristián (Chl)
JORDÁN, Rodrigo (Chl)
MONTES, Juan-Sebastián (Chl)

GAN, Francisco (E)
JUEZ, Alfonso (E)
PORTILLA, Ramón (E)
LHAKPA NURU I (Np)
PEMBA NORBU (NURU) II (Np)

PURTO, Mauricio (Chl)
ANG RITA (Np)
ANG PHURI (Np)
PRATT, Jonathan (UK)

EGUILLOR, Juan-María (Pitxi) (E)
FERNÁNDEZ, Francisco (Patxi) (E)
IÑURRATEGI, Alberto (E)
IÑURRATEGI, Félix (E)
BEREZIARTUA, Iosu (E)
REPÁRAZ, Mikel (E)
TOUS, Pedro (E)
TOMÁS, Juan (E)

PETIGAX, Giuseppe (It)
MAZZOLENI, Lorenzo (It)
PANZERI, Mario (It)
ROYER, Pierre (F)
LHAKPA NURU I (Np)
CHAMOUX, Benoît (F)
SANTIN, Oswald (It)
BLANC, Abele (It)
VERZA, Giampietro (It)

BERGER, Eugène (Lux)

DUJMOVITS, Ralf (Ger)
SONAM TSHERING (Np)

VINCENT, Michel (F)
DARSNEY, Scott (USA)

BERG, Wally (USA)
ORTEGA, Augusto (Per)
DE LA PARRA, Alfonso (Mex)
APA (Np)
KAJI (Np)

GRENIER, Philippe (F)
PELLÉ, Michel (F)
DEFRANCE, Thierry (F)
ROUSSEY, Alain (F)
AUBERTIN, Pierre (F)

1993
HEO, Young-Ho (SK)
NGATI (Np)

DAWA TASHI (Np)
†PASANG LHAMU (Np)
PEMBA NORBU (NURU) II (Np)
†SONAM TSHERING (Np)
LHAKPA NURU I (Np)
NAWANG THILE (Np)

QIMI (Chn)
JIA CHUO (Chn)
KAI ZHONG (Chn)
PU BU (Chn)
WANG, Yong-feng (Chn)
WU, Chin-hsiung (Tai)

LOWE, Alex (USA)

HELENEK, John (USA)
DUFFICY, John (USA)
BERG, Wally (USA)
SUTTON, Michael (Can)
APA (Np)
DAWA NURU I (Np)
CHULDIN TEMBA (Np)

KIM, Soon-Joo (SK)
JI, Hyun-Ok (SK)
CHOI, Oh-Soon (SK)
ANG DAWA (Np)
ANG TSHERING II (Np)
SONAM DENDU (Np)
RINZIN (Np)

GROOM, Michael (Aus)
†LOBSANG TSHERING BHUTIA (Ind)

TAYLOR, Harry (UK)
STEPHENS, Rebecca (UK)
ANG PASANG I (Np)
KAMI TSHERING (Np)

DOLMA, Dicky (Ind)
YADAV, Santosh (Ind)
KUNGA BHUTIA (Ind)
KUNWER, Baldev (Ind)
ONGDA CHHIRING (Np)
NA TEMBA (Np)
KUSANG DORJE (Ind)
DORJE I (Np)
THAKUR, Radha Devi (Ind)
SHARMA, Rajiv (Ind)
SHARMA, Deepu (Ind)
MARTOLIA, Savita (Ind)
DOLMA, Nima Norbu (Ind)
KUTIYAL, Suman (Ind)
NIMA DORJE I (Np)
TENZING (Np)
LOBSANG JANGBU (Np)
NGA TEMBA (Np)

LEFEVER, Mary (Dolly) (USA)
SELLAND, Mark (USA)
ARMATYS, Charles (USA)
PEMBA TEMBA (Np)
MOTI LAL GURUNG (Np)
SINCLAIR, Michael (USA)
RABOLD, Mark (USA)
PHINZO I (Np)
DORJE II (Np)
DURGA TAMANG (Np)

GUSTAFSSON, Veikka (SF)
ARNOLD, Jan (NZ)
HALL, Robert (Rob) (NZ)
GLUCKMAN, Jonathan (NZ)
ANG CHUMBI (Np)
ANG DORJE II (Np)
NORBU (NURU) (Np)

VITKAUSKAS, Vladas (Lit)

MOURAVLEV, Aleksei (Rus)
YANOCHKIN, Vladimir (Rus)
BASHKIROV, Vladimir (Rus)
KOROTEEV, Vladimir (Rus)

PIJANTE, Josep (E)
ANG PHURBA II (Np)
CADIACH, Oscar (E)

OÑATE, Joxe Maria (E)
ZERAIN, Alberto (E)
AGIRRE, José Ramón (E)
JANGBU I (Np)
ANG RITA (Np)

HARRIS, Jan (USA)
BROWN, Keith (USA)

PARK, Young-Seok (SK)
†AN, Jin-Seob (SK)
KIM, Tae-Kon (SK)
KAJI (Np)

STELFOX, Dawson (UK)

PARK, Hyun-Jae (SK)
PANURU (Np)

BERNARD, François (F)
CAYROL, Antoine (F)
GRAMMOND, Eric (F)
GYALBU (Np)
DAWA TASHI (Np)
ESTÈVE, Alain (F)
GIOT, Hubert (F)
NORBU (NURU) (Np)

KEY

Summiteers are grouped in each year by expedition and sequence of summiting.
Below is the key for the abbreviations used to denote the summiteers' nationality.
† indicates where a summiteer has died on the descent from Mount Everest.

A = Austria	Ger = Germany	Pak = Pakistan
Arg = Argentina	Gua = Guatemala	Per = Peru
Arm = Armenia	Hun = Hungary	Pl = Poland
Aus = Australia	Ice = Iceland	Por = Portugal
Bel = Belgium	Ind = India	RI = Indonesia
Bol = Bolivia	Ire = Ireland	Rom = Romania
Bra = Brazil	Irn = Iran	Rus = Russia
Bul = Bulgaria	Isr = Israel	S = Sweden
By = Belarus	It = Italy	SA = South Africa
Can = Canada	Jp = Japan	SF = Finland
CH = Switzerland	Kaz = Kazakhstan	SK = South Korea
Chl = Chile	Lat = Latvia	Slk = Slovakia
Chn = China	Lit = Lithuania	Slo = Slovenia
Col = Colombia	Lux = Luxembourg	Tai = Taiwan
Cro = Croatia	Mac = Macedonia	Tur = Turkey
Cz = Czech Republic	Mal = Malaysia	UK = United Kingdom
DK = Denmark	Mex = Mexico	Ukr = Ukraine
E = Spain	NL = The Netherlands	US = United States
Ec = Ecuador	Nor = Norway	Uzb = Uzbekistan
F = France	NP = Nepal	Ven = Venezuela
Geo = Georgia	NZ = New Zealand	Yu = Yugoslavia

NIMA GOMBU (Np)
OIARZABAL, Juan Eusebio (Juanito) (E)
ONGDA CHHIRING (Np)

HARRISON, Ginette (UK)
PFISTERER, Gary (USA)
BLANCO, Ramón (E)
HOYLAND, Graham (UK)
BELL, Steve (UK)
McIVOR, Scott (UK)
NA TEMBA (Np)
PASANG KAMI I (Np)
DORJE I (Np)
BARNICOTT, Martin (UK)
HEMPLEMAN-ADAMS, David (UK)
NOBMANN, Lee (USA)
TENZING (Np)
NGA TEMBA (Np)
LHAKPA GELU (Np)
ANG PASANG II (Np)

BERBEKA, Maciej (Pl)
LHAKPA NURU I (Np)
TINKER, Jonathan (UK)
BABU CHIRI (Np)

NAZUKA, Hideji (Jp)
GOTO, Fumiaki (Jp)
TANABE, Osamu (Jp)
EZUKA, Shinsuke (Jp)
OGATA, Yoshio (Jp)
HOSHINO, Ryushi (Jp)

1994
SUZUKI, Kiyohiko (Jp)
ATSUTA, Wataru (Jp)
NIMA DORJE II (Np)
DAWA TSHERING II (Np)
NA TEMBA (Np)
LHAKPA NURU I (Np)
ISHIKAWA, Tomiyasu (Jp)
NIMA TEMBA II (Np)
DAWA TASHI (Np)
PASANG TSHERING I (Np)

†SHIH, Fang-Fang (Tai)

LOBSANG JANGBU (Np)
HESS, Rob (USA)
FISCHER, Scott (USA)
BISHOP, Brent (USA)
SONAM DENDU (Np)
GORYL, Steven (USA)

ANG DORJE II (Np)
WENDEL, Hall (USA)
SEITZL, Hellmut (Ger)
KEATON, David (USA)
GUNDELACH, Ekkert (Ekke) (Ger)
HALL, Robert (Rob) (NZ)
VIESTURS, Edmund (Ed) (USA)
NIMA GOMBU (Np)
NORBU (NURU) (Np)
TAYLOR, David (USA)
KAGGE, Erling (Nor)

LHAKPA RITA I (Np)
CHUWANG NIMA (Np)
MAN BAHADUR TAMANG (Np)
KAMI RITA I (Np)
DORJE I (Np)
PAWLOWSKI, Ryszard (Pl)
CEDERGREEN, Robert (USA)
MORROW, Paul (USA)
ATHANS, Peter (USA)
BURLESON, Todd (USA)

HAHN, David (USA)
SWENSON, Steve (USA)
WHETU, Mark (NZ)
†RHEINBERGER, Michael (Aus)
SLOEZEN, Robert (Bob) (USA)

NUKITA, Muneo (Jp)
APA (Np)
CHUWANG NIMA (Np)
DAWA TSHERING III (Np)

HORNSBY, Charles (Charlie) (UK)
KIRKWOOD, Roddy (UK)
DORJE I (Np)
DAWA TEMBA I (Np)

1995
LOBSANG JANGBU (Np)

FURUNO, Kiyoshi (Jp)
IMOTO, Shigeki (Jp)
DAWA TSHERING II (Np)
PASANG KAMI I (Np)
LHAKPA NURU I (Np)
NIMA DORJE I (Np)

SHATAEV, Vladimir (Rus)
PROJAEV, Iria (Rus)
SHULJEV, Fedor (Rus)
KHAMITSAYEV, Kazbek (Rus)
VINOGRADSKY, Yevgeni (Rus)
BOGOMOLOV, Sergei (Rus)
KORENKOV, Vladimir (Rus)
ANG RITA (Np)

PUSTELNIK, Piotr (Pl)
BIANCHI, Marco (It)
KUNTNER, Christian (It)

PAWLOWSKI, Ryszard (Pl)
CATAO, Mozart (Bra)
NICLEVICZ, Waldemar (Bra)
RATCLIFFE, Graham (UK)
BOUKREEV, Anatoli (Kaz)
SITNIKOV, Nikolai (Rus)
JÖRGENSEN, Michael (DK)
JONES, Crag (UK)

CHENG, Kuo-Chun (Tai)
CHIANG, Hsiu-Chen (Tai)
MINGMA TSHERING I (Np)
LHAKPA DORJE III (Np)
TENZING NURU (Np)

HARGREAVES, Alison (UK)

PATSCHEIDER, Reinhard (It)
KIRSIS, Teodors (Lat)
ZAULS, Imants (Lat)

ONGDA CHHIRING (Np)
MALLORY, George (Aus)
HALL, Jeffrey (USA)
KAJI (Np)
LITCH, James (Jim) (USA)
AGUILAR, Daniel (Dan) (USA)
WANGCHU (Np)
PHINZO I (Np)
LYNCH, Colin (USA)
BUDNIK, Jay (USA)
RENEKER, Steve (USA)
WEDBERG, Kurt (USA)
JANGBU II (Np)

JOURJON, Luc (F)
BABU CHIRI (Np)

HINDING, Josef (A)

BULL, Bradford (USA)
HEINRICH, Tomás (Tommy) (Arg)
APA (Np)
ARITA (Np)
NIMA RITA (Np)

TONSING, Tony (USA)
MUSAL KAJI TAMANG (Np)

LACATUSU, Constantin (Rom)
CHILD, Gregory (Greg) (Aus)
KARSANG (Np)
LOBSANG TEMBA (Np)

KOTOV, George (Rus)
MAHRUKI, Nasuh (Tur)
SHEA, Jeff (USA)
LHAKPA GELU (Np)
TSHERING DORJE I (Np)
HACHE, Patrick (F)
HEMPSTEAD, Robert (USA)
LAMA JANGBU (Np)
BABU CHIRI (Np)
SMITH, Michael (Mike) (UK)
FALVEY, Patrick (Pat) (Ire)
ALLEN, James (Aus)

JO, Young-Il (SK)
†ZANGBU (Np)

HAN, Wang-Yong (SK)
HONG, Sung-Taek (SK)
TASHI TSHERING (Np)

PARK, Jung-Hun (SK)
KIM, Young-Tae (SK)
KIPA (Np)
ANG DAWA TAMANG (Np)

1996
BOUKREEV, Anatoli (Kaz)
BEIDLEMAN, Neal (USA)
ADAMS, Martin (USA)
SCHOENING, Klev (USA)
FOX, Charlotte (USA)
MADSEN, Tim (USA)
HILL PITTMAN, Sandy (USA)
†FISCHER, Scott (USA)
GAMMELGAARD, Lene (DK)
LOBSANG JANGBU (Np)
NAWANG DORJE (Np)
TENZING (Np)
TASHI TSHERING (Np)

KRAKAUER, Jon (USA)
†HARRIS, Andrew Michael (NZ)
GROOM, Michael (Aus)
†HALL, Robert (Rob) (NZ)
†NAMBA, Yasuko (Jp)
†HANSEN, Douglas (Doug) (USA)
ANG DORJE II (Np)
NORBU (NURU) (Np)

GAU, Ming-Ho (Makalu) (Tai)
NIMA GOMBU (Np)
MINGMA TSHERING I (Np)

†TSEWANG SMANLA (Ind)
†TSEWANG PALJOR (Ind)
†DORJE MORUP (Ind)
SANGE MUDOK (Ind)
RAM, Hira (Ind)
RAM, Tashi (Ind)
RAM, Nadra (Ind)
KUSANG DORJE (Ind)

HANADA, Hiroshi (Jp)
SHIGEKAWA, Eisuke (Jp)
PASANG TSHERING I (Np)
PASANG KAMI I (Np)
ANG GYALZEN II (Np)
KIKUCHI, Mamoru (Jp)
SUGIYAMA, Hirotaka (Jp)
NIMA DORJE I (Np)
CHUWANG NIMA (Np)
DAWA TSHERING III (Np)

TAKEUCHI, Hirotaka (Jp)
PEMBA TSHERING I (Np)
NA TEMBA (Np)
YAMAZAKI, Koji (Jp)

GANGDAL, Sven (Nor)
ULVUND, Olav (Nor)
DAWA TASHI (Np)
DAWA TSHERING II (Np)
ROSTRUP, Morten (Nor)
NEZERKA, Josef (Cz)
DE STEFANI, Fausto (It)
GYALBU (Np)

HINKES, Alan (UK)
DICKINSON, Matt (UK)
MINGMA DORJE (Np)
LHAKPA GELU (Np)
PHUR GYALZEN (Np)

KUZNETSOV, Petr (Rus)
KOKHANOV, Valeri (Rus)
SEMIKOLENKOV, Grigori (Rus)

RENARD, Thierry (F)
BABU CHIRI (Np)
DAWA I (Np)

VIESTURS, Edmund (Ed) (USA)
BREASHEARS, David Finley (USA)
SCHAUER, Robert (A)
JAMLING TENZING NORGAY (Ind)
SEGARRA, Araceli (E)
LHAKPA DORJE III (Np)
DORJE III (Np)
JANGBU II (Np)
MUKTU LHAKPA (Np)
THILEN (Np)

KROPP, Göran (S)
ANG RITA (Np)

MARTÍNEZ, Jesús (E)

KAMMERLANDER, Hans (It)

CONTRERAS, Yuri (Mex)
PONCE DE LEÓN, Héctor (Mex)

WOODALL, Ian (UK)
O'DOWD, Catherine (Cathy) (SA)
†HERROD, Bruce (UK)
PEMBA TENJI (Np)
ANG DORJE III (Np)
LAMA JANGBU (Np)

SUMARWATI, Clara (RI)
KAJI (Np)
GYALZEN I (Np)
ANG GYALZEN II (Np)
DAWA TSHERING III (Np)
CHUWANG NIMA (Np)

CHOI, Jong-Tai (SK)
SHIN, Kwang-Chul (SK)
PANURU (Np)
KIPA (Np)
ANG DAWA TAMANG (Np)

1997
APA (Np)

BOUKREEV, Anatoli (Kaz)
DAWA NURU II (Np)
BASHKIROV, Vladimir (Rus)

ASMUJIONO (RI)

FROLOV, Vladimir (Kaz)
MOLOTOV, Andrei (Kaz)
OVCHARENKO, Sergei (Kaz)
SUVIGA, Vladimir (Kaz)
†PLOTNIKOV, Ivan (Rus)
†SHEVTCHENKO, Nikolai (Rus)
FARAFONOV, Konstantin (Kaz)
LAVROV, Sergei (Kaz)
GREKOV, Dmitri (Kaz)
SOBOLEV, Dmitri (Kaz)
MOURAVEV, Dmitri (Kaz)
SAVINA, Lyudmila (Kaz)

LEE, In (SK)
ANG DAWA TAMANG (Np)

CHOUDENS, Antoine de (F)
CAGNIN, Stephane (F)
VASSILEV, Doytchin (Bul)

KEKUS, Nikola (UK)
OLAFSSON, Björn (Ice)
MAGNUSSON, Hallgrimur (Ice)
STEFANSSON, Einar (Ice)
BABU CHIRI (Np)
DAWA I (Np)
WARHAM, Mark (UK)
LHAKPA GELU (Np)
BLAKELEY, Eric (UK)
DAWA TENZI (Np)
RODRÍGUEZ, Hugo (Mex)

DANURI (Np)

EVANS, Andrew (Andy) (Can)

PEPEVNIK, Franc (Aco) (Slo)
KOZJEK, Pavle (Slo)

TASHI TENZING (Aus)
COTTER, Guy (NZ)
VIESTURS, Edmund (Ed) (USA)
CARTER, David (USA)
GUSTAFSSON, Veikka (SF)
ANG DORJE II (Np)
MINGMA TSHERING I (Np)

BREASHEARS, David Finley (USA)
ATHANS, Peter (USA)
JANGBU II (Np)
DORJE III (Np)
KAMI (Np)

HOBSON, Alan (Can)
CLARKE, Jamie (Can)
LHAKPA TSHERING I (Np)
GYALBU (Np)
TASHI TSHERING (Np)
KAMI TSHERING (Np)

DELGADO, Andrés (Mex)
TENZING (Np)
MUIR, Brigitte (Aus)
KIPA (Np)
DORJE I (Np)

NAGAPPAN, Mohandas (Mal)
MUNISAMY, Magendran (Mal)
NA TEMBA (Np)
DAWA TEMBA I (Np)
GYALZEN I (Np)
ANG PHURI GYALZEN (Np)
FURA DORJE (Np)

ZELINSKI, Aleksandr (Rus)
SOKOLOV, Sergei (Rus)

BERG, Wally (USA)
ANG PASANG I (Np)
PEMBA TENJI (Np)
MINGMA CHHIRI (Np)
NIMA TASHI (Np)
LHAKPA RITA I (Np)
KAMI RITA I (Np)
TENZING NURU (Np)

CONTRERAS, Yuri (Mex)
PAULS, Ilgvars (Lat)
DAWA SONA (Np)

BRICE, Russell (NZ)
PRICE, Richard (NZ)

DAQIMI (Chn)
TENZING DOJI (Chn)
KAI ZHONG (Chn)

1998
CHAVAN, Surendra (Ind)
DAWA TASHI (Np)
DAWA NURU II (Np)
THOMTING (Np)
NAWANG TENZING I (Np)
DHARMSHAKTU, Loveraj (Ind)
PHINZO NORBU (Np)

NIMA GYALZEN (Np)

ABE, Shoji (Jp)
NAKAJIMA, Toshiya (Jp)
PASANG KAMI I (Np)
NA TEMBA (Np)
ANG GYALZEN II (Np)
ONODERA, Hitoshi (Jp)
KAMIMURA, Hiromichi (Jp)
CHUWANG NIMA (Np)
DAWA TSHERING III (Np)

KURAHASHI, Hidetoshi (Jp)
SATO, Masaru (Jp)
NAGATA, Koichi (Jp)
HASHIMOTO, Hisashi (Jp)
SAKAMOTO, Shoji (Jp)
ANG MINGMA (Np)
YANO, Toshiaki (Jp)
KAWAHARA, Yoshinori (Jp)
GYALZEN I (Np)
KONDO, Kazuyoshi (Jp)
DAWA II (Np)

BOLOTOV, Aleksei (Rus)
PERSHIN, Valeri (Rus)
TIMOFEEV, Sergei (Rus)
VINOGRADSKY, Yevgeni (Rus)
MOSHNIKOV, Anatoli (Rus)
ROMAN, Gilles (F)
†ARSENTIEV-DISTEFANO, Francys (USA)
†ARSENTIEV, Sergei (Rus)

KULBACHENKO, Viktor (By)

HÁMOR, Peter (Slk)
ZBOJA, Vladimír (Slk)
PLULIK, Vladimír (Slk)
LUO CI (Chn)

MURAGUCHI, Noriyuki (Jp)
SAWADA, Minoru (Jp)
MINGMA TSHERING I (Np)
TSHERING DORJE II (Np)
PASANG KITAR (Np)

JAROS, Radek (Cz)
NOSEK, Vladimír (Cz)

HOFFMAN, Bob (USA)
BEAVON, Donald (USA)
SCATURRO, Pasquale (USA)
DEMAREST, Charles (USA)
COLE, Mark (USA)
APA (Np)
PEMBA NORBU III (Np)
NIMA RITA (Np)
GYALZEN II (Np)
CHULDIN NURU (Np)
ANG PASANG III (Np)
ARITA (Np)

GHASABANI, Jalal Cheshmeh (Irn)
NAJARIAN, Mohammad Hassan (Irn)
OLANJ, Hamid Reza (Irn)
ORAZ, Mohammad (Irn)
DAWA TENZI (Np)
CHULDIM (Np)
PEMBA RINZI (Np)

RHOADS, Jeffrey (USA)
TASHI TSHERING (Np)
RHOADS, Jeffrey (USA)
TASHI TSHERING (Np)
WHITTAKER, Tom (USA)
NORBU (NURU) (Np)
LHAKPA TSHERING I (Np)
DAWA SONA (Np)

BERG, Wally (USA)

RADJAPOV, Rustam (Uzb)
BASKAKOVA, Svetlana (Uzb)
SOKOLOV, Sergei (Uzb)
USAEV, Marat (Uzb)
GRIGORIEV, Oleg (Uzb)
FEDOROV, Andrei (Uzb)
DUKUKIN, Aleksei (Uzb)
TUKHVATULLIN, Ilyas (Uzb)
ZAIKIN, Andrei (Uzb)
BALMAGAMBETOV, Khaniv (Uzb)
MATS, Roman (Uzb)

LAMA JANGBU (Np)
LHAKPA GELU (Np)

GUARACHI, Bernardo (Bol)

SIEW, Cheok-Wai (Mal)
KHOO, Swee-Chiow (Mal)
KAMI RITA I (Np)
DORJE III (Np)
FURA DORJE (Np)
NAWANG PHURBA (Np)

DHILLON, Sundeep (UK)
WALSH, David (UK)
NIMA GOMBU (Np)
KUSANG DORJE (Ind)
NIMA DORJE II (Np)

BRICE, Russell (NZ)
TSUZUKI, Sumiyo (Jp)
KARSANG (Np)

†JENNINGS, Mark (UK)
NIMA WANGCHU (Np)

JOHN, Craig (USA)
DAWA NURU III (Np)
LHAKPA RITA II (Np)
ALPERT, Richard (USA)
SLOEZEN, Robert (Bob) (USA)
PANURU (Np)

SILVA, Alan (Aus)
LAUGHTON, Neil (UK)
GRYLLS, Edward (Bear) (UK)
PASANG DAWA (Np)
PASANG TSHERING II (Np)
ROCKENBAUER, Heinz (A)

PITARCH, Carlos (E)
KAJI (Np)
TASHI TSHERING (Np)

1999
ATHANS, Peter (USA)
CROUSE, William (USA)
CHUWANG NIMA (Np)
PHU TASHI (Np)
DORJE I (Np)
GYALZEN I (Np)
NA TEMBA (Np)
CORFIELD, Charles (UK)
CHUWANG NIMA (Np)
NIMA TASHI (Np)
DAWA SONA (Np)

RATCLIFFE, Graham (UK)
BROWN, Ray (UK)
AVILA, Elsa (Mex)
LAPKASS, Andrew (USA)
PASANG TSHERING II (Np)
TRUEMAN, Michael (UK)
PASANG DAWA (Np)

CHLUMSKA, Renata (S)
KROPP, Göran (S)
MINGMA TSHERING I (Np)
KAMI (Np)
ANG CHHIRI (Np)

VOYER, Bernard (Can)
DORJE III (Np)
CHHONGRA NURU (Np)

BABU CHIRI (Np)
DAWA I (Np)
NIMA DORJE II (Np)
SJÖGREN, Thomas (S)
SJÖGREN, Tina (S)
BABU CHIRI (Np)
DAWA I (Np)
NIMA DORJE II (Np)
DAWA TEMBA I (Np)

2000
†KOPYTKO, Vasili (Ukr)
TERZEOUL, Vladislav (Ukr)
FUKOLOV, Aleksandr (Rus)
ALEKSANDROV, Andrei (Rus)
BERSHOV, Sergei (Ukr)
IAKIMOV, Andrei (Rus)
KRAVCHENKO, Oleg (Rus)
NEDELKIN, Vladimir (Rus)
ZAKHAROV, Nikolai (Rus)
SEDUSOV, Boris (Rus)
BOKOV, Aleksei (Ukr)
AFANASSIEV, Oleg (Rus)

BAYONA, Jordi (E)
BELMONTE, Joan (E)
THOMTING (Np)
NIMA NURU I (Np)

MO, Sang-Hyun (SK)
PARK, Heon-Ju (SK)

BARRY, John (UK)
SALTER, Andrew (UK)
MURRAY, Polly (UK)
LAMA JANGBU (Np)
PEMBA GYALZEN I (Np)

SARKISOV, Lev (Geo)
GIGANI, Afi (Geo)
GUJABIDZE, Bidzina (Geo)
KASHAKASHVILI, Benedict (Geo)
CHEWANG DORJE (Np)
NAWANG TENZING II (Np)

NOGUCHI, Ken (Jp)

DAWA TSHERING III (Np)
NIMA WANGCHU (Np)
NAWANG WANGCHU (Np)
KRISHNA BAHADUR TAMANG (Np)

ANKER, Conrad (USA)
HAHN, David (USA)

MASELKO, Jacek (Pl)
†KUDELSKI, Tadeusz (Pl)
PAWLOWSKI, Ryszard (Pl)

GARCIA, Joao (Por)
†DEBROUWER, Pascal (Bel)

GUEVARA, Carlos (Mex)
RODRÍGUEZ, Hugo (Mex)
LHAKPA NURU II (Np)
MINGMA CHHIRI (Np)
PEMBA (Np)

APA (Np)
DIJMARESCU, Gheorghe (USA)

NANDA DORJE (Np)
BARTH, Fred (USA)

LUSHNIKOV, Andrei (Rus)

KHABAZI, Merab (Geo)
UGULAVA, Irakli (Geo)
TSIKHISELI, Mamuka (Geo)
MAN BAHADUR TAMANG (Np)

MARTINI, Sergio (It)
LAGO, María-Jesús (E)
SAMDU (Np)

ROBB, Geoffrey (Aus)
HENGGE, Helga (Ger)
KOZUKA, Kazuhiko (Jp)
KARSANG (Np)
LOBSANG TEMBA (Np)
PHURBA TASHI (Np)

VALLEJO, Iván (Ec)
ORONA, Heber (Arg)
WHEELOCK, Karla (Mex)
FURA DORJE (Np)
PIELA, Ari (SF)
MANIKEN, Antti (SF)

JIABU (Chn)
LUOZE (Chn)
BIANBA ZAXI (Chn)
RENA (Chn)
AKBU (Chn)
KUI SANG (Chn)
JIJI (Chn)
CERING DOJE (Chn)
LA BA (Chn)
ZAXI CERING (Chn)

KUSANG DORJE (Ind)
SANGE MUDOK (Ind)
PRAKASH, Amar (Ind)

O'DOWD, Catherine (SA)
WOODALL, Ian (UK)
LAMA JANGBU (Np)
PEMBA TENJI (Np)

TAKAHASHI, Ruchia (Jp)
PHINZO II (Np)
PALDEN NAMGYE (Np)

WEBSTER, Benjamin (Ben) (Can)
SABIR, Nazir (Pak)
DORJE I (Np)
DAWA NURBU (DANURU) (Np)
DORJE III (Np)
LHAKPA GELU (Np)
BOSKOFF, Christine (USA)
NAWANG WANGCHU (Np)

VRIJLANDT, Frits (NL)
WALTERS, Paul (UK)

MATSUMOTO, Nobuo (Jp)
ROSENBAUM, Roman (Aus)
LHAKPA NURU II (Np)
MINGMA TSHERING I (Np)
PEMBA GYALZEN II (Np)

OGIO, Yuji (Jp)
TENZING (Np)

NORBU (NURU) (Np)
YAMAMOTO, Toshio (Jp)
PASANG KITAR (Np)
NAWANG DORJE (Np)

HOSAKA, Akinori (Jp)
KODAMA, Takashi (Jp)
YASHIMA, Hiroshi (Jp)
NIMA GYALZEN (Np)
PEMBA DORJE II (Np)
KOBAYASHI, Juichi (Jp)
KONNO, Kazuya (Jp)
TANAKA, Toshio (Jp)
YAMASHITA, Tateo (Jp)
NAWANG TENZING I (Np)
GYALU LAMA (Np)
KARSANG (Np)
PASANG KAMI II (Np)

LAKPA (Np)
ANG PASANG III (Np)
ANG MINGMA (Np)
ANG PHURBA IV (Np)

JAMES, Mark (UK)
WHITE, Dan (UK)
NA TEMBA (Np)

DIJMARESCU, Gheorghe (USA)

GRANLIEN, Mads (DK)
NORRESLET, Asmus (DK)
DAWA CHIRI (Np)
DAWA TEMBA I (Np)
NIMA DAWA (Np)

BABU CHIRI (Np)
DAWA I (Np)

SMITH, Byron (Can)
LHAKPA TSHERING II (Np)
ANG DORJE II (Np)
MINGMA TENZING (Np)
MINGMA (Np)
TENZING DORJE II (Np)
NURU WANGCHU (Np)
KARCHEN DAWA (Np)

†YAN, Geng-hua (Chn)
LHAKPA TSHERING II (Np)

TASHI TSHERING (Np)
PHU TASHI (Np)
KAMI TSHERING (Np)
BROWN, Charles (Michael) (USA)
HAHN, David (USA)

GARRA, Juan José (E)
GONZÁLEZ, Manuel (E)
JARA, Iván (E)

CZERWIŃSKA, Anna (Pl)
PASANG TSHERING III (Np)

TOOSSI, Saeed (USA)
CHEWANG DORJE (Np)

CHUWANG NIMA (Np)
MINGMA CHHIRI (Np)
KAMI RITA I (Np)

APA (Np)
LHAKPA TSHERING III (Np)
KAMI RITA II (Np)
LEONARD, Lily (USA)
PEMBA TSHERING II (Np)
PEMBA CHUTI (Np)
WILLIAMS, James (USA)
ARITA (Np)
PASANG THARKE (Np)
NIMA (ANG NIMA) (Np)
SLAKEY, Francis (USA)
PEMBA NORBU III (Np)
DAWA JANGBU (Np)

LOCK, Andrew (Aus)
GIORGIO, Paul (USA)

KOBLER, Karl (Kari) (CH)
HURSCHLER, Josef (CH)
NAWANG THILE (Np)
FAHRNER, Bernhard (CH)
PEMBA DOMA (Np)

EZAKI, Koichi (Jp)
KUDO, Hiroshi (Jp)

NIMA GOMBU (Np)
MORO, Simone (It)
URUBKO, Denis (Kaz)

ALLEN, Richard (Ric) (UK)
STONE, Richard (Dick) (USA)
KENNY, Patrick (USA)
DOWN, Michael (Can)
COWEN, Tim (USA)
MINGMA NURU II (Np)
JACIMOVIC, Dragan (Yu)

GONZÁLEZ, Juan Carlos (E)
LHAKPA GYALZEN II (Np)

VOLODIN, Viktor (Rus)

KIM, Hwan-Koo (SK)
KIM, Seong-Cheol (SK)
KIM, Woong-Sik (SK)
HONG, Sun-Dok (SK)
JO, Cheol-He (SK)

KARNIČAR, Davorin (Davo) (Slo)
ODERLAP, Franc (Slo)
ANG DORJE II (Np)
PASANG TENZING (Np)
GOLOB, Tadej (Slo)
FLIS, Matej (Slo)
LAČEN, Gregor (Slo)

2001
OTIS, Michael (USA)
LA FRANCE, Terrence (USA)
MINGMA ONGEL (Np)
DAWA NURU III (Np)
LHAKPA NURU II (Np)
KAMI TSHERING (Np)

ROUX, Frédéric (F)
ROCHE, Bertrand (Zébulon) (F)
ROCHE, Claire (F)
TROMMSDORFF, Christian (F)
GATT, Stefan (A)

TORTLADZE, Gia (Geo)
TASHI (Np)

COLLET, Anna (F)
CHARDINI, Guy (F)
MULLER, Bernard (F)
IMAN GURUNG (Np)
TSHERING DORJE II (Np)
PEMA CHIRING (Np)
CHIRI (Np)

ANCIAUX, Yves (F)
PORTE, Jean-Marc (F)
MINGMA NURU III (Np)
ANG PASANG IV (Np)
PHINZO NORBU (Np)

McDERMOTT, Mark (UK)
HUNTER, Roland (UK)

GONZÁLEZ-RÚBIO, Fernando (Col)
BARRIOS, Manuel (Col)
ARBELAEZ, Marcelo (Col)
RUIZ, Juan Pablo (Col)

BALE, Richard (UK)
CARROLL, Dan (UK)

UTESHEV, Yuri (Rus)
KOZHEMYAKO, Nikolai (Rus)
FOIGT, Aleksandr (Rus)
ELEUCHEV, Amangueldy (Rus)
AKININA, Anna (Rus)
KRYLOV, Stanislav (Rus)
POPOV, Yevgeni (Rus)
BOCHKOV, Dmitri (Rus)

PERLIA, Philippe (Lux)
FRITSCHE, Theo (A)
STREIF, Josef (Ger)
FASCHING, Wolfgang (A)
GATT, Erich (A)
NAWANG WANGCHU (Np)

LAGUNILLA, Vicente (E)
RODRÍGUEZ, Pedro (E)
RAMOS, Martín (E)

STINGL, Jörg (Ger)

SIFFREDI, Marco (F)
BÖSCH, Robert (CH)
BINSACK, Evelyne (CH)
LOBSANG TEMBA (Np)
KARSANG (Chn)
PHURBA TASHI (Np)
MACKENZIE, Kieron (UK)
MILLER, Ellen (USA)
ISHIKAWA, Naoki (Jp)
KARSANG (Np)
WARNER, Christopher (Chris) (USA)

DAWA TEMBA II (Np)
LAPKASS, Andrew (USA)
NORRESLET, Asmus (DK)
VIÑALS, Jaime (Gua)

MINGOTE, Sergi (E)
THILEN (Np)

SAMPSON, Todd (Can)
PEMBA DORJE I (Np)

TEMBA TSHIRI (Np)

BENEGAS, Guillermo (Willi) (USA)
SPARKS, James (USA)
ALLAN, Alexander (Sandy) (UK)
PEMBA RINZI (Np)
PHANDEN (Np)
PEMBA GYALZEN I (Np)
PEMBA RINCHHEN (Np)

PRAKASH, Amar (Ind)
SINGH NEGI, Mohinder (Ind)
SINGH DHASILA, Chanchal (Ind)
CHAND, Neel (Ind)
SHEKHAWAT, Saurabh (Ind)
GIACHHO NEGI, Palden (Ind)
TIL BIKRAM BUDHATHOKI (Np)
PASANG TENDI (Np)
NGA TEMBA (Np)
LHAKPA NURU III (Np)
CHERING NORBU BODH (Ind)
DENDI (Np)
MINGMA TSHERING II (Np)
PASANG GELU (Np)
PASANG RINJI (Np)

FINDIK, Tunç (Tur)
GIORGIO, Paul (USA)
NIMA GOMBU (Np)
LHAKPA TEMBA (Np)

CUQ, Christian (Chl)
CUQ, Vivianne (Chl)
PRIETO, Cristina (Chl)
REUTER, Philippe (Chl)
SOTO, Patricia (Chl)
FURA DORJE (Np)
KAMI (Np)
CHHONGRA NURU (Np)
ONGCHHU (Np)

VALLEJO, Juan (E)
OIARZABAL, Juan Eusebio (Juanito) (E)
NIMA TAMANG (Np)

MacLAREN, Doug (Can)
O'BRYAN, Richard (Rick) (USA)
NIMA DORJE II (Np)
PASANG NARBU (Np)

CHESSELL, Duncan (Aus)
TSHERING PANDE BHOTE (Np)

DIJMARESCU, Gheorghe (USA)
LAKPA (Np)

ÁLVAREZ, Mikel (E)
GOÑI, Francisco (E)
REKETA, Julen (E)
THUKTEN DORJE (Np)
LHAKPA TSHERING II (Np)

MERELLI, Mario (It)
MONDINELLI, Silvio (It)
PASABAN, Edurne (E)
VALLEJO, Iván (Ec)
DAWA II (Np)

TOBIA, Marcus (Ven)
DELGADO, José (Ven)
PASANG TSHERING IV (Np)
LHAKPA THUDU (Np)

SORIA, Carlos (E)

FEAGIN, Nancy (USA)
OTXOA DE OLZA, Iñaki (E)
KILE (Np)
DAWA NURBU (DANURU) (Np)
LAMA JANGBU (Np)
LHAKPA GELU (Np)
MINGMA TSHERING I (Np)
DORJE IV (Np)

HENOSTROZA, Maximo (Per)
KELLY, Deryl (Can)
LANGLOIS, François (Can)
RODNEY, David (Can)
EDWARDS, Jason (USA)
ARITA (Np)
LHAKPA RITA II (Np)
DORJE III (Np)
TENZING (Np)
PASANG KITAR (Np)
TSHERING DORJE I (Np)
DAWA NURU I (Np)

NORBU (NURU) (Np)
NAWANG TENZING I (Np)

VERDEGUER, Jorge (E)
MINGMA THINDUK (Np)

BULL, Sherman (USA)
LHAKPA TSHERING IV (Np)
BULL, Bradford (USA)
MORRIS, Chris (USA)
BENITEZ, Luis (USA)
WEIHENMAYER, Erik (USA)
ALEXANDER, Eric (USA)
EVANS, Jeffrey (USA)
BROWN, Charles (Michael) (USA)
MACE, Charles (USA)
ANG SONAM (Np)
ANG PASANG III (Np)
ANG KAMI III (Np)
CHULDIN NURU (Np)
PEMBA CHHOTI (Np)
PHURBA BHOTE (Np)
LHAKPA TSHERING V (Np)
O'DONNELL, Michael (USA)
JOHNCK, Didrik (USA)

WAECHTER, John (USA)
WILSON, Gregory (Greg) (USA)
PHU TASHI (Np)
PASANG YILA (Np)

LAURSEN, Brian (Aus)
CHUWANG NIMA (Np)
NIMA NURU II (Np)

2002
APA (Np)
DAWA NURU (Np)
ANG SONA (Np)
TASHI TENZING (Aus)
SCHAFFTER, Stéphane (CH)
LAMBERT, Yves (CH)
VALLOT, Guillaume (F)
ARVIS, Philippe (F)

BENEGAS, Guillermo (Willi) (USA)
NIMA WANDEKI (Np)
GEIER, Robert (Aus)
WOOLUMS, Scott (USA)
RODI, Jason (Can)
PHANDEN (Np)
NANG CHOMBI (Np)
MINGMA CHHIRI (Np)
MINGMA TSHERING (Np)

PEMBA DOMA (Np)
LHAKPA TSHERING (Np)

UM, Hong-Gil (SK)
LEE, In (SK)
PARK, Mu-Taek (SK)

MURAGUCHI, Noriyuki (Jp)

SWARNER, Sean (USA)
NIMA GOMBU (Np)
KAMI (Np)

MILLER, Ellen (USA)
CHULDIM (Np)

WATANABE, Tamae (Jp)
NURU WANGCHU (Np)
CHEWANG DORJE (Np)
ANG PASANG (Np)

KHALATIAN, Igor (Arm)
PHURBA (Np)
NIMA NORBU (Np)

RA, Kwan-Ju (SK)

ERSHLER, Philip (USA)
ERSHLER, Susan (USA)
WHEELER, Edward (USA)
SMITH, Stuart (USA)
DANURU (Np)
MINGMA ONGEL (Np)
DORJE LAMA (Np)
MINGMA TSHERING (Np)

ÓLAFSSON, Haraldur Örn (Ice)
HIDDLESTON, David John (NZ)
CROUSE, William (USA)
PASANG TENZING (Np)
LHAKPA DORJE (Np)

STANFORD, Geoffrey (UK)
MORRIS, Michael (USA)
PEETERS, Randall L. (USA)
LHAKPA CHIRI I (Np)
PASANG DAWA (Np)
PASANG TSHERING (Np)
GURMIN DORJE (Np)
ERÖSS, Zsolt (Hun)

FOWLER, Charles (USA)

BIRD, Julio (USA)
LHAKPA GELU (Np)
LAMA JANGBU (Np)
PONCE DE LEÓN, Héctor (Mex)

BORISOV, Sergei (Rus)
BOLOTOV, Aleksei (Rus)

DIBONA, Mario (It)
WELLIG, Diego (CH)
BUMANN, Rasso (CH)
KOBLER, Karl (Kari) (CH)
MÉRAT, Michèle (CH)
CHASSOT, Raphael (CH)
NAWANG THILE (Np)
TASHI (Np)
AWANG (Chn)
PASANG (Chn)
PEMBA (Np)

ALLASON-PRITT, David (UK)
PEACOCK, Stuart (UK)
MOTHERSDALE, Christopher (UK)

YAMADA, Atsushi (Jp)
PHURBA TASHI (Np)
TAMURA, Shinji (Jp)
PHURBA TASHI (Np)

PERLER, Daniel (CH)
KRISHNA BAHADUR TAMANG (Np)

DIJMARESCU, Gheorghe (USA)

BAE, Young-Rok (SK)
PARK, Jong-Cheol (SK)
PASANG NURU (Np)
DAWA TSHERING (Np)

LARRANDABURU, Robert (F)
LAFITTE, Frédéric (F)
THILEN (Np)

BIELEFELDT, Hartmut (Ger)
BÄUMLER, Claudia (Ger)

HERMOSILLO, Jorge (Mex)

BONILLA, Badía (Mex)
FURA DORJE (Np)

CARRASCO, Demetrio (Mex)
SALAZAR, Javier (Mex)
PEÑA, Carmen (Mex)

EGOCHEAGA, Jorge (E)
NAWANG TENZING (Np)

MIYAZAKI, Tsutomu (Jp)
NAWANG SYATTY (Np)
MINGMA TSHERING (Np)

ISHIKAWA, Tomiyasu (Jp)
NIMA DORJE (Np)
TSHERING DORJE (Np)

CABAN, Miroslav (Cz)

NORTON, James (Jake) (USA)
KARMA RITA (Np)

KIRIEVSKI, Gennadi (Rus)
RAGOZIN, Valeri (Rus)
ERMACHEK, Yuri (Rus)
POVOLOTSKI, Vladimir (Rus)

NAGAMI, Shigeyoshi (Jp)
LHAKPA CHIRI II (Np)
TUL BAHADUR TAMANG (Np)
SATO, Shinji (Jp)
NOGUCHI, Koji (Jp)
PEMBA TSHERING (Np)
PHURBA CHHIRI (Np)

MORO, Simone (It)
CURNIS, Mario (It)
ANG MINGMA (Np)

ATHANS, Peter (USA)
HILLARY, Peter (NZ)
BISHOP, Brent (USA)
NIMA TASHI (Np)
DAWA (Np)
DAWA SONA (Np)
ARITA (Np)
KAMI (Np)

VILLAREAL, Alejandro (Mex)
THUKTEN DORJE (Np)

MAGLIANO, Alberto (It)
CHULDIN NORBU (Np)

BENITEZ, Luis (USA)
WITZIG, Arnold (CH)
LHAKPA RITA (Np)
PEMBA RINJI (Np)
LEROY, Joseph (USA)
KAMI RITA I (Np)
ANG PASANG (Np)
CHUWANG NIMA (Np)
ROBERTS, Michael (USA)

McDONALD, Cleve (USA)
MINGMA TSHERING (Np)
KAMI RITA II (Np)
PERALVO, José-Luis (Ec)
YODER, Karl (USA)
TEJAS, Vernon (USA)
TSHERING DORJE (Np)
PRITTIE, William (USA)

VAN DER MEULEN, Hans (NL)

†SIFFREDI, Marco (F)
PHURBA TASHI (Np)
PANURU (Np)
DAWA TENZING (Np)

ENDNOTES

These endnotes relate to references in the text of the book.

The Photographs, Joanna Wright

1. Mallory, George Leigh, in Charles Howard Bury *et al.*, *Mount Everest: The Reconnaissance, 1921*, New York: Longmans, Green, and London: Arnold, 1922; reprinted as *Everest Reconnaissance: The First Expedition of 1921*, edited by Marian Keaney, London: Hodder and Stoughton, 1991
2. Noel, J. B., *The Story of Everest*, Boston: Little, Brown, 1927; as *Through Tibet to Everest*, London: Arnold, 1927; reprinted (as *Through Tibet to Everest*), London: Hodder and Stoughton, 1989
3. Mallory *op. cit.*
4. Howard Bury *op. cit.*
5. Hillary, Edmund, in John Hunt, *Our Everest Adventure: The Pictorial History from Kathmandu to the Summit*, New York: Dutton, and Leicester: Brockhampton Press, 1954

The Highest Mountain in the World, John Keay

1. See, for instance, Noel, J. B., *The Story of Everest*, Boston: Little, Brown, 1927; as *Through Tibet to Everest*, London: Arnold, 1927; reprinted (as *Through Tibet to Everest*), London: Hodder and Stoughton, 1989
2. Colebrooke, Henry "On the Heights of the Himalaya Mountains" in *Asiatick Researches*, vol. 12, Calcutta: Asiatic Society of Bengal, 1816
3. See Webb, William, John Hodgson, and James Herbert in *Asiatick Researches*, vols 13 and 14, Calcutta: Asiatic Society of Bengal, 1818–1820
4. Markham, Clements R., *A Memoir of the Indian Surveys*, London: Allen, 1871; 2nd edition 1878, reprinted, Amsterdam: Meridian, 1968
5. Phillimore, Reginal Henry, *Historical Records of the Survey of India*, vol. 4, *1830 to 1843: George Everest*, and vol. 5, *1843 to 1860*, Dehra Dun: Surveyor General of India, 1958–68
6. Noel *op. cit.*

Chomolungma: Abode of the Gods, Ed Douglas

1. Howard Bury, Charles *et al.*, *Mount Everest: The Reconnaissance, 1921*, New York: Longmans, Green, and London: Arnold, 1922; reprinted as *Everest Reconnaissance: The First Expedition of 1921*, edited by Marian Keaney, London: Hodder and Stoughton, 1991
2. Bernbaum, Edwin, *Sacred Mountains of the World*, San Francisco: Sierra Club, 1990; reprinted Berkeley: University of California Press, 1997
3. Howard Bury *op. cit.*
4. Norbu, Namkhai, *The Crystal and the Way of Light: Sutra, Tantra, and Dzogchen, the Teachings of Namkhai Norbu*, compiled and edited by John Shane, New York and London: Routledge and Kegan Paul, 1986; reprinted, Ithaca, New York: Snow Lion, 2000.
5. Bruce, Charles Granville et al., *The Assault on Mount Everest, 1922*, London: Arnold, 1923
6. Trulshik Rinpoche, in conversation with the author
7. Quoted in Macdonald, Alexander, "The Lama and the General," *Kailash*, 1 (1973)
8. Noel, J. B., *The Story of Everest*, Boston: Little, Brown, 1927; as *Through Tibet to Everest*, London: Arnold, 1927; reprinted (as *Through Tibet to Everest*), London: Hodder and Stoughton, 1989

The Long Ascent, 1921–1953, Stephen Venables

1. Howard Bury, Charles *et al.*, *Mount Everest: The Reconnaissance, 1921*, New York: Longmans, Green, and London: Arnold, 1922; reprinted as *Everest Reconnaissance: The First Expedition of 1921*, edited by Marian Keaney, London: Hodder and Stoughton, 1991
2. Younghusband, Sir Francis, *The Epic of Mount Everest*, New York: Longmans, Green, and London: Arnold, 1926, reprinted, London: Pan, 2000
3. *ibid.*
4. *ibid.*
5. Graves, Robert, *Good-bye to all That*, London: Cape, 1929; New York: Cape and Smith, 1930; revised as *Goodbye to all That*, Garden City, New York: Doubleday, and London: Cassell, 1957; reprinted, New York: Anchor, 1998; Harmondsworth: Penguin, 1999
6. Letter from Ruth Mallory, quoted in *The Wildest Dream: Mallory, His Life and Conflicting Passions*, by Peter Gillman and Leni Gillman, Seattle: Mountaineers Books, and London: Headline, 2000

7. Letter to the *Morning Post*, Quoted in *Everest: A Mountaineering History*, by Walt Unsworth, Boston: Houghton Mifflin, 1981; as *Everest*, London: Allen Lane, 1981; third edition, as *Everest: The Mountaineering History*, Seattle: Mountaineers Books, and London: Bâton Wicks, 2000
8. Cobham, Sir Alan (editor), *Tight Corners*, London: Allen and Unwin 1940
9. Smythe, Frank, *Camp Six: An Account of the 1933 Everest Expedition*, London: Hodder and Stoughton, 1937; reprinted in *The Six Alpine/Himalayan Climbing Books* by Frank Smythe, Seattle: Mountaineers Books, and London: Batôn Wicks, 2000
10. Hunt, John, *The Ascent of Everest*, London: Hodder and Stoughton 1953; as *The Conquest of Everest*, New York: Dutton, 1954; second edition, Seattle: Mountaineers Books, and London: Hodder and Stoughton, 1993
11. Hillary, Sir Edmund, *View from the Summit*, London: Doubleday, 1999; reprinted, London: Corgi, 2000
12. Norton, Edward Felix *et al.*, *The Fight for Everest*, New York: Longmans, Green, and London: Arnold, 1925
13. Ullman, James Ramsey, *Tiger of the Snows: The Autobiography of Tenzing of Everest*, New York: Putnam, 1955; as *Man of Everest: The Autobiography of Tenzing*, London: Harrap, 1955; reprinted, London: Severn House, 1975
14. Hunt *op. cit.*

Sherpas: Tigers of the Snow, Tashi and Judy Tenzing

1. Shipton, Eric, *Upon That Mountain*, London: Hodder and Stoughton, 1943; reprinted in *The Six Mountain Travel Books* by Eric Shipton, Seattle: Mountaineers Books, and London: Diadem, 1985
2. Ward, Michael, "The Great Ang Tharkay: A Tribute," *The Alpine Journal*, Vol. 101 (1996)

The Continuing Challenge, Stephen Venables with Reinhold Messner

1. Hunt, John, *The Ascent of Everest*, London: Hodder and Stoughton 1953; as *The Conquest of Everest*, New York: Dutton, 1954; second edition, Seattle: Mountaineers Books, and London: Hodder and Stoughton, 1993
2. Oppitz, Michael, *Geschichte und Sozialordnung der Sherpa* [History and Social Structure of the Sherpas], Innsbruck and Munich: Univeritätsverlag Wagner, 1968

SUGGESTED READING

Bell, Sir Charles, *The People of Tibet*, Oxford University Press, 1928
Breashears, David & Salkeld, Audrey, *The Last Climb: The Legendary Everest Expeditions of George Mallory*, National Geographic, 1999
Bruce, Brigadier-General Hon. C. G., *The Assault on Mount Everest, 1922*, Edward Arnold & Co., London, 1923
Cameron, Ian, *Mountains of the Gods*, Century Publishing London, 1984
Clysdale, D & McIntyre D. F., *The Pilots' Book of Everest*, William Hodge & Co., Ltd., 1936
Dunham, Carroll & Baker, Ian, *Tibet: Reflections from the Wheel of Life*, Abbeville Press Inc., 1993
Fleming, Peter, *Bayonets to Lhasa*, Rupert Hart-Davis, 1961
French, Patrick, *Younghusband: The Last Great Imperial Adventurer*, HarperCollins Publishers, 1994
Gillman, Peter, *Everest: Eighty Years of Triumph and Tragedy*, Little, Brown and Company, 2001
Gregory, Alfred, *Alfred Gregory's Everest*, Constable, London, 1993
Hagen, Toni & Dyhrenfurth, G., *Mount Everest: Formation, Population and Exploration of the Everest Region*, Oxford University Press, 1963
Hillary, Sir Edmund, *High Adventure*, BCL Press, New York, 2003; London: *High Adventure*, Bloomsbury Publishing, 2003
Howard Bury, Lieutenant-Colonel C. K., *Mount Everest: The Reconnaissance, 1921*, Edward Arnold & Co., London, 1922
Hunt, John, *The Ascent of Everest*, Hodder & Stoughton, 1993
Hunt, John, *The Picture of Everest*, Hodder & Stoughton, 1954
Hunt, John, *Our Everest Adventure*, Brockhampton Press, 1954
Keay, John, *The Great Arc*, HarperCollins Publishers, 2000
Marshall, Howard, *Men against Everest*, Country Life Limited, 1954
Noel, J. B., *Through Tibet to Everest*, Edward Arnold & Co., 1927
Norgay, Jamling Tenzing, *Touching My Father's Soul*, HarperCollins, San Francisco, 2001
Norton, Lieutenant-Colonel E. F., *The Fight for Everest: 1924*, Edward Arnold & Co., 1925
Richardson, Hugh, *Ceremonies of the Lhasa Year*, Serina Publications, London, 1993
Rockhill, W. W., *Notes on the Ethnology of Tibet*, Government Printing Office, Washington, 1895
Ruttledge, Hugh, *Everest 1933*, Hodder & Stoughton Limited, 1934
Ruttledge, Hugh, *Everest: The Unfinished Adventure*, Hodder & Stoughton, 1937
Smith, J. R., *Everest: The Man and the Mountain*, Whittles Publishing, 1999
Tenzing, Tashi & Judy, *Tenzing Norgay and the Sherpas of Everest*, Ragged Mountain Press/McGraw Hill, 2001
Tilman, H. W., *Mount Everest 1938*, Cambridge University Press, 1948
Unsworth, Walt, *Everest*, Penguin Books Ltd., 1981
Ward, Michael, *The Mapping of Everest*, The Map Collector, Number 64, Autumn, 1993
Ward, Michael, *Mapping Everest*, The Cartographic Journal, June 1994, Journal of the British Cartographic Society

ROYAL GEOGRAPHICAL SOCIETY
WITH THE INSTITUTE OF BRITISH GEOGRAPHERS

The Society was founded in 1830 and given a Royal Charter in 1859 for "the advancement of geographical science." It was pivotal in establishing geography as a teaching and research discipline in British universities and has played a key role in geographical and environmental education ever since. It holds historical collections of national and international importance, many of which relate to the Society's association and support for scientific exploration and research from the nineteenth century onward.

Today the Society is a leading world center for geographical learning—supporting education, teaching, research, and expeditions, as well as promoting public understanding and enjoyment of the subject.

The Society welcomes those interested in geography as members. For further information, please visit the website: www.rgs.org

ROLEX The Royal Geographical Society (with The Institute of British Geographers) would like to thank Rolex for its generous support of the Everest Archive Project 2001–03. This support has allowed photographs taken on nine British Mount Everest Expeditions, of which a selection are featured in this book, to be cataloged and electronically databased. This important information will be available on-line and widely accessible.

The Mount Everest Foundation, formed by the Society and the Alpine Club, continues to support the exploration and understanding of the world's mountain regions. Over 1300 expeditions have received grants since 1953. Further details of MEF and their plans to celebrate the 50th Anniversary of the first ascent of Everest can be found on their website (www.mef.org.uk).

PICTURE ACKNOWLEDGMENTS

Royal Geographical Society images are found on the following pages: front cover, 2, 3, 4, 8, 9, 11 (Tibetan map), 12, 13, 14, 15, 16, 17, 19, 20, 21, 22, 23, 24, 25, 26, 27, 28, 29, 30, 31, 32, 33, 34, 35, 37, 38, 40, 41, 42 (bottom, left and right), 43, 44, 45, 48, 49, 52, 53, 54, 55 (bottom, left and right), 56 (top, bottom right), 57, 58, 59, 60, 61, 64, 65, 68, 69, 70, 71, 72, 73, 74, 75, 77, 78, 79, 80, 81, 82, 83, 84, 85, 86, 87, 88, 89, 90, 91 (bottom), 92, 93, 94, 95, 96, 97, 100, 101, 102, 103, 104, 105, 106, 107, 108, 110, 111, 114, 115, 116 (bottom), 120, 121, 122, 123, 124, 125, 126, 127, 128, 129, 130, 131, 132, 133, 134, 135, 136, 137, 138, 139, 140, 142, 143, 144, 145, 146, 147, 148, 149, 150, 151, 152, 153, 154, 155, 156, 158, 159, 161, 163, 164, 165, 166, 167, 168, 169, 170, 171, 172, 173, 175, 176, 177, 178, 179, 180, 181, 182, 183, 184, 185, 186, 187, 188, 189, 190, 191, 192, 193, 194, 195, 196 (all, except middle, right), 197, 198, 199, 200, 201, 202, 203, 204, 205, 206, 208, 209, 210, 211, 212, 213, 214, 215, 216, 217, 244 (except Ang Tshering), 245 (except Maj. Richard William George Hingston), 246, 247, 248

David Constantine/Royal Geographical Society: 18; Bruce Herrod/Royal Geographical Society: 224; Roger Mear/Royal Geographical Society: 241; Stephen Venables/Royal Geographical Society: 7, 235, 236

Other photographs are listed below:
Alpine Club: 118, 119, 141 (top); Lynn Binder: 174; Chris Bonington Picture Library: 227 (Doug Scott); Demetrio Carrasco: 221, 222, 234; Leo Dickinson: 238; Jeff Hall: back cover, 67; Sir Edmund Hillary: 160, 162; Raul Ledesma: 219, 240; Reinhold Messner: 228, 229, 233; Mountain Camera: 218 (Doug Scott), 223 (John Cleare); The John Noel Photographic Collection: 36, 39, 42 (top), 50, 51, 55 (top), 56 (bottom, left), 63, 76, 91 (top), 99, 109, 112, 113, 116 (top); 117, 196 (middle, right), 245 (Maj. Richard William George Hingston); Frank Nugent: 231; The Office of His Holiness the 14th Dalai Lama: 11; Jean Marc Porte: 239; Javier Salazar: 230; Tony Smythe: 141 (bottom); Swiss Foundation for Alpine Research: 157, 220; Stephen Venables: 46, 47, 225, 232, 243; Ed Webster: 226; Joanna Wright: 207, 244 (Ang Tshering)

Special thanks are due to the following:
The Alpine Club, London, Maragret Eccleston, Bob Lawford, Sue Lawford, Sandra Noel, the Mount Everest Foundation, George Band, Alfred Gregory, Peter Lloyd, George Lowe, Michael Ward, Mike Westmacott, Charles Wylie, Tony Smythe, Sue Thompson, John Bonham, Nick and Betsy Clinch, Nick van Gruisen, Jane Moore, Oliver Turnball, Roy Fox, Alex Fox, Max Communications, Sky Photographic, Julie Carrington, Clive Coward, Francis Herbert, Justin Hobson, David McNeil, Eugene Rae, Elliot Robertson, Sarah Strong, Dr. Andrew Tatham, Janet Turner, and Nigel Winser.

CHART OF THE ASCENT OF EVEREST

PREPARED BY CHARTWELL PRESS

This diagram illustrates the heights reached by various members of the 1953 expedition between April 11 and June 3, 1953, as well as the duration of time they spent at various elevations.

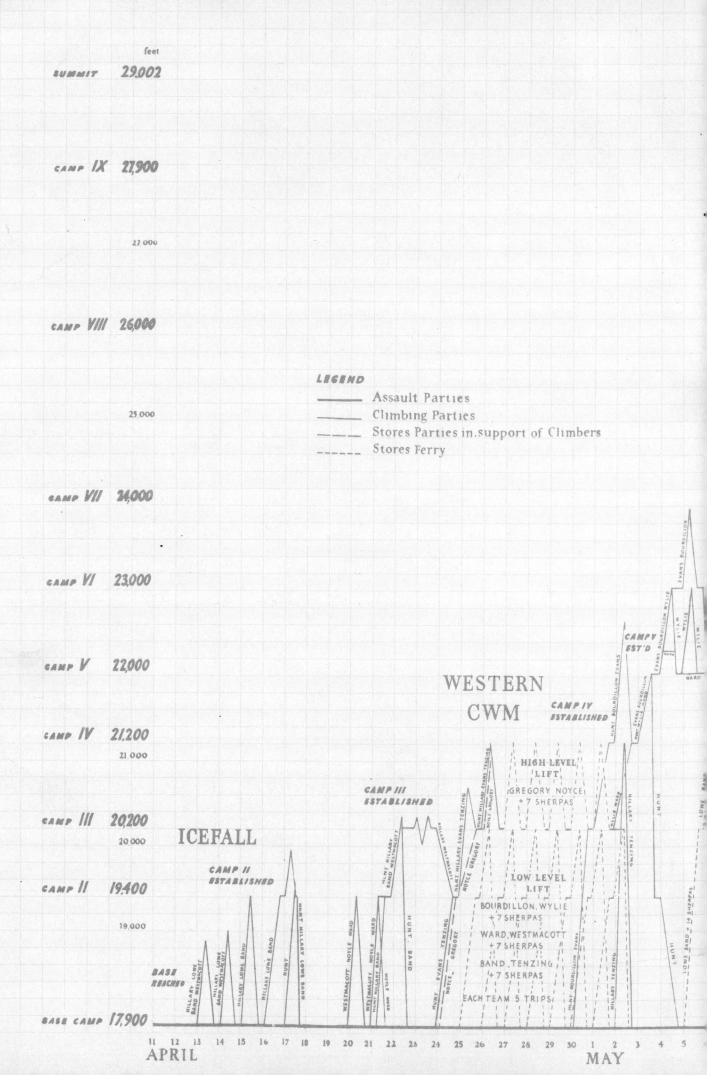